Design in the USA

Oxford History of Art

D1367693

Jeffrey L. Meikle is Professor of American Studies and Art History at the University of Texas at Austin. He is the author of *Twentieth Century Limited: Industrial Design in America, 1925–1939* (Temple University Press, 1979) and *American Plastic: A Cultural History* (Rutgers University Press, 1995), which was awarded the Dexter Prize by the Society for the History of Technology. His publications also include numerous articles, catalogue essays, and reviews. He has served as a consultant to the Art Institute of Chicago, the National Museum of American History, and the Wolfsonian Foundation.

Oxford History of Art

Titles in the Oxford History of Art series are up-to-date, fully illustrated introductions to a wide variety of subjects written by leading experts in their field. They will appear regularly, building into an interlocking and comprehensive series. In the list below, published titles appear in bold.

Oxford History of Art

Design in the USA

Jeffrey L. Meikle

OXFORD

UNIVERSITY PRESS

Great Clarendon Street, Oxford OX2 6DP

Oxford New York

Auckland Bangkok Buenos Aires Cape Town
Chennai Dar es Salaam Delhi Hong Kong Istanbul Karachi
Kolkata Kuala Lumpur Madrid Melbourne Mexico City Mumbai
Nairobi São Paulo Shanghai Taipei Tokyo Toronto
and associated companies in Berlin Ibadan

Oxford is a registered trade mark of Oxford University Press
in the UK and in certain other countries

© Jeffrey L. Meikle 2005
First published 2005 by Oxford University Press

All rights reserved. No part of this publication may be reproduced,
stored in a retrieval system, or transmitted, in any form or by any means,
without the proper permission in writing of Oxford University Press.
Within the UK, exceptions are allowed in respect of any fair dealing for
the purpose of research or private study, or criticism or review, as permitted
under the Copyright, Design and Patents Act, 1988, or in the case of
reprographic reproduction in accordance with the terms of the licences issued by
the Copyright Licensing Agency. Enquiries concerning reproduction outside
these terms and in other countries should be sent to the Rights Department,
Oxford University Press, at the address above.

This book is sold subject to the condition that it shall not, by way of trade
or otherwise, be lent, re-sold, hired out or otherwise circulated without
the publisher's prior consent in any form of binding or cover other than
that in which it is published and without a similar condition including
this condition being imposed on the subsequent purchaser.

0-19-284219-6

10 9 8 7 6 5 4 3 2 1

British Library Cataloguing in Publication Data
Data available

ISBN 0-19-284219-6

Picture research by Elisabeth Agate
Copy-editing, typesetting, and production management by
The Running Head Limited, Cambridge, www.therunninghead.com
Printed in China on acid-free paper by C&C Offset Printing Co. Ltd

Contents

For Aidai, Anna, and Andrew

Acknowledgements

My interest in the history of design has been stimulated over the years by discussions with Bob Bednar, Reggie Blaszczyk, Kate Catterall, Sally Clarke, Christina Cogdell, Tim Davis, Carolyn Thomas de la Peña, Joel Dinerstein, Dennis Doordan, Chris Fay, Robert Friedel, Peter Hales, John Heskett, Wendy Kaplan, Nic Maffei, the late Roland Marchand, Vicki Matranga, Shelley Nickles, Valerie Pearcy, Glenn Porter, Ray Sapirstein, Penny Sparke, Randy Swearer, and especially Victor Margolin. I appreciate the dedication of research assistants Sarah Mullen and Vanessa Meikle, who read through the complete run of *Industrial Design* magazine. Vanessa, my daughter, also offered a particularly insightful reading of the first draft of the manuscript. The earliest phase of this project was generously supported by a Fellowship from the American Council of Learned Societies, a Summer Stipend from the National Endowment for the Humanities, and a Faculty Research Assignment from the University of Texas at Austin. Rusty Sealy kindly provided a place to work at a critical moment. I'm grateful to colleagues at the Renvall Institute of the University of Helsinki who welcomed me as Bicentennial Fulbright professor during the year I completed this book. On Oxford's production team, I want to thank Elisabeth Agate for her determined tracking down of obscure images and David Williams for his superb managing of all aspects of editing and design. As always, my wife Alice was the best critic. She read each draft as an unwieldy manuscript became shorter and—I hope—more to the point.

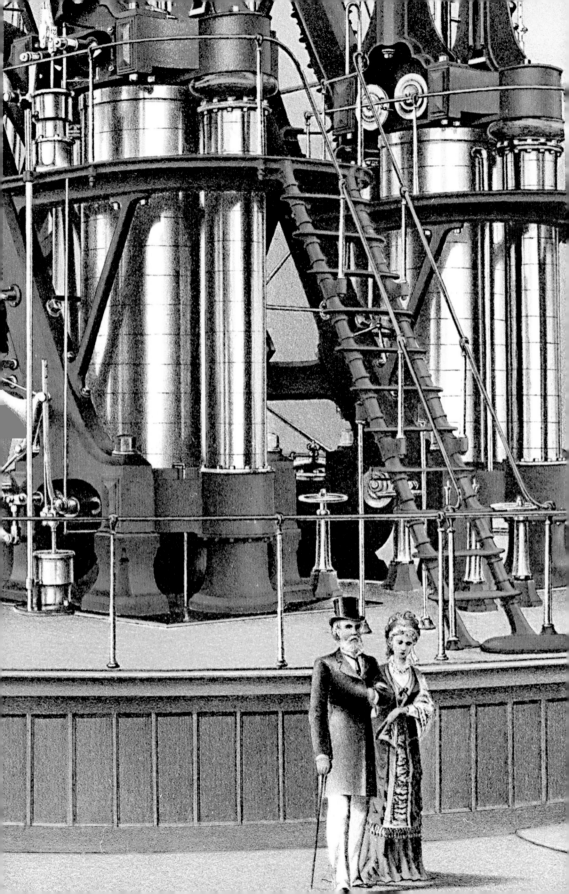

Introduction

American materialism

The first inhabitants of North America dwelt in a natural landscape shimmering with animistic significance. Each mountain, spring, or waterfall projected an aura of primal force or mythic event. Europeans who had settled the east coast in the seventeenth century violated this aboriginal sense of seamless union with the natural world. In New England, for example, colonists followed a grim Calvinist theology that steeled them to wrest a livelihood from a 'howling wilderness'. They celebrated their success in subduing the land as a sign of God's favour. Other settlers later adopted the rationalism of Isaac Newton, whom they thought had discovered the laws governing the movements of God's clockwork universe and, by extension, all of nature. The North American continent seemed either a storehouse of material resources ripe for exploitation or an empty Lockean *tabula rasa* waiting for Europeans to write upon it, to build a new civilization. Whether as Calvinist pessimists or Enlightenment optimists, the new Americans perceived their material surroundings as a vast natural realm at their disposal.

Some 150 years later, two revolutions coincided to shape the future of US history and design. While the American Revolution established a new type of democratic polity, the Industrial Revolution transformed traditional social patterns of working and living. The explosive growth of cities during the nineteenth and twentieth centuries separated people from natural rhythms and landscapes, placed them in artificial surroundings, and made them dependent on an increasing flow of factory goods—some essential for survival, others intended for comfort or delight, and all the result of planning by their designers and makers. American democracy depended on design at a time when the vision of a good life for everyone was becoming less spiritual and more material.

Now, at the opening of the twenty-first century, the inhabitants of the United States are enmeshed in artificiality. Americans cannot escape continuous contact with the results of human design at every scale—whether landscapes, cities, buildings, objects, or digital artefacts.

1 Chermayeff & Geismar

Pioneer section, 'A Nation of Nations' exhibition, National Museum of History and Technology, Smithsonian Institution, 1976

The open spaces and simple artefacts of this gallery reflected the austerity of early American material existence.

2 Chermayeff & Geismar

Neon signs, 'A Nation of Nations' exhibition, National Museum of History and Technology, Smithsonian Institution, 1976

The exhibition's final sections emphasized the overwhelming presence of visual communications in the twentieth century. An array of signs for ethnic eating and drinking establishments recalled the diversity of peoples who had settled in the US since independence 200 years before.

Maintaining viable communities depends on systems of communication and transportation. Bodily nourishment depends on mechanized farming and complex distribution systems. Daily life's simplest physical and emotional satisfactions depend on an array of material and digital products. The former blank slate of American nature has been overwritten by a complex assemblage of artificial constructs—all the result of rational processes of design.

The meaning of this continuing transformation emerges if we take an imaginary tour of an exhibition installed over a quarter century ago at the Smithsonian Institution in Washington, DC. 'A Nation of Nations', the centrepiece of the museum's celebration of the US Bicentennial in 1976, documented the expanding artificiality of everyday life over two centuries. Visitors entered the exhibit in a darkened passage devoid of material artefacts, lit only by an interactive map whose pinpoints of light traced migration patterns of settlers of different nationalities—including African slaves, who had no choice in the matter. Moving forward, visitors traversed a series of galleries, still dimly lit, with objects scattered left and right [1]. The limited number of these handmade things—wooden and iron tools, garments of linen and wool, a crudely printed broadside—suggested the scarcity of material possessions among colonists and pioneers. Continuing on, figuratively entering the nineteenth century, visitors passed displays ever more crowded with manufactured goods—an iron cooking stove, tinware, pressed glass, ornamental ceramics, a sewing machine, watches and mantle clocks, gaslight fixtures, a polished piano with ivory keys, beaver hats, satin ribbons, brushes and combs of tortoiseshell and celluloid, books and pamphlets, pens and pencils, daguerreotypes— often arranged in furnished interiors suggesting the greater materiality of everyday life.

As visitors approached the twentieth century, the arrays of artefacts became denser. Their forms and materials were more varied, their practical uses and status indicators more complex, offering evidence of a quantum leap in the realm of the artificial. Electrical devices emitting light, sound, and visual images proliferated. Accelerating through the final sections, 'A Nation of Nations' ended in sensory overload as conflicting information media—phonograph, radio, movies, television, neon and acrylic signs, corporate logotypes—competed for attention with a host of colourful products made of aluminium, steel, chrome, rubber, and plastic [2, 3]. All this constituted the ephemeral but still overwhelmingly material world of the Bicentennial present. Even a casual visitor absorbed a sense of the material basis of American life. Additional reflection brought an awareness of the degree to which the democratic pursuit of happiness was related to an increasing flow of material goods—all of them the products of design.

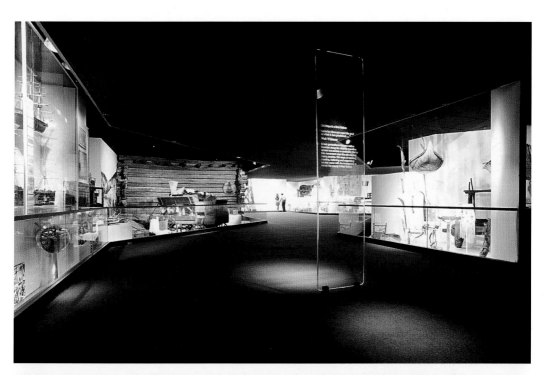

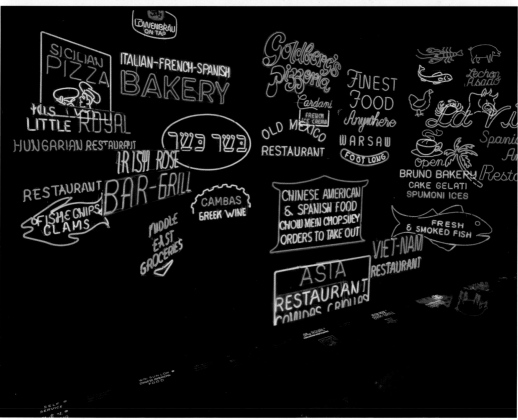

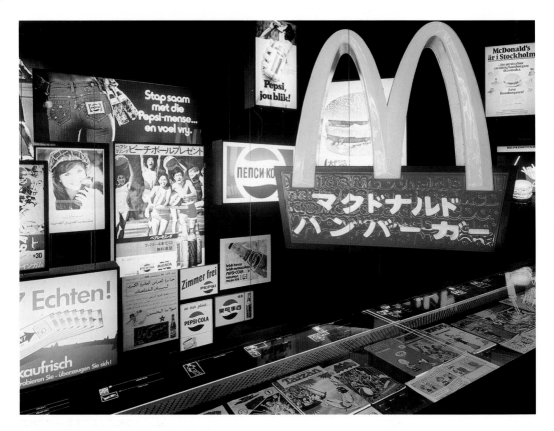

3 Chermayeff & Geismar

Commercial images, 'A Nation of Nations' exhibition, National Museum of History and Technology, Smithsonian Institution, 1976

Familiar American commercial icons in unfamiliar languages indicated a process of economic and cultural globalization whose extent probably surprised most visitors in 1976. American design has often involved attempts to create—and ultimately to export—a national culture.

Defining design

No one is quite sure how to define design. Is it process or product? Is it verb or noun? Is it a universal human endeavour or a response to particular historical circumstances? How should we consider it? Are we passive or active in response to it? Design is a complex activity affecting almost everything we use, touch, look at, or listen to. It shapes objects at every scale of the material environment, however large or small—toothbrushes and automobiles, microchips and medical scanners, building materials and planned communities, personal websites and the Internet that connects them. Such phrases as 'designer jeans' evoke superficial elements of style, while philosophical meditations on design often begin with prehistoric tools and subsume centuries of technological development under the rubric of design.

A more modest historical approach maintains that design emerged during the Industrial Revolution. Before then, an artisan laboured by hand to produce an object whose outline was set by tradition but whose final form varied according to imperfect materials, minor accidents in working the material, and a customer's wishes. An artisan's intention moved from mind's eye through hand's motion to the shaping of a physical object. This simple process, involving minute variations in oft-repeated motions under the intuitive direction of a

single individual, yielded to a more complex process when the factory replaced the workshop, when production of a series of nearly identical objects replaced the fashioning of unique artefacts. The task of planning or conceiving work was separated from the task of carrying it out. A new type of worker, the designer, devised two-dimensional patterns or three-dimensional prototypes to be copied by other workers using precise machines. Unlike an artisan, who communicated directly with individual customers, a designer guessed at the needs and desires of distant customers and accommodated them only generally. While an artisan received a direct reward from a satisfied customer, a designer received an indirect reward, a wage from a factory owner whose goals included minimizing costs and maximizing production as well as satisfying customers. The designer thus served two masters whose interests did not always coincide.

Constraints are the essence of the design process. A designer must integrate a complex set of often contradictory solutions when designing even the most ordinary object. A product's mechanically functional components must be arranged to operate efficiently with little waste of energy and human effort. They must be manufactured of durable materials and arranged to require little maintenance. A designer must also consider supply or manufacture of component parts and methods of final assembly of a product, not to mention packing, packaging, and retail display. Taken as a whole, the assemblage of parts must meet the needs of a range of diverse bodies and minds. It must be easy to operate and control, and remain safe during any conceivable use or misuse. As if this were not already difficult, an artefact's shapes, colours, and textures must not only suggest its functions but also appeal to an intuitive aesthetic sense whose shifting fancies seek novelty as often as harmony. Considering this web of conflicting requirements, a promoter of design once defined the profession's work as 'intelligence made visible'.[1]

Many observers take design on its own terms without exploring wider social or cultural significance. When they do place design in historical context, they often view it uncritically as evidence of humanity's progressive evolution. Design is considered as a means of extending rational control over human environments. According to the philosopher Herbert A. Simon, for example, design is 'concerned with how things *ought* to be'. The historian Henry Petroski has speculated that irritation and frustration provoke designers, who tweak things so that they 'do what they are supposed to do'. Taking a wider perspective, the critic Ralph Caplan echoes this theory of 'negative' motivation when he says that design 'is the only way we have of coming to terms with our own technology'. Designers 'work to reduce alienation' by humanizing or domesticating the products of the machine. In the final analysis, as the philosopher David Pye phrases it, 'design is a matter of imposing order on things'.[2]

However sensible such definitions of design may seem, however useful for understanding the motives of designers and the immediate results of their work, they ignore important questions: Whose order is it that design imposes? For what purposes? And with what results? Answers to these questions must be sought outside the design process, in its relationships with larger historical structures and patterns. Most general theories of design assume that design is unproblematic, that it exhibits a universal trend towards greater rationality, and that it works unambiguously for the betterment of humanity by easing the conditions of everyday life. However, such theories tend to be simplistic. Because design itself proceeds from the Industrial Revolution, which was one of the most significant and disruptive social transformations of the past three centuries, understanding the workings of design requires a historical interpretation. Paul Greenhalgh rightly claims the entire 'history of objects' as the domain of the design historian, encompassing 'the way we make things, the way we consume them, and the myriad of meanings they have for us'.[3]

Design and art

Such thoughts may seem to have little connection with the history of art. In fact, many historians and critics caution against looking at design in traditional art-historical terms, for example as a parade of such creative individuals as Louis Comfort Tiffany (1848–1933), Raymond Loewy (1893–1986), and Charles Eames (1907–78); or as a roster of aesthetically great works (Tiffany lamps, Loewy's teardrop pencil sharpener, and Eames's moulded fibreglass chair); or as a progression of aesthetic styles (Art Nouveau, Streamlined Moderne, and High Modern). Richard Buchanan, for example, ignores what he calls 'poetics' (defined as 'the study of products as they are') so he can focus on 'rhetoric' ('the study of how products come to be as vehicles of argument and persuasion about the desirable qualities of private and public life'). And yet, those very qualities of design, largely commercial and often pertaining to commodification, became the object of such significant late-twentieth-century art as the mass-produced silk-screened soup cans of Andy Warhol (1928–87). At the same time, designers and graphic artists applied techniques and motifs borrowed from so-called fine art, rendering them more accessible and placing them in the service of commerce, but also thereby opening them up to populist uses and meanings never intended by their creators. The sociologist Pierre Bourdieu refers to these two related processes when he describes 'a systematic reduction of the things of art to the things of life' and, running in the opposite direction, 'the stylization of life, that is, the primacy of forms over functions'.[4]

It may have been an exaggeration to claim that 'industrial design is

the art of the twentieth century'.[5] All the same, millions of Americans and others continue to seek aesthetic stimulation and emotional satisfaction through goods that are designed and manufactured not only to provide such fulfilment but also to meet functional needs and to yield capitalist profits. The purpose of this book is to trace the history of design in the US as a functional tool, as an economic force, and as the expression of a consumer culture that continues to transform everyday life. While always remaining aware of the full extent of design, our attention will focus on the vast array of commercially produced objects, most intended for personal use, which over time have made up an ever increasing component of the material world.

The Emergence of the American System, 1790–1860

1

During the earliest English settlement of the eastern seaboard in the 1600s, many colonists understood their lives as ruled by an overarching 'design'. Most extreme in this regard were the New England Puritans, who regarded themselves as God's chosen people and sought to build a spiritual 'city upon a hill'. Even in Virginia, settled for commercial motives, the concept of a grand design proved compelling. Protesting against imperial controls in the 1770s, Thomas Jefferson described a tyrannical 'design' to rob colonists of traditional English liberties. If God no longer directed events, then Enlightenment rationalists assumed that conscious human intention must be shaping society's course. Nothing could happen by chance. Everything happened 'by design'. Such uses of the word design might seem unrelated to the design of material artefacts, but there is indeed a connection. The Puritans anticipated a spiritual redemption of the material realm, counter to traditional wisdom which had held it to be unchanging and unregenerate. Reacting likewise against the stasis of medieval society, the patriots of the American Revolution sought to apply reason to create a society open to political experiment and social change. Such beliefs gave meaning to the experiences of ordinary men and women as they made their livings in the New World. Americans were prepared to participate actively in transforming the material environment—a process that involved them in design at every turn.

The myth of colonial self-sufficiency

Most North American colonists of the seventeenth and eighteenth centuries lived off the land as farmers. Even into the twentieth century, long after manufacturing and commerce had claimed most workers, many Americans continued to think of their nation as rooted in agriculture. But the self-sufficient, individualist yeoman farmer, famously celebrated by Jefferson in 1787 as the sole guardian of national virtue and independence because he remained free of debt and beholden to no one, unlike the industrial workers of Europe, was mostly a myth. Even during the earliest years of colonization, when few people lived beyond a subsistence level, most depended on others in the colonies

Detail of 20

and in Britain for material goods essential to survival or to self-respect. Many colonists, especially in New England, eked out a living raising foods for their own consumption. But New Englanders also harvested raw materials such as furs, fish, timber, and pitch for trade with Britain. Farmers in New York, New Jersey, and Pennsylvania produced wheat for export to other colonies and to Britain. Self-reliance failed most notoriously in the southern colonies, where planters relied on African slaves for intensive labour required to grow tobacco, indigo, and—later—cotton for export. In return, by 1750 the colonists were receiving a steady stream of manufactured goods from Britain: iron tools, hardware, nails, tinware, earthenware, glassware, pewter, window glass, clocks, carpets, bolts of cloth, buckles, and buttons.

At first only wealthy merchants in the seaports or the wealthiest southern planters could enjoy an array of imported goods. By the eve of the Revolution, however, they had trickled down to a wider market whose customers considered them no longer as luxuries but as necessities, or at least as things they could hope some day to possess—in effect, as objects of consumer desire just out of reach. Although the war disrupted foreign trade, citizens rushed to acquire imported goods after peace was declared in 1783. The political leader Tench Coxe (1755–1824) regarded this 'madness for foreign finery' as a 'malignant and alarming symptom'.[1] For him the solution was not the individual self-sufficiency of Jefferson's yeoman farmer but a national self-sufficiency derived from domestic manufactures and the mutual cooperation of trade. Coxe's overheated rhetoric suggested a fear of becoming too comfortably involved with the things of the material world. This ambivalence coloured American perceptions of 'finery', style and fashion, and—later—design. The work ethic of production that marked American culture even into the twentieth century masked a fear that people became weak and passive as they yielded to the attractions of consumption.

Colonial Americans had lived simply, however, and many continued to do so after independence. Especially in rural areas or small villages, they made many of their belongings at home, such as wooden dishes and utensils, brooms, baskets, butter churns, troughs for kneading dough, washboards, simple furniture, spinning wheels and looms, and rough linen and woollen cloth. But they also relied on craftspeople or artisans as sources for many goods essential to even the simplest lifestyle. Although the first colonists ground their own corn and wheat by hand, in most districts there was a miller using water power to turn large grindstones. Sawyers and their mills were equally important, as were blacksmiths, carpenters, coopers, shoemakers, tanners, and eventually weavers, tailors, hatters, and cabinetmakers. Many artisans were itinerant, stopping only long enough to satisfy local demand. Others who could not survive by their craft alone earned much of their living

through farming. Many villages supported several such individuals, bartering their work for that of others and for agricultural produce.

In port cities like Philadelphia, Boston, and New York, a diversified market economy developed by the mid-1700s. Specialized artisans plied their crafts in response to expanding consumer demand. Rapid population growth stimulated new construction, which gave employment to carpenters, masons, bricklayers, plasterers, and painters. Woodworking was taken up by joiners, turners, carvers, cabinet-makers, wagon and coach builders, wheelwrights, and coffin makers. A necessity like shoes evolved its own subsidiary division of labour: tanners, curriers, and dressers to prepare the leather, last makers to provide the wooden forms over which it was shaped, and heel makers. Other artisans earned their living as candle makers, saddle makers, silversmiths, clockmakers, engravers, printers, and, when social leaders sought reassurance of their status, as portrait painters. In 1792 a British visitor credited cosmopolitan Americans for being as advanced as Britons in the pursuit of style. After declaring the 'quick importation of fashions from the mother country' to be 'astonishing', he noted 'that a new fashion is adopted earlier by the polished and affluent Americans, than by many opulent persons in the great metropolis' of London.[2]

This comment suggested that cultural independence did not immediately follow political independence. At least into the 1830s and 1840s, when the rise of Jacksonian democracy coincided with the awakening of romantic nationalism, most Americans looked across the Atlantic for cultural guidance. But not everyone who sought to maintain appearances could afford furniture and tableware from Britain. Even many among the wealthy had to accept furnishings made in America. With city-dwellers pursuing the latest London styles, urban craftsmen satisfied the demand by directly copying imported goods or by borrowing motifs from pattern books such as Thomas Chippendale's *Gentleman and Cabinet-maker's Director* (1754). Chairs and cupboards made in Philadelphia or New York eventually reached the provinces, where they inspired local woodworkers to produce furniture that was meant to evoke up-to-date style, though it only faintly echoed the original British models.

Urban aspirations penetrated small towns and rural areas as fair-to-middling folks demanded more and better things than the bare necessities they had traditionally provided for themselves or obtained from neighbours. Anecdotal evidence appeared in 1787 in a popular magazine that described the marriage preparations of three sisters living on a farm near Philadelphia. The eldest, married in 1780, had to spin the family's best wool and flax to make her own shifts, stockings, and gowns. Two years later, however, the mother travelled to Philadelphia to buy her second daughter 'a calico gown, a calamanco petticoat,

a set of stone teacups, a half-dozen pewter teaspoons, and a tea-kettle'—none of which the mother had ever possessed. Three years after that, the youngest received 'a silk gown, silk for a cloak, a looking-glass, china, tea-gear, and other finery'.[3] Far from being coerced to consume things they did not need, this Pennsylvania farm family—and thousands of others like them—hungered for material goods and actively sought them out. The last thing they wanted was the self-sufficiency of Jefferson's archetypal yeoman.

This rising consumer demand generated social and economic pressures that transformed the material conditions of everyday life in the early nineteenth century. The process of making things changed as traditional craft methods evolved into machine-based factories staffed by unskilled labour. The process of acquiring things changed as warehouses, retail shops, and networks of peddlers replaced the traditional face-to-face meeting of artisan and customer. Developing unevenly here and there, these new forms of production and consumption comprised an 'American System' so unprecedented that a visiting delegation of British engineers in the 1850s coined that phrase to refer to it. Mediating between production and consumption, though no one knew quite how to talk about it, was design. Confronted with the challenge of satisfying a faceless multitude, makers and sellers of manufactured goods began to pay attention—at first naively and awkwardly—to appearance, attractiveness, and appropriateness. From the outset, design thus involved a confusion of motives. An emphasis on more than simple function suggested that design addressed a democratic people's desire not only to emulate those of higher social status but also to outshine them.

From craft to mechanized production

More than any other factor, the great western migration across the continent—a chaotic influx of varied peoples—determined the material parameters of everyday life in the United States. Between 1790 and 1860 the population increased from nearly four million to more than 31 million. At the same time population density more than doubled as people gravitated towards towns and cities where they rubbed elbows with diversity, aspired to possess more than they could personally make, and learned how to put on the appearance of enhanced social status in fluid, impersonal situations. An expanding population stimulated consumer demand for manufactured goods, challenging producers to devise innovative methods for supplying an ever higher volume of products. Unlike population growth in Europe, which was constrained by enclosed land, entrenched aristocracies, and relative scarcity, American growth during the early nineteenth century was surrounded by abundance and optimism. New

households required a steadily increasing supply of furniture, house-wares, domestic tools, and farming implements. As if rising consumer demand were not challenging enough for artisans and craftspeople, they also suffered an acute labour shortage. Farming attracted young men who would otherwise have entered apprenticeships and siphoned off skilled European immigrants who abandoned craft training to seek fortunes in the fertile soil of Ohio or Illinois.

Struggling to overcome labour shortages and meet runaway consumer demand, artisans and entrepreneurs devised the manufacturing side of the American System. For an individual manufacturer, the challenge was to produce a greater number of things—guns, clocks, or chairs, for example—in a fixed period of time, using unskilled labour, and without sacrificing the quality consumers expected. The solution involved rationalizing the steps involved in manufacture and mechanizing as many as possible. In traditional craft production, a single artefact took shape under the direction of a master craftsman who personally carried out or guided his apprentices in carrying out a series of operations involving different hand tools in a sequence that varied considerably with each individual artefact. The American System involved transferring these imprecise actions to a carefully sequenced series of specialized machine tools (milling machines, drills, presses, and lathes), each performing a single action so unvaryingly that it could be operated by a relatively unskilled worker, and so precisely that it yielded a series of nearly identical objects. The intuitive intelligence of the craftsman yielded to the rational intelligence of the mechanic who organized the precise, repetitive motions of a series of machines [4].

The logic of this new organization of work emerged over the first decades of the nineteenth century. For many years, historians traced the American System to Eli Whitney (1765–1825), who signed a contract with the US government in 1798 to supply 10,000 military muskets within two years—an impossible task given the painstaking intensive methods of a master gunsmith. To obtain the contract, Whitney promised interchangeable parts so precisely machined that a working musket could be assembled from pieces picked at random or from parts of damaged muskets salvaged from a battlefield. This concept was so attractive that the government tolerated delay after delay. The final musket was not delivered until 1809. Despite Whitney's claims, historians have proven he did not successfully produce muskets with interchangeable parts. Nor did he fully shift from craft methods to a series of machine tools, but his struggle pointed the way.

John H. Hall (1781–1841) finally made good on Whitney's promise in 1824 by delivering to the government 1,000 breech-loading rifles with fully interchangeable parts. In designing his machine tools, Hall developed a means of assuring precise dimensions as a part moved

4 Thomas Blanchard

Blanchard lathe, 1822
This machine tool cut irregular
three-dimensional wooden
forms by following the shape
of a full-sized model. Only the
model required the attention
of an artisan who in shaping it
became the designer of a
prototype. Invented by
Blanchard (1788–1864) for
making gunstocks, the
Blanchard lathe was later
applied to oars, wagon wheel
spokes, shoe lasts, axe
handles, and other wooden
artefacts.

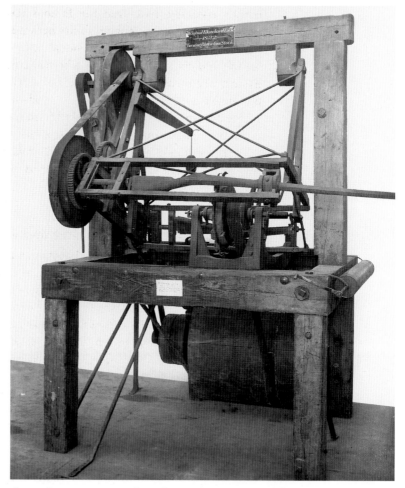

through a sequence of mechanical operations. The challenge was to overcome a multiplier effect in which a minor dimensional imprecision introduced by one machine became a major functional distortion when amplified by subsequent operations of other machines. His solution involved giving each piece of work a single register point at which it was clamped to each machine tool in the production sequence. Each tool thus started its work from the same fixed reference point, and Hall avoided the cumulative effects of random errors.

Although interchangeability of parts was to transform industry in the twentieth century, historians have exaggerated its significance to nineteenth-century manufacturing. Such a degree of precision appealed to government arms purchasers who could ignore high cost as they sought reliable performance under rigorous conditions. However, mechanics and entrepreneurs who expanded the American System to such consumer goods as clocks, reapers, sewing machines, and bicycles rarely sought interchangeability. Almost all manufacturers employed workers called 'fitters' who filed each part to the tolerances required for

proper assembly. Not even the famous revolvers of Samuel Colt (1814–62) boasted interchangeability because, unlike armies ordering thousands of identical guns, individual customers had no need for that feature and could not afford it. The real attraction of the American System was mechanization. Makers of consumer goods rationalized production and increased output of goods in the face of rising consumer demand. By transferring skill from human beings to machine tools, they could employ unskilled workers, often recent immigrants who tended to quit as soon as they had saved enough money to outfit themselves as farmers and move westward, where they would in turn contribute to rising consumer demand.

The debate over a functional 'American vernacular'

There was an urban class of merchants, manufacturers, financiers, and other entrepreneurs with a cosmopolitan interest in the latest fashions in fabrics and furniture from Europe, whose taste preferences may have exercised a trickle-down effect on the rest of the nation. The economic historian Nathan Rosenberg, however, has argued that most Americans were middling people with 'a relative simplicity of taste and a stress upon functionalism in design and structure', whose demands could be satisfied by a narrow range of goods.[4] This emphasis on democratic simplicity and efficiency is typical of interpretations of the cultural roots of design and material culture in the US—though often subtly modified by the observation that a frontier people tended to cut corners in their haste to develop the land, even as its abundance encouraged waste and impermanence.

American engineering practices of the nineteenth century diverged sharply from those of Europe. In house construction massive timber framing with painstaking mortise-and-tenon joints yielded to the balloon frame's forest of thin lightweight studs and joists quickly nailed together [5]. A similar divergence marked railway construction. While British engineers made deep cuts through hills and erected stone arches over valleys to keep tracks on the level, Americans threw up makeshift timber trestles when they had to, but otherwise they laid track along the rising and falling contours of the land. This approach required an overall elimination of weight, with light, flexible rails and locomotives mounted on wheel trucks capable of swivelling on sharply curving track. Visiting the Baldwin locomotive works in Philadelphia in 1838, the Scots engineer David Stevenson (1815–86) admired 'fine workmanship' in all parts 'indispensable to . . . efficient action' but noticed that 'external parts, such as the connecting rods, cranks, framing, and wheels, were left in a much coarser state than in engines of British manufacture'. Wondering why American ships were 'built . . . to last for only a short time', Alexis de Tocqueville (1805–59) was

5 Anonymous

Balloon-frame construction, c.1833

Chicago's expansion from a frontier outpost to a bustling city required the construction of large numbers of dwellings, thus stimulating development of balloon framing, which employed many thin wooden supports cut by sawmill rather than a few heavy hand-hewn timbers. An alternative theory suggests balloon framing was developed for the superstructures of Mississippi River steamboats. Either way, the emphasis was on a quick, cheap solution.

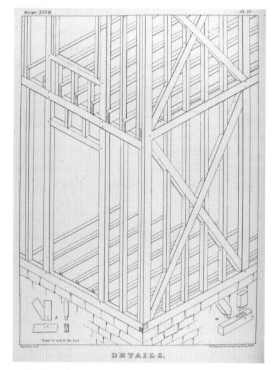

told that 'rapid progress' would render 'the finest vessel . . . almost useless if it lasted beyond a few years'.[5]

European observers concluded that practical considerations also took precedence in consumer goods. Francis Grund (1805?–63), a fact-finding German, declared that American furniture was better than any in Europe. He singled out New England rocking chairs as 'the *ne plus ultra*' of furniture—not for their admirable 'elegance' but for their 'excellent adaptation to the purpose for which they are intended'. Comments from two British sources, a London journalist and a newly arrived immigrant, represented a typical range of European opinion. Speaking generally, the journalist praised 'democratic' American industry for rejecting 'pomp and magnificence' and choosing instead to provide 'for the masses, and for wholesale consumption'. The immigrant, more grounded in immediate realities, observed that Americans had 'improved almost every object involving mechanical skill, from a stay-lace to a steam-boat'. But design improvements extended beyond function to more intangible qualities. From tables and chairs to brooms and brushes, 'articles of domestic use' made in America were 'lighter and more tasteful than similar articles in the "old country"'. Even de Tocqueville, the French traveller who published the most renowned analysis of Jacksonian democracy in the 1830s, meditated on the 'virtuous materialism' of Americans.[6]

Pondering the nation's abundance and rising population, de Tocqueville observed that as 'conditions of men . . . become more and more

equal, the demand for manufactured commodities becomes more general and extensive'. With 'poor or ignorant handicraftsmen' overwhelmed by 'fresh demands . . . on all sides', the initiative passed to 'large establishments' organized by a new class of capitalists employing 'a strict division of labor'. At first glance, de Tocqueville seemed to agree that this new system of 'greatest speed' and 'lowest cost' promoted simplicity of design. Sharing an 'absence of superfluous wealth' and a 'universal desire for comfort', Americans valued 'the arts that serve to render life easy' over 'those whose object is to adorn it'. They preferred 'the useful to the beautiful' and required that 'the beautiful should be useful'. However, de Tocqueville also noticed that quality suffered under this system. As evidence he cited the pocket watch, formerly a well-crafted precision instrument so expensive that only a wealthy man could afford one. Although new manufacturing techniques had democratized the pocket watch, they had also cheapened its quality. The aristocratic Frenchman scornfully noted that most watches were no longer 'worth much' now that 'everybody has one in his pocket'.[7]

To make matters worse, de Tocqueville observed that status anxiety often drove democratic Americans to pursue illusions of quality they could not afford. People who were rising in a fluid society experienced material desires growing 'faster than their fortunes', while those who were slipping down retained desires they could no longer satisfy. Whether rising or falling, members of a generally expanding middle class embraced a 'hypocrisy of luxury' and sought products endowed with superficially 'attractive qualities . . . they do not in reality possess'. Far from retaining frontier simplicity, the 'arts' in America made a virtue of 'imposture'. Entrepreneurs created such cheap impressions of wealth as 'imitation diamonds . . . easily mistaken for real ones'. Opposing the old provincial need to survive on as little as possible, according to de Tocqueville, was a democratic 'confusion of all ranks' in which 'everyone hopes to appear what he is not'. Americans of shifting status acquired clothes, furnishings, and other possessions whose broadly fashionable cut or extravagant decorative motifs conveyed often misleading impressions of strong personal identity and solid material worth.[8]

From the early nineteenth century to the present day, an emphasis on superficial effects has marked popular American design, which tends to exhibit a baroque exuberance of forms, materials, and colours. From the cast-iron kitchen stoves of de Tocqueville's time, covered in fanciful geometric or allegorical ornament, to the marbleized Formica plastic laminate of the 1950s, Americans have gloried in design that offered just a little bit more—and then some. This preference has often appeared gratuitous or even un-American, especially to mid-twentieth-century historians who valued functionalism. In 1948, for

example, John A. Kouwenhoven (1909–90) identified 'a democratic-technological vernacular' style whose functional simplicity, in his opinion, exemplified the best, most typically American examples of 'the design of useful things'. Such artefacts were distinct from those gaudy objects that through the years had aped the ornate traditions of European decorative arts. Kouwenhoven deplored a nineteenth-century tendency to emulate European goods because their contrived artificiality and lush ornament violated what he conceived as America's natural simplicity. According to de Tocqueville's shrewd assessment, however, the democratic 'passion for physical comforts' was expansive enough to embrace both functional simplicity and decorative extravagance—leading to a confusion of material virtues and vices that puzzled Kouwenhoven and which continues to perplex those who comment on American design.[9]

A world of goods

The consumption side of the American System thrived during the early nineteenth century. Many artisans, ranging from tailors and shoemakers to cabinetmakers and silversmiths, no longer restricted their work to 'bespoke' items made to order for specific patrons. Instead they worked ahead, fashioning goods in anticipation of future demand—a strategy that proved successful in coastal cities and inland market towns. Some artisans increased production to the point that they became entrepreneurs and withdrew from the actual making of things. Work was managed by experienced employees who had trained as apprentices. This system reduced stylistic inflections among individual artisans, yielding somewhat more anonymous general forms, especially in furniture. Regional differences remained, most notably in the work of rural artisans. However, these differences slowly blended and vanished as Americans worked their way through a succession of eclectic neoclassical styles copied from English pattern books. The delicate forms, veneers, and inlays of the early Federal style, which was dominant around 1800, yielded to the splayed klismos legs and sinuous S-curves of Greek revival [6], which then, by the 1830s, in their turn gave way to the heavy architectonic forms, pillars, and scrolls, and rich mahogany veneers of the Empire style.

Some of the more prosperous urban workshops assumed the functions of wholesale warehouses or retail stores. While continuing to oversee the making of products, their proprietors often subcontracted the shaping of smaller parts; in addition, they also obtained fully finished goods from small shops or individual artisans and offered them for sale. Middle-class shoppers could visit well-appointed, elegantly designed showrooms devoted exclusively to the sale of jewellery, furniture, dry goods, shoes, hats, or other limited classes of goods. In 1833,

6 Anonymous

Greek revival centre table
and lamp stand, 1820–30

Revival styles in furniture
spread from Europe to port
cities to smaller towns and
rural areas. The Greek revival
style appealed to citizens of a
new republic who aspired to
the imagined simplicity of
ancient Greece. These pieces
from Baltimore were painted
to imitate the grain of
rosewood and decorated with
stencils and freehand work.

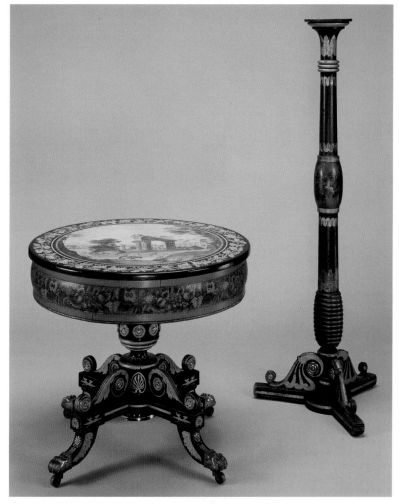

customers who were unable to visit the New York furniture showroom of Joseph Meeks, with its relatively inexpensive Empire tables and cabinets, could instead choose by number from among items offered on a lithographed broadside. The company boasted that it was 'impossible to exhibit all the patterns' because they had 'to keep [on hand] so great a variety, to suit the taste of our numerous purchasers'. Consumer demand kept the firm busy making 'alterations and improvements' to current designs and 'getting up new and costly patterns' in reaction to 'constantly varying' designs offered by competing manufacturers at home and abroad.[10]

Rural Americans gained access to consumer products by trading with a small army of peddlers travelling through the settlements and into the back country [7]. If farm families had earlier subsisted on whatever they could spin, weave, hew, whittle, or obtain from a few handier neighbours, the peddler's wagon now brought a captivating array of shiny new goods promising that everyday life would become

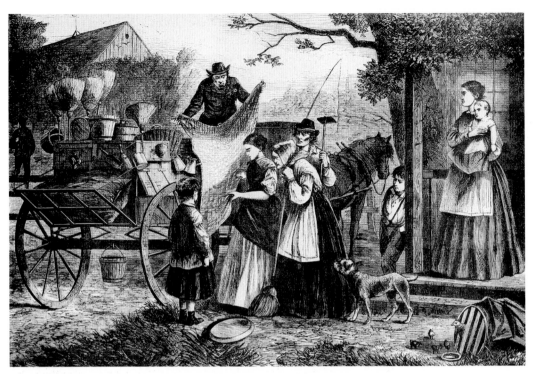

7 Anonymous

Nineteenth-century
engraving of a peddler
displaying his wares

This genre scene portrays the
peddler not as a disreputable
wanderer preying on the
unsuspecting but as a familiar
deferential figure at the
service of his customers,
whose respectable
appearances and well-
behaved children indicate the
social acceptability of this
early mode of acquiring
manufactured goods.

less harsh, more comfortable, and more filled with diversions. This jangling cornucopia on wheels yielded gadgets and notions, corn shellers, apple corers, china plates and cups, cast-iron pots, brass hardware, hand tools, bolts of calico, pins and needles, tin pails and baking ovens, knockdown furniture, clocks, brushes and combs, jew's-harps and whistles, thimbles, and on and on. The peddler's wondrous microcosm of the world of goods was as much an agent of modernization as any urban emporium.

Like most other aspects of early nineteenth-century society, peddling itself was an occupation in flux. Some peddlers were independents with a personal financial stake in the merchandise they offered for sale. Others worked on commission, distributing goods for general merchants or proprietors of manufacturing establishments. While some peddlers carried a remarkable diversity of merchandise, others specialized in a single category of goods, such as tinware, chairs, or clocks. Whole industries thrived and expanded by relying on peddling. As a distribution system it was so important that it stimulated road and turnpike construction during the 1820s and 1830s. Before railroads offered a competitive means of distributing goods in the 1840s and 1850s, many firms supplied dozens of peddlers who crisscrossed the nation in routes as well organized as those of the travelling salesmen of a later era.

Goods offered by peddlers were less impressive than those displayed by eastern retailers and their counterparts in western river towns

like Cincinnati, St. Louis, and New Orleans. Even so, peddlers contributed to blurring regional design styles and fostering national forms of material expression that dovetailed with de Tocqueville's analysis of a democratic people who found beauty in the useful but also sought to distinguish themselves through their possessions. This contrast appeared to good effect in the sale of tinware and of chairs, two types of mass-marketed goods distributed by peddlers. While tinware appealed mostly to practical convenience, even the most inexpensive chairs evoked a more complicated desire for emulative display.

Tinware depended on ingenuity of design for its value as a product. Its raw material, tinplate, was made in Wales from thin rolled iron that was coated with tin for rustproofing, cut into sheets, packed into boxes of 100, and shipped to the US. American tinsmiths used hand tools to cut, bend, shape, crimp, and solder tinplate sheets into useful objects. Over the years they devised a set of hand-operated gadgets, so-called 'Yankee machines', some resembling giant can openers, for speeding up such operations as bending the top edge of a tin pail down over a circular hoop of iron wire that provided its rigid shape. The tin industry was centred in New England, especially Connecticut, and encompassed small shops with a few tinsmiths and large establishments with several dozen workers. By 1812, production was rationalized to the point that five workers could keep 25 peddlers on the road, each driving a two-horse wagon hauling two tons of tinware.

Design entered the equation in the imaginative creation of scores of specialized tinware products—all of them cheap and practical, many of them wholly unprecedented as artefacts of everyday life [**8**]. The estate

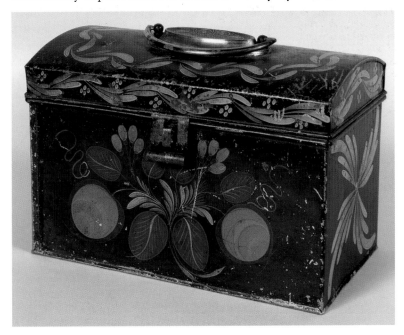

8 Anonymous
Tinware box, *c.*1825
Nineteenth-century Americans preferred decorative embellishment even on objects that were cheap, practical, and nearly disposable.

inventory of a New York tinsmith in 1837 listed tea canisters, spice boxes, bread trays, hanging lamps, strainers, graters, coffee pots, tea kettles, pails, pots and pans, boilers, foot warmers, measures, and dutch ovens. Some items had japanned finishes and were possibly enlivened by painted floral motifs. However, the key point was not the use of ornament but the industry's exploitation of a few basic forms and simple but ingenious processing operations to create a proliferating array of products whose designs and practical uses were ever more minutely differentiated. Tinware was also the first disposable product used by Americans. It was cheap, useful, and easy to discard when it wore out—or whenever a slightly different, more specialized, more cleverly designed alternative dangled bright and shiny from a peddler's wagon.

Although peddlers could easily transport a high volume of tinware, that was not always true for furniture. Even so, peddlers contributed to the success of Lambert Hitchcock (1795–1852), an entrepreneur who rationalized production and distribution of sturdy inexpensive chairs. Eventually he learned he had to attend to visual appearance when marketing goods that were substantial enough to embody the status of their purchasers. Hitchcock learned his craft traditionally as apprentice to a cabinetmaker at Litchfield, Connecticut. After he became an independent chair maker in 1818, the combined effects of rising consumer demand, labour scarcity, and difficult rural markets challenged him to do more with less. He used water power to operate mechanical saws (for cutting out parts) and lathes (for turning rungs and legs). His chairs were constructed of local birch, maple, and pine, and had rush seats woven from local cat's-tail reeds. Hitchcock's genius lay both in high-volume mechanization of chair making and in an innovative use of peddlers, with networks extending west and south from Connecticut. For them he prepared inexpensive kits of disassembled chair parts, light and tightly packed, which farmers as far away as South Carolina could purchase and assemble in do-it-yourself fashion.

This marketing ploy was so effective that demand for his chairs outstripped the ability of peddlers to satisfy it. As a result, Hitchcock built a larger factory in 1826 and was soon shipping 15,000 chairs annually down the Connecticut River to New York and from there to other eastern ports. By then, the backwoods chair maker had discovered the usefulness of design or styling [9]. No matter how practical the product devised by Hitchcock, even rural Americans—isolated settlers, Jefferson's yeoman farmers, and Kouwenhoven's vernacular-loving democrats—desired stylish goods with decorative flourishes echoing cosmopolitan goods. This desire for style strongly influenced another functional object, the inexpensive mass-produced shelf clock, whose purpose of marking time's passage declared the most humble owner to be in step with the modern era. The wooden shelf clock was

9 Lambert Hitchcock

Slat-back chair with cane seat, c.1826–35

Most of Hitchcock's chairs exhibited bright shiny paint and lavish stencilled ornament in place of the hand carving typical of more expensive furniture. Some were grained to imitate mahogany or rosewood by covering an undercoat of red paint with streaks of black. This chair sold for less than a dollar, which made it acceptable for ordinary kitchen use.

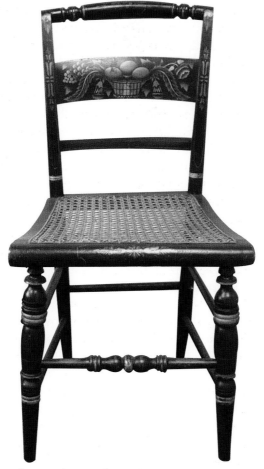

an innovative product whose manufacture and marketing exemplified the American System applied to consumer goods.

Clocks for the world

Clocks remained luxury goods into the nineteenth century. A master clockmaker painstakingly produced only 10 to 15 brass movements per year. To make the parts, he melted down old kettles, cast approximate shapes, slowly hardened them by hammering, and cut and filed gear teeth by hand. The face might come from an old pewter plate, with hands shaped and hammered from spoon handles. The result was a precision instrument, a unique mechanism with each part exactly fitted to mesh with all others. Each clock was 'bespoke' in advance for a patron who separately commissioned a cabinetmaker to fashion a wooden case, often richly inlaid and ornately carved according to current furniture styles. The result was a handsome instrument, usually six feet (about two metres) high and weighing a hundred pounds (45 kg), often a wealthy household's most expensive possession.

All this was changed by Eli Terry (1772–1852), a clockmaker whose innovations sped up the manufacturing process, lowered the cost, expanded the market, and democratized the clock. After establishing a shop at Plymouth, Connecticut, in 1793, Terry worked along traditional lines for several years. After about 1800, frustrated by a shortage of customers for his luxury product and influenced by local clockmakers of German descent, Terry abandoned brass and began making movements with wooden parts. While still hand-crafted, these wooden movements were cruder, less precise, and easier to produce. They ran for only 30 hours instead of the standard eight days, but they weighed less and could be sold for half the price of a traditional clock. A whole new market opened up. This changeover eased the labour shortage because Terry could hire farm boys familiar with wood as a material. Independently following the logic of military arms manufacture, he devised specialized lathes, saws, drills, and gear-cutters that further de-skilled the manufacturing process. By 1806 his shop had 200 clocks under manufacture simultaneously, and he ambitiously contracted to deliver 4,000 wooden clock movements within three years. After a year spent outfitting a water-powered factory, Terry made good on his promise. In moving from craft work to mass production, Terry so completely transformed his business that every middling person in America could aspire to own a clock—and thereby to assume the status traditionally indicated by such a possession.

Terry's other major innovation responded to the needs of peddlers and their customers. Despite a lighter, cheaper mechanism, his standard clock of 1810 was bulky to transport and required any self-respecting purchaser to hire a carpenter to construct a six-foot (two-metre) cabinet to house it (though an uncased clock could be hung on a wall with its pendulum swinging free). After several years of work, in 1816 Terry received a patent for a compact clock only 20 inches high, 14 inches wide, and 4 inches deep (50 by 35 by 10 cm). Its wooden movement was enclosed in a simple wooden case designed to sit on a shelf, thus eliminating the need to pay extra for a cabinet. This so-called shelf clock cost nothing more to produce and was easier for peddlers to transport. Terry's immediate success provoked competitors to violate his patent and take advantage of the seemingly limitless potential of democratic demand.

By some accounts that was the end of the story. But in fact competition forced Terry and his imitators to focus on style, even in a cheap mass-market product. In the same year that Terry patented the 30-hour shelf clock, he hired as a case maker Chauncey Jerome (1793–1868), who had already designed and built cabinets for another clockmaker. From his former employer Jerome borrowed the so-called 'pillar-and-scroll' design, which had delicate scrollwork on top and bottom, a graceful pillar on each side, and a glass door through which

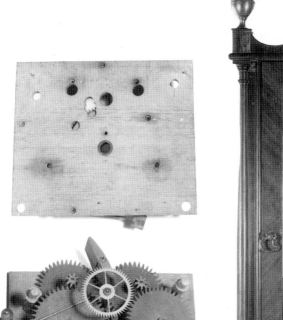

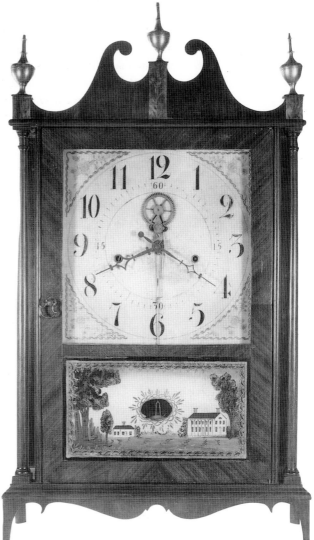

10 Eli Terry

Pillar-and-scroll clock with wooden works, c.1816
Terry's innovations democratized elite furniture styles in a compact form that allowed a single inexpensive but prized artefact to satisfy cosmopolitan desires. The relatively crude appearance of the wooden works offers a startling contrast to the stylish cabinet. The American System maintained surface appearances by cutting corners in production whenever possible.

was visible a printed clock face above a painted scene [**10**]. The resulting cabinet, in one historian's dismissive opinion, was 'nothing more than the original box clock design surrounded with some molding and painted glass'.[11] Yet that was the point. Easily created with power-assisted tools and inexpensive veneers, the pillar-and-scroll cabinet transformed a simple, cheap, crude clock into a miniature expression of the neoclassical style that defined high fashion for cosmopolitan Bostonians or Philadelphians. By 1820, Terry and his sons were supervising 30 workers in the annual production of 2,500 clocks in four major styles with many variants.

Individual members of a restless public who sought to distinguish themselves from each other by means of consumption were not long satisfied by functional simplicity, Yankee ingenuity, and other puritan design virtues that foreign visitors and later historians like

Kouwenhoven wrongly claimed as the sole significance of American manufacturing success. Instead, rising material desires and intense competition between firms stimulated styling, product differentiation, and other marketing strategies whose symbiotic relationship to production identified them as a vital, equal aspect of the American System. From the very beginnings of mass production, the American design vernacular oscillated between engineering and art, mechanics and marketing, function and ornament, reason and emotion, as it adjusted to practical needs and visionary desires.

All these motives propelled the flamboyant career of Jerome, who went into business for himself soon after the pillar-and-scroll's debut; it was he who later bragged, in his firm's slogan, that 'we make clocks for the world'. In 1825 he 'invented a new case', as he later phrased it, deftly appropriating the language of mechanism to refer to styling. This so-called 'bronze looking-glass clock' [11] was a slightly taller,

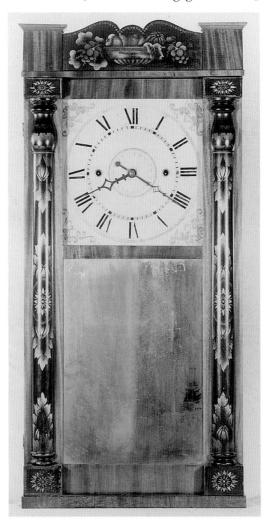

11 Chauncey Jerome

Bronze looking-glass clock, *c*.1827

Although Jerome's clock had a boxier cabinet that was marginally cheaper to manufacture than Terry's pillar-and-scroll, its greater size and ornate stencilling probably appealed to consumers as impressive styling improvements.

visually simpler shelf clock resembling a picture frame with S-curving side pieces enclosing the dial and a mirror. Rhetorically addressing the two aspects of the American System (namely, production and consumption), Jerome declared that this model 'revolutionized the whole business' as 'the richest looking and best clock that had ever been made for the price'. Although the looking-glass clock 'could be got up' for a dollar less than the pillar-and-scroll, it was so 'very showy' that consumers would pay two dollars more for it.[12]

Even more innovative was Jerome's return to brass movements after the economic depression of 1837 sent prices and sales plummeting. He used sheet brass from new rolling mills, specialized machine tools, and such clever stratagems as stamping extremely thin gear wheels with circular beading to strengthen them. Within a few years his eight-day brass movements completely replaced the 30-hour wooden ones. By 1850, Jerome's firm annually produced nearly 300,000 clocks, with the most basic costing 50 cents to produce and selling for $1.50. Jerome emphasized the production side of the American System when he claimed that success depended on 'every part of their manufacture' being 'systematized in the most perfect manner and conducted on a large scale'. According to an associate, however, the consumption side reigned supreme. Jerome's clocks appeared in a multiplying variety of sizes and styles during the 1840s and 1850s, ranging from turreted Gothic steeple versions to brightly painted rococo papier-mâché models inlaid with mother-of-pearl. In fact, 'the desire to make and sell great quantities' had stimulated so many 'new designs' that clock dealers became 'annoyed *and* bewildered'. Only a few movers and shakers like Jerome recognized that success or failure was in the hands of style-conscious consumers whose preferences changed frequently.[13]

Jerome's fame in Britain derived from his first shipment of brass clocks in 1842. The shipment's declared value was so low that customs agents assumed he was trying to avoid import duties. They confiscated everything and paid the declared value as compensation. Still believing Jerome to be bluffing, they confiscated a second shipment at the same declared value. Only when Jerome sent a third shipment did British customs believe he was really making clocks so cheaply. This story sparked considerable British interest in the American System. It was not surprising that British observers emphasized the functional simplicity of products displayed by Americans at the Great Exhibition, the first world's fair, held in London in 1851. For Americans, however, the exhibition held a different meaning. They were captivated by the extravagant ornamentation of Victorian furniture and decorative arts. Rather than reinforcing a supposed simplicity or primitivism, the exhibition focused American attention on the complicated relationship of art and industry. Manufacturers, journalists, and the growing ranks of

middle-class consumers became self-consciously aware, for the first time, of the significance of design.

The US and the Crystal Palace

Nothing like the Crystal Palace had existed before, shimmering over London's Hyde Park, 20 acres (8 hectares) of glass supported by a prefabricated cast-iron structure enclosing a collection of artefacts from around the globe. US participation in the Great Exhibition got off to a bad start owing to poor organization. Many displays were not yet installed when Queen Victoria opened the world's fair in May 1851. To make matters worse, the US executive committee had contracted for a space too large for the number of exhibits. Although most visitors were captivated by *The Greek Slave*, a chaste but enticing female nude by the American sculptor Hiram Powers (1805–73), many agreed with a journalist who disparaged the American section for its 'dreary and empty aspect'.[14] With British attention focusing on French decorative arts, there was little interest in utilitarian goods like Borden's meat biscuits, Goodyear's rubber boots and life-rafts, Cincinnati cured hams, and a towering pyramid of soap.

Over the summer, however, three highly publicized events provoked reassessment of practical Yankee ingenuity. The first involved an American locksmith who succeeded in picking a famous British bank lock, the 'Bramah', which had withstood all challenges since 1788. Adding insult to injury, his own 'Parautoptic' lock, on display at the Crystal Palace, resisted all attempts by British locksmiths. Just as impressive was the performance of the mechanical reaper invented by Cyrus McCormick (1809–84) [12]. The British press dismissed this

12 Cyrus McCormick
McCormick mechanical reaper, 1851
Some historians claim McCormick merely commercialized his father Robert McCormick's (1780–1846) invention. The machine exhibited in London was similar to that first introduced in 1831, which enabled two people (one on the horse, the other with a rake) to do the work of four or five using cradle scythes or twelve to sixteen with sickles.

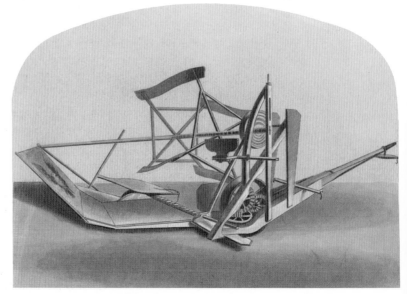

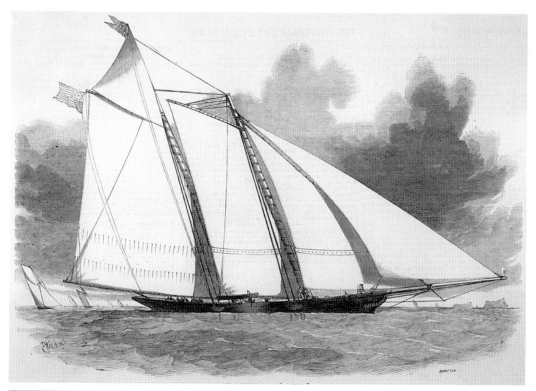

13 George Steers

Racing schooner *America*,
1851

Designed for John Cox
Stevens (1785–1857) of the
New York Yacht Club, *America*
was 109 feet (33 metres) long,
22 feet (6.7 metres) across,
and had a draft of 11 feet (3.4
metres). Steers (1820–56)
gained his experience as a
ship designer with fast pilot
schooners, which competed
with each other to reach
incoming vessels first, thus
gaining the right to pilot them
to harbour.

agricultural implement as 'a cross between an Astley's chariot, a tread-mill, and a flying machine'. Again the Americans had the last word when McCormick's horse-drawn machine was demonstrated in a field in Essex. While it handily mowed down rain-sodden green wheat, a competing British reaper clogged and failed. When returned to the Crystal Palace, the McCormick reaper attracted 'more visitors . . . than the Ko-i-noor diamond itself', according to a New Yorker. Finally, the sleek, flat-sailed schooner *America* [13] defeated 15 other yachts in a race around the Isle of Wight to win a prize that initiated the America's Cup series. This victory prompted the *Liverpool Times* to warn that 'America, in her own phrase, is "going ahead" and will assuredly pass us unless we accelerate our speed.'[15]

These exemplary triumphs of straightforward American design appealed to British reformers who had hoped the Great Exhibition would establish new standards of popular taste. Instead they recoiled in shock from displays of overwrought machine-made ornament, gaudy machine-printed patterns and colours, and supposedly vulgar imitations of one material by another. British manufacturers had spared no expense in designing and fabricating objects for display whose ornamentation exceeded anything available in London shops. Although some American products in the Crystal Palace seemed artless in their functional simplicity, many of them also embodied the luxurious ornamentation we now think of as epitomizing Victorian design. For

14 Cornelius & Baker

Gas chandelier exhibited in
the Crystal Palace, 1851
Critics of ornate Victorian
design and manufacture often
criticized the dishonesty of
using new or inexpensive
materials or manufacturing
techniques to imitate
expensive handwork or costly
materials. In this case, cast
iron stood in for wrought iron.

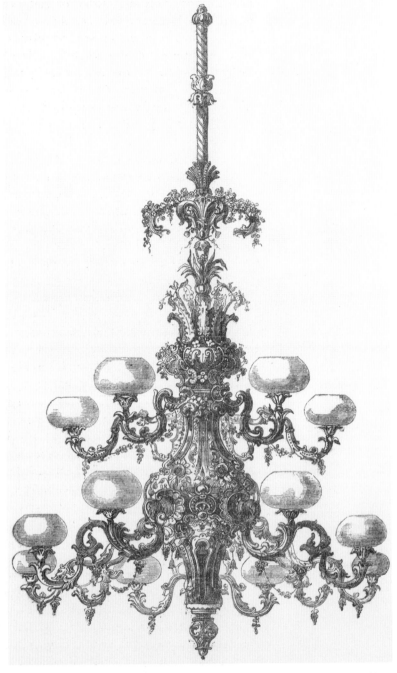

example, a massive 15-foot (4.6-metre) chandelier made by Cornelius
& Baker of Philadelphia [**14**] boasted a rich accumulation of brass
curlicues supporting 15 light globes activated by gascocks whose resemblance to 'bunches of fruit', according to an exhibition catalogue,
'combin[ed] beauty with utility'. The same guide described a huge
silver table centrepiece from Hooper & Co. of Boston, with branches

dripping with vines and clusters of fruit, as an object 'of very tasteful design' with 'decoration . . . neither too sparing . . . nor too profuse'. To cite a final example, a rosewood piano, ornately carved in rococo style by artisans at Nunns & Clark of New York, offered evidence of increasing 'taste for the elegant and the beautiful' as Americans 'advance[d] in intellectual power' and sought out 'the refinements of life'. Even if some Americans rejoiced with Horace Greeley (1811–72), the editor of the *New York Tribune*, at seeing McCormick's 'ungainly' reaper win out over the 'thousand and one beautiful knick-knackeries' of the Great Exhibition, the trend in American popular design was running towards ornamentation. Clever engineering developments enabled ever cheaper mechanical imitation and reproduction of wealthy materials and hand-crafted forms. The tide of supposedly tasteless products that disgusted British reformers was about to become a democratic flood in the US.[16]

One American appalled by this prospect was Horatio Greenough (1805–52), a sculptor who toured the Crystal Palace while visiting London in September 1851 on his way home after many years in Italy. He complained to the philosopher Ralph Waldo Emerson (1803–82) about American citizens 'struggling' to attain beauty while the 'excremental corruptions' of foreign 'gewgaws and extravagance' washed over them. Greenough developed his opinions in a collection of essays describing how British manufacturers had 'overwhelmed us with embellishment, arbitrary, capricious, setting at defiance all principle, meretricious dyes and tints, catch-penny novelties of form, steam woven fineries and plastic ornaments, struck with the die or pressed into moulds'. Unfortunately, he continued, 'our own manufacturers have caught the furor, and our foundries pour forth a mass of ill-digested and crowded embellishment'. Americans had 'negative quantities to deal with, before we can rise to zero'.[17]

In place of the 'excremental' excesses of Victorianism, Greenough proposed an organic or evolutionary theory of design. Appealing to nature, he suggested that just as the structures and forms of animals indicated progressively more successful adaptation to function, so did the forms of such artefacts as a trotting wagon and the yacht *America*, whose designer, at the end of the long historical development of sailing vessels, had 'reduced locomotion to its simplest elements'. Equating aesthetic beauty with efficiency of form and perfect adaptation to function, rather than with mindless imitation of past styles or wealthy luxuries, Greenough described the process by which a 'cumbersome machine' evolved into a 'compact, effective and beautiful engine'. To dismiss American simplicity of design as an 'economical' or 'cheap' style was a serious error. Instead, forthright simplicity was 'the dearest of all styles' because it required 'much thought, untiring investigation, ceaseless experiment'.[18]

Greenough's essays attracted little attention, but Emerson echoed them in such philosophical writings as an essay on 'Beauty', proposing that 'the line of beauty is the result of perfect economy'. Rejecting the emulation of wealthy display that de Tocqueville had observed in democratic Americans, Emerson boldly stated that 'if it is done to be seen, it is mean'. His friend Henry David Thoreau (1817–62), who abandoned worldly pursuits to live for two years in a hut on the shore of Walden Pond, bitterly lampooned the 'modern drawing room' of the middle class, 'with its divans, and ottomans, and sunshades, and a hundred other oriental things . . . invented for the ladies of the harem and the effeminate natives of the Celestial Empire [China], which Jonathan [the simple New England farmer] should be ashamed to know the names of'.[19] Although Greenough's ideas went underground, by way of Emerson and Thoreau they later inspired the famous dictum of the architect Louis Sullivan (1856–1924) that 'form follows function', and through him reached Frank Lloyd Wright (1867–1959). Just as important for the study of American design was the rediscovery of Greenough's essays in the 1940s, an event that shaped Kouwenhoven's influential theory of an American functional vernacular style.

However, that vernacular style existed during the first half of the nineteenth century only in the production side of the American System—in the manufacturing tools and practices devised in federal armouries, clock manufactories, and other mills and workshops. The consumption side was equally innovative in terms of volume and low cost of goods made available to a democratic middle class, but popular desires ensured that designers of consumer goods would emulate European luxury rather than impose vernacular simplicity. The new material world of the mid-nineteenth century was embodied in the comforts of plush abundance, not in the sacrifices of austere practicality. A historian like Kouwenhoven might celebrate the functional design of such artefacts as the chairs produced for sale after 1850 by the Shakers, a communitarian religious sect whose workshops advertised 'durability, simplicity and lightness'.[20] But middle-class Americans of that era desired and demanded more for their money.

Consumer design in the 1850s

Evaluating the US performance at the Great Exhibition, Greeley insisted 'we can and must do better next time'.[21] An opportunity arose two years later in 1853 when the Exhibition of the Industry of All Nations opened in a domed octagonal iron-and-glass structure known as the New York Crystal Palace. With one third of its space reserved for domestic exhibits, American firms could hope for a better showing than in London. However, the opening was delayed until July, giving an official delegation of British observers time to investigate the work-

ings of the American System. George Wallis (1811–91), the director of the Government School of Art and Design in Birmingham, spent 11 weeks visiting mills and workshops in New England, the mid-Atlantic states, and the Ohio Valley. As a design educator, he paid particular attention to consumer industries. American use of styling in marketing goods impressed him as effective—and thus a threat to British manufacturing.

As the earliest trade to be mechanized, by steam in Britain and water power in the US, the textile industry had employed artists to devise patterns or designs for weaving and printing since the late-eighteenth century. Although Wallis saw many immigrant designers from England, Scotland, and France, he also favourably commented on work by graduates of the Boston School of Design, founded in 1851. Several other schools were also training women as pattern designers. The Franklin Institute absorbed an existing design school in Philadelphia in 1850, and Cooper Union took over another in New York in 1858. Whether or not such schools were responsible, Wallis observed a general 'good taste' in colours and patterns as he visited fabric and carpet mills in New England. Designs varied according to 'the market or class of customers for which the goods are intended'. A calico printer in Pawtucket, Rhode Island, produced 'showy patterns, large in form, and strong in contrasts of colour' for distribution to southern and western states, while northeastern states received 'smaller patterns, more subdued in colour, and approaching to the best character of goods used in England'. For the most part, Americans followed European styles as manufacturers and merchants pored over reports of the latest French fashions before making decisions. However, Wallis reserved his sharpest criticism for an American original—a machine-woven carpet with alternating portraits of George Washington and views of Mount Vernon. All of it, to his dismay, was 'intended . . . to be walked upon!'[22]

After examining products from many consumer industries, Wallis concluded that Americans of all classes indulged 'a love of display' that could be playful, hedonistic, or annoyingly shrill. Even an artefact as large and solid as a cast-iron cooking stove displayed somewhat elusive new style qualities. Too large and heavy for peddlers, iron stoves were made regionally by about 200 companies, with Cincinnati alone producing 50,000 stoves each year. Wallis marvelled not only at their size, and at the natural abundance that allowed Americans to burn forests for fuel, but also at the cleverness of stove design and marketing. Manufacturers displayed 'ingenuity' in devising integrally cast ornamentation that helped 'to strengthen the panels, sustain the angles, and hide defects in casting', but they carried the search for 'novelty' to such extremes that the result often seemed more an 'excrescence' than a 'decorative adjunct'. Most surprising to Wallis was the use of brand

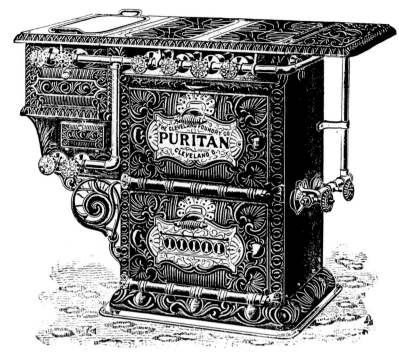

15 Cleveland Foundry Co.
'Puritan' gas stove, 1898
It is difficult to believe that neither producers nor consumers realized the irony of the Puritan name. This stove, which burned gas rather than wood, exhibits a mania for covering all the surfaces with intricate geometric patterning typical of the late nineteenth century. However, the desire to distinguish even such obscure regional products was already evident when Wallis made his American tour in 1853.

names to distinguish the indistinguishable, with each stove boasting 'a distinct title by which it is known in the market'. The 'euphony' of these names was 'often more amusing than appropriate', and he would have appreciated the so-called 'Puritan' model of several decades later with its heavily ornamented surfaces [**15**].[23]

A few years later Wallis would have encountered the sewing machine as a new consumer product with considerable investment of effort in design and marketing. He and other British delegates were aware of how the recent invention had decentralized the garment trade and fostered 'putting out' schemes and sweatshops. As of yet, however, the sewing machine was not domesticated as a machine for personal use by middle-class women. The company founded by Isaac M. Singer (1811–75) in 1851 was one of many seeking to perfect and exploit the new technology, but Singer did not introduce the first home machine until 1856. Two years later an advertising brochure heralded its 'lighter and more elegant form' and declared it 'a machine decorated in the best style of art, so as to make a beautiful ornament in the parlor or boudoir' [**16**].[24] The company employed young women to demonstrate the machines in urban showrooms that were lushly carpeted, carved, and gilded. Just as importantly, Singer initiated an instalment purchasing plan—the first ever for a consumer product. Eventually, as the Singer machine became a staple of middle-class homes, sales agents met annually to review consumer preferences and offer suggestions for design changes both mechanical and decorative.

Wallis's investigation of other industries from inexpensive pressed

16 Isaac M. Singer

Sewing machine for
household use, 1856

The first domestic sewing
machine was japanned in
black, ornamented with
painted scrollwork
surrounding floral
decalcomania, and mounted
on a stand supported by cast-
iron ivy vines. It had to be
naturalized and domesticated
for the parlour.

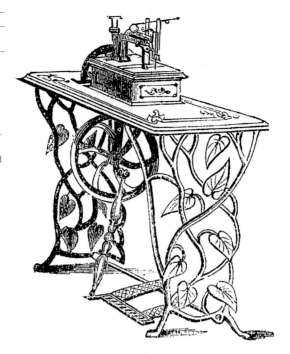

glassware [**17**] to cast-iron building fronts yielded evidence of 'a vague
seeking after novelty' that merged by degrees into 'an almost Oriental
love of splendour'. Although he so admired some 'useful and cheap'
furniture from the Midwest that he shipped it home to England, he
concluded that Americans had moved beyond the 'simpler habits and
tastes' of their early history. Furniture revealed 'redundancy and over-
ornamentation' as its makers sought to 'crowd as large an amount of
work into as small an amount of space as possible.'[25] Here Wallis might
have been referring to the rococo revival furniture of John Henry

17 Anonymous

Pressed glassware, 1830–50

Cheaply priced for a
democratic market, pressed
glassware was made by
pouring molten glass into cast-
iron moulds to create identical
pieces whose ornate
patterned surfaces simulated
the results of labour-intensive
techniques such as cutting
and engraving.

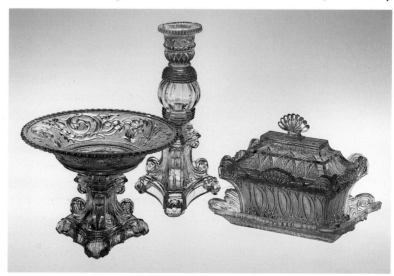

18 John Henry Belter

Rosewood sofa, *c.*1850

In making sofas like this, workers steamed and pressed thin layers of rosewood into sensuously curved, structurally sound laminated plywood. Mechanical presses punched the backs with lacy fretwork patterns of vines, leaves, grapes, and flowers, which were finished out by hand.

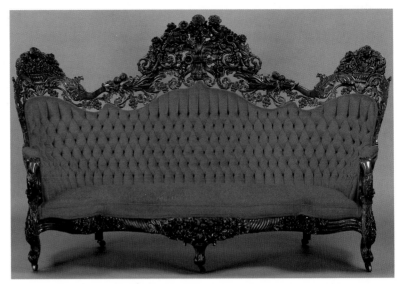

Belter (1804–63), a German immigrant in New York, whose innovative technology created chairs and sofas with complex arabesques simulating hand carving [**18**]. Although Belter's 'pressed work' (as he called it) was too expensive for the average citizen, the papier-mâché furniture that had inspired him quickly made its way down class lines. Papier-mâché appealed to manufacturers because it could be easily shaped, sawed, polished, and used to imitate expensive materials. Its 'plasticity and malleability', according to the design historian Clive D. Edwards, suggested 'a potential control over form that was unheard of'.[26]

That unprecedented degree of unfocused control worried Wallis as he pondered his American tour. His hosts regarded their rapid progress beyond frontier scarcity and simplicity with a blend of wondrous awe and smug acceptance. They had little idea how to direct their energies towards greater refinement and civilization. Wallis found manufacturers and consumers locked in a vicious circle of responsibility for the American System's cultural failings. Manufacturers had no alternative but to supply 'glittering nonsense' in response to voracious public demand. At the same time, the public enjoyed 'little choice' because everything available projected 'an enormous display of unmeaning decoration'. Constant exposure to 'ugliness and exuberance' provided by ignorant manufacturers made public taste ever more 'vitiated and depraved'. And so it went. Seeking a solution, Wallis looked to 'more enlightened manufacturers' as the 'real instructors . . . of the taste of the people'. If this select group maintained its principles in the face of the current democratic lack of taste, they would eventually be rewarded by a more sophisticated public, owing in part to increased transatlantic travel and greater awareness of refined European decorative arts. Although Wallis predicted the slow emergence of a 'national style', he failed to realize that most people would continue to desire an

extravagance in design appropriate to the apparently unlimited abundance of the new world.[27]

That in fact was the meaning of the exhibition of 1853 that had brought Wallis to the US in the first place. When the doors of the domed New York Crystal Palace finally opened, it was clear that the organizers had learned too well the lessons of their London model. British design reformers had regarded the 1851 exhibition as a failure because it celebrated an extravagance they considered tasteless and morally corrupting. But that very extravagance proved seductive to American visitors. The New York organizers hoped to demonstrate in 1853 that the US could emulate and surpass what Europeans had displayed two years earlier. As an expensive illustrated guidebook explained, the fair sought 'to promote a correct appreciation of what is really beautiful in the arts of design—to awaken in the people of the United States a quicker sense of the grace and elegance of which familiar objects are capable—and to encourage our manufacturers by placing before them the productions of European taste and skill'. Above all, if only for the economic necessity of international competitiveness, Americans needed to learn the value of 'an alliance of art with commercial industry'.[28]

As distilled in the pages of *The World of Science, Art, and Industry*, the exhibition continued to reflect the split personality of the American System. On the one hand, practical ingenuity was in evidence in articles on the cotton gin, bridge engineering, shipbuilding, glass manufacture, and similar topics scattered at random. On the other hand, popular desire for elegant consumer goods shone through in detailed engravings of heavily ornamented tea sets, pianos, music stands, vases, ewers, candelabra, lighting fixtures, table centrepieces, fireplace surrounds, crystal decanters, wallpaper, tables, and chairs. A massive carved oak sideboard from Bulkley & Herter of New York, which was a centrepiece both of the exhibition and of the catalogue [19], appeared fit for 'an English manor-house or an Austrian castle'. Scattered throughout the book, in no particular order or scale, with silverware next to statuary, revolvers next to papier-mâché novelties, these images generated a complex phantasmagoria, as in the exhibition itself [20], pleasantly disorienting, which invited viewers to aspire to the artefacts displayed, to imagine a time when such goods would be 'within the reach of the mechanic and tradesman as well as the opulent and noble'. Dismissing the perspective of Greenough or Emerson, the authors insisted that 'the plainness that was once satisfactory' was no longer enough for American consumers who demanded 'decoration in every branch of manufactures'.[29]

Even more enthusiastic was newspaper editor Greeley, a social reformer and abolitionist, for whom the New York Crystal Palace offered evidence that the nation's mechanics, artisans, and designers

19 Gustav Herter

Carved oak sideboard, 1853
According to the 1853
exhibition catalogue, Herter
designed the sideboard,
E[rnest] Plassman contributed
the carving, and together they
supervised its construction for
Bulkley & Herter of New York.
Inspired by French models,
the piece portrays hunting and
fishing trophies to indicate the
prowess of the household's
provider. Herter (1830–98)
and his brother Christian
(1840–83) established Herter
Brothers and designed
interiors for the wealthy during
the late nineteenth century.

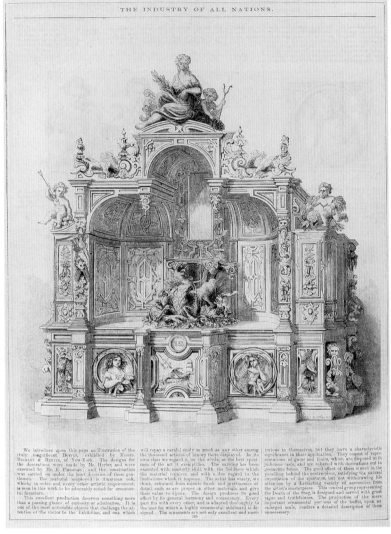

We introduce upon this page an illustration of the truly magnificent Buffet, exhibited by Messrs. BULKLEY & HERTER, of New York. The designs for the decorations were made by Mr. Herter, and were executed by Mr. E. Plassman; and the construction was carried on under the joint direction of these gentlemen. The material employed is American oak, which, in color and every other artistic requirement, is seen in this work to be admirably suited for ornamental furniture.

This excellent production deserves something more than a passing glance of curiosity or admiration. It is one of the most noticeable objects that challenge the attention of the visitor to the Exhibition, and one which will repay a careful study as much as any other among the thousand articles of luxury there displayed. In its own class we regard it, on the whole, as the best specimen of the art it exemplifies. The carving has been executed with masterly skill, with the boldness which the material requires, and with a due regard to the limitations which it imposes. The artist has wisely, we think, refrained from minute finish and prettinesses of detail, such as are proper in other materials, and give their value to *bijoux*. The design produces its good effect by its general harmony and consistency. Every part fits with every other, and is adapted thoroughly to the uses for which a highly ornamental sideboard is designed. The ornaments are not only excellent and meri-torious in themselves, but they have a characteristic significance in their application. They consist of representations of game and fruits, which are disposed with judicious taste, and are relieved with decorations cut in geometric forms. The good effect of these is seen in the panelling behind the centre-piece, satisfying the natural expectation of the spectator, but not withdrawing his attention by a distracting variety of accessories from the artist's masterpiece. This central group representing the Death of the Stag, is designed and carved with great vigor and truthfulness. The production of the mere important ornamental portions of the buffet, upon an enlarged scale, renders a detailed description of them unnecessary.

had 'democratized the means and appliances of a higher life'. Modern progress was 'bringing . . . the masses of the people up to the aristocratic standard of taste and enjoyment and . . . diffusing the influence of splendor and grace over all minds'.[30] Greeley's conflation of the material and the spiritual indicated that American culture still looked back to that formative era when God's design and the shaping of a new world seemed one and the same. Within a few years, however, the crisis over slavery threatened to shatter that spiritual design and the resulting Civil War interrupted the flow of material goods. Already, however, the nation had moved beyond the subsistence economy of early colonists and settlers and had come to accept a dependence on the greater complexity of an expanding material world. That world of goods seemed heavier, less buoyant, and considerably more artificial as the nation entered a post-war era that was known, not without reason,

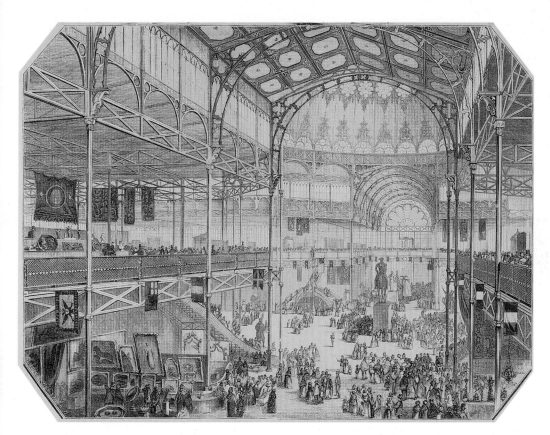

20 Georg Carstensen and Charles Gildemeister

New York Crystal Palace, 1853, interior
Even more than the original Crystal Palace in London, New York's imitative version encompassed a hodgepodge of manufactures and objets d'art. Fire consumed the structure by Carstensen (1812–57) and Gildemeister (1820–69) in 15 minutes in 1858.

as the Gilded Age. The extravagant visions of the New York Exhibition of 1853 were to become democratic realities during the final decades of the nineteenth century when middle-class consumers emulated an upper-class Aesthetic movement that promoted rich, exotic, many-layered domestic interiors. Eventually, however, a spirit of reaction set in as designers and promoters associated with a nostalgic Arts & Crafts movement looked back to the simplicity that was lost when everyday life filled up with manufactured things. Even the reformers were to learn, however, that simple things are never really that simple.

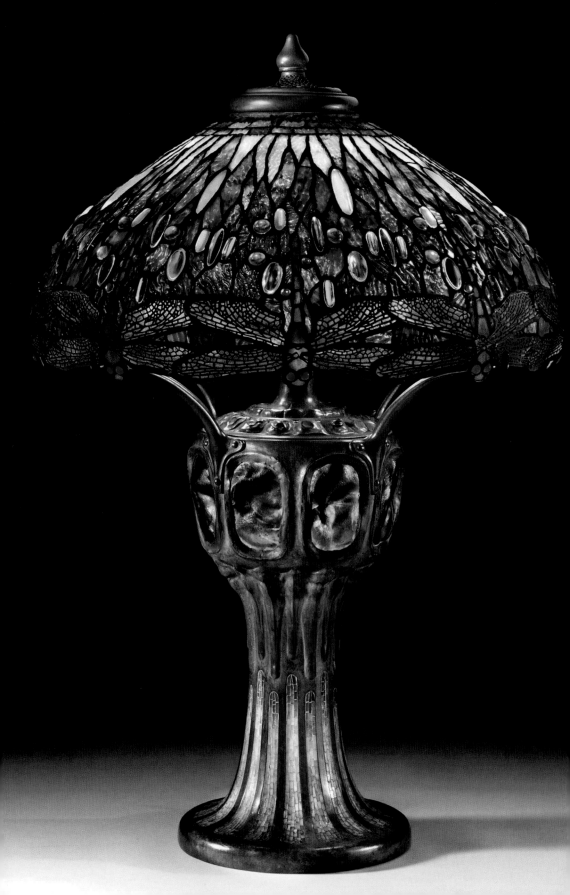

Art and Industry in the Gilded Age, 1860–1918

2

The most famous statement ever made by a US historian came in 1893 when Frederick Jackson Turner (1861–1932) meditated on the 'closing' of the frontier. Turner feared that without a continuing supply of uncleared land for new settlers, population pressures would erode the pioneer virtues of individualism and egalitarianism. During his lifetime the young historian had already witnessed disorienting social, economic, and technological changes. The population had doubled since 1860, reaching 63 million in 1890. One of seven inhabitants was foreign-born, and immigrants kept pouring into the country. While 80 per cent of Americans had made their living through agriculture in 1860, four decades later 40 per cent of the population lived in cities and towns with over 2,500 inhabitants. Native-born men and women abandoned rural life to seek their fortunes in New York, St. Louis, Chicago, and smaller regional cities already hard-pressed to accommodate the influx of immigrants. Only nine cities had more than 100,000 inhabitants in 1860. By 1900 there were 28 such cities, and their share of the national population had risen from 8 per cent to nearly 20 per cent.

Urbanization utterly transformed all aspects of life, including the economic relationships of people who within living memory had relied on peddlers for tinware, clocks, and chairs. Large cities depended on national markets exchanging raw materials and manufactured goods by railroad or by shipping on the Great Lakes and the Mississippi River. The web of tracks expanded from 30,000 miles (48,000 km) in 1860 to nearly 260,000 miles (418,000 km) in 1900. Furniture companies in Michigan sent goods across the country, as did carpet mills in Pennsylvania, brass foundries in Connecticut, and even the comb-makers of Leominster, Massachusetts, who used horn from Chicago packing plants. Urban workers earned wages in exchange for labour or collected salaries for managing those who worked with their hands. Most manufacturing occurred in small shops or factories and involved semi-skilled workers operating machines that required dexterity and alertness. Even so, the orders—and the designs that defined the work—came from elsewhere. Labourers sought satisfaction and self-expression outside the workplace, working mostly so they could consume.

21 Clara Driscoll
Dragonfly lamp of Favrile glass and bronze, c.1906
Driscoll's original dragonfly lamp of 1900 sparked a mania among the upper classes for lamps from Tiffany & Co. Although fabricating a lamp in a particular design began with a standard pattern for the leaded framework, artisans arranged variously coloured and textured pieces of glass to create a nearly unique product. The Tiffany lamp domesticated electric light by shading its modern efficiency under a pre-modern aestheticism.

American manufacturing rose from insignificance in 1860, when the US trailed Great Britain, France, and Germany, to global pre-eminence in 1900, with annual production surpassing all three competitors combined. Even so, people had to learn to be consumers—how to invest time and energy in shopping, how to gain emotional release by acquiring material things, and how to construct and express personal identity by arranging and displaying possessions. No longer acquainted with the makers of goods they consumed, they relied on new sources of information and distribution. Advertising became more sophisticated. Journalists defined trends and publicized novelty. Local retailers depended on travelling sales agents for attractive brochures, store displays, and hints for using unfamiliar products. Most persuasive for urban consumers were department stores with glittering show windows and counters displaying cosmopolitan goods that could be visually consumed even by people who could not yet afford them. And farm families became consumers while poring over thousands of tiny illustrations in mail-order catalogues from Montgomery Ward and Sears, Roebuck, whose self-proclaimed 'Consumers Guide' was emblazoned with an overflowing cornucopia [22]. Visual appearance —the most basic concern of design—assumed greater economic and cultural significance as a 'touch-oriented, local world of production' yielded to a 'sight-oriented, broader world of consumption'.[1]

The house beautiful

Tension between tradition and modernity centred on the home, the focus of a cult of domesticity during the nineteenth century. Originally perceived as the humble abode of a yeoman farmer and his hard-working wife and children, or as an urban workshop inhabited by an artisan and his equally industrious family, the American home took on more complex ideological significance when men moved into the outside world to make their livings as wage earners, salaried clerks and managers, and independent entrepreneurs. Women stayed at home, sheltered and protected, unsullied by modern life's corrupting influences. The ideal woman extended a redemptive influence over her husband and children not only through her moral superiority but also by furnishing and maintaining the home as an environment of moral reform and recuperative calm. A proper domestic interior, encompassing everything from carpets and wallpaper to furniture and decorative objects, offered a comforting refuge and inspired a mood of spiritual contemplation. These effects ironically depended on manufactured goods obtained from the same commercial and industrial world whose negative influence the home was intended to counteract. From about 1870 to the turn of the century, middle-class homes proliferated with ornate objects intended to demonstrate status through emulative

22 Sears, Roebuck and Co.
Cover of *Consumers Guide: Catalogue No. 108*, 1899
The mail-order company promised that 'our trade reaches around the world'; however, this illustration celebrated material abundance flowing out mostly to America's agricultural heartland.

display. Domestic interiors thus worked at cross-purposes as a newer competitive impulse conflicted with an earlier intention to uplift or reform. A Trojan horse—overstuffed of course—was hauled into the American parlour.

The nineteenth-century home economist Catharine Beecher (1800–78) worked on the traditional side of this domestic divide. In 1869 she published a self-help manual on *The American Woman's Home* with her sister Harriet Beecher Stowe (1811–96). They said little about provisioning, shopping, or consuming—as if these were dangerous activities exposing women to a deceitful commercial world. Instead they focused on the 'Christian home' as a place encouraging 'every

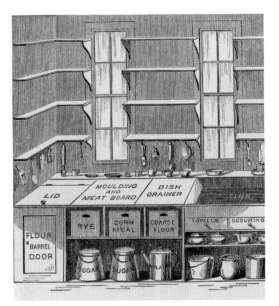

23 Catharine Beecher and Harriet Beecher Stowe

Food preparation and cleaning facilities for the ideal kitchen, 1869

Unlike most late nineteenth-century experts on domesticity, the Beechers emphasized functional efficiency. A separate stove room enabled venting of heat away from the rest of the house. There is an institutional quality to this design, with everything 'so arranged that with one or two steps the cook can reach all he [sic] uses' (34).

member of a family to labor with the hands for the common good' in a manner 'at once healthful, economical, and tasteful'. As long as the home remained light, well ventilated, and efficient (with a kitchen organized like a self-contained ship's galley [**23**]), then its physical arrangement would support its spiritual mission. A sensible taste did not depend on costly display, they insisted, dismissing as wasteful the popular 'curlywurlies' of exterior trim and the 'whigmaliries' that disfigured so many interiors. Decorating a tasteful, morally invigorating parlour involved no more than a few chromolithographs and plaster casts of 'renowned statues' to provide 'a really elegant finish'.[2]

Although mid-twentieth-century champions of functionalism admired the Beechers' detailed kitchen plans, practical suggestions for central heating and ventilation, and sensible attitudes about home decoration, few nineteenth-century contemporaries shared their belief that a simple aesthetic was next to godliness. As the Gilded Age progressed, domestic interiors became more ornate, more crowded, more expressive of the proliferating abundance of society as a whole [**24**]. Today we wonder how people, especially women encumbered by bustles and multiple skirts, could move among so many overstuffed couches and chairs, tables, plant stands, folding screens, and easels, all designed in an eclectic array of historically allusive styles. Mantles, shelves, and table tops were loaded with vases, portraits, ceramic plates, marble busts and statuettes, inlaid boxes, curiosities of brass and copper. Even a room's permanent surfaces—floor, walls, and ceiling—often reflected intricate patterns. Parquet flooring, carpets with geometric figures or natural imagery, panelling, mouldings, wallpapers, and patterned ceilings created rich, complex backdrops for furniture, draperies, and decorative objects. Each of a room's many objects

24 Anonymous
Entry hall of the
Van Alstyne–Dickson
house, Houston, Texas,
*c.*1900

The eclecticism of this interior
defies precise stylistic
categorization, though it
seems to aspire to baronial
splendour. Such random
clutter was already two or
three decades out of date—
perhaps a sign of
provincialism, perhaps of the
age of the owner.

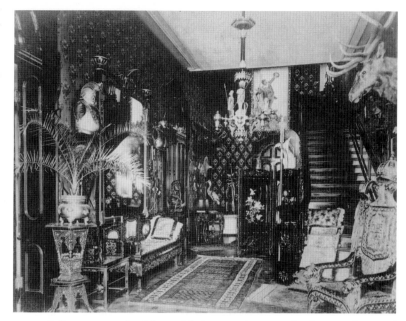

potentially resonated with multiple meanings—whether sentimental or intellectual, personal or cultural—and each connected or collided with others in a complex symphony of material, visual, and mental effects. Although the contents of the home tended to be commercial artefacts, with emotional associations built into them during design and manufacture, people carefully acquired and arranged them to express their own taste and ultimately their own unique character.

For the most part Americans embraced this new culture. They often sought guidance from handbooks such as *Art Decoration Applied to Furniture* (1878), whose author Harriet Prescott Spofford (1835–1921) declared there was 'no reason for simplifying . . . the splendor of the drawing-room but the insufficiency of one's purse'. There could never be 'too much in the room' so long as one could 'move about, without knocking over the furniture'. Even so, the most popular domestic manual was Charles Eastlake's *Hints on Household Taste* (1868), which appeared in seven US editions in 15 years. Eastlake (1836–1906), the secretary of the Royal Institute of British Architects, took a dim view of visual excess on both sides of the Atlantic. Sparing neither producer nor consumer, he maintained that 'vulgarities of design' would abound 'as long as gaudy and extravagant trash is displayed' in the shops and 'as long as people of humble means . . . insist on assuming the semblance of luxuries which they cannot really afford'. If consumers could be taught to demand quality as opposed to stylistic extravagance, then manufacturers would be forced to instruct designers to create 'good artistic furniture . . . quite as cheap as that which is ugly'. Despite his intentions, a so-called Eastlake style became only the latest in a series of styles—Empire, Pompeiian, Louis Quatorze, Renaissance, Gothic

Bedroom suite in the
Eastlake style, *c*.1875
Made of American black
walnut with bird's-eye maple
veneer, these pieces were
typical of custom furniture
inspired by Charles Eastlake.
The relatively severe
ornamentation accentuates
the austere simplicity of the
architectonic Gothic revival
forms.

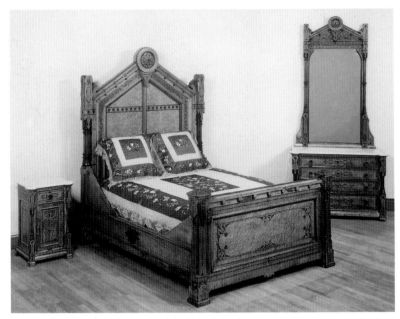

revival—whose eclectic recombinations demonstrated the very 'thirst for novelty' he attacked.[3]

This Eastlake style emphasized simple angular forms echoing the verticality of Gothic revival, pegged joints, woods of contrasting colours, and finishes revealing the wood's natural grain. Most typical was an incised geometric ornament adopted by cabinetmakers Isaac Elwood Scott (1845–1920) of Chicago and Daniel Pabst (1826–1910) of Philadelphia for pieces commissioned by wealthy patrons [**25**]. The ease with which wood could be incised by machine also recommended the Eastlake style to the growing furniture industries of Chicago and Grand Rapids, Michigan. In 1876 a correspondent complained to *American Architect* that Chicago was 'deluged with imperfectly-made imitations of medieval work' and feared a scandal 'if Eastlake should come over here, and see such abominations!' Clarence Cook (1828–1900), the author of a popular collection of essays on *The House Beautiful* (1878), referred caustically to the 'labor-saving appliances' of 'immense furniture-mills' where 'the logs go in at one door, and come out at another fashioned in that remarkable style known here as "Eastlake"' [**26**].[4]

Some critics feared the uncontrolled democratization of luxury had gone too far. Edward Morse (1838–1925), who admired the simple interiors he had experienced during a long visit to Japan, dismissed the typical American parlour as a 'curiosity shop' with a 'maze of vases, pictures, plaques, bronzes' and 'suffocating wall-papers, hot with some frantic design'. Other commentators asserted the dangerous psychological influence of a 'villainous, bad design . . . upon a sensitive mind'. Eastlake had described an 'unfortunate invalid . . . condemned to

26 Phoenix Furniture Co.

Typical factory-built bedroom suite, 1878

Mass-market furniture manufacturers in Grand Rapids, Michigan, 'built up' furniture by an additive process employing a large kit of decorative elements. This system enabled differentiation of price levels within a common stylistic range. Each level added more trim elements to an underlying structural form. The vast number of permutations enabled easy introduction of seemingly new lines.

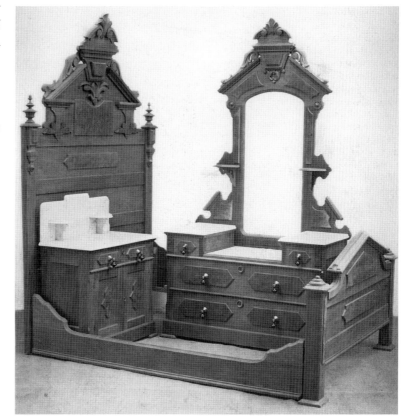

puzzle out the pattern of the hangings over his head'. This characterization paled next to Walter Smith's vivid portrayal in 1873 of a delirious typhoid victim who 'perceive[d] on all sides a fiery red eye gazing on him'. Smith (1838–88), an art educator, reported that even after the patient's fever broke and he regained his senses, an appalling wallpaper pattern continued to afflict him with 'indescribable . . . torture', compelling him to count the room's red dots, 'from floor to ceiling, from one wall to another'. Two decades later Charlotte Perkins Gilman (1860–1935) published a famous short story, 'The Yellow Wall-Paper', about a woman undergoing a forced rest cure who gradually goes mad as she obsesses over 'one of those sprawling flamboyant patterns committing every artistic sin', one whose 'lame uncertain curves . . . constantly irritate and provoke study', one with 'a recurrent spot where the pattern lolls like a broken neck and two bulbous eyes stare at you upside down'.[5]

Gilman's horror story suggests a nagging suspicion that something was fundamentally wrong with the overwrought designs that so abundantly defined the 'house beautiful'. Such fears had surfaced earlier at the time of the Centennial Exhibition held at Philadelphia in 1876 to celebrate the hundredth anniversary of independence. Organizers sought to prove that a strong Union, reforged during the Civil War,

27 George H. Corliss

Corliss Engine, 1876

Donated to the Centennial Exhibition by its designer, the Corliss Engine was actually two identical steam engines, mounted in parallel, each with a grand arc-like beam swinging above a simple, powerful A-frame and a gleaming cylinder and piston together rising 40 feet (12 metres) from the floor. A single flywheel was mounted vertically between them, seeming almost to float on air despite its 56 tons (57 tonnes).

was taking its destined place as an economic leader among the world's industrial nations. They hoped that the design qualities of goods exhibited in Philadelphia would finally establish American commercial independence from Europe. However, in the same way that many observers had regretted the British showing at the Crystal Palace in 1851, some were disappointed with what they saw in 1876. Confronted by the 'contorted and agonized' designs of American furniture, an anonymous journalist felt 'like rushing away as from a nightmare'.[6] Although most ordinary people felt comfortably at home in a rich, colourful, complex abundance of eclectic patterns and shapes, the conflicting experiences of the Centennial inspired a diverse range of individuals to attempt, in one way or another, to bring greater coherence and a more cosmopolitan awareness to the design of domestic furnishings and interiors.

The Centennial Exhibition

Situated in a parkland across the Schuylkill River from the centre of Philadelphia, the Centennial Exhibition was the largest world's fair yet, attracting 10 million visitors. Two long, low conservatories of glass and iron housed most of the exhibits. It was a sign of the nation's ongoing social transformation that the Main Building, with 20 acres (8 hectares) of space displaying objects of consumption, was nearly twice as large as Machinery Hall, which displayed the engines of production. Even so, all eyes turned to the centre of Machinery Hall on opening day. There, standing on a platform, President Ulysses S. Grant and Emperor Pedro II of Brazil opened valves releasing steam to drive the huge Corliss Engine [27]. Its majestic flywheel began silently to turn, powering the shafts that operated thousands of machines, all operating together in a grand industrial fugue.

Historians have devoted much attention to the vast steam engine, named after its builder, the engineer-entrepreneur George H. Corliss (1817–88). They have described it as a prime symbol of the age of energy or as an awe-inspiring avatar of the technological sublime. Others have focused, more prosaically, on the Corliss Engine as an example of the practicality of authentic American design as opposed to European decorative excesses slavishly imitated by too many American manufacturers. But John Hertzman has found more than purely functional considerations in the engine's design. Noting that Corliss had received substantial design assistance from Nathaniel Greene Herreshoff (1848–1938), a designer known for elegant yachts, Hertzman claims that a single-pistoned steam engine could have powered everything in Machinery Hall, but placing two identical engines side by side created a compelling formal symmetry. The Corliss Engine in motion presented a harmonious contrast of two different formal systems: the

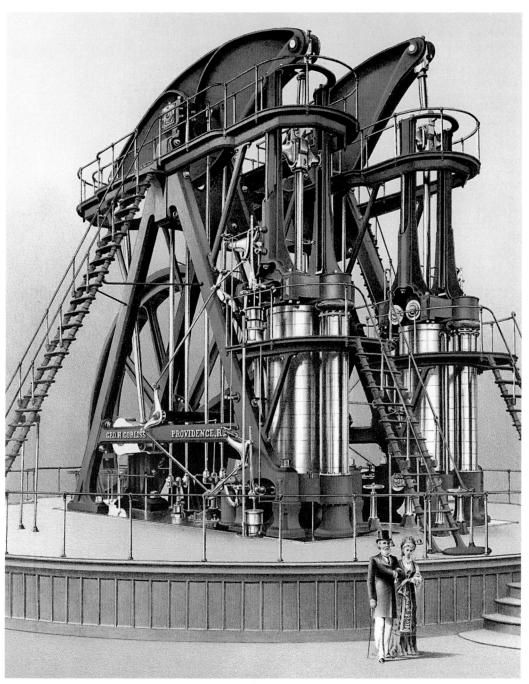

'linear, planar, stable, painted-as-cast surfaces' of the supporting frame and the 'curved, polished, unpainted moving parts' of pistons and flywheel. The result seemed 'utterly natural, artless, and easy', but in Hertzman's opinion, the Corliss Engine was a 'highly artful contrivance' exemplifying an American design tradition enriched by 'continual infusions of relatively sophisticated international experience'.[7]

28 James Whitehouse

William Cullen Bryant Vase, 1875

With medallions designed by the sculptor Augustus Saint-Gaudens (1848–1907), this monumental vase referred to several of Bryant's most celebrated poems in a complex ornamental scheme whose sense of two-dimensional layering anticipated the post-Centennial Aesthetic movement. The poet presented the vase to the Metropolitan Museum of Art in 1877.

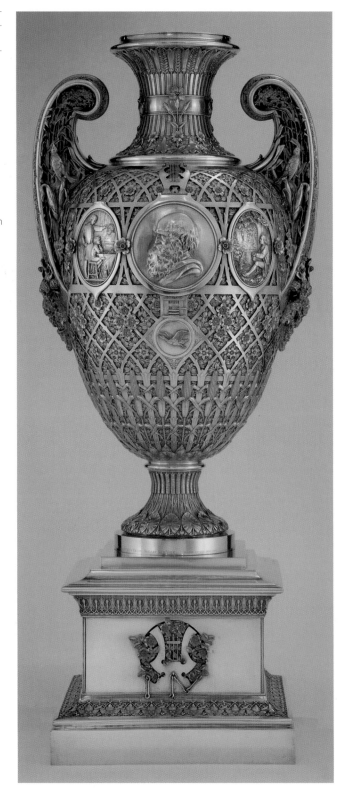

Although US companies dominated Machinery Hall with its engines of production, that was not true of the Main Building, which celebrated the culture of consumption with goods from all over the globe. The experience of many visitors was summed up by the critic James Gibbons Huneker (1857–1921), who went to the fair at the age of 19 and recalled that there he 'suffered' his 'first severe attack of cosmopolitanism'. Walter Smith reported that American visitors 'gained for the first time a realizing sense of the luxury of the old world'.[8] However, the Main Building did contain some objects of US manufacture generally considered praiseworthy. Art critics of the time singled out the Bryant Vase [28], an ornate silver urn nearly three feet (one metre) high, designed and crafted by James Whitehouse (1833–1902) of Tiffany & Co. in honour of the nature poet William Cullen Bryant. The cast-iron chandeliers of Cornelius & Sons of Philadelphia, restrained in their gilt geometric splendour, came in for special mention, as did the organs of Mason & Hamlin of Boston [29], whether housed in a simple Eastlake case or in a high carved cabinet with exposed pipes rising to a dome of architectural splendour. Sympathetic observers also mentioned a variety of innovative patent furniture—adjustable chairs, camp stools, folding card tables, and even

29 Mason & Hamlin

Organ crafted for the Centennial Exhibition, 1876 Firms such as this Boston manufacturer spared no expense in creating unique objects for display along with their standard product lines. Thousands—perhaps millions—of visitors saw them first-hand; such showpieces enjoyed a longer secondary life when reproduced in parlour books like the three-volume *Masterpieces of the Centennial International Exhibition Illustrated* (1876–8).

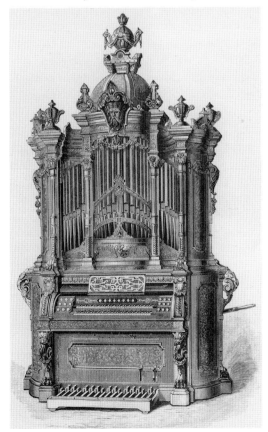

The practical Yankee tinker's
approach to design
sometimes yielded impractical
results. Hess's model, which
was actually manufactured for
a while, was possibly the
convertible piano-bed
reportedly displayed at the
Centennial. Sheet music in
this patent drawing cleverly
bears the song title, 'Rock me
to sleep Mother'.

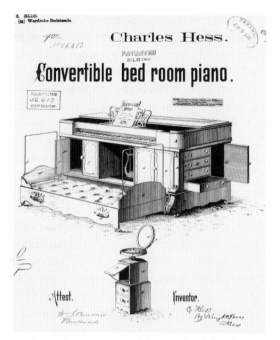

a piano that converted into a bed [**30**]. These suggested a national tendency towards gimmickry. Their cleverness could not make up for the fact that most American furniture at the Centennial—'stacks of it, acres of it', according to the art critic George Ward Nichols (1831?–85)—was 'unattractive, awkward in shape, and imperfect in workmanship'. He could only conclude that 'as an art, industrial design has been but little cultivated in this country'.[9]

Foreign displays at the Centennial so greatly influenced design in the US during the next quarter century as to suggest that 1876 was a watershed. Smith praised several British furniture companies for their 'artfully arranged' model rooms with 'bric-a-brac and knick-knacks . . . disposed about in studied carelessness . . . to suggest occupancy'.[10] Through this innovative display technique fair-goers witnessed the integration of the various elements of a room to create an ensemble and began to perceive domestic spaces as artificially contrived sets. These British exhibits, with medieval-inspired Queen Anne or Tudor cabinets and tables, marked a retreat from the baroque extravagance of earlier revival styles familiar to American consumers, who were now exposed to a more refined mode of design. With journalists and critics so frequently attacking the ease with which cheap-looking goods could be sawn, pressed, or moulded, it came as a pleasant surprise to some of them to witness the aesthetic quality of inexpensive electroplated tea services, centrepieces, and vases displayed by Elkington & Co. of London. Equally inspiring—and mentioned as frequently—were the bentwood chairs and tables of Thonet Brothers of Vienna. Their manufacturing process, yielding a product of strength and elasticity,

revealed a technological genius equal to that of American patent furniture but with more simple, elegant results, verging on an aesthetic that twentieth-century design critics were self-consciously to regard as modern.

Among the most popular displays were handcrafted objects. While manufacturers imitated their refinement through mass production, individuals sought personal renewal by creating similar objects through their own labour. The glorious colours of hand-woven carpets from Europe and the Near East served as a liberating influence on producers of mundane textiles. The proprietor of a Philadelphia textile mill credited the Centennial with moving his industry beyond boring 'black broadcloth and haircloth'.[11] In the field of ceramics, visitors admired the brilliant hues of Lambeth Faience, painted by decorators at Doulton & Co. before it was glazed, and noted impressive pieces produced in a similar process by the Haviland firm of Limoges, France. Wealthy amateurs were soon reproducing and extrapolating from what they had seen at the fair, thereby founding the American art pottery movement. Similar inspiration struck some upper-class women who viewed a popular display of embroidered wall hangings and coverlets with stylized Pre-Raphaelite designs hand-stitched by the Royal School of Art Needlework.

Although foreign exhibits were responsible for stimulating a growing interest in craft production, a few observers pointed out the impressive simplicity of furniture and other crafts displayed by the native-born Shakers, who had been active for the past half century in constructing the buildings and domestic fittings of their religious communities. For the most part, however, Americans thought of their nation's current production as enmeshed in the gears and wheels of Machinery Hall. When they considered American crafts, they recalled colonial ancestors who had won the independence the Centennial was celebrating. Pavilions of Massachusetts and Connecticut exhibited colonial furniture [31], often highly restored or wholly fabricated according to notions of a time that was fast receding into patriotic myth. Such displays stimulated a market for antiques and eventually a demand for reproductions, often historically inaccurate or stylized, which defined a so-called colonial revival.

All the same, most American visitors to the Centennial were enthralled with the foreign exhibits, especially unfamiliar decorative arts displayed by exotic non-European countries: Indian jewellery and bronzes, carved Moorish screens, Egyptian leather goods, and especially the unprecedented riches of Japan, a distant country only hesitantly 'opened' to western trade after the visit of Commodore Matthew Perry's naval fleet in 1853. Edward Morse recalled the 'novelty and beauty' of Japanese objects on display—'lacquers, pottery and porcelain, forms in wood and metal, curious shaped boxes, quaint ivory

31 Anonymous

Interior, Connecticut
Cottage, Centennial
Exhibition, 1876

The state of Connecticut
evoked historical traditions
with a vast 'colonial' hall
furnished with a massive
dining table, Windsor chairs, a
grandfather clock, a spinning
wheel, various smaller
souvenirs and relics, and a
fireplace more appropriate to
a Victorian mansion. This main
room was housed in an
oversized 'cottage' whose
heavy wooden framing
clashed with its picturesque
detailing.

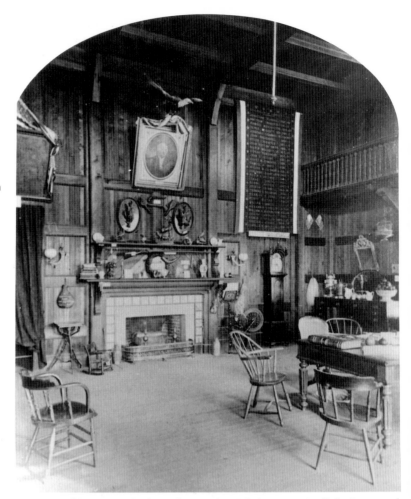

carvings, fabrics in cloth and paper', with 'enigmatical' designs and 'strange caprices in their ornamentation' that 'surprised and yet delighted us' [**32**]. These fascinating objects sparked a 'Japanese craze'. While visitors could acquire inexpensive Japanese souvenirs in a bazaar attached to a small tea house, thousands of artefacts displayed in the Main Building were snatched up, according to Nichols, 'by eager connoisseurs and the great museums of this country and Europe'. Capitalizing on this interest, the jewellers Tiffany & Co. commissioned the British designer Christopher Dresser (1834–1904), who was in Philadelphia in conjunction with the Centennial, to go to Japan to purchase decorative objects. He brought back 8,000 porcelains, bronzes, textiles, silks, jewellery, lacquerware, and enamelled screens—'the largest and most important collection of Japanese goods ever offered for sale'—half of which were immediately sold at auction, with Tiffany offering the remainder at retail.[12]

Within a few years, Japanese bronzes, vases, and prints of varying quality and authenticity further complicated the clutter of middle-

class parlours. Such objects appealed not so much 'because they are more vital or truthful', according to an astute observer, 'but because they are so foreign to us that the mind makes no attempt to adjust them to our surroundings'. It was part of their special charm that one could 'live in them as in strange lands, delighted with their beauty and novelty'.[13] The Centennial's most important legacy was not, as some historians have maintained, a recognition of American superiority in practical technology. Instead, the exhibition's profusion of exotic foreign goods, arrayed in scenes of visual intoxication, inspired a sensual delight in material things, an appreciation of beauty for its own sake, and a desire to aestheticize the home, the former cradle of national virtue. The varied experiences of the Centennial encouraged a generation of young men and women of the privileged classes to define an American civilization whose material parameters would encompass more than the nuts and bolts of the Yankee tinker. However, as they sought to sketch its outlines and embroider its details, they were caught up in a debate over design philosophies and practices that originated across the Atlantic. The cultural independence promised by the Centennial proved illusory at worst and difficult at best.

32 Anonymous
Japanese screen and bronzes, Centennial Exhibition, 1876

Although Frank Lloyd Wright later admired the economical lines of Japanese prints and aspired to the simplicity of Japanese dwellings in his residential architecture, visitors to the Centennial viewed decorative objects such as these not in isolation but against a backdrop of hundreds of similar artefacts whose overall impression was of a restless, stimulating exoticism.

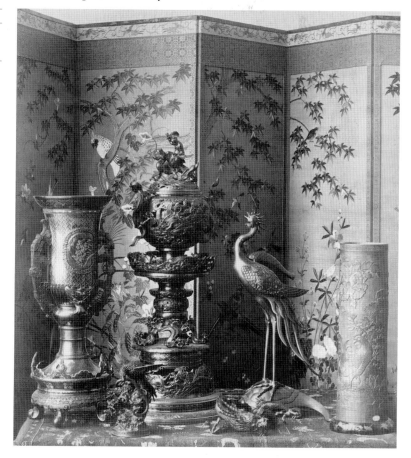

The two paths of Victorian design theory

After the Philadelphia exhibition the public became highly sensitized and aesthetically aware. Many books advised middle-class householders on navigating through a bewildering array of furnishings, carpets, wallpapers, and bric-a-brac. The domestic handbooks of Cook and Spofford, for example, both appeared in 1878. For professionals, *The American Architect and Building News* began publishing during the Centennial year with coverage of all aspects of design, including domestic interiors and furnishings. Artists and craftspeople founded organizations to support their activities, most open to serious amateurs as well as professionals. Among these were the Tile Club and the Society of American Artists in 1877 and the New York Etching Club the following year. Enthusiasm was not limited to a northeastern elite. The Irish writer Oscar Wilde (1854–1900) attracted substantial crowds around the country on a ten-month tour in 1882, speaking diffidently on such topics as 'The Decorative Arts' and 'The House Beautiful'. Not realizing Wilde cribbed his material from the English designer William Morris (1834–96), audiences nodded in agreement at his critique of 'the sordid materialism of the age' and felt uplifted by his insistence that 'nothing that is made is too trivial or too poor for art to ennoble'.[14]

A casual observer would not have realized that a serious rift divided this fledgling design movement. Disagreement involved a wide range of issues—decorative styles, educational philosophies, theories of capital and labour, and moral reform—that were all inextricably linked. In Britain, where the debate originated, the two sides could be characterized as the craft-oriented, tradition-inspired followers of John Ruskin (1819–1900) and an industry-friendly, progress-oriented group based at the South Kensington Museum (later renamed the Victoria & Albert Museum). American enthusiasts did not always make this distinction: interior decorating firms simultaneously announced the availability of wallpapers designed both by William Morris and Christopher Dresser, two designers whose ideas and works exemplified the opposing sides of the argument.

Dresser has often been considered the first industrial designer because he consulted with British firms manufacturing everything from glassware to cast-iron furniture. As an instructor at the design school associated with the South Kensington Museum, Dresser presented a theory of design that was published in two influential works, *The Art of Decorative Design* (1862) and *Principles of Decorative Design* (1873). Both enjoyed wide American readership after the Centennial. There was nothing romantic in Dresser's view of designing goods for everyday use. The process was pragmatic or instrumental, with the designer as a trained specialist working to facilitate the manufacture of an object both useful and pleasing to its purchaser and profitable to its manufacturer. In Dresser's opinion, 'utility' and 'beauty' were not

'inseparable'. Either could exist without the other. Things that were clearly 'useful' were unfortunately 'often ugly'. And those that were 'beautiful' were 'often inconvenient to use'. The design process was constructive or additive, with 'ornament' defined as 'that which [is] superadded to utility'. It was the job of the 'ornamentist', as Dresser significantly referred to the designer, to ensure that a 'work of utility' was also a 'work of beauty'. Unlike Ruskin's followers, who considered designing inseparable from making, Dresser maintained that the designer's contribution to industry was not labour but intelligence. For Dresser, the value of a product depended on 'the *knowledge* displayed in the using and adorning the material, and not upon the amount of labour expended upon its construction'. It was the designer, a specialist, who possessed and applied that knowledge in the service of products whose overarching value lay in the aesthetic pleasures they afforded those who used or contemplated them.[15]

Dresser's opponents in the great design debate, Ruskin and Morris, believed in the morally redemptive power of craft production. As a Gothic revivalist, Ruskin celebrated the picturesque imperfections of the great cathedrals, handcrafted over generations by independent artisans. Romanticizing the medieval guilds, he envisioned brotherhoods of craft workers rising to replace the alienated labourers of Manchester and Birmingham. Adopting Ruskin's philosophy of art and labour, Morris attempted to apply it in his own career as a designer and a proprietor of workshops devoted to printing, weaving, embroidery, metalwork, and woodworking. While Dresser worked as a design consultant for the very manufacturers who maintained the factory system, Morris sought, at least in theory, to avoid its degrading effects on labour by involving his workers in all aspects of the project at hand. Just as designing and crafting objects of beauty would ennoble ordinary people, so too would living in homes surrounded by such objects. As Morris observed in 1877, design's dual purpose was 'to give people pleasure in the things they must perforce *use*' and 'in the things they must perforce *make*'. At present, however, society was degraded by so-called 'manufacturers'—'capitalists and salesmen' who had 'never' done 'a stroke of hand-work in their lives'—who undertook to 'cheerfully furnish' ugly things to an ignorant public craving 'something new' and 'cheap'. Morris exhorted his followers to 'create a demand for real art'. They must, according to a statement that became the main aphorism of a self-conscious Arts & Crafts movement, 'have nothing in your houses that you do not know to be useful, or believe to be beautiful'.[16]

For a time tensions ran high between supporters of these opposing British philosophies of design, the aesthetic versus the moral, one advocating design as a source of visual and tactile pleasure, the other as a source of moral reform. Ruskin had thrown down the gauntlet in 1859 with a lecture on 'the two paths' that attacked the South Kensington

group for its degenerate hedonism, and Dresser had issued *The Art of Decorative Design* as a rebuttal and defence of his practices. At that time Americans remained oblivious because slavery and secession consumed their attention. Later, during the post-Centennial rush of interest in the decorative arts, people embraced anything up-to-date whether it emanated from South Kensington or Morris's workshops. However, a gradual shift occurred over several decades as Americans followed first one path and then the other. Given economic competition with Europe, it made sense for Americans as producers to follow the model of South Kensington. And as consumers they pursued the visual wealth revealed at the Centennial and in doing so created what art historians later referred to as the Aesthetic movement. Upper-class tastemakers sought out exotic Japanese and Islamic imports. They patronized decorators whose work contributed interiors of a sensory richness and complexity offering both aesthetic stimulation and escape from modern life into a dreamlike fantasy world. The middle class,

33 Hopkins & Dickinson Manufacturing Co.

Ornamental door knobs, 1879

These brass door knobs from a hardware factory in New Jersey displayed raised medallions and intricate geometric patterning reminiscent of the Bryant Vase. Mass-produced building materials from hardware to flooring exhibited an abhorrence of empty surfaces and a desire for ornamental richness at all scales as the middle class sought to emulate social aristocrats.

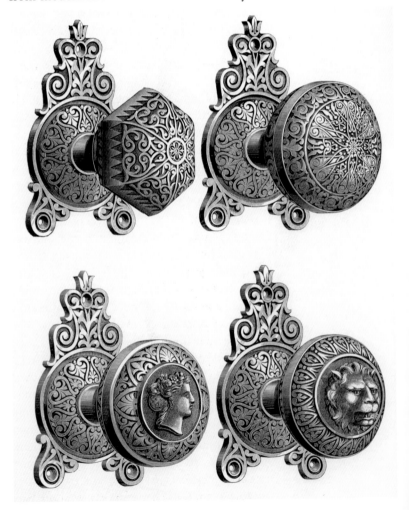

seeking to emulate people of higher status (as de Tocqueville had pre-dicted), preferred products whose more broadly ornate decorative forms and patterns—caricatures of those set by the tastemakers—also contributed to defining the Gilded Age [33]. Eventually a reaction set in, however, as progressive politics led the middle class to an awareness of an increasing gap between rich and poor—a condition that visual and material excesses tended to highlight. Seeking a sense of greater personal authenticity and atonement for their own good fortune in a competitive Darwinian world, some members of the middle class eventually abandoned the hothouse artificiality of the Aesthetic move-ment for the rustic earnestness of the Arts & Crafts movement.

South Kensington in the new world

Supporters of the decorative arts viewed the Centennial as an oppor-tune moment for an all-out design campaign. They were buoyed by the presence of Dresser, who delivered three lectures to mark the founding of the Pennsylvania Museum and School of Industrial Art. Soon to be installed in Memorial Hall, a permanent building display-ing painting and sculpture at the Centennial, the new institution was modelled after the South Kensington Museum. It would provide young designers with practical training for industry and an opportu-nity to study the best examples of the fine and decorative arts selected from the Centennial's thousands of artefacts. An American prototype for the new design school existed in Boston, where the Massachusetts Normal School of Art had opened in 1873. Its director Walter Smith was charged with addressing the lack of trained designers in the state's textile and carpet-weaving industries. As a graduate of South Kensing-ton and former director of design schools in England, Smith held a design philosophy similar to Dresser's and became a leading organizer in the growing movement to make US industry more competitive through design.

Like Dresser, Smith considered the designer to be engaged in a lit-erally constructive process, supplying additional value to something that already existed. Although he hoped to see 'all articles of domestic use . . . redeemed from . . . hopeless ugliness', the utilitarian function of many objects rendered their design quality of only secondary value. The 'lines of structure' of 'a kitchen-pail' need not be 'pleasing to the eye' so long as it was 'constructed' to 'do honest work'. Although there was 'a certain beauty in fitness' for use, that was not the designer's main business. Instead, the designer's training and talent rightly came into play with 'an object of ornament, [such] as a brooch', which demanded 'taste and skill displayed in the application of ornament or decoration . . . above and beyond what . . . utility requires'. Smith and others of his generation recognized a fundamental gap between use and appearance

and granted distinct roles to engineer and designer. Occupational tags like 'decorative artist' or 'ornamentist' acknowledged primary concern for surface effects—an approach twentieth-century modernist design critics later harshly judged as superficial. However, those same critics would have praised as proto-modern another aspect of Smith's concept of the design process. Whether working in two or three dimensions, a designer's most important task was to create 'a good model'. Unlike the romantic advocates of the craft tradition, he realized that designing implied creating a pattern or prototype for other workers to reproduce by hand or machine.[17]

Smith recognized that designers did not control the process. Too often their best work was perverted by the manufacturer, who, 'putting his taste above that of the trained artist, makes some change that he thinks will make the article more salable and popular'. Nor were manufacturers entirely to blame. The ignorant 'multitude' would demand 'meretricious' goods until 'educated up to an appreciation of true honesty in construction, fitness of ornament to material and decorative subordination'. According to Smith, a combination of universal art education, design schools, art museums, and exhibitions such as the Centennial would improve conditions on all fronts and yield an unbeatable 'art power'. Enlightened manufacturers would recognize good design when they saw it, well-trained designers would be ready to create it, and the general public, having received a fundamental art education in the schools, would rise up to demand it. Another vocal supporter, Isaac Edwards Clarke (1830–1907), predicted that 'thousands and thousands of home missionaries of the beautiful' would force manufacturers 'to comply with this demand' or 'yield their markets to foreign competitors'.[18] Many manufacturers took the new design gospel to heart and lobbied for education of professional designers and of teachers to bring drawing skills and a sense of taste to children in state schools. By 1885 nearly forty institutions, ranging from museum schools and art associations to public and private universities, were dedicated to training designers, artists, and art teachers. Design was becoming a recognized profession, though one whose mostly anonymous practitioners had to negotiate the space between profit-seeking capitalists and novelty-seeking consumers. Only a small group of new elite designers, inspired by the Centennial's exotic displays, attained public status as they created interiors, furnishings, and decorative objects so shimmeringly fanciful that they nearly escaped the domain of such a prosaic word as 'domestic'.

The Aesthetic movement

The wealthiest urban Americans—financiers and entrepreneurs like the Carnegies and Vanderbilts—began employing interior decorators

at the time of the Centennial. As Harriet Spofford observed in 1878, a professional decorator entered a new townhouse 'the moment the masons leave' and created a 'homogeneous whole' encompassing 'the frescoes of the ceilings, the colors of the carpet and curtains and furniture covers, the wood-work of the furniture and of the walls'. Comprehensive service reassured nouveaux riches who feared their own taste and flattered cultivated clients learning to navigate a flood of new motifs. The earliest firms, such as Herter Brothers and L. Marcotte & Co., expanded from custom furniture to dark architectonic panelling and cabinetry with ornate carving. A journalist described their showrooms as muffled in 'drapery' of 'subdued colors' and exuding the 'quiet atmosphere' of 'picture galleries'. As the Aesthetic movement took hold, these 'museums of household art' assumed a 'cosmopolitan wealth of design' displaying all 'the beautiful national types, the Persian, the Indian, Moorish, Chinese, Japanese, Venetian', inspiring decorators to transcend the predictable forms of the American Empire style. Among them were Candace Wheeler (1827–1923) and Louis Comfort Tiffany, who formed the partnership of Tiffany & Wheeler in 1879. As Tiffany explained to Wheeler, they were 'going after the money there is in art, but art is there all the same'.[19]

Wheeler came to design in her early fifties, though she had long moved in New York art circles. Attending the Centennial, she was transformed by the sight of exquisite large-scale embroideries of the Royal School of Art Needlework, designed by Walter Crane (1845–1915) but executed by anonymous female artisans. Wheeler returned home to found the New York Society of Decorative Art, which offered women training and employment in needlework, wood carving, and china painting. With this practical experience behind her, Wheeler accepted Tiffany's proposal that they collaborate in designing interiors. Two decades younger, Tiffany had declined to enter his father's jewellery firm, seeking instead to become a painter. A complex figure who proved as much entrepreneur and inventor as artist, Tiffany realized he would never be a great painter and sought a challenge to engage all sides of his personality.

Although it was standard practice for architects to shape the interiors of houses, few orchestrated such details as wall and floor patterns, furnishings and upholstery, draperies and tapestries, even objets d'art. As Wheeler later recalled, she was responsible for 'the fitting of any and every textile used in the furnishing of a house to its use and place'. Tiffany contributed a talent for general synthesis. Others who occasionally collaborated included the painters Samuel Colman (1832–1920), who worked with colours and patterns, and Lockwood de Forest (1850–1932), who focused on wood carving and decorative painting of wood. The task of Tiffany & Wheeler was similar to that of a painter. Working together to coordinate all elements, they created an

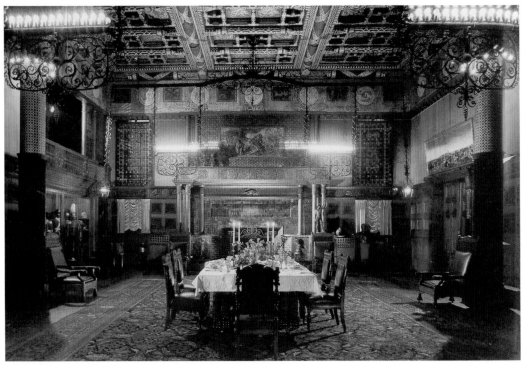

34 Tiffany & Wheeler

Veterans' Room and Library,
Seventh Regiment National
Guard Armory, New York,
1880

An oak wainscot served as the
ground for grotesque
woodcarving and a frieze of
medallions featuring allegories
of war. Other features included
a coffered ceiling patterned in
yellow and red, hanging
candelabra of screen-like
wrought iron, large columns
with upper reaches wrapped
in stylized chain mail, stained
glass, and a marble and brick
fireplace surmounted by blue
glass tiles.

atmospheric 'picture within which and against which one's life and the life of the family is to be lived'.[20]

The firm's spectacular success demonstrated that the economic and cultural elite were ready for a sophisticated approach to design. In four years of collaboration, projects ranged from the writer Mark Twain's house at Hartford, Connecticut, to four rooms in the White House for President Chester A. Arthur. Their most significant project, the only one still extant, was the Veterans' Room and Library of the Seventh Regiment National Guard Armory in New York [34]. This major effort, completed in 1880, included architectural detailing by Stanford White (1853–1906), a decorative frieze by painters Frank Millet (1846–1912) and George Henry Yewell (1830–1923), a sculptural relief by Augustus Saint-Gaudens, glass mosaics by Maitland Armstrong (1836–1918), and textile work by Wheeler's daughter Dora (1857–1940). As coordinated by Tiffany, the Veterans' Room excluded the outside world and enveloped inhabitants in an illusion of an infinite regression of complexly textured interpenetrating screens and surfaces. Each surface at every scale was intricately patterned in an interrelated manner foreshadowing the theory of fractals. This shimmering unreality, so typical of Aesthetic movement interiors, fulfilled Wheeler's principle that 'we must avoid' being 'constantly reminded of the wall as a wall, as a solid piece of masonry'.[21] The room afforded a haven of male domesticity in which veterans could contemplate past and future national glories as part of a long chivalric tradition.

Both Wheeler and Tiffany left interior decoration when their partnership dissolved in 1883. Their subsequent careers were similar in that each oversaw the design, manufacture, and marketing of discrete objects, though Tiffany achieved greater success. Continuing to work in textiles, Wheeler shifted from embroidery to appliqué. Rejecting the British emphasis on two-dimensional patterns based on stylized natural forms or geometric abstractions, she employed a three-dimensional pictorial emphasis reminiscent of her work as an amateur nature painter—an approach enhanced by the layered quality of appliqué [35]. Employing artists to conceive designs, Wheeler introduced machinery for printing fabrics and for simulating embroidery in

35 Candace Wheeler

Appliqué panel of silk velvet on silk and metallic fabric, *c.*1884

Designed by Wheeler for her firm Associated Artists, this appliqué panel possessed a ground fabric with a golden metallic sheen woven by the firm of Cheney Brothers. Wheeler's dedication to naturalistic realism led her to depict the tulips not in first bloom but in decay, when their petals were about to fall.

a patented process. Although she addressed an elite clientele and never attained high-volume production, she rejected the romantic view of the artist-craftsperson and accepted South Kensington's view of the designer as a professional figure charged with enhancing the beauty of things.

Her former associate Tiffany, described by the historian Neil Harris as 'our first great industrial designer', even more fully exemplified the ideals of Dresser.[22] However, Tiffany did not work as a consultant to a variety of manufacturing firms. Instead he was an entrepreneur, the proprietor of the firm Tiffany & Co., developing a system for producing minutely varied but nearly identical artefacts that spread the Aesthetic movement's ideology of art for art's sake to the middle class. After Tiffany perfected a process for making opalescent or iridescent stained glass, his workshop created custom designs for residential and commercial clients, culminating in 1902 in a spectacular dome of blue, green, and gold glass for the Marshall Field department store in Chicago. By then Tiffany was producing trademark lampshades of randomly shaped shards of iridescent coloured glass set in lead, sometimes inspired by Native American motifs and generally conveying a shimmering warmth similar to that of the Veterans' Room. When these lamps first went on sale in 1895, the *New York Times* referred to them as 'curious and entirely novel, both in color and texture'.[23]

The ensuing craze for Tiffany lamps guaranteed the firm's success for several decades. As entrepreneur and proprietor, Tiffany depended on in-house designers. Arthur John Nash (1849–1934) and his son Leslie Hayden Nash (1884–1958) supervised the glass-blowing operation, created many of the opalescent effects, and designed hand-blown bowls and vases. Clara Driscoll supervised the women's glass-cutting department and designed many lamps, including the dragonfly [21], winner of a design award in 1900 at the Exposition Universelle in Paris, where the general display of Tiffany Studios evoked praise for its 'dumbfounding versatility'.[24] Driscoll's annual salary of $10,000 made her one of the highest paid women in the US. Other employees worked in metals, creating lamp bases in cast bronze or copper sheet, silver repoussé boxes, and jewellery. Still others designed and made ceramic vases and bowls. By 1910 Tiffany employed 200 designers and artisans, making thousands of artefacts per year, some still on a custom basis but most sold through catalogue or in exclusive shops across the country. Each glass-shaded lamp followed one of many specific designs but differed slightly because it was made by hand. In Harris's memorable phrase, Tiffany was a businessman engaged in 'personalized industrial production'. His enterprise benefited from both 'the cachet of the artist' and 'the advantages of a brand name'.[25]

Popularity of Tiffany lamps indicated middle-class desire to appropriate the cosmopolitan aestheticism of the upper class by possessing

an iconic miniature. The high point of the Aesthetic movement for the upper class had come in 1883 with the publication of a two-volume work on *Artistic Houses*, subtitled as 'views of a number of the most beautiful and celebrated homes in the United States'. Available only to 500 subscribers, the set opened with four full-page photographic plates of Tiffany's apartment on East 26th Street, whose library suggested the multi-layered effect of the Veterans' Room. Other interiors included those of financiers and industrialists (J. Pierpont Morgan, William H. Vanderbilt, Marshall Field), politicians (Ulysses S. Grant, Hamilton Fish), and artists (Samuel Colman, Frank Furness). Although some rooms echoed Louis Quatorze or Empire style and others announced the colonial revival, most revealed the complex patterned surfaces, rich wallpapers, geometric panels and coffered ceilings, Japanese and Islamic motifs, shimmering latticed screens, and enveloping sweep of the Aesthetic movement [36]. While exotic objets d'art abounded on sideboards, the emphasis was not so much on a profusion of objects as on the richness of the overall effect. The visual complexity of these inner landscapes created an energizing haven from the crudeness of the industrial world that made it all possible.

But even as a sense of exotic plenitude was reaching an upper-middle-class audience through Tiffany and other art manufacturers

36 Herter Brothers
Library, William H. Vanderbilt house, New York, 1882
The decorating firm designed the entire mansion on Fifth Avenue, with plans drawn up by staff architect Charles Atwood (1849–95). Vanderbilt lived in the house for only three years before his death. This photograph from *Artistic Houses* dates from soon after its completion.

37 J. H. Boughton Co.

Parquet flooring
commercially manufactured
in 'Japanese pattern', 1893
The Aesthetic movement's
exoticism reached
standardized building
materials for the upper middle
class by the late nineteenth
century. Products such as
Boughton's 'artistic wood
floors', marketed by a
Philadelphia firm, offered
people of modest wealth
decorative effects such as
those of *Artistic Houses*.

PLATE No. 341. JAPANESE PATTERN

We can lay them from our regular stock in an endless variety of styles, in geometrical or scroll patterns

BOUGHTON'S IMPROVED

End=wood and Mosaic Floors

7-8 INCH THICK MADE TO ORDER IN GREAT VARIETY.

GET OUR ESTIMATE OF PRICES

9

[**37**], negative reactions set in among the elite and among politically progressive members of the middle class who realized they could not aspire to such rich displays—nor was it seemly in the face of the bitter labour struggles of the time. One of the first among the elite to dissent from the Aesthetic movement was Edith Wharton (1862–1937), later a perceptive novelist of New York's high society, who with the interior decorator Ogden Codman Jr. (1863–1951) published a treatise on *The Decoration of Houses* (1897). Because they advocated a trickle-down theory according to which 'every carefully studied detail . . . will in time find its way to the carpenter-built cottage', they also blamed the 'ugliness' of mass-market designs on the vulgar taste of the elite. Inspired by the pure white symmetry of the grand neoclassical buildings of the Columbian Exposition in Chicago in 1893, Wharton and Codman argued against a 'labyrinth of dubious eclecticism' and in favour of proportion and symmetry.[26]

However, they did not contest a basic assumption of the Aesthetic movement, inherited from South Kensington, that design's major cultural function was to enhance the aesthetic experience of life for

its own sake. A cynic could argue in response that the only motive for improving the quality of design throughout society, other than economic, was to protect cultivated individuals from exposure to aesthetic abominations perpetrated by others. Social progressives believed the US could not afford such selfish hedonism. For example, Herbert Croly—editor of the journal *Architectural Record* and later the author of a major progressive political treatise, *The Promise of American Life* (1909)—thought that the concept of art for art's sake smacked of a decadence more European than American. Middle-class promoters of design at the end of the nineteenth century tended to reject the extremes of the Aesthetic movement and instead celebrated design as a moral activity leading to the reform of society. Those who followed this second path, that of Ruskin and Morris, included potters and woodworkers, artists and architects, philosophers and reformers, and thousands of ordinary people who sought furnishings they believed would express their own authentic individuality. Ironically their quest for simplicity and comfort as opposed to ornament and luxury smoothed the way for the cleanlined functionality of the mass-produced goods of the twentieth-century machine age.

The Arts & Crafts movement

Like so much else, the Arts & Crafts movement in America had its roots in the Centennial Exhibition. Inspired by handmade objects on display, whether needlework or pottery or wood carving, people wanted to try it themselves, learn the techniques, master and extend them, and thus create unique objects of beauty. From that personal involvement came the Arts & Crafts emphasis on authenticity, which eventually changed from active to passive, from making to having. People came to believe that virtue emanated from possessions that evoked national traditions of organic nature and colonial simplicity, regardless of whether or not their owners had anything to do with making them, or even whether or not they were actually made by hand.

Making and decorating pottery appealed to early Arts & Crafts enthusiasts, especially women. Unlike needlework, which evoked domesticity, pottery allowed upper-class women to transcend traditional endeavour by establishing studios and working outside the home. Visitors to the Centennial had admired the underglaze decoration of faience pieces from Doulton and Haviland, as well as the colourful glazes of stoneware from Japan and China. Among those who returned home inspired were Mary Louise McLaughlin (1847–1939) and Maria Longworth Nichols (1849–1932), who soon clashed over the development of the Rookwood Pottery in Cincinnati. They already participated in a lively art scene sparked by several Ruskinian instructors at the

University of Cincinnati's School of Design. One of them, Benn Pitman (1822–1910), had earlier taught McLaughlin china painting, or the art of decorating glazed pottery. Energized by the Centennial, she began experimenting with underglaze decoration, the painting of pottery slips prior to glazing, a process that yielded the 'appearance of a painting in oil'.[27] Nichols approached the subject more circumspectly by illustrating a book on *Pottery: How It Is Made, Its Shape and Decoration* (1878) written by her husband, the art critic George Ward Nichols. A year later McLaughlin invited local pottery decorators to join her in the Cincinnati Art Pottery Club. When her invitation to Maria Nichols went astray, the latter sensed a slight and founded the Rookwood Pottery in 1880.

One of the most successful Arts & Crafts ventures, Rookwood followed a common trajectory as it moved from initial idealism to commercial success. At first the amateur club and the fledgling art pottery coexisted, sharing facilities at a commercial pottery. Nichols established a gendered division of labour that became standard at most art potteries, hiring an experienced male potter to throw blanks on the wheel. The decorators were women, at first upper-class volunteers from the club but soon replaced by paid employees. Within a year Rookwood produced several thousand pieces in 70 shapes, each uniquely decorated in lustrous floral imagery with reflective overglazing.

Frustrated by her inability to supervise a business, Nichols hired William W. Taylor (1847–1913) as manager in 1883. He immediately closed the pottery's decorating school and evicted the Cincinnati Art Pottery Club, leading an embittered McLaughlin to sue Nichols over who had first developed Rookwood's method of underglaze decoration. Over the following decade, Taylor hired chemists, installed a steam engine to turn the potters' wheels, tracked sales in a 'shape book', measured the productivity of female decorators who completed on average one-and-a-third pieces per eight-hour day, and hired male designers, several of whom went to Europe or Japan for additional training. Although Nichols retained a studio, she sold out to Taylor in 1889 in recognition of his effective management. Two years later, when the pottery moved to a new complex of half-timbered Tudor buildings, Rookwood annually produced 11,000 pieces, distributed by high-end retailers. Although Arts & Crafts advocates pointed out that the famous Cincinnati pottery was 'not merely a workshop' but also 'a school of handicraft, an industrial art museum, and a social center', it was actually a business from which such elements had been eliminated and whose labour and production were gently but efficiently supervised.[28]

By 1910 the labour-intensive hand-painting of detailed pictorial decoration [38] was yielding to dull, earth-toned matt glazes which appeared natural, organic, or rustic, and thus more handmade, no

38 (above) **Albert R. Valentien**
Vase, 1898
Trained at the School of Design of the University of Cincinnati, Valentien (1862–95) was the first professional decorator at Rookwood Pottery in 1881 and served as head decorator for much of the next 24 years. This glossy vase, with its somewhat exaggerated but still naturalistic irises rendered through underglaze painting, was typical of Rookwood's output during the pottery's first two decades.

39 (above right) **Anonymous**
Humidor, 1902
One of the first of the Rookwood Pottery's matt-glazed wares, this humidor possessed decorative elements modelled by hand rather than delineated in paint on a smooth surface. Eventually this new technique and 'look' dominated Rookwood's output, with many shapes being cast in moulds.

matter what the reality [**39**]. Seeking a mail-order market, in 1904 Taylor commissioned a national advertising campaign from the J. Walter Thompson agency. The resulting booklet emphasized Rookwood's 'radical difference from commercial industries' owing to 'the individuality of its artists' and 'their freedom of expression in the ever-changing language of an art that never repeats itself'. By then, many pieces were actually cast in low relief from moulds, rather than thrown on a wheel, a practice that gave each model an identical form. This was defended in 1903 by a former Rookwood designer, Artus Van Briggle (1869–1904), who had established a pottery in Colorado Springs. As reported by *House Beautiful*, a magazine close to the Arts & Crafts movement, Van Briggle considered it better 'to spend unlimited time and thought in carrying out an idea which may be worthy of repetition . . . than to attempt for every vase a new design which must of necessity often be careless and hasty in thought and execution'.[29] Although different pieces from the same mould actually varied owing to the unpredictability of glazing, the trend was away from the crafting of unique artefacts by skilled artisans and towards the making of standard products by relatively unskilled workers following a prototype created by a master designer—precisely the path proposed by Dresser and the South Kensington group.

Not all art potteries followed Rookwood's lead. Some potters worked as individual artists shaping truly unique works. Among these independents was Adelaide Alsop Robineau (1865–1929), an intellectual who founded the journal *Keramic Studio* at Syracuse in 1899,

40 Adelaide Alsop Robineau
Scarab vase, 1910
Robineau earned wide recognition with a prize for 55 pieces displayed at Turin in 1911. She sculpted this porcelain vase while affiliated with the American Women's League school in St. Louis. After throwing the form and glazing it white with turquoise accents, she carved the pattern, creating a dramatic contrast between glazed and unglazed areas. Entitled 'The Apotheosis of the Toiler', it represented the never-ending labour of women and Robineau's own dedication.

translated a treatise on Sèvres clays and glazes, and worked more than a thousand hours on the minute filigree of the 17-inch (43-cm) Scarab vase [40]. At the opposite extreme was George Ohr (1857–1918), the so-called 'mad potter of Biloxi', whose extravagant buffoonery and self-promotion made him a tourist attraction on the Mississippi Gulf coast, where he created tens of thousands of proto-modern pieces [41]. Some potteries romanticized regional culture. In Bucks County, Pennsylvania, for example, the Harvard-educated folklorist and local

41 George Ohr

Vase, *c*.1895–1900

Ohr created thousands of vessels like this by throwing pots on the wheel in a traditional manner and then heroically crushing and deforming them into organically resonant shapes that were often hilarious, sexually suggestive, or nightmarish.

historian Henry Chapman Mercer (1856–1930) established the Moravian Pottery and Tile Works in 1898 to manufacture decorative tiles ornamented with hand-pressed moulds. Mercer extrapolated from vernacular motifs of descendants of German immigrants and employed a rough technique and warm, earth-toned glazes to evoke the rustic simplicity of peasant art.

Regional distinctions marked the philosophy or ideology of Arts & Crafts as a general movement. Two organizations established in Boston and Chicago in 1897 exemplified distinct poles, with Boston retaining an aristocratic orientation to the Aesthetic movement and Chicago promoting a populist approach. The power behind the Society of Arts and Crafts, Boston (as it was formally known) was Charles Eliot Norton (1827–1908), a professor of fine arts at Harvard, who sought to erect high Anglo-American standards against an immigrant democracy which he believed threatened to 'sweep away natural distinctions of good breeding and superior culture'. Although the society organized annual exhibitions of work from throughout the Northeast and maintained a public salesroom, non-practising connoisseurs served as jury members and maintained control of the society —with the result, as one member complained, that they were 'playing at Arts and Crafts' with 'more talk than work'.[30]

In Chicago, by contrast, social reformers led the way. The Chicago Arts and Crafts Society was founded in a meeting at Hull-House, a settlement house run by Jane Addams (1860–1935) and Ellen Gates Starr (1859–1940) for the betterment of the surrounding urban immigrant population. Hull-House's varied programmes already included craft workshops for evening recreation and a museum of women's weaving techniques organized to instil immigrant children with pride

in their heritage. The society's constitution echoed the social concerns of Ruskin and Morris by addressing 'the present state of the factories' and arguing that 'the machine [must] no longer be allowed to dominate the workman and reduce his production to a mechanical distortion'.[31] In many ways the Chicago society functioned like its counterpart in Boston, scheduling lectures, mounting exhibitions, and making handcrafted goods available for purchase, but it retained an ideological devotion to improving the situation of workers.

At the turn of the century the Arts & Crafts movement was gaining such momentum among the middle class as a design style that philosophical or ideological content often receded into the background. Whether harking back to Tudor England or to colonial times, the plain, dark, heavy, rough-hewn chairs, benches, tables, and bookcases of so-called mission furniture defined a simple comfort that transformed the American home. Historians have recently associated it with the cult of the strenuous life popularized by Theodore Roosevelt, but as long ago as 1927 a furniture trade journal referred to the mission style as evidence of 'a masculine uprising, a full size man's revolution' against the feminine domesticity of the parlour [**42**].[32] Mission furniture, constructed of inexpensive oak rather than more expensive hardwoods typically used for furniture, embodied in material form a desire for thrift and denial of luxury at a time when the middle class

42 L. & J. G. Stickley Co.
Morris chair, *c.*1910
Named after William Morris, the wide, low armchair with an adjustable back and upholstered cushions became synonymous with the concept of Arts & Crafts or mission furniture. The Stickleys, who were in competition with their brother Gustav, fabricated this model in quarter-sawn oak.

was caught economically in an inflationary squeeze of rising prices and stagnant incomes. At the very least, the plain forms and simple organic materials of the mission style suggested a rejection of the lush artificial abundance of so many Gilded Age interiors.

Mission furniture burst on the American scene in 1900 at the dawn of a new century. Proclaimed by the Tobey Furniture Co. as 'the new furniture' in an advertisement in the *Chicago Tribune*, it marked 'a departure from all established styles, a casting off of the shackles of the past'. Even so, a verbose text referred not only to Ruskin and Morris, to 'old-fashioned rush bottoms', and even to 'Spanish leather, fastened with big-headed oxidized nails', but also to such modern forms of expression as the 'Glasgow School of Design' of Charles Rennie Mackintosh (1868–1928) and the 'bold lines' of 'the impressionist style of painting'. Among the seven pieces illustrated were a solid, boxy rocker studded with nails, a trestle-style library table, an organically shaped 'poppy table', and an angular plant stand inlaid with art tiles. From this 'first slight harvest' would follow 'a variety of furniture that will be thoroughly practical, not too good for daily use, moderate in price, in demand by people of culture and taste, and that will help to make life better and truer by its perfect sincerity'. This single astonishing sentence encompassed all the actual attractions of the mission style from simplicity and reasonable price to authenticity and moral uplift.[33]

The furniture maker responsible for designing and fabricating the Tobey Co.'s new line was Gustav Stickley (1858–1942) of Syracuse, New York. Energetic and intellectually curious, he was transformed by a trip to Britain and the Continent in 1898, which had brought him face-to-face with the furniture of Art Nouveau, the Vienna Secession, and the Glasgow School. After his return Stickley began thinking of an American national style that would distil the nation's original relationship with nature as reflected in the best of its colonial, Shaker, and frontier traditions. The result was this new line, which Stickley displayed in July 1900 at the furniture industry's Grand Rapids trade show. There it was seen by a buyer for Tobey who recognized Stickley's genius and contracted to distribute the furniture nationally. A reviewer in *House Beautiful* declared that this 'sensible furniture' would finally abolish 'cheap veneer, . . . jig-saw ornament, [and] poor imitations of French periods' by putting 'honest workmanship within the reach of the masses'.[34] Although Stickley's association with Tobey lasted only briefly, it brought him national attention that encouraged him to develop and market his own Craftsman line. That mission furniture had become a fad was certified in 1904 when Sears, Roebuck and Montgomery Ward joined a host of other imitators by offering mail-order variants.

There has been much debate over who came up with the concept of 'mission' furniture, where the term came from, and precisely what it

43 J. W. Mason & Co.

Mission settee, 1879

The existence of this illustration from a New York furniture catalogue complicates the question of the origin of mission furniture. The plain horizontal lines and flat vertical back slats of this so-called 'mission settee' exactly prefigured the mission style of 20 years later, though its front legs exhibited a flourish of mechanical turnery.

meant. In 1901, a trade journal argued it was 'furniture with a mission' —to 'teach' the need for 'good material, true proportion, and honest workmanship'. Nearly a century later, the architectural historian Richard Guy Wilson extended that metaphor by noting the furniture's 'missionary' goal as part of a larger 'search for a way of life that was true, contemplative, and filled with essences rather than superficialities'. Stickley's contemporaries often took a more prosaic view, as did a Sears, Roebuck catalogue whose text solemnly declared in 1908 that mission furniture 'derived its name from original pieces found in an old Spanish Mission in Southern California' [43].[35]

The real question is not the origin of the style (which had many influences) nor of the mission name (which is irrecoverable) but the supposed centrality of Stickley. Some historians have resurrected rival designers, correctly arguing, for example, that the furniture shops of Grand Rapids supported several truly innovative contributors to Arts & Crafts, such as Charles P. Limbert (1854–1923), whose low architectonic pieces reflected a preference for Vienna but also anticipated Expressionist design of the 1920s [44]. Other historians have promoted the reputation of the L. & J. G. Stickley Co., which in 1902 began making mission furniture in Fayetteville, New York. Correcting an earlier historical interpretation which had Gustav producing truly handcrafted furniture while his brothers Leopold (1869–1957) and John George (1871–1921) produced only machine-made knock-offs, they have demonstrated that Gustav's employees relied just as much on machinery to cut the quarter-sawn oak from which his furniture was constructed, to plane it, to cut out blanks for hand finishing, and to produce mortise joints. In fact Stickley admitted so in 1904, echoing the labour philosophy of Arts & Crafts by stating that his use of machinery 'eliminated the laborious, repetitive tasks associated with woodworking' and freed workers for truly creative aspects of their craft. According to this revisionist interpretation, the supposed imitator Leopold really differed from Gustav only in that he was 'little

44 Charles P. Limbert Co.

Oak table, *c.*1905

Limbert claimed his furniture was inspired by that of Dutch peasants; however, he also acknowledged debts to the Scots designer Charles Rennie Mackintosh and to the Vienna Secession. Limbert's firm supplied furniture to the Old Faithful Inn at Yellowstone National Park in 1906.

interested in selling a lifestyle'. Gustav, on the other hand, did sell a lifestyle, and that made all the difference.[36]

Stickley perceived his Craftsman enterprise as more than a furniture company. Syracuse boasted an active Arts & Crafts community in which he became a leading light after returning from Europe. Among its members was the potter Robineau, but of greater significance for Stickley was her friend Irene Sargent (1852–1932), a former student of Charles Eliot Norton and a professor of art history at Syracuse University. Sargent encouraged the furniture maker to consider his professional activity as part of a larger social process. In 1901 Stickley began publishing *The Craftsman* magazine with Sargent as managing editor and frequent contributor. The first two issues—mostly written by Sargent—celebrated Ruskin and Morris. For the next 15 years *The Craftsman* was the most significant Arts & Crafts journal in the US, featuring an eclectic array of authors discussing everything from art pottery to the new town movement. Although Stickley was in the business of selling Arts & Crafts furniture distributed by more than 40 retail stores, he encouraged subscribers to become craftsmen in their own right, thus in theory renouncing potential revenue. The magazine included measured drawings of his company's own pieces so hobbyists could make them by hand at home. He also published picturesque renderings of Craftsman homes for which one could purchase detailed architectural plans. More than a businessman, Stickley thought of himself as working for 'the great middle classes', for ordinary people 'possessed of moderate culture and moderate material resources, modest in schemes and action, average in all but virtue'. His 'simple, democratic art' offered them the possibility of 'material surroundings conducive to plain living and high thinking'.[37]

A certain shallowness slipped into the vision. For a tired manager or office clerk to fantasize about making mission furniture at home

became almost as significant as any attempt actually to do so. And it did not really matter if workers who were subject to the division of labour had used machines in making Craftsman furniture so long as the product looked handmade. Before Stickley it was a longstanding paradox of the Arts & Crafts movement that ordinary people could not afford to purchase furnishings and decorative objects that promised to improve their aesthetic taste and uplift them morally. By making Craftsman products affordable to the masses, or at least to comfortable members of the middle class, Stickley reduced the effectiveness of such artefacts to a matter of appearance, of visual surface —or, one might say, a matter of design, even of packaging. The distance was not so far from Stickley to Elbert Hubbard (1856–1915), a former salesman and genial fraud who established the Roycrofters at East Aurora, New York. There he offered rustic lodgings, inspiriting lectures, and the run of the workshops to exhausted business leaders seeking therapeutic renewal. This establishment, which in Hubbard's own words 'began as a joke' but 'resolved itself into a commercial institution', churned out copper curios [45] for sale at hundreds of outlets 'scattered from Maine to California'.[38]

Ultimately the Craftsman vision differed little from that which had engaged the design sense of the American middle class since at least the Civil War: the nurturing of a 'fine home spirit—the old traditional devotion to parents and the fireside', as Stickley phrased it.[39] Even so, the dark fumed oak of a heavy mission rocking chair, or the irregular shape and earth-toned glaze of a late Rookwood vase, or the smoky hammered copper surface of a Roycroft candy dish appeared to be worlds away from the rich materials, complex pattern vocabularies, and sophisticated juxtapositions of the late nineteenth-century Aesthetic movement. For all its nostalgic harking back to traditions in which the ancestors of many middle-class Americans had not even participated, the Arts & Crafts style also directly responded to a desire for simple comfort and thus clearly reflected the functional require-

45 Roycrofters

Copper smoking set, *c.*1909
The rustic hammered surfaces and oversized brads of these articles suggest Elbert Hubbard's emphasis on an appearance of almost primitive technique. His workshops carried to an extreme the development of craft work as a fetish.

46 Anonymous

Arts & Crafts domestic interior, Dallas, Texas, c.1908

Dark woodwork, brick fireplace, and slatted mission furniture evoke the simplicity of a rural English cottage or a frontier outpost from 50 years before. However, the sense of flowing spaces, accentuated by this expansive view from living room into dining room, prefigures the open plans of modern architecture—as does the austere simplicity of the furnishings.

ments of a new century in which efficiency, precision, speed, and other machine values took precedence over all tradition [**46**]. The 'fine home spirit' evoked by Stickley, no matter how it was stylistically garbed— whether in heavy mission oak, or in the more commercially popular pressed-back chairs and claw-footed pedestal tables of golden oak, or decades later in the smooth teak surfaces of Scandinavian modern— proved to be a domestic ground zero, a bare organic minimum required for sheltering people from the full effects of machine-age modernity. With the design of the domestic realm more or less settled in a manner that made at least a paraphrased reference to tradition, Americans could finally respond to the challenge posed by the Centennial's Machinery Hall and attempt to determine an appropriate design aesthetic for the machine itself. But the more functional that bare domestic minimum itself became, the closer the home moved towards becoming, in the famous formulation of the modernist architect Le Corbusier (1887–1965), a 'machine for living'.

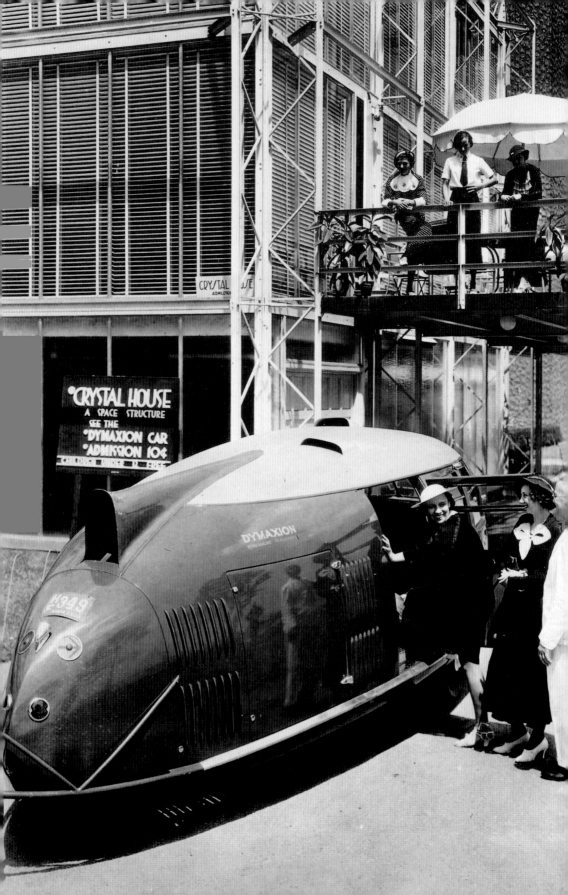

Designing the Machine Age, 1918–1940

3

Domestic interiors of the early twentieth century owed much to the design movements of the previous century. In 1929 the sociologists Robert (1892–1970) and Helen (1896–1982) Lynd offered generic descriptions of homes of different economic classes in the small Midwestern city of Muncie, Indiana. The 'wealthy' inhabited 'large, heavy brick or stone affairs' or 'rambling, comfortable frame houses'. Interiors echoed the Aesthetic movement with 'wide rooms, soft hangings, old mahogany, [and] one-toned rugs or deep-colored Orientals' set off by 'individual touches, a piece of tapestry on the wall, a picture not seen elsewhere, a blue Chinese bowl'. The family of a 'working man' with a steady job typically inhabited a modest 'bungalow', its living room scattered with 'artificial flowers', 'elaborately embroidered pillows', and knick-knacks in the mode of a Victorian parlour. If prosperous, such a family might enjoy the comfort of overstuffed furniture. If less so, they might possess 'straight-lined "mission" of dark or golden oak'—evidence that the Arts & Crafts had moved down the social ladder. The poorest workers lived in rickety little houses with 'odd pieces of furniture' and 'soiled, heavy quilts'. In one such shanty, 'almost totally without furniture', an investigator encountered a prophetic sight. A woman wearing a 'soiled and badly torn gingham dress' was operating 'an electric washing machine'. Here, without any masks of nineteenth-century propriety, was a foregrounding of technological modernity—the central focus of design in the twentieth century.[1]

Transition from tradition to modernity dominated the Lynds' book *Middletown* (1929), whose subtitle announced *A Study in Modern American Culture*. Using the 1890s as a benchmark for a romanticized age of tradition, they recorded the modern developments of the 1920s. Inhabitants of Muncie subscribed to nationally distributed magazines and began listening to network radio broadcasts—media which channelled national advertising for brand-name products ranging from medicine and cosmetics to packaged foods, electrical appliances, and automobiles. Recently wired for electricity, the city's 9,200 households purchased more than 370 washing machines, 460 toasters, 700 vacuum cleaners, 1,100 irons, and 1,100 hair curlers during six months in 1923. While new labour-saving appliances promised relief from household

47 Buckminster Fuller and Starling Burgess
Dymaxion automobile, 1933
Visitors to the Chicago Century of Progress Exposition in 1934 marvelled at the streamlined Dymaxion, an experimental car, displayed next to an uncompromisingly all-glass Crystal House designed by architect George Fred Keck (1895–1980). In this view, designer Fuller (1895–1983) escorts two stylishly dressed women on a tour of the car. Contemplating the prospect of a technological utopia proved to be a popular diversion during the difficult years of the Great Depression.

chores, Hollywood films prompted audiences to aspire to a cosmopolitanism previously known to only a few well-heeled citizens. A similar glamour emanated from the automobile, whose recent mass availability liberated young people from adult supervision, opened up vistas of independence and mobility, and blurred differences between rural and urban experience. With two cars for every three families in Muncie, the automobile was 'an accepted essential of normal living'. Middle-towners regarded a technological future with enthusiasm but also worried about loss of tradition, erosion of domestic values, and a rising materialism captured in Robert Lynd's observation that people were no longer making a living but '*buying* a living'.[2]

As a consumer culture assumed social dominance for the first time in history, the commercial practice of design became more significant than ever. New products—automobiles, phonographs, radios, toasters, washing machines, refrigerators, vacuum cleaners—had to be given forms reflecting modernity. Places where they were sold or promoted—shops, showrooms, department stores, trade shows, and exhibitions—had to be made visually and stylistically coherent. Consumers had to decide how much to modernize domestic surroundings. Would acquiring a modern-looking radio for the living room stimulate a desire to replace traditional furniture with something more up-to-date? Or would it serve as a token of modernity among the comforts of a traditional interior? Or would timid consumers avoid modern styles and instead select a radio disguised in eighteenth-century trappings? Manufacturers and designers had to determine what consumers wanted and then provide it—but with subtle innovations to keep them slightly off balance, disposed towards novelty and further consumption. While nineteenth-century pattern designers and decorative artists had supplied furnishings that supported traditional domesticity, industrial designers of the early twentieth century sought to give coherent shape to mass-produced artefacts in an era self-consciously referred to as the machine age.

The New Housekeeping and the elimination of waste

Lewis Mumford (1895–1990), who wrote frequently about the culture of technology, remarked in 1927 that the kitchen and the bathroom were 'the aesthetic sanctuaries of the American home'. By that he meant to praise their modern functional simplicity in contrast to living rooms and bedrooms dominated by cheap machine-made imitations of historical styles. Proponents of a new science of home economics had been making similar arguments for several decades. In 1896 Helen Campbell (1839–1918) published her course lectures from the University of Wisconsin, advising students of 'household economics' to 'examine the kitchen of a buffet car or of a ship' and to observe 'what a

laboratory is' and 'how a store is arranged'. Disparaging 'superfluous
. . . trimmings' that were 'pasted on, tacked on, nailed on, [or] glued
on', Campbell declared that 'use, ease, and economy' determined 'the
beauty of any usable thing'. A properly trained 'woman of business'
would select furniture 'for a purpose', not because it allowed one frivo-
lously to 'express' one's 'personality'.[3]

As the home economics movement gathered momentum, promot-
ers turned to organizing work in the home. Servants had become
problematic as more people of lower income aspired to a democratized
middle-class status. Seeking to liberate women from 'drudgifying
housework' and preserve their 'individuality and independence' while
elevating their status as housewives to that of a scientific profession,
Christine Frederick (1883–1970) proposed a 'gospel of efficiency' in
her articles published in 1912 in *Ladies' Home Journal* and collected
two years later as *The New Housekeeping*.[4] Borrowing from Frederick
Winslow Taylor (1856–1915), whose time-and-motion studies were
inspiring manufacturers to increase worker productivity, Frederick
exhorted housewives to 'eliminate lost motion' by standardizing work
routines. After a woman had timed all tasks from mixing a layer cake
(10 minutes) to cleaning the bathroom (20 minutes), she was to con-
struct daily schedules and coordinate her household with a card file.[5]

Another promoter of domestic Taylorism was Mary Pattison
(1869–1951), whose treatise on *Principles of Domestic Engineering* (1915)
explained 'modern machines, modern methods, and modern motives'
in the service of 'elimination of human and material waste' and 'conser-
vation of time, health, money, and beauty'. Unlike Frederick, Pattison
focused on the tools of the trade. She particularly recommended the
Steiner Family Motor, an electric motor that could power a coffee mill,
ice cream freezer, dough mixer, laundry mangle, meat chopper, and
other individual devices. Echoing Campbell's aesthetic functionalism,
Pattison insisted that a domestic machine's parts had to be integrated
in a 'charming and efficient unit of use and beauty, embodying form,
color, proportion and composition'. She exhorted housewives to select
well-designed appliances as they engaged in their central social role as
consumers. In a bold proclamation later repeated by advertising execu-
tives, marketing experts, and industrial designers, she declared 'the
woman' to be 'the purchasing agent for the home', engaged in a task of
such great 'moral responsibility' as to demand 'a collective effort'. The
cumulative rational choices of consumers would exert pressure on the
market, thereby 'molding the future conditions under which purchas-
ing must be done'. As the century progressed, however, designers of
mass-marketed goods assumed the role of mediators between pro-
ducers and consumers, trying not only to ascertain what consumers
wanted but also to convince them to desire things they might not have
imagined on their own.[6]

Hoosier kitchen cabinet,
*c.*1910

The lower section held pots
and pans, a bread drawer,
cutlery drawers, and racks for
storing plates. The upper
section contained a flour bin, a
sugar bin, tea and coffee
canisters, spice racks, and
shelves for cups and saucers.
An aluminium-surfaced shelf
extended 16 inches (40 cm) to
create a 'work table' at an
ideal height for someone
sitting on a stool. The Hoosier
cabinet joined Beecher's
efficient kitchen to the
national penchant for
gadgetry.

No other consumer product embodied the aims of home economics
as well as the Hoosier kitchen cabinet [**48**], introduced around 1898 by
the Hoosier Manufacturing Co. of New Castle, Indiana (only 15 miles
[24 km] from Muncie). The Hoosier cabinet was imitated by other
manufacturers and sold widely into the 1920s. Its name became a
generic term reflecting no-nonsense Midwestern practicality. As if
responding to Campbell's call for a kitchen arranged like a ship's galley,
the cabinet's anonymous designers packed everything needed for food
preparation into a single compact unit 6 feet (1.8 metres) high and 40
inches (100 cm) wide. Taking up 'less floor space than a kitchen table',
the Hoosier cabinet was marketed as 'a work-saving, comfort-giving
kitchen convenience' that combined 'pantry, cellar and cupboard' and
thereby 'save[d] time by saving steps'.[7]

Although the Hoosier cabinet anticipated the modern concept of
built-in kitchen cabinets and counters, a traditional appearance belied
its dedication to functionality. A typical model possessed an Arts &
Crafts exterior of golden oak with a vestigial decorative pediment

referring vaguely to rural colonial carpentry. Just as the Hoosier cabinet echoed the vernacular forms of hutches and pie safes, the earliest electric refrigerators resembled the heavy, boxy form of the icebox. Manufacturers and their designers only hesitantly defined forms adequate for expressing the radical modernity of refrigerators, washing machines, toasters, and radios. Already, however, tastemakers were following home economists in rejecting the rich interiors of the nineteenth century—whether the drawing rooms of the Aesthetic movement or the picturesque compositions of Arts & Crafts. Prompted by progressive campaigns for cleanliness and hygiene and by electric lighting (which favoured unadorned surfaces), design writers began to advocate a domestic aesthetic of airiness and light.

Among them was Elsie de Wolfe (1865–1950), a flamboyant Manhattan socialite who gave up acting for interior design and published *The House in Good Taste* in 1913. De Wolfe's conversational tone belied her seriousness. Rejecting nineteenth-century clutter, she advised readers to 'decorate ... by a process of elimination', to clear away until 'architectural spaces are freed' and 'the architecture of the room becomes its decoration'. She envisioned a forward-looking 'American Renaissance' whose domestic spaces would be 'individual expressions of ourselves, of the future we plan, of our dreams for our children'. Although de Wolfe favoured chintz fabrics and liked the contrast of eighteenth-century French furniture against all those recently liberated walls, she emphasized a preference for 'light, air and comfort', for 'plenty of optimism and white paint' [49]. Hardly a supporter of the functional efficiency of home economics, de Wolfe nonetheless prefigured the modernist design aesthetic of the twentieth century.[8]

49 Anonymous

Breakfast room, Sam Bell Maxey house, Paris, Texas, *c.*1915

By the early twentieth century new styles of home decoration and consumption spread rapidly to all parts of the US. This room's walls and breakfast set, recently renewed with white paint and accented with chintz seat covers and curtain, were influenced by Elsie de Wolfe. Although the result was not precisely modern, it indicated a break with the previous century's eclectic clutter.

Art Deco and the new American tempo

The design community seemed out of touch with everyday life after the First World War. Manufacturers considered design, as during the nineteenth century, as endless variations on traditional decorative patterns applied to furniture, lighting fixtures, silverware, ceramics, wallpaper, and fabrics. Charles R. Richards (1865–1936), a decorative arts expert, surveyed the field of 'art in industry' in 1920, concluding that Americans remained dependent on Europe for patterns to copy and for immigrant designers more savvy than those graduating from American art schools. Cynicism reigned, as in the case of a textile manufacturer who boasted, 'give me a collection of historic motives . . . and a piece of tracing paper, and I can take any man in my establishment and make a useful designer of him in a few days'. In 1917 the Metropolitan Museum of Art in New York established an industrial art division to encourage manufacturers to copy from objects in its collections. Long headed by Richard F. Bach (1887–1968) as a 'missionary service' seeking to overcome 'the curse of the average', the division held an annual exhibition of commercial goods paired with the museum pieces that had inspired them. In 1924, the same year the Met opened a wing devoted to colonial furniture, a critic complained that objects presented as examples of current industrial art looked like 'authentic antiques'.[9]

Only a few mavericks opposed this moribund design establishment. One was John Cotton Dana (1856–1929), director of the Newark Museum, whose enthusiasm for local industry led him to display a room full of bathtubs. In 1912 he welcomed a travelling exhibition of 1,300 useful objects designed by members of the Deutscher Werkbund, a progressive German design association, which had already been rejected by the Met as too commercial. Dana maintained that everyday products required aesthetic treatment appropriate to the times. Seconding his dissent was Royal Bailey Farnum (1884–1967), who became director of the Massachusetts School of Art in 1921 and steered it away from the Arts & Crafts approach promoted by most art schools. One of his instructors provoked a journalist by declaring that 'a man might design a garbage can . . . just as fine as anything in the Boston Museum'.[10] These minority views were prophetic of things to come when art and industry finally converged and endowed machine-made goods with forms expressive of the machines used to make them.

The catalyst was a world's fair at Paris in 1925, the Exposition Internationale des Arts Décoratifs et Industriels Modernes whose style was referred to later as Art Deco. A sympathetic observer described it as 'a cubist dream city', while a hostile critic dismissed the 'mad and colorful conglomeration' as 'the most serious and sustained exhibition of bad taste the world has ever seen'.[11] Though startlingly coloured, buildings

50 Joseph Hiriart, Georges Tribout, and Georges Beau

Pavilion for Galeries Lafayette, Exposition Internationale des Arts Décoratifs et Industriels Modernes, Paris, 1925

The stepped outline, central sunburst motif, diagonal plan, combination of rectangular and curvilinear forms, and stylized sculpture of this pavilion exemplified the exposition's Art Deco architecture. The partnership of Hiriart (1888–1946), Tribout (1890–1970), and Beau (1892–1958) also participated in the Exposition Internationale des Arts et Techniques dans la Vie Moderne in Paris in 1937.

were laid out in conservative symmetrical plans derived from the Beaux-Arts tradition [**50**]. However, geometrical outlines, flat surfaces, and stylized motifs broke with the ornate Beaux-Arts neoclassicism familiar to Americans since the World's Columbian Exposition at Chicago in 1893. Most interiors displayed exotic veneers, luxurious fabrics, and geometric patterns abstracted from the sinuous forms of Art Nouveau. Earnest Elmo Calkins (1868–1964), an advertising executive who was soon to promote design as a sales technique, reported that some of this 'new art' was 'too bizarre', but it was 'diabolically clever' and 'achieve[d] a certain exciting harmony'. Another American visitor declared the exposition 'a definite break with the past' for an era 'differing . . . radically from any preceding one'.[12]

An official US report noted that the government had sent no exhibits to Paris because 'American manufacturers and craftsmen had almost nothing to exhibit conceived in the modern spirit'. A delegation of observers included arts administrators Bach and Farnum, executives from the textile and furniture industries, department store executives, and a number of architects, designers, and craftspeople. Their report warned that a 'distinct advantage' in trade would go to that 'nation which most successfully rationalizes' the 'modern movement'.[13] But Art Deco had already arrived in the US. An exhibition of French decorative arts, including de luxe furniture ensembles by Emile-Jacques Ruhlmann (1879–1933) and glassware by René Lalique

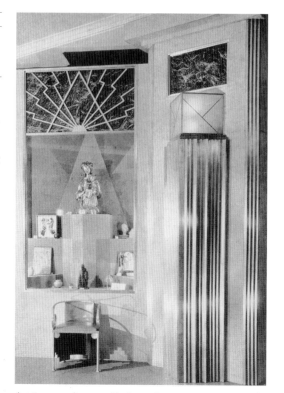

51 Lee Simonson

Installation for 'Art-in-Trade Exposition', Macy's department store, New York, 1927

A proponent of the Expressionist 'new stagecraft' in the theatre, Simonson provided display cases whose cork panels were fitted in Cubist-inspired patterns and trimmed in metal. Above each case a gleaming grille represented a stylized sunburst motif with its rays rendered as zigzag lightning bolts—a mechanized American variant of the common French motif.

(1860–1945), travelled to nine art museums. Abandoning his historicist approach to industrial arts, Bach welcomed the show to the Metropolitan Museum in February 1926 and then opened a small gallery for displaying the Met's own recent acquisitions from Paris. Wealthy collectors acquired unique furnishings created by French designers and craftspeople, and exclusive New York stores were already commissioning designs for fabric patterns and ceramics from Americans whose extrapolations from French geometric motifs referred explicitly to such emblems of modernity as automobiles, airplanes, zigzag bolts of electricity, and Manhattan's skyscrapers.

That art and commerce were merging was suggested in May 1927 when Macy's department store assumed the guise of an art museum with a four-day Art-in-Trade Exposition designed by Lee Simonson (1888–1967) [**51**]. In addition to objects from Paris, Macy's displayed works by Americans—graphics by Rockwell Kent (1882–1971), stylized sculptural pieces by Paul Manship (1885–1966) and Hunt Diederich (1884–1953), and patterned silks by Edward Steichen (1879–1973), Helen Dryden (1887–1934), and René Clarke (1886–1969). Most striking was an ensemble of Paul T. Frankl's so-called 'skyscraper furniture' [**52**]. A recent arrival from Vienna, Frankl (1886–1958) claimed that if the US had exhibited a full-sized skyscraper at Paris in 1925, 'it would have been a more vital contribution in the field of modern art than all the things done in Europe'. Simonson drew a democratic lesson from

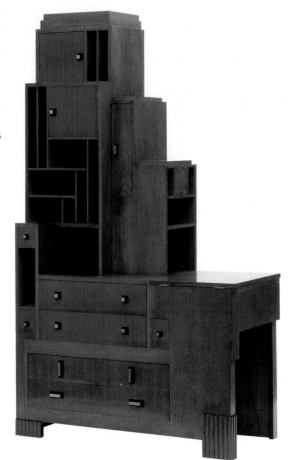

52 Paul T. Frankl

Skyscraper desk and bookcase, c.1928

Intended for patrons of his New York gallery, the vertical 'cubistic' assemblages of Frankl's skyscraper furniture echoed the setback outlines of the Art Deco office buildings then transforming Manhattan's skyline. Although modernist critics disparaged such representational forms, they were central to popular expressions of modernity between the world wars.

the show, maintaining that 'the spirit of the machine age' required art to be 'simplified if it is going to be produced on a large enough scale for most people to afford and enjoy it'. All the same, Macy's exposition—along with window displays for Fifth Avenue shops by emerging designers like Donald Deskey (1894–1989) and Norman Bel Geddes (1893–1958) [**53**]—proclaimed a luxurious machine-age style, soon to be dubbed 'modernistic', accessible only to the wealthy.[14]

This transformation of the decorative arts, inspired by Paris 1925 but soon dedicated to expressing a 'new American tempo' of skyscrapers, radio, movies, jazz, speakeasies, and motorcars, owed much to European immigrants with boundless enthusiasm for the brash modernity of their new home.[15] Among them were Joseph Urban (1872–1933) from Vienna, who worked as a stage designer for the Metropolitan Opera and the Ziegfeld Follies before opening a showroom for the rectilinear furniture of the Wiener Werkstätte, and Kem Weber (1889–1963), a Berliner trapped in the US during the First World War, whose elegant geometric forms and machined materials evoked a more austere machine aesthetic than that of Paris. Ilonka Karasz (1896–1981), who came from Budapest in 1913, was known for

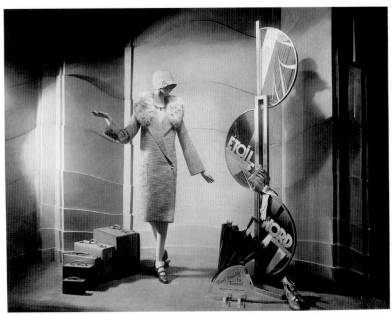

53 Norman Bel Geddes

Window display, Franklin
Simon store, New York, 1927
Like Simonson, Geddes
applied experience in the 'new
stagecraft' to the design of
smaller displays. His series of
changing windows utilized
modular backdrops, dramatic
lighting, and a few selected
products as props to convey a
mood of exclusivity. This
example employed sections
from French commercial artist
A. M. Cassandre's (1901–68)
poster for the 'Étoile du Nord'
train in a sinuous reference to
a railway semaphore.

richly coloured textiles exhibiting stylized variations on Hungarian
folk themes, often knotted or woven by her sister Mariska (1898–1960),
and for warm, bright interiors with furniture more informal than that
of the French. More recent European arrivals included metalworker
Walter von Nessen (1889–1943), silversmith Peter Müller-Munk
(1904–67), and Erik Magnussen (1884–1961), a Dane whose silver
coffee service, 'The Lights and Shadows of Manhattan' [**54**], captured
the extravagance of American Art Deco de luxe. Among the native-
born Americans in the movement were Ruth Reeves (1892–1966),
whose block-printed cotton fabrics for W. & J. Sloane, such as 'Man-
hattan' [**55**] and 'American Scene', consisted of montages of urban
scenes. Ceramist Viktor Schreckengost (b. 1906), who trained at the

54 Erik Magnussen

Silver coffee service, 'The
Lights and Shadows of
Manhattan', Gorham
Manufacturing Co., 1927
Also known as 'Cubic', the
triangular facets, sharp
angles, and abrupt reflections
of this coffee service
demonstrated more aptly than
any other contemporary
artefact the commercialization
of fine-art motifs. Art Deco as
it developed in the US marked
the popularization of Cubism.

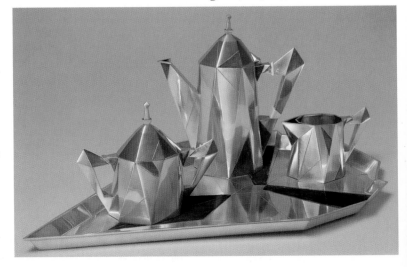

55 Ruth Reeves

Block-printed cotton fabric, 'Manhattan', W. & J. Sloan, 1930

The tight diagonal trellis of this pattern brought order to lively sketches of Manhattan landmarks ranging from the traditional (St. Patrick's Cathedral, Castle Clinton), to the pre-modern (Brooklyn Bridge, Woolworth building), and the most up-to-date (Chrysler building)—all woven together by the motion of plane, train, auto, and steamship.

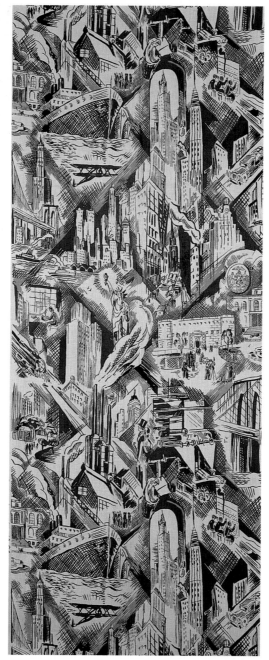

Cleveland Institute of Art and in Vienna, emblazoned punch bowls with bold caricatures and catchwords rendered as commercial signs ('jazz,' 'follies', 'dance', 'stop'). Gilbert Rohde (1894–1944) offered his 'Rotorette', a table whose wide cylindrical base rotated to reveal hidden liquor bottles, while Russel Wright (1904–76) supplied chrome-plated cocktail shakers, and Deskey, soon to design the interiors of Radio City Music Hall, marketed aluminium side tables with reflective black

56 Donald Deskey

Decorative screen, *c.*1929

When arranged in sharp folds, this decorative screen's three panels, each lower than the previous, formed a zigzag that was echoed in patterns of paint and metal leaf on each panel. Fabricated by the designer's own firm, Deskey–Vollmer, such screens were a purely decorative part of a range of furnishings that also included chairs and tables.

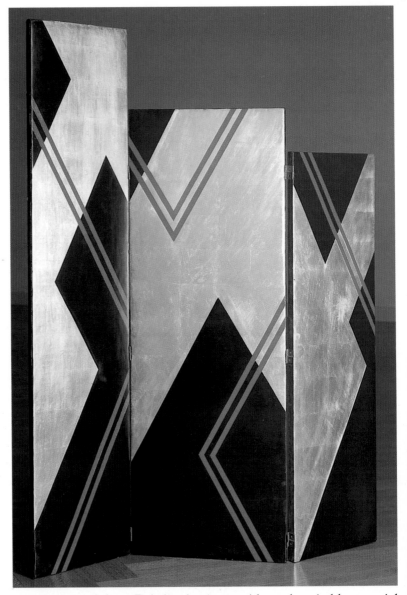

tops fabricated from Bakelite laminate—'the only suitable material that could withstand the alcoholic concoctions of that era' [**56**].[16]

Modernistic design was adopted by the architects Ely Jacques Kahn (1884–1972), Harvey Wiley Corbett (1873–1954), and Raymond Hood (1881–1934), all of whom profited from the decade's economic boom with commissions for Manhattan skyscrapers. Soon every city from Providence to Fort Wayne and beyond boasted a token Art Deco tower, a bank, or insurance building, to assert the community's up-to-date modernity. While furniture designers like Frankl borrowed from the setback outline mandated for tall buildings by New York City's zoning law of 1916, the architects furthered the popularity of machine-

age motifs by using them to ornament the exteriors and public spaces of such structures as the New York Telephone and Chanin buildings and, in the 1930s, the Chrysler and Empire State buildings. The interaction of designers and architects was recognized by the Metropolitan Museum in 1929 when it opened 'The Architect and the Industrial Arts', displaying 13 room interiors, each designed entirely by a single architect from general concept to individual pieces of furniture. The displays represented an evolving American Art Deco style emphasizing modern materials, machined textures, and sweeping horizontals. The show was visited by 186,000 people in seven months, and industrial arts curator Bach, fully won over, declared it 'reasonable groundwork upon which a representative modern style may be built'.[17]

The American Union of Decorative Artists and Craftsmen offered further evidence of the success of modernistic design. Founded in 1928, AUDAC quickly enrolled more than a hundred members, exhibited five model rooms in a 'Home Show' at Grand Central Palace in 1930, mounted a display of 'Modern Industrial and Decorative Arts' at the Brooklyn Museum in 1931, and in the same year published a book-length survey of design in the US. This first and only *Annual of American Design* testified to tremendous energy, but its glossy photographs also indicated a gap between democratic aspirations and elite realities. Coffee and soup packaging by Joseph Sinel (1889–1975) and celluloid dresser sets by Frankl catered to upper-middle-class consumers, but most illustrations portrayed interiors of wealthy homes or fashionable shops, hand-crafted ceramics and metalwork, unique pieces of furniture in aluminium and Bakelite, custom hardware for the Adler Planetarium, the conference room of the J. Walter Thompson advertising agency, even the interiors of Brooklyn's luxurious Hotel St. George and the passenger liner *Leviathan*. By contrast, essays contributed by designers and critics in support of a new national style emphasized design's role in transforming the lives of ordinary Americans. Mumford's lead article praised 'machine work' for promising to end 'conspicuous waste'. Simonson, anticipating wide distribution of plastics, argued that modern design would 'fail to have any widespread effect in re-forming American taste' until designers could make use of 'cheap composition materials, standardized in form'. For Frankl, the most socially radical in his comments despite his custom furniture, the new movement would have little permanent significance until designers abandoned their 'subservience to a demand for novelty by the irresponsible and the sophisticated'.[18]

Most of the *Annual*'s contributors wrote in support of reforming and modernizing popular taste by shaping mass-produced goods. However, as the book's illustrations suggested, there was as yet little popular demand for modernistic design of the sort that had transformed the material surroundings of upper-class Manhattanites. The

new motifs, textures, and materials of Art Deco filtered down slowly to middle-class citizens who might admire the stylish appearance of a downtown bank or dress shop but who still trusted to tradition in furnishing their homes. This situation began to change not through the efforts of designers or promoters but in response to a fundamental crisis of modernity itself. The economic disaster of the Great Depression, preceded by intense competition in sales of new automobiles owing to a saturated market, prompted manufacturers to try anything that promised relief—including the redesign of their products according to new aesthetic principles.

Henry Ford learns the most expensive art lesson in history

The automobile was the most significant technology of the twentieth century, transforming the way almost all people lived, worked, and identified themselves. More than any other manufactured artefact, it engaged the attention of designers, of critics predicting design trends, and of anyone interested in the appearance of things. In 1916 the automotive engineer William B. Stout (1880–1956) observed that the motor car was no longer 'merely a mechanism for traveling' but 'a part of the home equipment . . . standing at the door . . . reflect[ing] the personality and the taste of the home within'. Announcing that 'style has come to the automobile', he maintained that car manufacturers would soon 'take every advantage of art knowledge' to create 'an appeal consistent with its mechanical performance'.[19] The automobile was a luxury in 1916, with 3.4 million passenger cars registered, one for every 25 inhabitants. However, the success of the Model T Ford soon transformed popular fantasy into universal reality. Even then, one of every two new cars was a utilitarian Model T [**57**], first introduced in 1908, cheaply mass-produced on a moving assembly line since 1913, and sold for about $500. By 1928, there were more than 20 million automobiles registered, one for every six people. In the meantime style had become central to selling cars. For many Americans the focus of materialized identity had shifted outward from the relatively fixed traditional domesticity of the home to a perpetually changing public realm of technology. Eventually this outward machine-age gaze turned back inward to appliances and home furnishings, but the American love affair with the automobile was the start of it.

Evidence of design's significance came in May 1927, when Henry Ford (1863–1947) shut down the vast River Rouge plant, an international symbol of industrial modernity, and quit making the Model T. He was reacting to competition from General Motors, whose low-end Chevrolet, only slightly more expensive than a Model T, sported a lower, more rounded, better integrated silhouette. The automotive market was approaching saturation. Most people who wanted cars

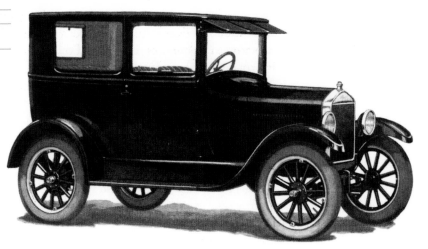

57 Ford Motor Co.
Model T Tudor (two-door) sedan, 1926
Henry Ford regarded the automobile as a purely utilitarian machine and supposedly said customers could have 'any color they want as long as it's black'.

already had them, and new car sales were mostly replacements for unstylish Model Ts. Despite Ford's key role in industrialization, he was ambivalent about progress and had long considered the Model T as a tool for improving the lives of farmers. But Alfred P. Sloan Jr. (1875–1966), president of General Motors, recognized the automobile's radical cultural novelty. He realized the public would reward a manufacturer who enabled them to drive inexpensive cars resembling the sleek, hand-crafted Auburns and Marmons of the upper class.

Sloan's strategy at General Motors transformed the marketing of automobiles and the design of most other mass-produced consumer products. The first part of the strategy involved rationalizing the various brands GM had acquired through corporate takeovers. From the inexpensive Chevrolet up through Buick and La Salle to the most expensive Cadillac, there was a model for every price bracket and always something higher to aspire to. GM also perfected a system of 'flexible mass production', basing the different product lines on a limited number of chassis sizes and body types and differentiating them with minor cosmetic variations in fenders, bumpers, radiator grilles, chrome accents, and interior details, very much as the furniture makers of Grand Rapids had built up stylistically distinctive cabinets or bedsteads by adding layers of differing ornament to otherwise identical forms.[20]

The second part of GM's marketing strategy put this hierarchy of models into dynamic motion through time. The so-called annual model change, firmly established by 1927, was intended to stimulate demand by introducing minor styling changes into each model each year to create an impression of novelty even if a car's mechanical functions remained essentially unchanged. Dramatic, newsworthy design changes occurred initially only in the most expensive models, thereby raising expectations among consumers who could afford only lower-priced models. In subsequent years such innovative details would

migrate down the line, enabling even purchasers of the lowly Chevy to enjoy features recently limited to society's economic elite—but subtly reinterpreted to reflect the presumed vulgarity of lower income groups.

Under Sloan's guidance, General Motors developed an overarching design policy. In 1927 he established an Art and Color Section with a staff of 50. As director he appointed Harley Earl (1893–1969), a designer with experience creating custom auto bodies for Hollywood actors. Earl had just achieved a resounding success for GM with the 1927 La Salle, which boasted long front fenders, a roof gently rounded at the back, elongated side windows, and such elegant detailing as a chrome band between cowl and hood. As the Art and Color Section set to work on other GM models, the concept of the motor car as a thing of beauty, not merely of utility, became democratized. Using modelling clay over full-sized wooden forms, Earl's stylists sculpted low-slung bodies notable for integrating the formerly disparate parts —engine and passenger compartments—of a closed automobile. These stylistic innovations exploited a shift in manufacturing from labour-intensive composite bodies of sheet metal on wooden frames to 'all-steel' bodies stamped in huge presses with dies whose wide-radiused curves encouraged a sculptural flair. Earl brought style to the masses.

Although developments at GM echoed for decades, immediate attention in 1927 focused on the Ford Motor Co. With journalists wondering whether Henry Ford would ever make another car, his associates were busy designing and tooling up for the Model A [58], introduced to great fanfare five months after the demise of the Model T. Although the new model was easier to shift and drive, endearing it to the increasing ranks of female drivers, stylistic improvements were modest. The Model A appeared somewhat sleeker, with lower road clearance, a longer wheelbase, bumpers of two flat parallel strips of chromed steel, a radiator with an elegantly curved frame, and a gently rakish backward slant. Even so, compared with GM's bottom-of-the-line Chevrolet, there was nothing particularly innovative about the Model A. Its significance lay in the fact that America's most famous industrialist, the inventor of the mass-production assembly line, had to spend $18 million on retooling just to keep pace with more artful competition.

Ford's experience made an impression on other business executives who faced market saturation, consumer resistance, falling sales, and intense competition. Two out of three businessmen surveyed about the significance of 'art and business' spontaneously mentioned the Model A conversion as a cautionary tale. One executive referred to it as 'the most expensive art lesson in history', a phrase that carried special significance for those who heard his prepared remarks at a dinner meeting on 29 October 1929, the day the bottom fell out of the stock market.[21] With the economy sliding from recession into depression,

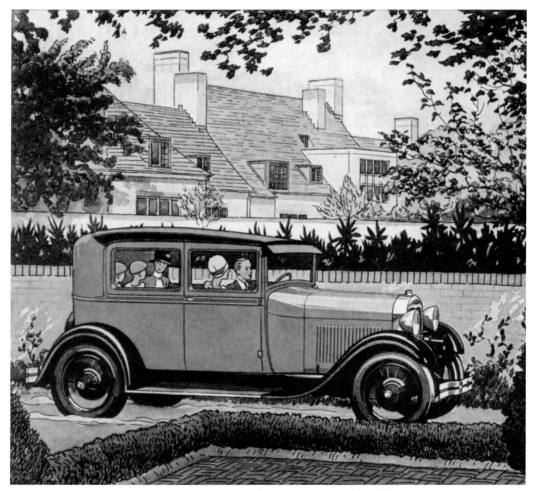

58 Ford Motor Co.

Model A Tudor (two-door)
sedan, 1928

Guided by Edsel Ford
(1893–1943), who had long
chafed at his father's refusal to
realize the increasing
importance of appearance in
selling cars, body designer
József Galamb (1881–1955)
gave the Model A an
integrated form that brought it
into line with styling
developments at General
Motors. The new car was
available in four colours.

many manufacturers turned to product design, both as a means of overcoming competition in their own industries and later as a panacea for restoring the entire nation's economic health.

The rise of industrial design

The profession known as industrial design emerged during the Great Depression of the 1930s. Until then, most people who identified themselves as designers, including those who developed the Art Deco style, had followed in the path of the Aesthetic movement by providing the upper classes with furnishings and interiors. Even Tiffany's table lamps had reached no further than the upper middle class—and had maintained an illusion of uniqueness. The situation changed as the economic collapse and the ongoing democratization of consumption paradoxically worked together to give designers for mass production greater influence and status than they had ever enjoyed before. The urban middle class was already favourably inclined to new styles like

Art Deco through magazines, advertising, movies, and department stores. Even during the Depression, as the Lynds found when they revisited Muncie, people remained 'hypnotized by the gorged stream of new things to buy'.[22] However, few people could satisfy their expansive desires. Desperate competition forced manufacturers to rely on anyone who persuasively claimed an ability to endow everyday products with distinctive modern qualities that would attract a dwindling public of active consumers. Those who offered this essential service became known as 'industrial designers'—a phrase evoking businesslike practicality rather than the pre-industrial aura surrounding the various 'applied arts' or 'arts in industry'.

Many of the new industrial designers started out in advertising. Geddes, for example, worked as an advertising illustrator in several Detroit agencies, applying a dappled Impressionist style to images of automobiles and other products, before becoming an avant-garde stage designer in the 1920s. Another Midwesterner, Walter Dorwin Teague (1883–1960), joined the Calkins & Holden agency as an illustrator in 1908 and later achieved success as a freelancer creating decorative borders around advertisements for luxury products. And Raymond Loewy, who emigrated from France after the First World War, made a good living with fashion illustration and advertisements in the Deco style for Fifth Avenue shops. The advice that a manufacturer ought to employ a designer often came from an advertising executive who despaired at the task of stimulating sales of a lacklustre product. Stanley Resor (1879–1962), president of the J. Walter Thompson agency, put several people in touch with Geddes in 1928 and 1929 [59]

59 Norman Bel Geddes

Dressing table, Simmons Furniture Co., 1932
Part of a line of steel bedroom furniture, this dressing table was angular, modernistic, finished in bright, reflective black enamel, and accented in chrome. Although Geddes described the line as an innovative departure from cheap metal furniture grained to simulate wood, his office provided Simmons with many such imitative designs in the mid-1930s.

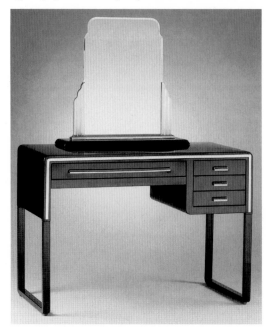

and continued to do so as late as 1936, long after the designer had established himself.

One of industrial design's most tireless promoters was Calkins of the Calkins & Holden agency, who since 1905 had advocated high-quality illustrations in magazine advertising. By the late 1920s he was advising manufacturers to hire commercial artists to improve product appearance. At a business conference in 1930 Calkins blamed the economic breakdown not on 'over-production', or the manufacture of too many goods, but on 'under-consumption'. Somehow consumption had to be made as efficient as production. His solution involved the so-called 'consumption engineer' who would work 'scientifically' to 'find out what is clogging the flow of goods and remove the obstacle'. This new expert would anticipate 'changes in buying habits' and create 'artificial obsolescence' by convincing people that 'prosperity lies in spending, not in saving'. Essential to the process was design, defined by Calkins as 'a pleasing working out of the envelope of the product'—a result exemplified for him in such objects as Geddes's bedroom furniture and Teague's colourful Art Deco cameras for Eastman Kodak [**60**]. The Calkins & Holden agency established an Industrial Styling Division to provide their advertising clients with package and product design. Until 1936 it was headed by Egmont Arens (1889–1966), who

60 Walter Dorwin Teague
Camera and package,
Eastman Kodak Co., 1930
Teague's office modernized several existing cameras by providing graphic designs for decorative panels. The pattern on this camera owed something to Dutch painter Piet Mondrian (1872–1944). However, such geometric designs were also typical of hand-tooled leather boards of expensive Art Deco books—which this rectangular camera with its pebbled artificial leather case resembled.

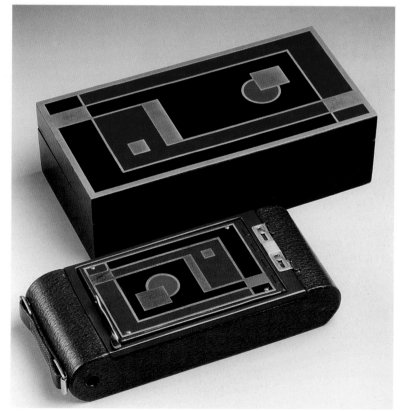

collaborated with a colleague in developing their boss's Taylorist approach in a treatise on *Consumer Engineering: A New Technique for Prosperity*. They claimed that by encouraging people to 'use up styles' as if they were 'soup or cigarettes', industrial designers would provoke 'silent and bloodless revolutions in the habits of nations'.[23]

Department stores also played an important role in leading manufacturers to the gospel of design. An executive of Jordan Marsh in Boston asserted in 1929 that 'department stores are the museums of today'. Not only did they 'reflect good taste'; they also served as 'a great educating force in the community'. But to do that, their representatives had to be well versed in matters of style. The traditional department store 'buyer' had selected his stock from among those goods already made by potential suppliers. In a competitive market, however, the buyer yielded to the 'stylist', usually a young woman, frequently a recent college graduate. According to an executive of the Kaufmann store in Pittsburgh, her job was to 'look at our merchandise through the eyes of our better educated, cultivated clientele'. Or, as the Jordan Marsh executive phrased it, she had to address 'style' as 'the interpretation of a mode of living'. After the economic collapse, the most savvy stylists not only dictated to a store's buyers but also worked directly with outside suppliers to ensure that goods reflected the modern aura demanded by shoppers. That effort often involved the redesign of unsatisfactory products with direct input from the stylist, who thus verged on becoming a designer in her own right.[24]

Although the Chicago mail-order houses did not share the prestige of Macy's or Jordan Marsh, they too had to keep up with the demand for modern styling. Montgomery Ward and Sears, Roebuck faced unprecedented competition as rural families drove their Model T Fords into town to shop. Both companies responded by opening retail stores and entering aggressively into the design movement of the 1930s. High-volume sales gave them greater clout with suppliers than any single department store stylist could attain and also brought awareness of contemporary styles to a wide public. Montgomery Ward opened a Bureau of Design in 1931. As director the company hired Anne Swainson (*c*.1900–55), a native of Sweden educated in applied arts at Columbia University, who had been working as a 'fashion coordinator' at Chase Copper & Brass. The most influential woman in American industrial design during the 1930s, Swainson began by redesigning Ward's catalogue, abandoning old-fashioned woodcuts for artful photographs of products. Overcoming resistance from outside suppliers, she insisted on the authority to approve or reject all products. By 1935 she supervised 30 designers who devised products and packaging for manufacture by the company's suppliers. She staffed the Bureau with commercial arts graduates of the Armour Institute of Technology and the Art Institute of Chicago, and then trained them as industrial designers.

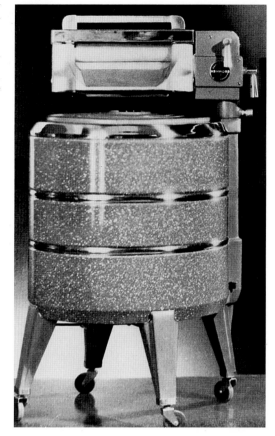

61 Henry Dreyfuss

Toperator washing machine, Sears, Roebuck and Co., 1933

Emphasizing cleanliness, Dreyfuss avoided the usual dirt-catching joint between the lower motor housing and the upper washtub by enclosing both in a continuous enamelled shell with three polished bands encircling the washer to hide assembly bolts. To further emphasize cleanliness, Dreyfuss left the interior of the tub white.

While Montgomery Ward pioneered one response to the challenge of integrating art and industry by establishing an in-house design staff, Sears, Roebuck initially chose the other common response—reliance on independent consultant designers for individual projects. As its first experiment, the company hired Henry Dreyfuss (1904–72) to design a washing machine in collaboration with the supplier's engineers. Dreyfuss was a New Yorker who had apprenticed in stage design with Geddes and worked in that field before drifting into designing suspender fasteners, cosmetic bottles, and other small products. His Toperator washer, introduced by Sears in 1933, exhibited a careful blend of functional and psychological considerations [**61**]. While the name indicated that all controls were consolidated on the wringer arm for easy access and comfortable operation, the exterior shell of mottled blue-green enamel offered a hint of stylistic sophistication to the most hard-working farm wife. In six months Sears sold 20,000 of these 'designer' appliances with a replica of Dreyfuss's signature on each.

After this triumph, Sears asked Dreyfuss to design a new Coldspot refrigerator. When he declined owing to his similar project for General Electric, the company hired Raymond Loewy. After abandoning illustration, Loewy had served as in-house 'art director' for Westinghouse

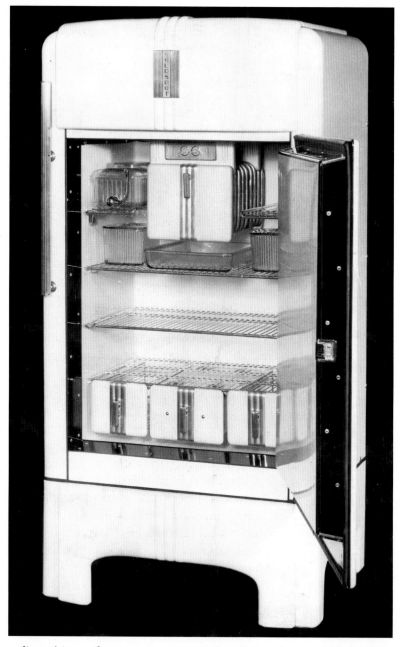

62 Raymond Loewy

Coldspot refrigerator, Sears, Roebuck and Co., 1935
The first in a series of four Coldspots designed by Loewy's office and introduced annually from 1935 to 1938, this refrigerator emphasized clean lines and convenient controls. Loewy also indulged some gimmickry in the door release, a long vertical bar that someone with both hands full could operate with the nudge of an elbow.

radio cabinets from 1929 to 1931 before becoming an independent consultant and designing car bodies for Hupmobile. The previous Coldspot refrigerator was a clumsy box on flimsy-looking stamped metal legs with horizontal mouldings interrupting its vertical continuity of line. Loewy emphasized verticality by employing long, slender hinges and running three parallel ribs up the middle from bottom to top—a theme echoed inside on the door of the freezer compartment and the fronts of three drawers [**62**]. Sales increased so much after the

refrigerator's introduction in 1935 that Sears asked Loewy for a series of three annual model changes. His in-house case study, an exercise in waffling, explained that his original design was not a 'masterpiece' but 'a step in the evolution toward perfection'.[25] Subsequent Coldspot models teetered between minor cosmetic tinkering and substantive aesthetic improvement, suggesting that in the long run the design of everyday consumer appliances might lose its celebrity prestige and become anonymous, ordinary, and ultimately invisible.

The upmarket business magazine *Fortune* favourably portrayed industrial design in 1934 in an anonymous article written by George Nelson (1908–86), who later became a furniture designer. By then, hiring a consultant was taken for granted by many major companies seeking to maintain a competitive edge. Nelson reported that about 25 independent design consultants had set up offices in the US. Out of 10 designers profiled by *Fortune*, most had offices in Manhattan. All but two of those were independent consultants, the exceptions being Donald Dohner (1897–1943), who was art director at Westinghouse, and George Sakier (1897–1988), the head of the Bureau of Design at American Radiator and Standard Sanitary, who was responsible for designing bathroom fixtures. The most successful consultants inspired confidence while displaying unique personalities. Teague, for example, appeared as a consummate businessman. Loewy preserved his accent and styled his personal appearance in the popular image of a French designer. Of the group, Dreyfuss, who affected neutral brown suits, appeared most seriously concerned with the functional fit of product to user. The exuberant Geddes, on the other hand, already a Broadway celebrity, came across as a 'P. T. Barnum of industrial design' whose visionary projects had 'cost American industry a billion dollars' for retooling.[26] His polar opposite was Harold Van Doren (1895–1957), a former museum administrator whose scholarly demeanour reassured Midwestern clients who visited his office in Toledo, Ohio. Despite differing personalities, this small group of consultant designers developed a common operating mode that brought a success denied to those who offered manufacturers only pretty pictures.

A designer's staff typically consisted of two or three key associates trained in engineering or architecture. Some remained with the same office throughout their careers, became partners, and gained power equal to that of the 'name' who fronted the office. Others left after gaining sufficient experience to direct a manufacturer's in-house design department or establish their own consultant practice. Several less experienced art or architecture graduates served as draftspeople. Most offices also supported a model maker, a business manager, a personal secretary for the head, and sometimes a public relations expert to keep his name in the news. Although a large staff indicated the importance of teamwork, each major consultant designer maintained the public

fiction that he alone was responsible for his work. During the 1930s, signed products were common, and no press report ever identified staffers who had contributed to a product designed by Raymond Loewy or Norman Bel Geddes. Behind the scenes, however, manufacturers appreciated the fact that they were getting more than personal flair.

When an office was commissioned to design a product, the designer himself toured the manufacturer's plant with a couple of associates and met with executives, product engineers, and the marketing staff—all of whom had to be convinced that a consultant could complement their efforts. After examining earlier models and other brands, conducting market surveys, and sometimes observing the behaviour of shoppers, the designer's team analysed all aspects of the project—relative costs of potential materials and manufacturing processes, functional elements and user interfaces, aesthetic problems of form, colour, and texture, and social or cultural considerations. With general parameters established, draftspeople prepared scores of preliminary sketches, three or four of which yielded formal renderings for presentation to the client. In a few offices, designers 'sketched' in clay, much like Earl's automobile stylists. After a single design was selected, a plaster presentation model was painted and finished to look exactly like a finished product —often with such precise dimensions that it could yield production blueprints. A design team sometimes also prepared packaging and might make suggestions for marketing and advertising campaigns.

Such a rigorous process suggested a conscious effort to enact 'consumption engineering'. Unlike the earlier Aesthetic and Arts & Crafts movements, whose central philosophies had sought to transform the domestic sphere for the good of those who inhabited it, the design movement of the 1930s sought to absorb the domestic sphere into a larger, more efficient production–consumption machine. Some industrial designers had little regard for the public. Sinel, for example, regarded the 'mass' as 'Coney Island-minded' and responsive to 'gaudy, tricky things'. Equally condescending was Loewy, who stated that a designer 'uses simple language that is easily understood' because 'he is addressing himself to the masses'. More typical among comments committed to print was Van Doren's warning not to underestimate the taste of the public but to take a 'middle course' by making available 'the best it will absorb'. But even he stated that 'the goal of design is sales—at a profit'. Reacting to hostile British criticism of American commercialism, Loewy declared that for American designers a 'conception of aesthetics consists of a beautiful sales curve, shooting upward'. His elegant image suggested an aesthetic orientation in the very act of seeming to deny it. While stimulating sales by manipulating visual forms and surface qualities of consumer products, industrial designers also created a new American design vocabulary that gave

expression to the machine age and enabled the so-called masses to envision a material world beyond the traditional forms of comfortable domesticity or heavy industry.[27]

Machine aesthetics

When the industrial design profession emerged, it was not clear that practitioners would formulate a national style. Despite such triumphs as the McCormick reaper in 1851 and the Corliss Engine in 1876, a cultural inferiority complex still held decorative artists captive to European trends. And those two iconic machines reflected such a functional simplicity that they offered little guidance for creating objects with greater leeway for stylistic interpretation. Even Teague's modernistic Kodak cameras followed Dresser's additive or constructive theory, with flat geometric patterns applied to surfaces of cameras that in some cases were already available in plain black. Designers struggled to find a machine aesthetic both intellectually defensible and commercially viable. They sought a new style that would honestly express the technological modernity of American life. But that style also had to appeal to consumers.

The style they developed was streamlining, based on the new science of aerodynamics and borrowed from the emerging technology of aviation, where it was both functional (essential to efficient flight) and organic (inspired by natural forms such as birds, whales, and even a hen's egg). Within a few years streamlining spread from planes, cars, and trains to non-moving artefacts at every scale—from radios and vacuum cleaners to store fronts and restaurant interiors. Streamlining swept past other expressions of modernity with an irresistible metaphoric power [**63**]. At its most literal, streamlining allowed a vehicle to travel quickly or efficiently by eliminating wind resistance. At the next

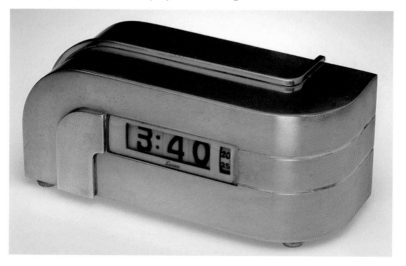

63 Kem Weber
Zephyr digital electric clock, Lawson Time Co., *c.*1934
The sweeping brass lines of the Zephyr embodied the concept of speed without directly borrowing from vehicular forms, though its name derived from the Burlington railroad streamliner introduced the same year. Numerals on rotating faceted dials clicked into place as hours and minutes changed, with the seconds spinning by so quickly as to offer a continuous sense of motion.

level, as a commercial metaphor, the streamlining of consumer prod-
ucts solved the marketing problem of *sales* resistance. A design
promoter claimed that 'streamlining a product and its methods of mer-
chandising is bound to propel it quicker and more profitably through
the channels of sales resistance'. And he alluded to a third level of
metaphor, as a referent to the spirit of the age, when he stated that
'streamlining a thing strips it for action, throws off impediments to
progress'.[28] Streamlining lubricated the flow of goods to consumers,
but it also expressed a popular belief that social processes had to be
made smoother and less complex. Society had to become as efficient as
the most up-to-date technology if it was to flow smoothly, without
friction, through the chaos of the Depression.

A desire for coherence favoured a style that could be applied at any
scale from the personal to the architectural. Teague, the most philo-
sophical of commercial designers, perceived a 'new order emerging' in
reaction to social disorders originating in the Industrial Revolution.
His own style, as realized in such objects as glassware with fluted
columnar stems for the Libbey Glass Co. [**64**], tended towards an
austere neoclassicism appropriate to his rationalist philosophy. Follow-
ing Le Corbusier (and unconsciously echoing Greenough), Teague
argued that 'basic laws of design' were 'invariable' because they
'derive[d] their validity from the structure of this universe and the
structure of our perceiving minds'. Anyone who rejected random
'caprice' would recognize 'the beauty of precision, of exact relation-
ships, of rhythmical proportions'. The perfect design for any object
could be derived from 'the function which the object is adapted to
perform, the materials out of which it is made, and the methods by
which it is made'. Rejecting the whimsy of much modernistic work, he
described the true designer as 'not an inventor trying to create new and
unprecedented forms' but an 'explorer seeking the one perfect form
concealed within the object beneath his hand'. However, he recog-
nized that 'the ultimate form . . . may forever elude us' because
technological progress kept changing the parameters of existing arte-
facts and introducing new ones. Even so, it was possible to achieve a
'beauty' so 'obviously right' that a 'client will recognize it and want to
produce it, [and] the public will recognize it and want to buy it'.[29]

Other industrial designers stated similar philosophies in trade jour-
nals published for engineers, manufacturers, and marketing experts.
Such words as function, simplicity, and rightness frequently appeared.
However, business executives were looking for sales, not ultimate
form. And most designers doubted that function was the only quality
of a machine aesthetic. Indeed, how could one distinguish a functional
product from one that merely looked functional? And for that matter,
products sharing in the mystique of airplanes, autos, radios, and sky-
scrapers ought to look functional. Most modernist design, not only

64 Walter Dorwin Teague and Edwin W. Fuerst

Embassy stemware, Libbey Glass Co., 1939

Used in the State Dining Room in the Federal Building at the New York World's Fair of 1939, this glassware embodied Teague's restrained neoclassicism, based on a Platonic design philosophy that ideally tended towards static perfection—a goal in ironic tension with commercial design's perpetual search for stylistic novelty. Teague's collaborator Fuerst (1903–88) was an in-house designer at Libbey.

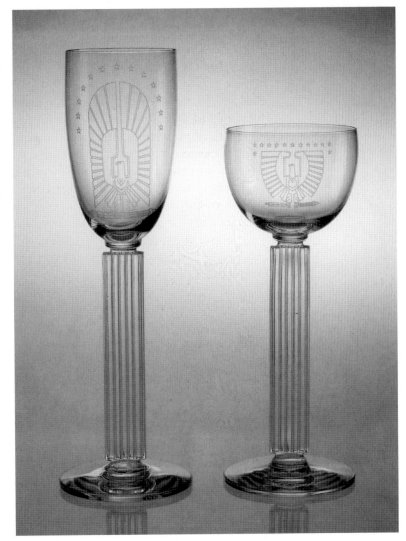

American consumer products but even the architecture of Le Corbusier, carried expressive significance, and designers recognized that fact. Frankl, for example, wrote that 'art of today . . . must express the life . . . of invention, machinery, industry, science and commerce'. Dohner insisted that an 'intelligent and competent designer' would 'always design to express function' even when his forms were not 'exclusively functional'. Geddes claimed that while 'function . . . is fixed, its expression in form may vary endlessly under individual inflection'. And Dreyfuss asserted that an 'object should look like what it can do'. Finally, most self-consciously, the Chicago partners J. F. Barnes and Jean Reinecke (1909–87) rejected 'form follows function' as a 'Platonic . . . hangover'. Their challenge was to find 'the most economical use of suitable materials . . . to express . . . the use of the machine, and to visualize its efficiency and dependability'. Their ultimate goal in a

single phrase was 'visual efficiency'. That concept refocused the whole point of design on an object's rhetorical or communication value—that is, on its ability to evoke emotional responses from those who viewed it.[30]

As a style, streamlining not only expressed function or identified a product with the spirit of the age. It also smoothed over functional elements whose complexity otherwise might have confused consumers. Middle-class Americans were just as ambivalent about technology as their nineteenth-century counterparts. But now they were supposed to embrace the machine not only in the workplace but also in the home. Domestic technologies had to be domesticated. Although the easiest way of assimilating a new technology was to disguise it in an earlier form, as when a wooden radio console resembled a cabinet for storing sheet music, designers used streamlining to domesticate consumer products without disguise. Whether for a radio or a washing machine, an automobile or a refrigerator, the goal, in Teague's words, was to use a single flowing shell or housing to encompass a visually disparate 'assemblage of castings, stampings, pipes, rods, gears, controlling instruments' so they would appear 'as one functioning organism'.[31] That final word suggests that streamlining—and ultimately the industrial designer—served not only to domesticate but also to naturalize, to make the machine as one with nature.

Streamlining in motion

'To-day, speed is the cry of our era, and greater speed one of the goals of to-morrow.'[32] So declared Geddes in *Horizons* (1932), published at the height of business infatuation with industrial design. Filled with science-fiction visualizations of teardrop cars and buses, a sleek tubular train, a torpedo-shaped ocean liner, and a vast flying wing with teardrop pontoons, *Horizons* struck a responsive chord in automotive and railway executives who received promotional copies and in people who saw its models and renderings reproduced in newspaper and magazine articles [**65**]. Geddes considered the teardrop—the shape taken by a drop of water sliding down an inclined surface—as the form

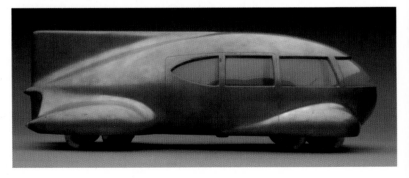

65 Norman Bel Geddes

Model of Motor Car Number 9, *c.*1932

Fabricated of brass, this model car came close to the teardrop ideal except for somewhat stylized fenders and a rear stabilizing fin. Geddes assigned arbitrary numbers to his visionary designs to suggest dramatic progress.

66 Buckminster Fuller and Starling Burgess

Dymaxion automobile, 1933
The most radically aerodynamic of many experimental streamlined cars, the Dymaxion attracted much favourable publicity until it was involved in an accident fatal to the other car's driver.

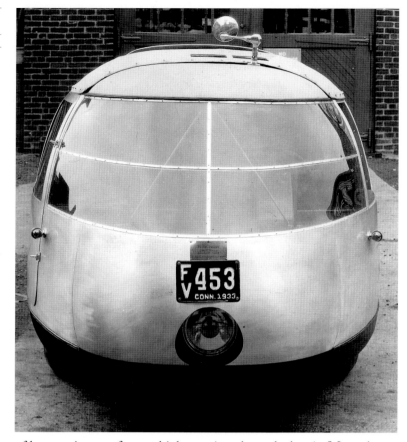

of least resistance for a vehicle moving through the air. More than a year earlier, the Society of Automotive Engineers had given 'almost unanimous approval' to the concept of a teardrop car with a broad, bulbous front flowing smoothly back over a tapering rear-engine compartment as 'the final evolution' of auto body design.[33] A series of experimental teardrop cars culminated in the Dymaxion in 1933 [**47**, **66**]. Sleek and low, enclosed within a curved monocoque shell of duralumin, the three-wheeled Dymaxion was a collaboration of Buckminster Fuller, a mystical philosopher-designer with connections to *Fortune*, and Starling Burgess (1878–1947), a designer of prize-winning yachts. Although they had hopes of mass-producing the Dymaxion, only a few were ever fabricated.

In the meantime, engineers Fred Zeder (1886–1951) and Carl Breer (1883–1970) at the Chrysler Corporation had been conducting aerodynamic wind-tunnel tests of teardrop prototypes for several years, and they used Geddes's *Horizons* to convince the company's marketing executives to allow them to proceed with a radically streamlined automobile, the Airflow, in 1934 [**67**]. The aerodynamic engineer Alexander Klemin pronounced it an effective compromise 'between ideal aerodynamics and practical automobile design'. The Airflow initially

excited the public, but its design departed too radically from the expected. Although sales were disappointing, the Airflow contributed to a streamlining fad among the public and convinced General Motors and Ford to employ it as a styling device throughout their automotive lines, from the sleek Lincoln Zephyr of 1936, with its flaring radiator grille and sculptural teardrop fenders, to the lowliest Chevrolet. Detroit's styling studios soon became adept at 'designing for eye resistances rather than wind resistances'.[34]

Horizons also had a dramatic impact on the railroads. Hoping to win back passengers from the automobile, railway executives sought to imbue rail travel with an up-to-date image of modernity. Within months of publication of Geddes's book, the Union Pacific and Burlington lines announced plans for the first passenger streamliners. Completed early in 1934, the Union Pacific's M-10,000 [**67**] and the Burlington Zephyr [**68**] were intended as fast three-car commuter trains. Their innovative designs incorporated internal combustion engines and light bodies of aluminium or stainless steel that made starting and stopping quicker than with heavy steam engines, but it was their sleek aerodynamic forms that attracted public attention. During the spring and summer of 1934, both trains toured the nation and drew thousands of sightseers. Many people walked through the trains during brief stops in small towns. Others in rural areas crowded

67 Chrysler Corporation and American Car & Foundry Co.
Chrysler Airflow automobile and Union Pacific M-10,000 streamliner, both 1934
The Airflow's streamlined silhouette resembled that of an elongated Volkswagen, with fenders nearly integrated into the body. The M-10,000, built by ACF and the Pullman Co. for the Union Pacific railroad, possessed a structurally innovative aluminium monocoque body. Its colour scheme featured a wide band of rich mustard yellow running the train's full length through contrasting brown.

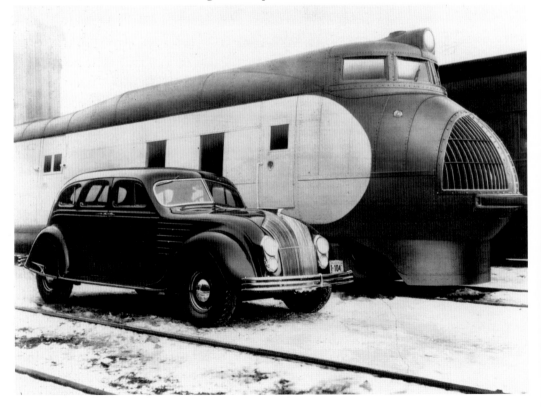

to local crossings as the trains came sweeping through at announced times. Thousands more viewed the two trains as star attractions of the second season of the Century of Progress Exposition at Chicago. Surrounded by the fair's modernistic Art Deco structures, they heralded streamlining as a commercial design style more in harmony with a wish to escape from the Depression. To the mass-circulation *Saturday Evening Post*, the Zephyr offered 'the first dramatized portent . . . of change and progress . . . since the crash of prosperity five years ago'.[35]

Within a few years all major railroads had ordered new fleets of streamlined locomotives and passenger cars. Although many locomotives were diesel powered, most railroads also felt compelled to transform traditional steam locomotives by covering their complex exteriors of cab, boiler, pipes, and stacks with smooth streamlined shrouding. Most companies merged old and new locomotives into distinctive fleets marked by trademark exterior silhouettes and colour schemes. Dreyfuss, for example, provided the New York Central with a fleet of slant-fronted steam locomotives in an elegant grey, while Otto Kuhler (1894–1977), a designer who specialized in railroad work, employed a similar shape but lighter colours for the Milwaukee line. Loewy gained much attention with his bullet-nosed K4S steam locomotives [69], a retrofitting for the Pennsylvania railroad, which

68 Edward G. Budd Manufacturing Co.

Burlington Zephyr streamliner, Chicago, Burlington & Quincy railroad, 1934

Renamed the Pioneer Zephyr when the railroad installed a fleet of Zephyrs, the three-car train possessed a stainless steel body engineered by Edward G. Budd (1870–1946) and a diesel-electric engine manufactured by General Motors. This calendar illustration from 1939 portrays a literal domestication of the machine.

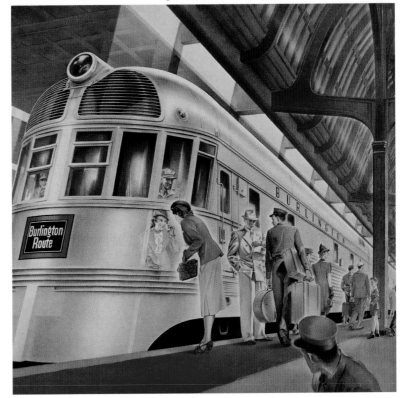

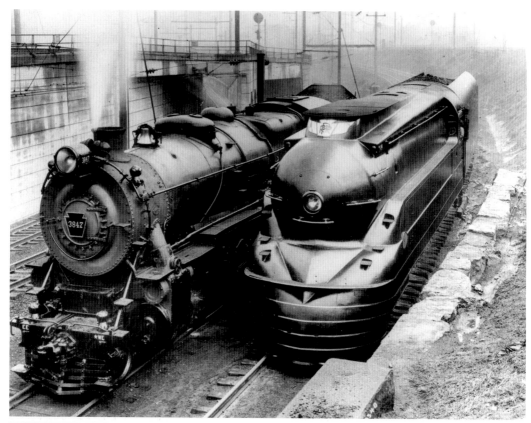

69 Raymond Loewy

K4S steam locomotive
before-and-after,
Pennsylvania railroad, 1936
Although the public
responded favourably to the
updating of older locomotives
by the addition of streamlined
shrouding, railway employees
complained of difficulties
gaining access to working
parts for routine maintenance.
In other words, form trumped
function.

ultimately had to pay royalties to Kuhler because he had first intro-duced such a design for the Milwaukee. To some extent, designers borrowed techniques and designs from the automotive industry. For example, Loewy specified a smooth, all-welded steel exterior shell for the Pennsylvania's GG-1 [70], an electric locomotive whose prototype was assembled from plates joined by thousands of visually distracting rivets. The new body was, in automotive fashion, set down by crane onto the chassis of a completed locomotive. General Motors captured the diesel locomotive market by the end of the 1930s, housing all tech-nical configurations in a standard shell whose high projective front curved back to a windshield running the full width of the cab, which for the first time gave locomotive drivers the same visibility enjoyed from an automobile. At that point the heyday of streamlined loco-motive design ended, with differentiation occurring only through paint schemes and logotypes. In the meantime, industrial designers were devising sleek railway interiors in such new materials as brushed aluminium, Formica plastic laminate, and cork panelling—a refreshing alternative to the dull colours and dark wood panelling of traditional railway interiors. By 1936 a passenger trapped on an unconverted train could complain that 'such quaint specimens' seemed 'as out-moded as a Model T Ford'.[36]

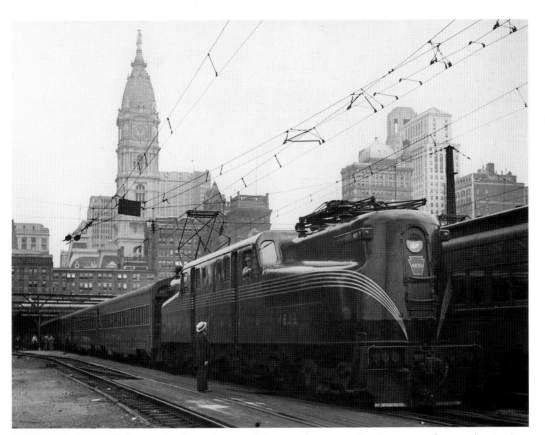

70 Raymond Loewy
GG-1 electric locomotive, Pennsylvania railroad, 1935
Although Loewy did little more than specify a smooth welded shell and refine the 'cat's-whisker' paint scheme, he often took credit for designing this locomotive—an example of the penchant of most early industrial designers for inflating their contributions beyond styling to engineering.

Bridging past and future, the streamliner suggested smooth progress —exactly what the American people wanted in uncertain times. When consumer engineer Arens returned late in 1934 from touring with a lantern slide lecture entitled 'See America Streamlined', he reported an 'amazing response'—a 'welling up of national enthusiasm' for streamlining, which had 'captured [the] American imagination to mean modern, efficient, well-organized, sweet, clean and beautiful'. To Arens, this 'crystallization of mass psychology' seemed 'to release the wishes and hopes of people in all walks of life whose will and whose energy' were 'chained down by the circumstances of the depression'. Public acceptance of streamlining indicated it satisfied a genuine cultural need, but the streamline style also lent itself to commercial manipulation, as Arens recognized when he advised that it be used as a 'selling tool'. The style which had originated in the science of aerodynamics quickly passed into the emotional realms of commerce and culture.[37]

The debate over streamlining

Streamlining became the dominant commercial design style in two or three years, spreading to non-vehicular objects at every scale—from

71 Raymond Loewy

Teardrop pencil sharpener, 1934

An object of much notoriety among design circles of the 1930s, this prototype was never manufactured. When asked about its functionality, Loewy responded with two small sketches, one depicting an ordinary pencil sharpener bristling with exposed parts, the other his streamlined design. The former, he explained, was a greasy, dirty mess; the latter could be quickly dusted with the wipe of a tissue.

72 Walter Dorwin Teague

Service station for the Texas Co. (Texaco), 1936

Teague's office devised prototypes for various urban and rural situations. Hundreds of service stations in this particular design were constructed throughout the Midwest and West. Although Teague employed streamlined motifs, his stylistic restraint ensured that Texaco's stations reflected a certain timelessness. White porcelain-enamel steel panels retained a pristine appearance for decades.

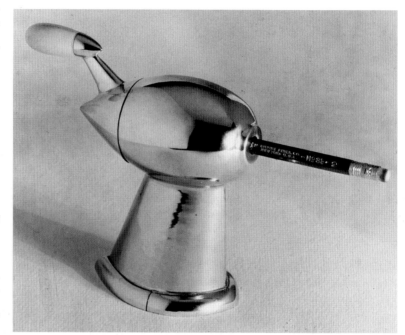

Loewy's teardrop pencil sharpener, looking so much like an airplane engine and propeller [**71**], to Teague's crisp white service station for Texaco, with curving canopy and three green parallel flow lines [**72**]. The new style and the designers who had developed it came under attack from critics at the recently founded Museum of Modern Art (MoMA) in New York, who had singled out Le Corbusier and the Bauhaus in Germany as exemplary sources of pure functional modern design. Two quite different exhibitions in April 1934 highlighted the opposing sides. Most of the leading commercial designers were represented in an 'Industrial Arts Exposition' that opened at Rockefeller

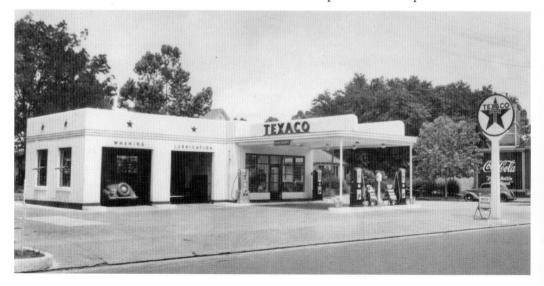

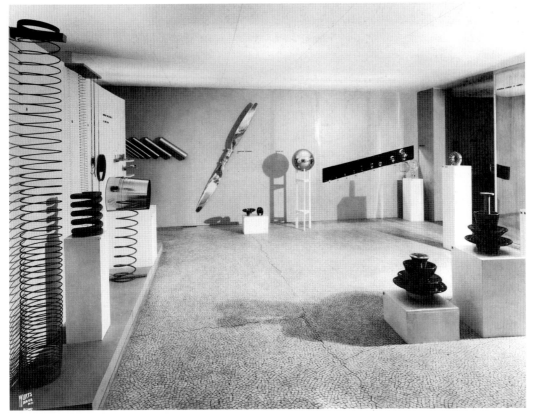

73 Museum of Modern Art, New York

Installation for 'Machine Art' exhibition, 1934

In addition to the industrial items visible here, including a ball-bearing displayed on a plinth, abstracted from its functional context, Johnson exhibited scientific measuring instruments, stainless steel restaurant cookware, a gleaming nautical propeller, and the cross-section of a large wire cable.

Plaza in the heart of machine-age America's most recent architectural marvel. Sponsored by the National Alliance of Art and Industry (an association set up by John D. Rockefeller Jr. and the Carnegie Corporation), the exposition proposed 'to celebrate the emergence of an American style' uniting 'beauty and sales value'.[38] In addition to Loewy's pencil sharpener, the many displays included a Todd Protectograph check printer by Dreyfuss, a Holly Carburetor bathroom scale by Van Doren, and a Wurlitzer radio by Russel Wright.

Four blocks north, in a brownstone that was then home to MoMA, itself a Rockefeller family project, an entirely different interpretation of 'Machine Art' was under way [73]. Curated by Philip Johnson (b. 1906), who later became a prominent architect, the show included a few token consumer products such as a severely modernistic toaster and a circular electric clock without numerals. However, pride of place went to anonymous examples of industrial products abstracted against neutral backgrounds. Johnson's catalogue essay attacked the 'neoclassic trappings and bizarre ornament' of French design and the American 'desire for "styling" objects for advertising'. Alfred H. Barr Jr. (1902–81), MoMA's director, emphasized 'the perfection of modern materials and the precision of modern instruments' in an unconscious industrial art that relied on the 'practical application of geometry'.[39]

Privately, in a letter to Geddes, Barr denounced streamlining as an 'absurdity' resulting from a 'blind concern with fashion' that made it 'difficult to take the ordinary industrial designer seriously'.[40]

Defenders of streamlining might have claimed that it marked the emergence of a true national style emphasizing the practical genius of American technology and its consumer economy. Streamlining avoided both the hothouse excess of French Art Deco and the cold precision of Bauhaus design. Streamlining could also be defended on technical grounds. Products of sheet metal, for example, required rounded edges for strength and ease of assembly, while plastic appliance housings had to be rounded to permit machine polishing of the moulds, to facilitate the smooth flow of molten resin, and to give finished products a durability not possible with sharp rectilinear forms. Ultimately, however, streamlining was a popular expressive style. Although industrial designers liked to invoke the inspiration of fast vehicles, their work involved a commercial motive that was fundamentally domestic in nature. Van Doren, writing in a practical textbook, advised prospective designers that 'the manufacturer who wants his laundry tubs . . . streamlined is in reality asking you to modernize them, . . . to make cast iron and die-cast zinc and plastics and sheet metal conform to the current taste' for 'soft flowing curves' [**74**].[41]

74 Harold Van Doren
Model E wringer washing machine, Maytag Co., 1939
Also known as the Master model, this washer forecast the wider radiuses and thus 'softer' curved forms typical of design in sheet metal after the Second World War.

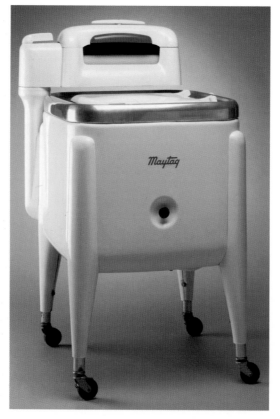

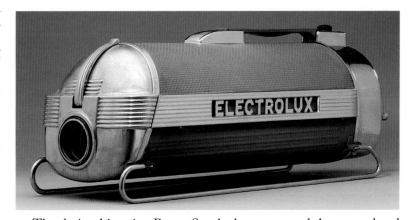

75 Lurelle Guild

Model 30 vacuum cleaner, Electrolux, 1937

Even domestic appliances like the vacuum cleaner assumed sleek machine-age form during the 1930s. Working for a Swedish company with a factory in Connecticut, Guild (1898–1986) specified cast aluminium end-pieces, a steel canister, vinyl sheathing, and sled runners for the Electrolux cleaner. While echoing the form of a streamliner, it also announced a simplicity of control over the household environment—at least in terms of cleanliness.

The design historian Penny Sparke has suggested that a gendered interpretation explains the bitter animosity of the attacks on commercial industrial design. She maintains that standards of the sort promoted by Johnson and Barr, appealing to 'universal values and the pure logic of function', actually marked an attempt 'to set the cultural terms of reference for modernity such that women, with their new-found power as consumers, would not take over the reins'. In fact, however, this rearguard action failed because both Art Deco and streamlining successfully addressed symbolic needs of the women who became the primary consumers in American society. Sparke finds it ironic that 'the feminisation of technological consumer goods was initiated through that most symbolically masculine of objects, the American automobile'. Inverting the usual interpretation of technological symbolism, she argues that by emphasizing 'the creation of a visual whole and . . . concealing the complex mechanisms within', streamlining actually followed the aesthetic of the Victorian parlour, in which an 'abundance of textiles' produced 'continuity and flow' and 'disguise[d] the separateness of . . . component parts' [**75**].[42]

The world of tomorrow

Whatever streamlining's unconscious meaning, it represented a common assumption that society's larger processes had to be rendered smoother, less complex, more frictionless in operation. The streamlining of appliances, vehicles, and even the interiors of government buildings visually expressed this desire. The style's association with aerodynamics and speed suggested a faith in technological progress. At the same time its rounded, enclosing forms, particularly when applied to architecture, suggested a need for protection and stability. Above all, streamlining revealed an obsession with control. This cultural imperative attained fullest expression at the New York World's Fair of 1939–40 [**76**]. Held on the eve of a war that soon revealed the dark side of the urge for control, the fair was dedicated to the theme of 'building the

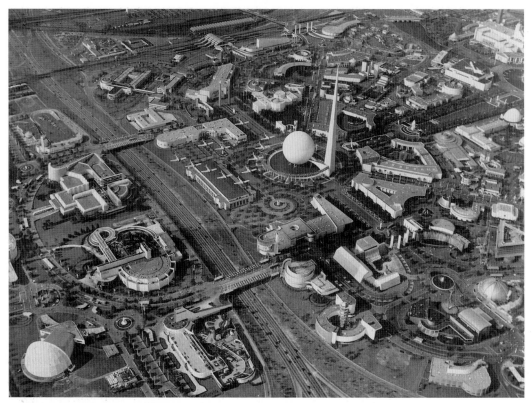

76 New York World's Fair of 1939–40

Overview, with Trylon and Perisphere 'theme center' Although the grounds consisted of traditional radial avenues, the architecture emphasized curvilinear forms, windowless enclosures, air-conditioned interiors, all-encompassing artificial environments, and controlled access and flow for visitors— all to become typical of commercial and public spaces in the late twentieth century. In a limited sense, the fair's designers did succeed in predicting 'the world of tomorrow'.

world of tomorrow', a phrase suggested by Teague. Enthusiastic critics observed that the fair's curvilinear forms, created mostly by industrial designers rather than architects, indicated wide acceptance of streamlining as a national design style. Flowing effortlessly on escalators, revolving platforms, conveyor-belt chairs, and on foot through one-way exhibits ('follow[ing] the line of least resistance just as water does'[43]), visitors marvelled at a projected future world of television, talking robots, intercontinental rocket travel, and quite a number of current appliances.

The historian David E. Nye has pointed out that many exhibits emphasized the theme of control by placing visitors in positions of commanding observation over 'miniaturized landscapes of the future'. The most successful of these was the General Motors building, designed by Geddes's office as a vast freeform structure whose automotive curves were dismissed by a hostile critic as 'a giant blow-up of an industrial designer's clay model'. On the other hand, an admirer described the GM building as a 'vast carburetor, sucking in the crowd by fascination into its feeding tubes'. After snaking along switchback ramps into a narrow entrance, visitors were rewarded with a ride in upholstered seats along a conveyor belt offering aerial views of the Futurama, a series of dioramas extending over 36,000 square feet (3,300 square metres), portraying futuristic transcontinental highways

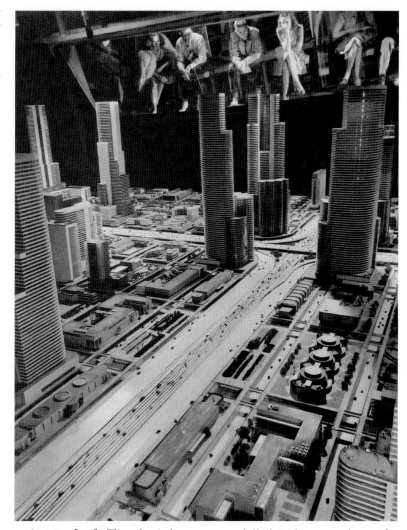

77 Norman Bel Geddes

Futurama or 'Highways and Horizons' exhibit, General Motors building, New York World's Fair of 1939–40

This project, which GM hoped would stimulate demand for federally funded superhighways, exposed the dilemma of commercial design. While Geddes conceived the Futurama as a functional projection, meticulously planning every detail, a vague narration covered only the broadest generalities. Visitors received buttons proclaiming 'I have seen the future' but did not know what they had seen.

and cities [**77**]. The final diorama, modelled in larger scale as if a viewer's plane were coming in for a landing, presented a close-up of an urban street intersection with streamlined building façades and elevated walkways across lower-level traffic lanes. As visitors exited from the ride, they found themselves outside, in the middle of a full-scale version of the intersection they had just surveyed in model form. There was one significant difference, however. Although the dioramas, including the final close-up, contained teardrop vehicles such as those Geddes had promoted in *Horizons*, the full-sized outdoor intersection displayed current GM autos and trucks designed not by a visionary consultant designer but by anonymous employees of the GM Styling Division. Geddes had energetically fought that decision and was denied nothing else in a project costing $8 million, but there was a limit to what even he could accomplish at a world's fair described by *Life* as 'a magnificent monument by and to American business'.[44]

Viewed from the present, the utopian optimism of the 1930s appears serene. In 1985 a documentary film, *The World of Tomorrow*, portrayed the New York World's Fair in an elegiac manner, implying nostalgia for an innocent vision of coherence. In actual fact, the Depression hardly suggested coherence to those who endured it. Economic hardship and disparity, hopeless migrations, unprecedented political experiments, and threats of totalitarianism and war contributed to an uncertainty that approached a national identity crisis. The fate of the American experiment seemed to hang in the balance. Many people looked not to the future but to the past for confirmation of national purpose. A desire for meaningful continuity found expression in the popularity of handmade crafts from the Appalachians and the Southwest, as well as in reproductions of colonial furniture and photographs of reconstructed colonial scenes marketed by Wallace Nutting (1861–1941). Other indications of Americans looking backward included the popularity of Margaret Mitchell's novel of agrarian loss, *Gone with the Wind* (1936), and the fabrication of such pre-industrial outdoor museums as Rockefeller's Colonial Williamsburg

78 Frederick Rhead

Fiesta dinnerware, Homer Laughlin China Co., 1936 Inexpensive Fiestaware, the result of market research carried out by Rhead (1880–1942), was available in a range of colours intended to encourage informal mixing and matching.

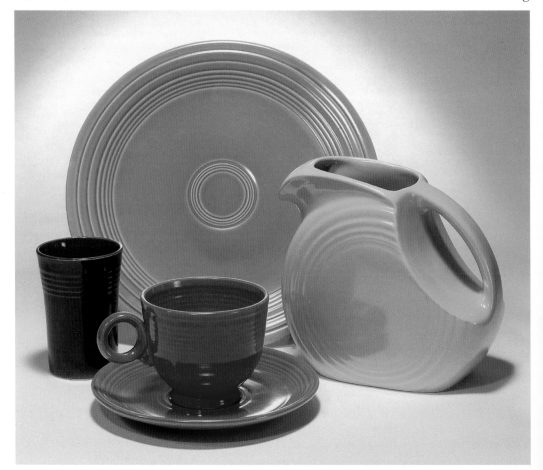

and Ford's Greenfield Village. Even the wildly popular, brightly colourful Fiesta dinnerware could face either way, as the historian Regina Lee Blaszczyk has reminded us, with its concentric rings evoking either the 'marks left by the old potter's wheel' or the 'futurist imagery' of streamlining [**78**].[45] Americans of the Depression years experienced less coherence and expressed less faith in technological utopia than some of their descendants might like to think.

But if that is so, then it becomes difficult to make sense of the artefacts of an optimistic machine-age streamline style inherited from the 1930s—in image and in material reality: all those gleaming smooth-shrouded locomotives, rounded automobiles with teardrop fenders, radio cabinets with glossy black Bakelite curves, 'cleanlined' washing machines and refrigerators, all those bus terminals, gas stations, movie theatres, and restaurants with curving marquees and smooth horizontal façades of stucco or enamel-steel. One must try to reconcile them with the expressions of despair and celebrations of the past that also marked the decade. Did the visual coherence and utopian promise of the streamline style truly embody the aspirations of many Americans, or did streamlining reveal little more than consumer capitalism coming to maturity with a self-conscious awareness of how to stimulate desire and manipulate behaviour? It is possible to document the style, but the emotion stirred by the first sight of a Zephyr locomotive cannot be recovered.

High Design versus Popular Styling, 1940–1965

4

Soon after the US entered the Second World War, Loewy was commissioned to redesign a cigarette package [**79**]. The old pack sported a red bull's-eye against a dark green background. Loewy's office abandoned the drab green colour and instead dramatically placed the red circle against a white background. When the new package appeared in 1942, radio commercials declared 'Lucky Strike green' had 'gone to war'. So too did designers, who were in great demand as manufacturers converted from civilian to military production. War contracts stimulated industrial design's growth and brought respect from engineers who had dismissed the field as sales promotion. With research and development accelerating, designers gained experience with new materials and manufacturing processes that were soon to transform the post-war world.

Designing for war

War work for established designers encompassed everything from uniform insignia and training manuals to medical devices and heavy equipment. When the Joint Chiefs of Staff of the Army and Navy needed a strategy room, Loewy collaborated with Teague and Dreyfuss, coordinating interiors, communications media, and display devices. While Teague's office made naval artillery controls as obvious as possible, fitting them to a range of physical and mental capabilities, Dreyfuss did the same for the Army. Geddes, on the other hand, fresh from supervising the General Motors Futurama, focused on projects involving scale models, such as kits for training Navy recruits to recognize ships and aircraft, topographic models for planning operations, and camouflage techniques.

Design for wartime not only enabled leading offices to expand their staffs but also afforded employment to individuals who worked within the armed forces. Viktor Schreckengost, for example, was designing bicycles when he joined the Navy at the age of thirty-seven. His projects ranged from devising a key for interpreting radar patterns to constructing topographic models for an invasion of Japan. By the end of the war he was serving as director of the Naval Research Center, where

LUCKY STRIKE **GREEN**
HAS GONE TO WAR!

So here's the smart
new uniform for
fine tobacco

LUCKY STRIKE

CIGARETTES

79 Raymond Loewy

Lucky Strike cigarette pack, American Tobacco Co., 1942

In response to the requisitioning of green inks for military use, Loewy delivered a more vivid package while retaining the trademark bull's-eye device. He also placed the emblem on both front and back by eliminating a block of text, thereby ensuring the pack would serve as advertising no matter which way it fell when discarded.

he developed a system for measuring muscular movements as a guide to fitting amputees with artificial limbs. Don Wallace (1909–90) had studied in the late 1930s at the Design Laboratory in New York, a short-lived school organized by Rohde under the Federal Arts Project, and had briefly designed craft products to be fabricated by the National Youth Administration in Louisiana. After enlisting in the Army, Wallance was assigned to the Quartermaster General's office, where his projects ranged from tents for long-term encampments to caskets for soldiers' remains. Before leaving military service, he designed furniture for officers' quarters in hot, humid regions of the Pacific. To overcome warping frames and sticking drawers, Wallance developed dressers and cabinets with stable aluminium frames and plywood panels.

Plywood, which enjoyed a reputation as a modern miracle material, was used for aircraft fuselages and wings, hulls of PT (patrol torpedo) boats, radio towers, and prefabricated structures. Unlike earlier plywood, which easily delaminated, the new material was bonded by a synthetic resin so strong that the wood failed before the glue. Among those who perfected new uses for this light structural material was Eliot F. Noyes (1910–77), a Harvard-educated architect who resigned as director of MoMA's industrial design department to work on plywood gliders for the military. Noyes had become acquainted with new applications of plywood while organizing an exhibition on 'Organic Design in Home Furnishings', which featured several chairs collaboratively designed by Eero Saarinen (1910–61) and Charles Eames that had unprecedented one-piece structural shells bent into compound curves. Late in 1942, Eames and his wife Ray Kaiser Eames (1912–88) contracted with the Navy to supply moulded plywood splints for the broken legs of wounded sailors [**80**]. They hoped to apply similar

80 Charles and Ray Eames

Plywood leg splint, US Navy, 1942

Assisted by Harry Bertoia, the Eameses developed a compression moulding technique to manufacture light, thin-walled, organically form-fitting splints, sculptural in appearance as well as functional. By the end of the war they had delivered about 150,000 splints.

plywood manufacturing techniques to inaugurate a post-war revolution in furniture design. Their sense of anticipation was shared by Noyes, Wallance, Schreckengost, and other designers who emerged from the experience of military design still young enough, in their mid-to-late 30s, to dream of reshaping the world.

Planning for peace

Established industrial designers had been thinking about the future throughout the war. Planning for after the war had two overlapping but contradictory motives. In the first place, manufacturers were desperate for images of new products, however sketchy, to hold out to consumers unable to purchase anything but bare necessities. After years of deprivation the American people wanted to see what they were fighting for. Advertising agencies responded with renderings of science-fiction cities, teardrop autos with plastic bubble domes, and an airplane in every garage. Many industrial designers contributed to this new advertising genre. Two Detroit partners, Carl Sundberg (1910–82) and Montgomery Ferar (1909–82), offered illustrations of a plastic refrigerator, a moulded plastic chair with transparent legs, and a shark-nosed bus with an acrylic turret for the driver. Arens touted a cylindrical plywood refrigerator, while Deskey proposed a cordless speaker phone with push buttons and a microfilm directory. The plausibility of Deskey's telephone suggested the second motive for post-war planning—the desire of manufacturers to have innovative goods ready as soon as the war ended. Deskey exhorted fellow designers to 'look beyond the defense emergency' and to 'design tomorrow's product now' so as to enjoy 'a tremendous sales advantage'.[1]

After peace came in August 1945, designers, promoters, and entrepreneurs rushed into schemes for addressing the pent-up material desires of a population that had endured more than 15 years of economic hardship. Some projects were more plausible than others. Among the former was Tupperware, flexible polyethylene refrigerator dishes with an airtight seal invented by Earl S. Tupper (1907–83). Among the latter was the ConvAIRCAR, a hybrid auto-plane vehicle developed by the Consolidated Vultee Aircraft Corporation of San Diego with design assistance from Dreyfuss [**81**]. Although the company promoted the tiny teardrop auto as having 'all the advantages of a Cadillac', this so-called 'only automobile that flies' looked supremely awkward in flight.[2] Equally unusual in form though better integrated was the futuristic Wichita house [**82**], conceived by Buckminster Fuller as a do-it-yourself kit to be mass-produced at the Beech Aircraft Corporation in Wichita, Kansas. Fuller hoped to sell 250,000 houses per year for $6,500 each, including assembly, with each unit to be shipped by cargo plane in a returnable stainless steel tube. Neither the

81 Henry Dreyfuss

ConVAIRCAR, Consolidated
Vultee Aircraft Corp., 1947
Looking as if inspired by
wartime advertising, this
vehicle consisted of an
automobile with a light,
fibreglass-reinforced plastic
body surmounted by a
detachable aircraft fuselage
and wings. After flying to a
distant city, a pilot could
deploy struts to support the
fuselage and drive out from
under the plane. Dreyfuss
presumably styled the auto
exterior and interior.

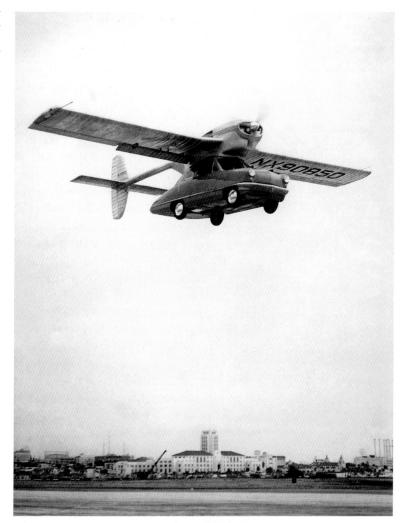

82 Buckminster Fuller

Wichita house, Beech
Aircraft Corp., 1946
Fabricated from curved
aluminium alloy panels with
sheets of acrylic glazing
deployed in a continuous
ribbon, the Wichita enclosed a
thousand-square-foot (93-
square-metre) circle of
climate-controlled space. A
wood floor and fabric-covered
interior brought domestic
warmth to an otherwise
austere structure.

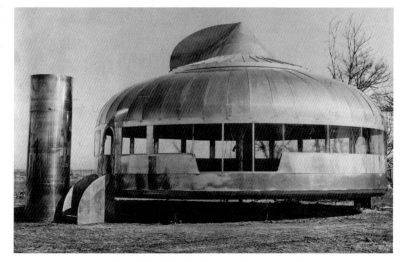

Wichita house nor the ConvAIRCAR went further than functioning prototypes.

Fuller was the most radical among the designers who saw prefabrication as the solution to providing houses for veterans and their families. Almost no housing had been constructed in the US since 1929, so interest surged in 1946 as dozens of promoters sought to take advantage of federal subsidies for prefabrication. Most schemes employed plywood instead of emulating the aviation and automotive industries with aluminium and sheet steel. Even Deskey, best known for his modernistic interiors, couched a radical prefabrication plan so as to appeal to a public seeking modernity in traditional guise. His company Shelter Industries offered a house of plywood panels assembled around a one-piece utility core with kitchen and bath, designed by Deskey and manufactured by the Borg-Warner Corporation [**83**]. However modern the factory-built structure, its striated plywood surfaces evoked 'weathered wood' and afforded a 'quality of nostalgia, of romantic living'. According to Deskey, the challenge was to design a prefab house to 'grow old gracefully'. Countering Le Corbusier's famous maxim, Deskey claimed that a house was 'something more than "a machine for living"'.[3]

This common attitude appeared in an influential book entitled *Tomorrow's House* (1946), published by George Nelson and Henry Wright (1910–86), the editors of *Architectural Forum*. Appalled that 'less honest thought goes into the design of the average middle-class house than into the fender of a cheap automobile', they offered witty

83 Donald Deskey
Prefabricated house erected in Connecticut by Shelter Industries, 1946
Inside and out, Deskey employed Weldtex plywood panelling, which he had developed for the U.S. Plywood Corp. Vertically scored with parallel striations of varying depth and width, Weldtex possessed a pleasantly irregular surface that absorbed paint well and disguised the grain of inexpensive Douglas fir.

advice for young couples and photographs of recent houses by such architects as Harwell Hamilton Harris (1903–90) and Caleb Hornbostel (1905–91). Avoiding the austerity of early European modernism, these houses revealed textures and colours of native stone and exposed wood. Even so, their open plans, horizontal lines, and glass walls marked them as thoroughly modern. The authors invoked American tradition when they referred to the typical 'big room' as 'the first time a room for the whole family has appeared . . . since the days of the farmhouse kitchen'. Echoing the moral reformism of the nineteenth-century cult of domesticity, they suggested that this self-consciously named 'family room' offered evidence of 'a deep-seated urge to reassert the validity of the family by providing a better design for living'.[4]

This theme accurately suggested the cultural mood of a nation emerging from economic depression and global war. Although the expanding middle class of Americans might seem like thoroughly modern individuals, at home with change, uprooted by the war, abandoning old neighbourhoods and farmsteads to live in newly constructed suburbs like Levittown, enjoying the latest cars and washing machines loaded with gadgets and chrome, they also sought in their surroundings the traditional symbolic reassurance of home. The modernism of the post-war 'American century' was not that of self-conscious intellectual or artistic elites but instead evolved out of the daily needs and casual emotions of ordinary people, sometimes passively consuming, sometimes passionately seeking stimulation. Designers found it difficult to discern their shifting concerns but occasionally successfully intuited popular desires and reflected them back to the public in material goods.

As comments by Wright and Nelson suggested, the moralism of nineteenth-century design theories never quite vanished even as the market for consumer goods expanded among a new suburban middle class. Opinions about design revealed a split between those who defined it as a rational process of organizing and improving everyday life and those who defined it as a means of stimulating sales by appealing to irrational emotions. At the extremes this debate pitted those who admired clarity of function against those who promoted ephemeral styles and products.

These contradictory approaches were dramatically juxtaposed in January 1945 in an article on Nelson's Storagewall—the first in *Life*'s series on 'the post-war house' as 'a useful, efficient place for living'.[5] Contemplating the deep, narrow closets of old houses crammed with stuff and the wasted space of interior walls, Nelson proposed a modular storage system running floor to ceiling between rooms, replacing traditional walls. A living room might have open and closed shelving alternating with a built-in phonograph and fold-down writing desk, while cabinets opening onto the other side of the wall, along an entry-

84 George Nelson

Storagewall illustrated in *Life* magazine, 1945

The designer presented Storagewall as a rational means of bringing domestic chaos under control, but this photograph's surreal imagery suggested an unprecedented proliferation of material goods. The 'array of goods' photograph became a journalistic cliché. Whether posing a family on the lawn with all their possessions or with a year's supply of groceries, such images celebrated America's material abundance.

way, would conceal coats, umbrellas, and sports equipment. The ideal post-war house would have a place for everything, with everything in its place. All the more startling, then, was a full-page colour photograph of a mock-up of Storagewall [**84**] with its smooth modular components arrayed in rational precision. The viewer's attention is drawn not to Storagewall, however, but to the chaos from which it rises, a massive jumble of goods piled up on the floor—books, phonograph records, bingo game, Chinese chequers, wicker picnic hamper, clock, rackets, fishing rods, croquet set, and dozens of smaller things. As if to identify the nationality of this accumulation of products, a US flag rises behind a woman who sits on the floor, contemplating her situation. Although Nelson intended to convince readers they might assert rational control over their surroundings using the Storagewall system, this surreal image instead provoked a sense of things—literally *things*—out of control. If the average American family already possessed 10,000 individual objects, as Nelson claimed, then who could imagine what the promised post-war abundance would unleash? The split between reason and emotion, or between what was considered

good for people and what they really wanted, defined post-war design. As two decades of deprivation and sacrifice ended, that conflict began to emerge.

Rational design and the Cranbrook legacy

Critics as various as Lewis Mumford and Philip Johnson had celebrated the Bauhaus for promoting functionalism without recourse to commercial expressionism. Its influence had grown as refugee instructors and students, among them Marcel Breuer (1902–81), Walter Gropius (1883–1969), and Ludwig Mies van der Rohe (1886–1969), fled Nazi Germany and eventually settled in the US. Only one of them, László Moholy-Nagy (1895–1946), tried to re-create the exhilarating atmosphere of the original Bauhaus. Arriving in Chicago in 1937 to organize a New Bauhaus for the Association of Arts and Industries, Moholy-Nagy discovered that the mansions of his patrons revealed 'not the slightest influence of any modern taste'. Among them, fortunately, was Walter Paepcke (1896–1960), president of the Container Corporation of America, who had already begun hiring modern graphic designers to create high-minded corporate-image advertising. Paepcke encouraged Moholy-Nagy as he organized a progressive design curriculum emphasizing the student's total aesthetic and humanistic development. Despite criticism that Moholy-Nagy allowed the New Bauhaus to 'lose itself in theory and become a hot-house product too far removed from the ebb and flow of American life', Paepcke supported him through financial crises, relocations, and name changes. By then, students had shifted orientation enough to engage in wartime experiments with bed springs made from wood, and Moholy-Nagy encouraged apprenticeships with industry. He admitted in 1946 that America had required him 'to relearn completely my ideas about design'. The Institute of Design survived his premature death as part of the Illinois Institute of Technology (IIT), but its Bauhaus legacy remained little more than a memory.[6]

The Cranbrook Academy of Art near Detroit proved more successful at preparing designers for post-war work because its director Eliel Saarinen (1873–1950) advocated a practical approach to tangible problems. A leader of Finland's National Romantic architectural movement before coming to the US in 1923, he had used rusticated stone, native woods, textured weavings, and irregular structural massing to evoke a vernacular tradition. With funding from the newspaper publisher George G. Booth (1864–1949), Saarinen opened Cranbrook in 1932, designed its buildings and furnishings, and hired instructors for studios devoted to woodworking, weaving, metalworking, and ceramics. The Finnish designer Alvar Aalto (1898–1976) was simultaneously developing chairs whose bent plywood frames and seats echoed the tubular

steel chairs of the Bauhaus but expressed an opposing aesthetic of organic shapes and natural materials. When Aalto visited Cranbrook in the late 1930s, his example motivated instructors and students to extend Saarinen's Arts & Crafts traditionalism to an organic humanism that was truly of and for the modern world.

An impressive number of talented designers emerged from Cranbrook's studios. Among them was Jack Lenor Larsen (b. 1927), the leading post-war American textile designer, best known for devising methods for retaining the qualities of hand weaving in work done by machine. His instructor Marianne Strengell (1909–98) received numerous commissions not only for custom interior pieces but also for fabrics and patterns for automotive upholstery. Another Cranbrook student, Florence Schust (b. 1917), joined the staff of Hans Knoll's (1914–55) small New York furniture company in 1943 and soon married her boss. After his death, she directed Knoll Associates until 1959 and remained as a design consultant until 1965. With her Cranbrook background moderated by subsequent architectural study with Gropius and Mies, Knoll established an understated modernism of refined, precisely finished materials as the standard for American corporate interiors in the 1950s and 1960s.

Among the designers who worked with Knoll Associates was Eero Saarinen, Eliel's son, who extended the Cranbrook legacy furthest by transforming its Arts & Crafts organicism into expressive sculptural forms that seemed to spiritualize the jet age. After studying architecture at Yale, he returned to Cranbrook in 1936 and worked with Eliel into the war years, except for a brief stint with Geddes in 1938, drafting the sweeping curvilinear façades of the General Motors building at the New York World's Fair. This experience exposed Eero to the technological expressionism of streamlining, which resurfaced in his architectural work of the late 1950s—the freeform TWA terminal in New York, the soaring Dulles airport outside Washington, and the gleaming stainless-steel Gateway Arch in St. Louis.

Most influential of the post-war designers who emerged from Cranbrook was the team of Charles and Ray Eames. Charles had worked nearly a decade as a residential architect in St. Louis when Eliel Saarinen admired some illustrations of his work, offered him a fellowship to Cranbrook in 1938, and later appointed him instructor of design. Ray Kaiser arrived at Cranbrook to learn weaving in the autumn of 1940 after studying painting for six years with Hans Hofmann (1880–1966) in New York. She was then using amorphous biomorphic forms reminiscent of paintings by Jean Arp (1887–1966) and Joan Miró (1893–1983). Soon after her arrival at Cranbrook, MoMA announced the competition for 'Organic Design in Home Furnishings'. By 'organic', Noyes was referring to objects whose forms revealed 'harmonious organization of the parts within the whole'. But as Eero and

Charles took up the challenge, assisted by a Cranbrook team including Harry Bertoia (1915–78), Don Albinson (b. 1915), and the newcomer Kaiser, they raised their sights beyond mere furniture, seeking—as Eames recalled—to declare a 'statement of purpose'. The outcome was an organicism that united the warmth of natural wood, the forms of biomorphic art, and the function of conforming to human shapes.[7]

Noyes planned 'Organic Design' like an architectural competition, seeking plans and drawings from which a jury including Aalto and Breuer would select winning entries to be fabricated in collaboration with furniture manufacturers. Eames and Saarinen courted disaster by submitting photographs of scale models so well crafted by Albinson that the jury assumed they were viewing full-sized prototypes. After their subsequent victory over hundreds of entrants, the team had eight months to perfect the moulding of plywood into complexly curved, human-form-fitting shells based on plaster moulds. This proved immensely difficult. In the end they could not prevent the outer layer of wooden laminate from splintering at major bends, and fabric had to be glued over the surfaces to disguise the flaws. Even so, the two Cranbrook designers garnered favourable publicity from the exhibition [**85**]. As each went his separate way, both continued to seek a fit between people and their furniture that was more organic than any yet attained by European modernists or American commercial designers. Their approaches differed. Wallance, who was researching a book on the design process, observed in 1950 that Saarinen was 'absorbed by the sculptural aspect' of design and devoted little attention to 'technical and production details'. Eames, on the other hand, 'concentrate[d]

85 Museum of Modern Art, New York

Installation for 'Organic Design in Home Furnishings' exhibition, 1941

Especially when covered in heavily textured upholstery fabric to disguise splintering plywood surfaces, the sprawling, complex one-piece forms of Eames and Saarinen's award-winning chairs announced a transition away from the precise machined surfaces of both American streamlining and European modernism.

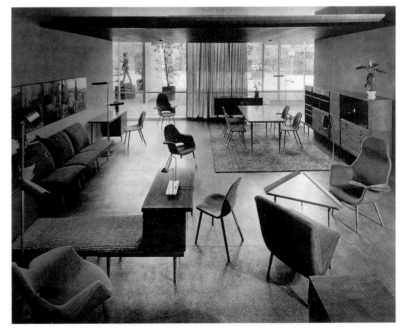

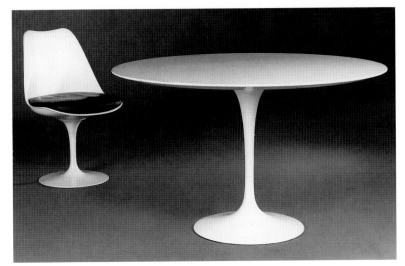

86 Eero Saarinen

Tulip chair and table, Knoll Associates, 1956

An icon of elite design, the Tulip exemplified Saarinen's concern for achieving sculptural form even at the cost of violating the modernist dogma of truth to materials. Beneath the chair's continuous pristine surface lurked a material incongruity. It was actually constructed of two parts—a fibreglass-plastic shell and an aluminium pedestal strong enough to support the shell.

intensively on technical problems' and personally followed 'the entire job from initial studies to fabrication of tools and dies'.[8]

Organic sculptural form took precedence in Saarinen's two major post-war chair designs for Knoll Associates. The first was the so-called Womb chair, designed in 1946 and introduced in 1948. Seeking a material more malleable than plywood, Saarinen opted for a thin shell of fibreglass-reinforced polyester, a new plastic composite. The entire shell, inside and out, was covered with a thin layer of foam rubber and tightly upholstered. Two thin foam cushions in the same fabric formed the seat and offered back support while fitting snugly into the shell. Hovering on stainless-steel struts, the Womb chair visually fulfilled the promise of its name. More uncompromising in appearance was the Tulip chair, also known as the pedestal chair, introduced by Knoll in 1956 [**86**]. With this elegant sculptural object, pristine and white, Saarinen achieved his goal of eliminating the typical 'slum of legs' beneath most chairs.[9]

While Saarinen moved towards formal simplicity, the Eameses favoured visual complexity within a clear rational framework. In contrast to Saarinen, who pursued an aesthetic of integration, they operated through addition and juxtaposition. Driven by Charles's enthusiasm for rational technique and Ray's appreciation for the sensuality of materials and patterns, the Eameses' work transformed the pure modernist grid with a visual playfulness reflecting an ongoing cultural shift from the mechanical to the organic. By the end of the war, they had established a workshop in a former auto repair shop in Venice, California. Although they pursued income-producing projects such as fabricating thin wrap-around plywood radio cases for several manufacturers, their attention, and that of a team including Albinson, Bertoia, and the graphic artist Herbert Matter (1907–84), remained focused on plywood furniture.

After much experiment they recognized the conceptual error that had plagued the Cranbrook project. Even a side chair was too complex a form to be pressed in compound curves from a single sheet of plywood. Bertoia claimed the insight came to him as he walked along the beach. Picking up a mussel shell with its halves hinged together, he realized that seat and back had to be two different pieces. By the end of 1945 the Eameses were manufacturing a dining chair and a lounge chair of similar construction, each consisting of separate concave pieces for the back and seat, curved for comfort and seeming to float free in a support assemblage of bent plywood. The chairs possessed a low, sprawling solidity but paradoxically evoked lightness, comfort, and informality. In 1946 the Eameses devised a variant with thin steel rods for legs—an arrangement that afforded a more industrial, less craft-based appearance. At the same time, they were developing a series of moulded plywood tables and low cabinets set on bench-like platforms. Like Nelson, whose Storagewall articles had recently appeared, the Eameses sought to rationalize post-war life, to render it easy and transparent, but also lively and playful.

Herman Miller and modern design

A show at MoMA in March 1946 gave the Eameses the break that made their careers. 'New Furniture Designed by Charles Eames' cavalierly but typically overlooked Ray's contribution to an array of chairs, tables, and modular cabinetry presented in casual room arrangements [87]. Ignoring aesthetics, the museum praised 'standardization' and

87 Charles and Ray Eames

Installation for 'New Furniture Designed by Charles Eames' exhibition, Museum of Modern Art, 1946

Displayed in room arrangements emphasizing both a contemporary post-war informality and a modernist insistence on a place for everything, the Eameses' furniture announced a domestic aesthetic of warmth and simplicity. Bertoia claimed the inspiration for abandoning single-shell plywood chairs and moving to separate seat and back.

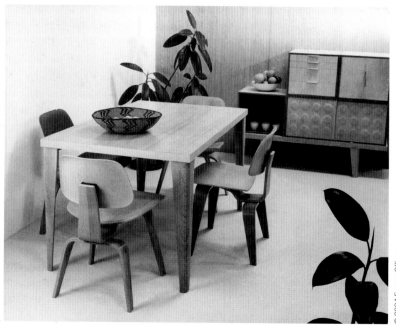

© 2004 Eames Office

'interchangeability', illustrated manufacturing processes, and displayed a chair bouncing around in a large revolving barrel to prove 'durability and strength'.[10] Nelson, who had recently become design director at the Herman Miller Furniture Company, viewed the exhibition with mixed feelings. Although his personal agenda included plywood chairs, he realized Eames was way ahead of him, and he persuaded the company president D. J. De Pree (1891–1990) to hire Eames as a consultant designer.

Herman Miller was as significant as MoMA in establishing a post-war tradition of elite modern design. Established in 1905 in Zeeland, Michigan, the company initially specialized in cheap, vaguely traditional dressers for Sears, Roebuck. After being purchased in 1923 by three investors including De Pree and his father-in-law Herman Miller (1867–1948), the company changed its name and shifted to relatively accurate period reproductions. Sales slumped so much during the Depression that De Pree responded favourably in 1930 when Gilbert Rohde walked in unannounced, preaching the gospel of 'moderne' styling. The company survived the decade on Rohde's work, balanced occasionally by tasteful traditional furniture such as a simple Shaker-inspired line designed by Freda Diamond (1905–98) in 1938. After Rohde's sudden death in 1944, De Pree searched long and hard for a new design director, finally saw an article about Storagewall, sought out and hired Nelson, and soon acquired the Eameses on an ongoing contract basis.

Nelson actually displayed considerable practical savvy in defining Herman Miller's post-war course. Before actually going to work, he educated himself by profiling the furniture industry for *Fortune*. According to a fellow journalist, his review in January 1947 was a 'painfully precise analysis' that 'cut the industry into shreds'. Nelson reported that furniture remained 'a craft product built around one material—wood—using techniques that originated centuries ago'. The industry was trapped in a system of trade shows that required something new and different every six months. Because the various functions of furniture actually changed little over the years, manufacturers were dependent on styling gimmicks to suggest novelty. Wandering the 2-million square feet (186,000 square metres) of the American Furniture Mart in Chicago, Nelson encountered 'the same imitative period pieces repeated without end, radios artfully hidden in sewing tables, bars tucked away in hassocks, and beds that try to look as if George Washington had slept in them'—with a few so-called 'modern' pieces 'suggesting a point of origin near a jukebox factory'. Although the magazine illustrated some exceptions to this 'colorless mediocrity', Nelson concluded that most companies gave the public 'what it wants' by supplying 'borax' (furniture 'of the lowest possible taste and quality').[11]

However, Nelson believed there was room for high production values and discerning taste. In declaring furniture the nation's second largest consumer durable goods industry, he invited comparison with the auto industry. Because a few automakers shared all that business, each company did have to design for mass appeal. But furniture sales were divided among thousands of companies. In an article two years later on 'Business and the Industrial Designer', Nelson advised small-scale producers to stop trying to design for 'all of the 147 million people in the U.S.'. A company with a capacity of only 100,000 units in a market of 10 million ought 'to bring out a design that not more than 500,000 people could possibly like, rather than scramble for a piece of the big market on the same basis as everyone else'. For Herman Miller to produce tasteful modern furniture for a discerning niche market made smart business sense.[12]

Over the next decade a stream of iconic furniture designs moved through Herman Miller's showrooms. The Eameses continued to tinker with the one-piece form-fitting shell even after the company began distributing and eventually manufacturing their multi-part plywood chairs. They experimented with stamped sheet metal but abandoned it in 1948 for the sensuous possibilities of fibreglass-reinforced polyester, as manifested in a prototype known as 'La Chaise' because its shape echoed Gaston Lachaise's (1882–1935) voluptuous nude sculptures. This approach led in 1950 to a simple plastic shell armchair and side chair. They came with a variety of bases (wooden legs, straight steel rods, wire strutwork, or wooden rockers) and finishes (fabric cover, upholstered pad, or the revealed surface of swirled fibreglass embedded in polyester resin). The so-called Eames Storage Unit also went on the market in 1950—a modular system of thin, industrial-looking chrome-steel framing filled in with shelves, drawers, and panels of brightly coloured Masonite and plastic-laminated plywood. Then in 1956 came the reclining Lounge Chair and Ottoman [88], which marked a luxurious return to plywood, with the chair's articulated rosewood shells enclosing leather-upholstered foam cushions—soon a favourite of corporate executives. Two years later Herman Miller introduced the Aluminum Group, high-backed aluminium-framed sling chairs for indoor–outdoor use. Furniture design at the Eames office was indebted to Albinson, who claimed that Charles 'came to me with . . . his furniture ideas' and 'expected me to work out all the problems, and design them, and get them built into production'.[13] Even so, one can see Charles's influence in the emphasis on rational fabrication and Ray's influence in the rich abundance of bases and finishes. The Eameses offered Herman Miller customers a kit of bright, colourful parts from which to construct playful backdrops for uncluttered post-war lives [89].

Additional Herman Miller furniture designs flowed from Nelson's

**88 Charles and Ray Eames
with Don Albinson**

Rosewood lounge chair and
ottoman, Herman Miller,
1956

Combining visual directness
with material splendour, the
Eameses created the perfect
chair for a business executive
hoping to convey exquisite
taste and social privilege. The
chair's apparent simplicity was
belied by the complexity of its
multiple-layered foam
cushions, covered in leather,
and of their mounting within
thin plywood shells.

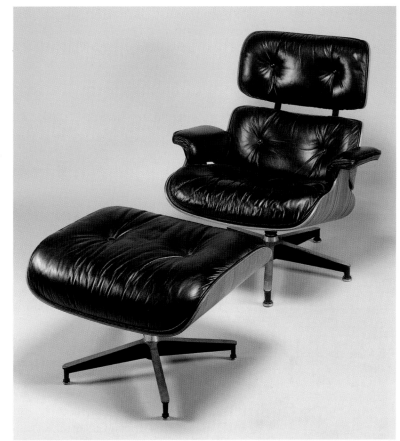

89 Anonymous

Interior, T. G. Owen & Son,
Mississippi, c.1952

Not all purchasers or
merchandisers of Herman
Miller furniture displayed it as
the firm's showrooms
suggested. This florist and gift
shop in Mississippi offered
Eames chairs in plywood and
fibreglass and Isamu
Noguchi's signature coffee
table, all from Herman Miller,
along with nondescript blonde
tables and cabinets, shapeless
upholstered pieces with
stumpy wooden legs, and
distinctly middlebrow lamps
and ashtrays—all set off by an
Arts & Crafts ceiling.

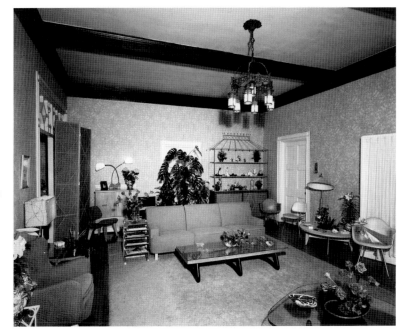

90 Irving Harper for George Nelson

Ball clock, Howard Miller Clock Co., 1950

The advent of the nuclear age inspired designers of everything from logotypes to this clock, which evoked atomic models with small wooden balls on steel rods replacing traditional numerals. Harper's design also echoed the Tinkertoy construction set popular with children in the 1950s. Such witty objects indicated a tendency to move away from the agendas of both machine functionalism and organic domesticity.

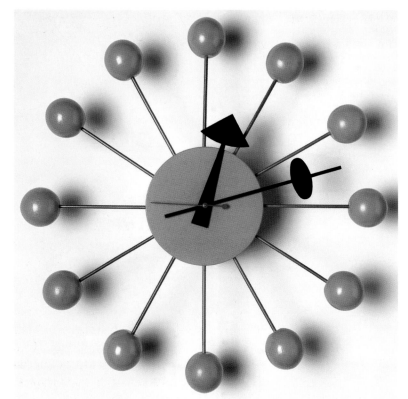

New York office with considerable contributions from Irving Harper (b. 1916) and Ernest Farmer. Nelson and his associates also created accessories for the Howard Miller Clock Company (connected to Herman Miller). Most widely known of the many wall clocks whose designs employed conventions of contemporary graphic illustration was the playfully abstract Ball clock [**90**], designed by Harper in 1947 and first offered in 1950. Nearly as successful were the Bubble lamps constructed from a translucent, self-webbing plastic sprayed onto wire ribbing in various shapes. Hanging from their power cords, they floated like Japanese lanterns. Nelson continued to perfect the Storagewall idea, introducing the Comprehensive Storage System in 1957, which suspended shelves and cabinets from floor-to-ceiling tubes of extruded aluminium. His firm also provided Herman Miller with several visual gags masquerading as seating. The Coconut chair of 1955 toyed with the Eameses' plastic shell by presenting a generous concave uphol-stered wedge, shaped like a triangular section from a coconut shell, which rested on three splayed wire legs. Even more playful was the Marshmallow sofa of 1956 [**91**], with 18 upholstered discs resting on a nearly invisible metal frame.

Other designs from the late 1940s and 1950s assumed iconic status among those who sold, bought, or wrote about elite post-war furnish-ings. There was the often-imitated free-form glass-topped coffee table

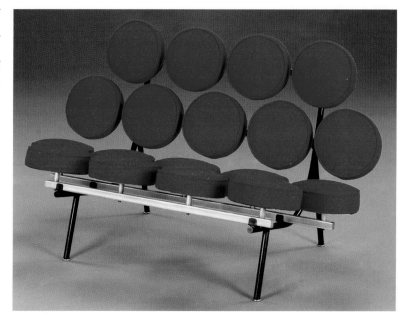

91 Irving Harper for George Nelson

Marshmallow sofa, Herman Miller, 1956

With this sofa the Nelson office reached the limit of its flirtation with pop playfulness. As reproduced in photographs, the Marshmallow seems big and brassy. In fact it is low, narrow, and distinctly uncomfortable.

by the sculptor Isamu Noguchi (1904–88), which appeared in Nelson's first Herman Miller collection, and the Diamond chair, a sculptural wire shell designed by Bertoia for Knoll Associates after he left the Eameses in protest at not being credited for his work. Edgar Bartolucci and Jack Waldheim (1915–2002) received acclaim for the Barwa chair of 1947, a minimal frame of tubular aluminium covered in canvas, with parallel rockers precisely bent so that a slight movement would shift its balance from a sitting to a reclining position. Most widespread, reaching all economic classes through inexpensive knock-offs, was the sling or butterfly chair [**92**], designed by Jorge Ferrari-Hardoy (1914–76) in the late 1930s and sold in its patented version by Knoll.

92 Jorge Ferrari-Hardoy

Sling or butterfly chair, 1938

Easily assembled by slinging a piece of leather or canvas between two sets of sharply bent continuous steel rods, the butterfly chair epitomized material simplicity, functional efficiency, and physical mobility. Its popularity among all classes suggested the possibility of truly democratic design. And its expressive visual forms, complex though immediately perceived, evoked effortless forward motion and flight.

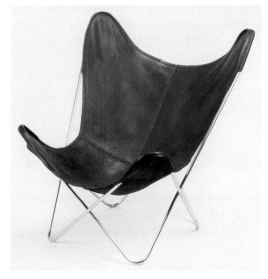

The visual qualities of the butterfly chair resonate with textile designer Larsen's memories of 'the velocity with which design exploded out of the dim war years'. He and his friends and associates entered the post-war era brimming with 'the optimism of a world to be made over' in 'simple and clear' terms of 'logic, coherence, beauty, and meaning'. The butterfly chair responded to their call for 'clean, spare, logical solutions supported by common sense'. The sling chair was also championed by Edgar Kaufmann Jr. (1910–89) of MoMA, who featured it with seven modern chairs in a short primer entitled *What Is Modern Design?* (1950). Distinguished by its presence among pieces by Mies, Breuer, Saarinen, and Eames, the simple sling embodied an understated aesthetic appropriate to an anonymous engineering vernacular. However, it also appeared as the best designed of a self-consciously over-designed lot. Although Larsen affectionately referred to MoMA as the 'mother church' of modern design, that phrase suggested an institution that was setting and enforcing standards to control design's explosive velocity. That is precisely what Kaufmann and MoMA were all about.[14]

'Good Design' at the Museum of Modern Art

When Kaufmann joined MoMA in 1946, he had already experienced both art and commerce, studying design in Vienna, painting in Florence, and architecture with Frank Lloyd Wright. He had also worked in home furnishings in the family department store, Kaufmann's in Pittsburgh, a leader in 'moderne' styling during the 1930s. Late in that decade Kaufmann met John McAndrew (1904–78), MoMA's new curator of architecture, when the latter visited Fallingwater, the holiday house Wright had just completed for the Kaufmanns in western Pennsylvania. Kaufmann assisted in selecting items for McAndrew's first design show, 'Useful Objects under Five Dollars', in 1938 and arranged for a travelling installation in the family store. The commercial spirit of this series of exhibitions, which ran most years until 1948, appeared in a press release for 1939. The display of well-designed useful objects at prices within reach of the average person was presented 'not only for the enjoyment of the public but for the guidance of shoppers' now that 'the Christmas season is upon us'[15] Most objects displayed were truly modest. Those from 1938 included plastic measuring spoons, a plastic brush and comb set, a pocket knife, drinking glasses from Woolworth, a travel iron, a rubber-coated wire dish drainer, and a wooden cigarette box from the Southern Highland Craft Guild. Although most objects were anonymously designed, some were credited to commercial designers; in 1941 a plastic Montgomery Ward flashlight, a Scotch tape dispenser, and a Super juicer were all noted as designed by Barnes & Reinecke. By the time the series ended (with its

price limit raised to $100), Kaufmann had joined MoMA full time and was preparing for a much more ambitious 'Good Design' show, the first in a series devoted to the union of art and industry.

The first 'Good Design' exhibition of 1950 set a pattern. Hoping to involve conservative furniture manufacturers, Kaufmann staged the first phase of a year-long competition on the industry's own turf, within the vast Merchandise Mart in Chicago. A jury composed of Kaufmann, the textile designer Alexander Girard (1907–93), and the curator of decorative arts at the Art Institute of Chicago, examined new furniture and housewares at the Mart's regular winter show in January. Their selection of objects of 'excellent appearance' and 'progressive performance' appeared in a space set aside within the Mart for 'Good Design', with an installation by the Eameses.[16] The summer furniture show in June required a repetition of this process, with Kaufmann joined this time by the director of the Institute of Design, Serge Chermayeff (1900–96), and by a manufacturer from Philadelphia. These juried displays remained in place in the Merchandise Mart throughout the year, serving as certified examples of 'Good Design' to manufacturers, designers, and wholesale buyers. The public phase of the project began in November 1950 when a 'Good Design' exhibition opened at MoMA for two months. Comprising the best from the two Chicago displays, this exhibition in New York also featured an installation by the Eameses. The show's timing enabled MoMA again to offer a Christmas shopping guide to the most tasteful chairs, tables, cooking utensils, serving dishes, dinnerware, glassware, flatware, bowls, baskets, carpets, and fabrics.

Although Kaufmann engaged different installation designers in subsequent years, and the final show in 1954 brought together the best objects from preceding years, 'Good Design' otherwise functioned in a similar manner each year. It marked a departure from recent MoMA design competitions. Rather than soliciting new work from designers, as in 'Organic Design', Kaufmann was limited by contract with the Merchandise Mart to selecting from among furnishings already commercially available. The programme marked an even sharper break with the design standard established at MoMA by Johnson's 'Machine Art' exhibition of 1934, with its machine forms abstracted from reality and arranged to suggest timeless perfection. The general mood of 'Good Design' was necessarily domestic [**93**]. More to the point, all the objects were new to the market. However timeless good design might be in theory, in practice it involved perpetual novelty. Even MoMA was forced to compromise when attempting a union of art and commerce, though the goal was to encourage manufacturers and wholesale buyers to strive for higher levels of taste in consumer goods. Kaufmann assumed that improvement would in turn eventually reach ordinary Americans. But the museum's assumption of superiority was

93 Museum of Modern Art, New York

Installation for 'Good Design', 1952

Not identified in MoMA's files as being an installation from Chicago or New York, this view indicates the importance of having sufficient space to appreciate the objects aesthetically as objects rather than as the equipment of everyday life.

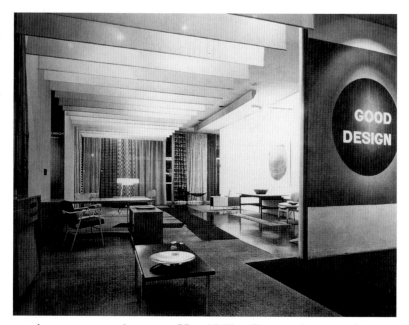

not lost on some observers. Harold Van Doren, for example, who attended the New York opening in 1950, was irritated by the 'air of Lady Bountiful going democratic'. In his opinion the 'pitifully inadequate selection' of 'pretty ash trays' and '$60 salad bowls' revealed MoMA as 'incapable of coming to grips with the realities of design in everyday life'.[17]

After Kaufmann left in 1955, the museum renounced reform—a sign of recognition that it had lost its bid to shape the taste of the nation—in favour of a permanent collection exhibiting timeless aesthetic quality. In 1959 the curator Arthur Drexler (1925–87) admitted to collecting 'no television sets, no refrigerators, no telephones, and only a relatively few mechanical appliances' because their appearance depended on 'commercial factors irrelevant, or even harmful, to aesthetic quality'. Instead, MoMA put its imprimatur on a collection ranging from Tiffany and the Bauhaus to Herman Miller. Although the selection favoured eccentric American inventor-designers, whether Tupper and his plastic refrigerator dishes or Peter Schlumbohm (1896–1962) and his laboratory-inspired Chemex coffee pot [**94**], it also encompassed such contemporary European designers as Arne Jacobsen (1902–71), Marcello Nizzoli (1887–1969), Dieter Rams (b. 1932), and Tapio Wirkkala (1915–85). Drexler expected MoMA's design collection to stand for 'a thousand years' as a 'record' of 'the most beautiful artifacts of our time'. Years later, however, it became apparent that objects of the sort MoMA celebrated mostly appealed to the taste and aspirations of a particular elite at a particular time. In 1983 the sociologist Herbert J. Gans (b. 1927) described a major retrospective design show organized along MoMA lines at the Philadelphia Museum of

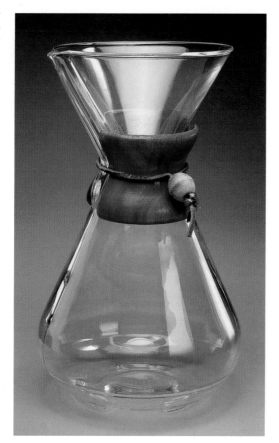

94 Peter Schlumbohm

Chemex coffee pot, 1942
Despite the simple elegance
of the Chemex, its inventor
was not a typical MoMA
designer. Schlumbohm,
holder of a doctorate in
chemistry, was a bit of a crank
who patented several
household devices
extrapolated from laboratory
apparatus or technique. In
1949 he marketed a cigarette
holder employing filter paper
inserted into a brass cone and
funnel to eliminate tar and
nicotine without limiting
flavour.

Art as a rewarding 'treasure trove of progressive upper-middle culture'.
The critic Joseph Masheck (b. 1942) said much the same thing when he
defined the Eames lounge chair as 'the kind of chair in which a liberal
Republican or a Democrat of the professional class sits and waves
"Hiya, fella" to a man in a Barcalounger'.[18]

Populuxe

Until recently design historians tended to conceive of their subject in
elitist terms and accepted the historical narrative implied by MoMA's
permanent collection. In 1985, for example, Esther McCoy defined the
years 1945 to 1960 as 'the rationalist period' and declared that 'the most
enduring of the objects are those which sprang from the intellect rather
than the sensibilities'. She would have endorsed an opinion from 1952
'that Eames, who never doctored the curve of a toaster . . . is one of our
most genuinely *industrial* designers'.[19] Even then, however, most
designers did indulge in doctoring curves as a means of appealing to
consumers' desire for sensuous delight and personal self-expression.
While most middle-class Americans had never heard of Eames, they
were familiar with Russel Wright, whose signature was stamped on the

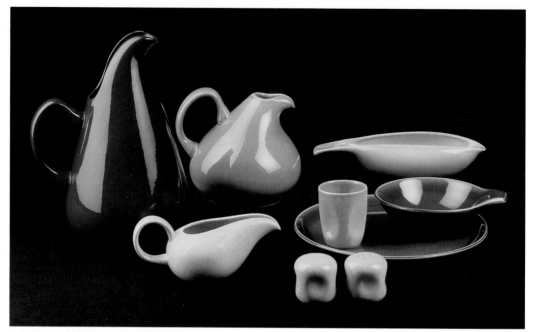

95 Russel Wright

American Modern
dinnerware, Steubenville
Pottery, 1939

Lacking experience with
ceramics, Wright modelled
prototypes by hand without
considering ease of
production—a factor in his
long search for a pottery that
would reproduce such
unorthodox shapes. Although
Frederick Rhead, designer of
Fiesta dinnerware, dismissed
American Modern by
comparing its sugar bowl to an
'infant toilet', the pottery had
sold 80 million pieces when
production ceased in 1959.

bottom of each piece of his phenomenally successful American Modern dinnerware [**95**].

Wright developed American Modern in the late 1930s as a set of dishes both appropriate to the new informality of servantless entertaining and inexpensive enough for everyday use. Seeking to domesticate modernism for popular consumption, he borrowed the dinnerware's soft, wide curves from Arp and Salvador Dalí (1904–89), and its earthy colours and irregular glazes from handmade pottery. Sales of American Modern skyrocketed in the late 1940s as a starter kit became a popular wedding gift for middle-class couples. Other designers were also moving from rational functionalism to free-form expressionism. The potter Eva Zeisel (b. 1906) recalled that 'all sorts of things suddenly began to melt, to become soft'. Trained in Budapest, she had arrived in New York in 1938. Liberated by the critical and commercial success of American Modern, Zeisel created a radically different set of dinnerware for the Red Wing Pottery, introduced as Town and Country in 1947 [**96**]. She described its 'variety of different shapes' as 'relate[d] to each other like the members of an extended family'. Soft, round, biomorphic forms in an assortment of brightly coloured glazes displayed wide flaring spouts and handles. Zeisel's success with Town and Country and the greater success of American Modern indicated a fundamental shift in design preferences—one that led even Wright to complain years later that his 'religion' of 'contemporary' design had been 'defeated' by the onslaught of 'postwar affluence' around 1953.[20]

As the historian Shelley Nickles has demonstrated, recently empowered consumers avidly believed that 'more is better'.[21] Whether

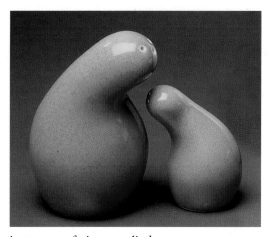

96 Eva Zeisel

Town and Country
dinnerware, Red Wing
Pottery, 1947

Unusual among the pieces
were the salt and pepper
shakers with their amusing fat-
bottomed humanoid shapes,
perfect for grasping and
uncannily similar to the
creature known as the Shmoo,
which debuted in Al Capp's
comic strip *Li'l Abner* in 1948
and became a popular
sensation. Placed together, the
larger looked as if it were
bending down to comfort the
smaller.

97 Anonymous

Kelvinator Foodarama
refrigerator, Nash-Kelvinator
Corp., 1955

This top-of-the-line model
offered side-by-side
refrigerator and freezer
compartments. Both the
Foodarama and the nearby
stove, probably also
manufactured by Nash-
Kelvinator, reflect the influence
of automotive styling.

in terms of size, applied ornament, or eye-catching colours, their desires could not be ignored. Refrigerators, for example, which had always been white in colour, were offered in pink or turquoise [**97**], and were designed as an ensemble with the same company's matching stove and washing machine. More efficient insulation yielded a thinner-walled refrigerator door, which left space for storing food inside the door. The exterior metal shell of the door was often stamped (for rigidity) with flared decorative motifs echoing the tailfins emerging from Detroit's assembly lines. New features ranging from revolving trays and automatic icemakers allowed appliance manufacturers to promote their refrigerators as 'femineered' for the busy housewife. New plastics

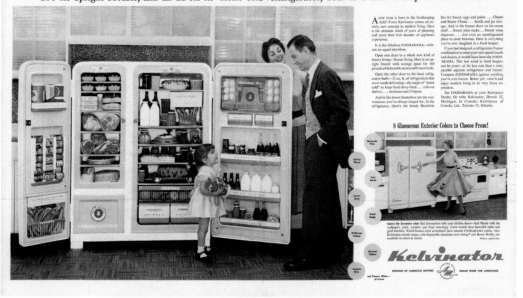

like polystyrene permitted coordination of colourful but inexpensive decorative schemes on drawers and compartment doors. Stoves offered even greater potential for decorative extravagance, with the backsplash often boasting a complicated 'Buck Rogers instrument panel' of plastic framed in an excess of chrome.[22] Owing to a new process for stamping sheet metal, most kitchen appliances gradually took on a trim rectilinear appearance, referred to as 'sheer' in an advertising campaign for Frigidaire in 1957. The bulging streamlined refrigerators and washers of the late 1940s appeared obsolete, no matter how well they continued to run.

Although it was harder to sell to middle-class consumers in the 1950s after pent-up post-war desires were satisfied, continuing economic improvement allowed most people to make discretionary purchases they did not really need. Rising sales of leisure goods and other democratic luxuries—ranging from patio furniture and sporting equipment to television consoles and 'high-fidelity' audiophile components—suggested that Americans wanted to be entertained as they shopped. More seriously, they wanted to invest themselves in their purchases. They desired products that allowed them to express individual identity during a time of promising but confusing social mobility. They took it for granted, as a nation whose science and engineering had won the war, that products worked. A desirable product had to possess a symbolic component communicating something of value above and beyond utility. As a staff writer for the professional journal *Industrial Design* explained, a new 'product romanticism' privileged 'the enticement of the eye'. The earlier emphasis on 'structure and simplicity' had 'run out of steam' because it did not 'satisfy two very genuine parts of human nature': a delight in that which is 'opulent, barbarous, romantic', and a desire to take comfort in that which is 'humble, self-evident, nostalgic, plain'.[23]

These comments went a good way towards reconciling the mix of past- and present-inspired styles found in so many middle-class households. There was nothing incongruous in a 'Scandinavian contemporary' living room furnished with light, wood-framed, slab-cushioned sofa and chairs, kidney-shaped coffee table, free-form ceramic ashtray, pole lamp with cone shades at various angles, and South Seas 'Tiki' masks on the wall, juxtaposed with an 'early American' dining room furnished with maple table, turned-spindle captain's chairs, hurricane-lamp chandelier, and a rustic cupboard in the corner with machine-carved plate rails. Together these granted symbolic expression to differing aspects of personal identity, often divided between a desire to embrace the present and a nostalgic regret for tradition passing too quickly.

Product romanticism also partially explained the proliferation of kitchen appliances, not only refrigerators, washers, dryers, and dish-

washers, but smaller specialized machines such as juicers, toasters, mixers, blenders, can openers, and ice crushers. All looked vaguely like small automotive parts, trim items, bumper protrusions, instrument panels, or hood ornaments. All visually reflected the flashy technology embodied in the long, low dream machine parked out in the garage. They foreshadowed a future of push-button ease in which all techno-logical processes, even those of the household, would occur magically with no human effort or intervention. All the more essential, then, was a symbolic identification with the automobile, the era's supreme per-sonal expression of the romantic promise of contemporary technology.

Even so, there was something profoundly domestic about popular automotive design of the 1950s. With a few exceptions such as the General Motors Corvette and Ford's Thunderbird, the post-war American automobile was intended as a family car. Automotive design was as much about interiors as exteriors. Even modestly priced cars offered luxurious comfort. Loose suspension minimized the feel of the road as driver and passengers settled back into large, deep, sofa-like seats—with a feeling of comfort reinforced by ribbed and quilted upholstery, padded dashboards and side panels, large armrests in the back seat, and thick carpeting on the floor. Power steering, power brakes, automatic transmission, and air conditioning reinforced a sense of cruising down the road in a self-contained bubble. Despite the influence of automotive styling on appliances around 1950, the influence came full circle a few years later as auto instrument panels took on a degree of richly excessive ornamentation, with rear-lit plastic inserts and mouldings that were already typical of kitchen appliance controls. And popular pastel colours may have migrated from kitchen to car and not the other way around. Even Loewy complained at a meeting of the Society of Automotive Engineers in 1955 that 'one of America's most remarkable machines' was being 'camouflage[d] . . . as a piece of gaudy merchandise'. He abhorred its 'sensual and organic' guise and hoped to see it restored to its rightful place as a 'cleancut expression of mechanical excellence'.[24]

Much of the animosity directed at popular design by high-culture critics derived from a gendered perspective similar to that implied by Loewy's outburst. While his adjective 'cleancut' implied a trim, lean, effective masculinity, his use of 'sensual' might have referred to the past several years' Cadillac models, each of which bore two bullet-shaped protrusions on the front bumper, larger each year, sometimes referred to as 'Dagmars' in reference to the physique of a popular television actress. Or it might have referred generally to the excess of chrome, the tailfins, the two-tone colour schemes, the synthetic plush interiors —all of it more a matter of fashion (the domain of women) than of the engineering background Loewy— despite the clear motive of styling running through his career—liked to summon up. More direct than

Cadillac Eldorado
automobile, General Motors
Corp., 1958

Introduced late in 1957, this model is generally considered the most garish. Its styling represented a minor reworking of the previous year's model with more flare to the tailfins and additional chrome, including five horizontal 'windsplits' in front of the rear wheel opening. This advertising illustration establishes an explicit connection to the full skirts of women's fashions.

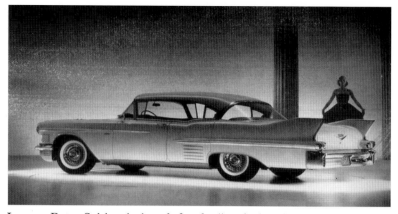

Loewy, Peter Schlumbohm defined a 'borderline between the virility of invention and the femininity of fashion' as central to product design. The design historian Lesley Jackson maintains that Christian Dior's (1905–57) sensational 'New Look' of 1947, with its wasp waist, sculpturally exaggerated bust and hips, and full, voluminous skirt, extended a spirit of 'wastefulness and indulgence' from fashion to product design in general. Jackson's expansive interpretation of women's fashion brings new meaning to flaring tailfins, sculpturally divided two-tone panels, plush interiors, and Cadillac's absurd Dagmars [**98**]. Despite this obvious feminization, design historian Sparke advises against considering female consumers as passive victims of designers and their corporate employers. Instead she maintains that feminized products 'bore witness to the expanding power of the female consumer'. Here one might consider Tupperware, a simple but cleverly functional product. While its inventor Earl Tupper exemplified the rational ideal invoked by Schlumbohm, his efforts at selling the stuff went nowhere despite its presence in MoMA's permanent design collection. Eventually a savvy saleswoman, Brownie Wise (1913–92), ignored Tupperware's boring status as a 'tasteful, restrained' industrial product and instead succeeded wildly by emphasizing its 'fashionability and sensuality'.[25]

More important than any single type of consumer product or decorative motif was the sheer multiplication of objects. As a vast assemblage, they signified democratic abundance itself, prefigured in that promiscuous variety of objects stacked around the plain modernist monolith of Nelson's Storagewall. At the end of the decade, a cover story in *Time* referred to a 'flood of new products' transforming 'the American way of life'—a 'rich harvest . . . incredible only a few years ago'. The historian Thomas Hine has described a 'baroque' explosion of products 'available in a lurid rainbow of colors and a steadily changing array of styles' as 'commonplace objects took extraordinary form'. Writing in 1986, Hine coined the word 'populuxe' to characterize American popular design of the 1950s and the lifestyle it expressed. He described it as 'a synthetic word', thereby referring to the malleable

synthetic plastics from which so many inexpensive commercial products were moulded in novel forms and equally synthetic colours. Hine intended 'populuxe' to convey a paradoxical conflation of 'populism and popularity' with 'luxury, popular luxury, luxury for all'. The concept went beyond a straightforward materialism of 'merely having things'. Instead it referred to 'having things in a way that they'd never been had before', invoking 'outright, thorough vulgar joy in being able to live so well'.[26]

On the other hand, this was an era known for social conformity in the face of long-term cold war tensions. If one accepts the historian Alan Nadel's persuasive arguments for a seriously repressive 'containment culture' enveloping most middle-class Americans in the 1950s, then it becomes harder to accept the concept of the populuxe era as an expansive time when ordinary 'good-living', 'pleasure-loving' Americans indulged in a 'remarkable free spirit', took 'unshackled pleasure in the appearance of things', and enjoyed material affluence, flashy cars, gimmicky appliances, and playfully quirky furniture.[27] These phrases from *Industrial Design*'s annual design review for 1955 might seem like empty hyperbole. But there may be another explanation. Against a dominant social attitude of repressive conformity, populuxe catered to desires for release by offering at least the symbols of an explosive break-out culture.

The sensuous, unconstrained forms of that culture were starting to appear as early as 1945, when a reporter for *Interiors* commented on the function of the 'woggle', defined as 'any one of those strange amorphous shapes' (later typically referred to as amoeboid) which were defining the outlines of 'table tops, display shadow boxes, carpets and linoleum inlays'. As absurd as the woggle might appear to a rational viewer, its 'praiseworthy object was to break the cold monotony of too geometric an interior'. By the mid-1950s, when the rational design culture of the Eameses and Saarinen, of Herman Miller and Knoll Associates, was coasting on prior achievements, the break-out sensuality of populuxe culture was reaching full force. Deborah Allen reported in *Industrial Design* that the new model cars of 1957 were 'as expensive, fuel-hungry, space-consuming, inconvenient, liable to damage, and subject to speedy obsolescence as they have ever been'. Even so, she praised their designers for being 'deeply and boldly concerned with form as a means of expression'. In her annual review of two years earlier, Allen had described the typical automotive form as 'exploding'. 'The modern car', she wrote, 'is designed to look as though it were exploding into space'. Its 'visual center of gravity' had shifted forward to the engine, meaning 'that everything behind the front . . . must appear to trail off into space'. Unlike the cars of the 1930s and 1940s, which offered a 'fairly literal translation of aerodynamics', the new models did not even 'try to withstand the effects of speed'. Instead, she

99 Anonymous

Sylvania Dualette television,
Sylvania Electric Products,
Inc., c.1959

The model's appearance of
upmarket bohemian cool and
the pristine white table and
coffee pot established a
tension with the automotive
styling of this portable
television set in two-tone
polystyrene plastic.
Accompanying an
advertisement in the trade
journal *Modern Plastics*, this
illustration omitted an
intrusively oversized channel
selector located in the lower
left corner of the actual set.

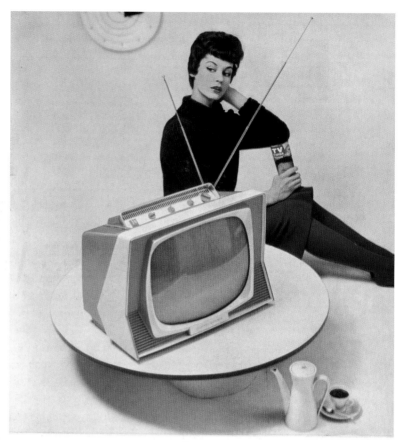

Doubly Desirable... *Catalin* **STYRENE**
HEAT RESISTANT – HIGH IMPACT

The new luxury Dualette TV set by Sylvania* is designed to serve
a double purpose ... as a lightweight dual-speaker portable ... and
as a chic table model, handsome on all sides, even the back. There-
fore the plastic for the cabinet, molded in two sections, had to
meet twin requirements ... feather-light toughness for portability
... lustrous beauty of hue and of surface, in three charming color
combinations to blend with room decor when seen from any direc-
tion. Sylvania's choice of molding compound for the cabinet was
an obvious one ... heat resistant, high impact CATALIN STYRENE.

The desirability of CATALIN STYRENE—*the gem of plastics*—
is dual in another sense, too, for its value to molders and manu-
facturers is twofold: first, Catalin offers the widest range of formu-
lations, with the very highest standards of quality ... and, secondly,
Catalin — through its strategically located facilities in the East,
Midwest and South, linked in a sales-office-to-warehouse teletype
network — routes orders to molders with on-the-dot scheduling.
This double assurance of basic-material satisfaction is yours when
you specify Catalin Styrene, Polyethylene and Nylon molding
compounds. Inquiries invited.

*Dualette is custom molded for Sylvania Home Electronics, a division of Sylvania Electric Products, Inc., Batavia,
N. Y., by Buffalo Molded Plastics, Inc. of New York and Buffalo Molded Plastics, Inc. of Pennsylvania.*

Catalin Corporation of America **One Park Avenue, New York 16, N. Y.**

observed almost gleefully, 'they disintegrate, and the cant [of the roof-
line] is a definitive expression of disintegration'.[28]

The most expressive populuxe designs—not only automobiles but
also multicoloured plastic radios and televisions [**99**], chrome-banded
dinette tables with marbleized Formica tops and matching vinyl-
covered tube-steel chairs, kitchen appliances with jet-age bright work
and controls, two-tone vacuum cleaners, and coffee shops and gas
stations with soaring cantilevered roofs [**100**]—suggested that an
exploding material environment could not be contained. Nor could
ordinary Americans who revelled in material goods as a birthright and
used them to escape social or political situations over which they had
no control. As designer Müller-Munk observed in 1951, behind 'the

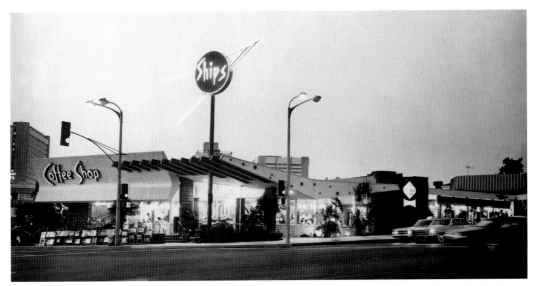

100 Martin Stern Jr.
Ship's Westwood Coffee
Shop, Los Angeles, 1958
(demolished in 1984)
Located on Wilshire
Boulevard, Ship's Westwood
was the most expressive of
the so-called 'googies'
constructed to accompany
LA's automotive lifestyle. The
rocketing sign suggested a
culture nearing the take-off
point. Stern (1917–2001)
became a leading architect of
Las Vegas casinos in the
1960s and 1970s.

assertive glitter and smooth shapes of our appliances there is the buoy-ancy and optimism of a whole people who refuse to accept any condition or product as static'. As it turned out, however, the sophisti-cation of the design process that brought populuxe into being tended to flatten differences. Nelson had forecast this effect in 1946. Worrying about potential blandness, he used the analogy of the canned meat product Spam, 'originally made of good beef, with herbs, onions, garlic, and so on'. But in response to multiple complaints objecting to this or that individual ingredient, anything with flavour was removed and the result was 'mush'. Commercial product design moved slowly but surely from an initial exuberance, sometimes gaudy or vulgar, towards a deadening sameness, safe but not exciting and certainly not liberating.[29]

Industrial design as a post-war profession

As consumption of flashy new products increased exponentially, designers receded into anonymity. Although the industrial design pro-fession expanded greatly from 1945 to 1965, its members enjoyed little of the sort of publicity that made Geddes and Loewy household names in the 1930s. To some extent designers were victims of success. Stream-lined designs of the Depression were often little more than projective visions—and their creators newsworthy because they promised some-thing just out of reach in a fast-approaching 'world of tomorrow'. When that future actually arrived, those who had given shape to it had become 'organization men' working as consultants or in-house design-ers for large firms which took credit for whatever they had created. Those industrial designers who did retain public reputations were the exception. Loewy landed on the cover of *Time* in 1949, his debonair

face surrounded by a montage of vehicles, appliances, and other products, including the famous Lucky Strike pack. But Loewy was already sliding into a comfortable role as front man in three different offices: an automotive studio that designed cars for Studebaker in South Bend, Indiana; a Chicago office headed by Fritz Wagner and then Richard S. Latham (1920–91) that focused on products and packaging; and the New York headquarters, where William T. Snaith (1908–74) ran a division of commercial architecture, mostly designing retail stores for large chains. An exception like Russel Wright limited his work to housewares and enjoyed the glamour of a fashion designer.

Despite relative anonymity, business flourished with the economic boom. Although Geddes closed his office owing to ill health, Teague and Dreyfuss maintained large consultant practices and acted with Loewy as leaders of the profession. In 1944, Teague and Loewy formed the Society of Industrial Designers (SID) to establish professional rather than commercial status so as to claim a tax break in New York. They also hoped to ensure good designers for their drafting rooms by influencing training programmes at such schools as Carnegie Institute of Technology, Pratt Institute, Rhode Island School of Design, and Syracuse University. Finally, as demonstrated by a promotional campaign and travelling exhibition, they hoped to convince executives of their serious role. If the designer was ever a mere 'stylist', that day had passed. He was now 'an individual who combines engineering with functional styling'.[30]

Arens, Deskey, Dreyfuss, Geddes, Van Doren, and Wright were also among the 15 founding members of SID. Most had offices in New York or the Northeast (Van Doren having moved to Philadelphia in 1941). Of the two Midwesterners, Brooks Stevens (1911–95) had worked in Milwaukee since the 1930s, and John Gordon Rideout (1898–1951) was located in a Cleveland suburb. Except for Ray Patten (1887–1948), the head of appliance design at General Electric, all the founders were independent consultants. It was hard for an in-house designer to qualify for membership because SID's by-laws required a member to have worked for three companies and to have carried three designs through to mass production. The latter requirement distinguished SID from the American Designers Institute, founded in 1939, whose members, including Eames and Nelson, concentrated on fabrics, ceramics, and furniture—usually produced in small batches. ADI (renamed the Industrial Designers Institute in 1949) had several hundred members by 1947, while SID had 78 members and climbed to 98 in 1949—a sign of industry's reliance on design consultants after the war and of the emergence of a second generation of designers.[31] SID retained an elitist perspective during the 1950s, changing its name in 1955 to the American Society of Industrial Designers to indicate its nationwide base. In 1965 it merged with the craft- and furniture-

oriented IDI to form the Industrial Designers Society of America (IDSA).

Another sign of the profession's coming of age was the launch of the journal *Industrial Design* in 1954. Spun off from *Interiors*, which since 1945 had carried the subtitle + *industrial design*, the magazine was co-edited by Jane Fiske Mitarachi (b. 1927)[32] and Deborah Allen. Although *Industrial Design* carried news about the profession as well as profiles of designers, it made its reputation with an annual design review of products in various manufacturing fields, regular reports on design education, and an irregular series of special issues. Letters to the editor revealed tension between designers looking for practical reports on new plastics or colour trends and a staff whose highbrow orientation reached far enough to encompass an article by the Marxist sociologist C. Wright Mills (1916–62), who attacked designers for using 'magical gloss and dazzle' to promote 'status obsolescence'. For the most part the magazine honoured its prospectus, which had promised to connect designers, manufacturers, and materials suppliers around the concept of 'product planning' as the only viable response to 'the insatiable appetite of the public for new designs'.[33]

Although the success of *Industrial Design* certified that the profession had come of age, the journal also emphasized the anonymity of most product designers by suggesting the degree to which the design process had become predictably routine. In addition, profiles of young designers revealed a second and even third generation emerging—few of whose members could hope to have the influence the founders had wielded in the 1930s. Some of the newcomers became independent consultants. Others worked for consultant designers and dreamed of establishing their own offices. Most joined in-house design departments at hundreds of companies specializing in everything from cooking utensils and cameras to typewriters and power tools. Consultants referred derisively to in-house design staffs as 'captive' because employees were perceived as working on minor variations of the same boring products. Occasionally a company with an in-house staff would hire a prominent consultant for a special project or to reinvigorate its own designers. But prominence was relative. Few post-war commercial designers garnered reputations extending beyond their own profession and the corporate managers with whom they worked. The celebrity system of the 1930s had all but vanished.

The most anonymous post-war designers worked in-house for the automotive industry. With the exception of Studebaker, the major car manufacturers followed the lead of General Motors in organizing the design process. Harley Earl, who was elevated to the rank of corporate vice-president in 1940, remained the autocratic head of the Styling Division until 1958, when he picked William L. Mitchell (1912–88) as his successor. Earl established a system of closed studios, one for each

make (Cadillac, Oldsmobile, Buick, Pontiac, and Chevrolet), one for automotive interiors (employing mostly women), one for trucks, and another for Frigidaire electrical appliances. Stylists (as the industry referred to designers) worked in each studio behind closed doors, in theory not discussing their work with members of other studios. Earl dropped hints as to what was happening elsewhere, cross-pollinating so that GM makes bore a family resemblance while remaining visually distinctive. Unable to draw or model with any fluency, Earl was famous for his ability to examine a full-sized profile drawing of an automobile and then to indicate, often while slouching back in a chair and casually pointing with the toe of his shoe, which line had to be dropped a quarter inch to achieve perfection.

Most designers did not last long at GM. Many entered fresh from design school with high expectations. Some had attended Pratt or Illinois Institute of Technology, while others came from schools catering to Detroit's needs. Early on, many graduated from the Detroit Institute of Automobile Styling, which Earl established in 1938. After it closed around 1948, attention shifted to the Art Center School in Los Angeles. Earl sometimes visited to look over the students, and both GM and Ford had already provided occasional grants after the school moved to a new campus in 1946. The Art School of the Detroit Society of Arts and Crafts established a programme in transportation design in 1959 (later renamed as the Center for Creative Studies). Wherever they came from, young stylists became enmeshed in a creative factory system similar in spirit to a Hollywood studio. Detroit automakers employed over 500 designers in 1955. Those who worked for Earl discovered they were part of a 'revolving door policy'. Even the best, except for a few who proved indispensable, did not last long. Earl assumed stylists did their best work at the start of their careers, so he hired them, harvested their ideas, and fired them. Harper Landell (1918–97) recalled being in a probationary group of 25 who entered GM's Oldsmobile studio in 1940. Only five remained at the end of a year. Although Landell considered Earl 'a great man to work for', he did not stay long but moved through a series of in-house jobs with non-automotive companies before entering consultant Van Doren's office in 1947. After the latter's death 10 years later, Landell took over the practice. Although he succeeded more dramatically than many, his story resembled those of most second-generation industrial designers.[34]

A special issue of *Industrial Design* in 1955 declared Detroit to be not only 'the center of the biggest, liveliest and most adored consumer industry in the country' but also 'the design center of the USA'.[35] The continual exodus of experienced designers from automotive studios facilitated the expansion of in-house design departments in other industries, carried automotive design concepts and idioms into those

industries, brought an element of routine to a design process that had formerly seemed a bit mysterious, and thereby contributed to shifting the balance of commercial design from New York towards the manufacturing cities of the upper Midwest.

A half dozen consultant design firms were active in Detroit in 1955, employing 100 designers and working for clients distributed equally between Michigan and the rest of the US. Among the earliest established was the partnership of Carl Sundberg and Montgomery Ferar in 1934. Unable to find work as an architect with a degree from MIT during the Depression, Ferar had taken a job at GM, where he met Sundberg. The firm of Sundberg–Ferar was one of the nation's leading design offices by 1945 and thrived for decades in Detroit's industrial milieu. Typical of their work was a series of air compressors and paint sprayers for the DeVilbiss Company in the 1940s [**101**]. They also pioneered the creation of corporate image, coordinating a common look for IBM's early computers and showrooms in the 1950s before Noyes took over that role and earned a reputation for understated corporate modernism.

Detroit was also home to Lawrence H. Wilson Associates, seven partners who had recently taken over the office of George Walker (1896–1993), an independent consultant since 1929, who left to become vice-president for styling at Ford Motor Company. Another office, the Walter B. Ford (1920–91) Design Corporation, was founded in 1948 by several former GM automobile stylists. Even Earl recognized the lucrative prospects for non-automotive design and founded Harley Earl, Inc., an independent company employing 20 designers by 1955. Over the years, his staff worked on everything from Wear-Ever

101 Sundberg-Ferar

Air compressor, DeVilbiss Co., 1940

The industrial appearance of this dark grey, granular-surfaced, die-cast steel casing and its rugged setback cooling fins was typical of such products as medical equipment, movie cameras, and slide projectors throughout the 1940s and early 1950s. This relatively dull styling mode was as typical of the period as the flashier populuxe.

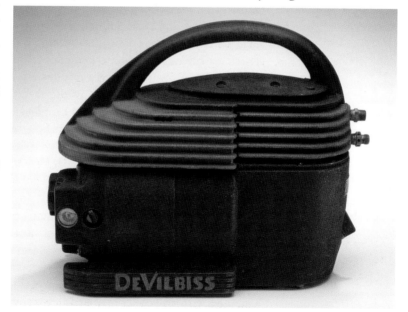

aluminium cooking utensils to Bissell carpet sweepers and Clark forklift trucks. *Industrial Design* portrayed the principals of these Detroit firms in a series of 'array of goods' photographs, posing on a well-trimmed lawn with all the products they had recently designed: lawnmowers, table saws, vacuum cleaners, carpet sweepers, water heaters, washers and dryers, furnaces, water fountains, luggage, air conditioners, televisions, and other mostly utilitarian artefacts—all rendered in a competent anonymous style composed of boxy shapes, crisp lines, and dull neutral colours.

The Midwest's other major design centre, Chicago, was indebted to the large mail-order firms. In a special issue in 1956 *Industrial Design* reported that the city supported 30 independent design studios with an average of 10 designers in each. Nearly two-thirds had opened since the end of the war. While a similar number claimed to accept commissions for 'anything from toothpicks to tractors', a handful specialized in graphic design or home furnishings and interiors. Many of the principals of the older firms had worked during the 1930s either at Sears, Roebuck or, more often, at Anne Swainson's Bureau of Design at Montgomery Ward. One of the first of Swainson's alumni to open an independent office was Dave Chapman (1909–78) in 1936. The commission that made his name in the design profession came from Brunswick-Balke-Collender in the early 1950s. When the company sought to move beyond a traditional involvement with billiards and bowling alleys by marketing a line of steel office furniture, Chapman advised them to avoid competition in that market and instead to become the first company with a line of durable modern tube-steel and plywood furniture for school classrooms—a smart move with the post-war baby boom just beginning. His designs for Brunswick proved so successful that they were pirated by a company that had examined the final plans while negotiating to become a subcontractor. Chapman reaped considerable publicity from a successful patent suit, won several awards for the furniture, and earned a reputation as a savvy trend-spotter.

Many other former Swainson employees remained in Chicago as independent consultants, while others relocated throughout the Midwest. Richard S. Latham of Loewy's Chicago office, for example, had originally worked at Montgomery Ward. Joining the Loewy office in 1945, he converted a wartime Hallicrafters short-wave radio for consumer use by simplifying its controls and striving for a utilitarian aesthetic meant to evoke the precision of a Leica camera [102]. Demonstrating a successful consultant's facility with different materials, styles, and audiences, Latham was also responsible for the flared, wasp-waisted porcelain china pieces of Coffee Service 2000, introduced by the German firm Rosenthal in 1954 [103]. The following year he joined with two other former Loewy employees in partnership as

102 Richard S. Latham for Raymond Loewy

S-40A short-wave radio receiver, Hallicrafters Co., 1946

Latham retained a no-frills military aesthetic while simultaneously providing an asymmetrically balanced front-panel composition. The radio's style only *appeared* unselfconscious.

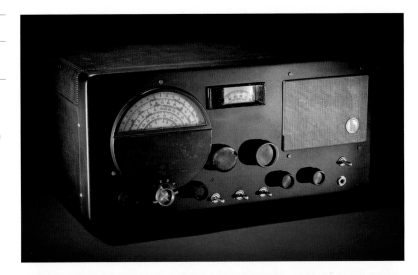

103 Richard S. Latham for Raymond Loewy

Coffee Service 2000, Rosenthal, 1954

Latham's porcelain coffee pot brought an aura of pure modernist design to populuxe styling. However, the set was also available with applied starbursts and other patterns and in at least one two-tone variant that echoed Magnussen's 'The Lights and Shadows of Manhattan'.

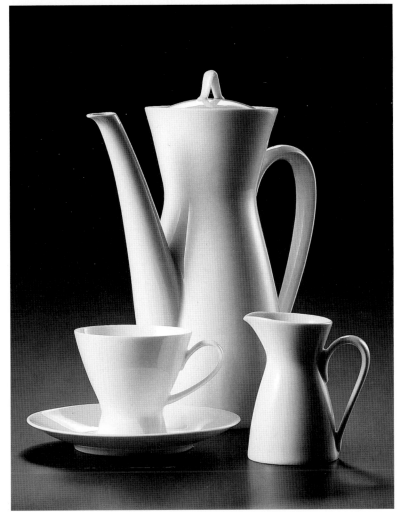

Latham, Tyler, Jensen. Among their first clients was Ekco Products Company, a manufacturer of inexpensive kitchen utensils whose management required assistance in developing new products—in other words, using design expertise not to improve appearance but to introduce novelty to a drab field. Some of Swainson's designers, such as Herbert Zeller, chose the corporate route. After working as an in-house designer for three different companies in the 1940s, he joined Motorola in 1949, became director of design in 1956, and supervised 13 designers and three model-makers in turning out nearly 100 different radios and televisions annually, with styles ranging from bright, crisply moulded plastics for portable sets to innocuous Scandinavian modern and showy French Provincial for console or cabinet furniture models.

Among the 30 independent consultant designers in the Chicago area in 1956 were several others who had opened offices during the 1930s, including Jean Reinecke (formerly in partnership with J. F. Barnes), whose projects included a washer and dryer for Whirlpool with decorative plastic backsplashes, and Brooks Stevens from nearby Milwaukee, whose office's work ranged from packaging for Miller High Life beer to Evinrude outboard motors [104] and the Willys Jeepster station wagon, something of an 'alternative' automotive icon. Often working for regionally based companies whose mundane products

104 Brooks Stevens

Evinrude Lark outboard motors, 1959–62

Once the outboard motor for small recreational boats was perfected technically, a designer's brief consisted solely of annual minor stylistic changes. Stevens's task was complicated by the fact that the same company owned both Evinrude and its main competitor, Johnson. The outboard motors of each company shared the same working parts and differed only in superficial externals.

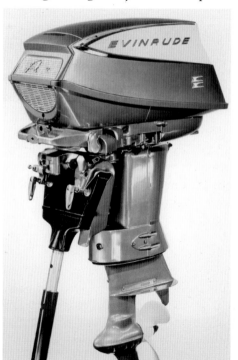

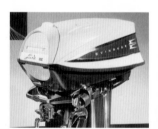
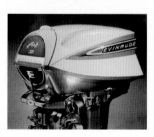

were mass-produced and distributed nationally without editorial fanfare, Midwestern designers excelled in an art of the practical addressing perceived realities of everyday life. They had to juggle sometimes contradictory motives. Simultaneously they had to economize manufacturing and marketing processes, simplify functional uses of ever more complicated devices, and appeal to the tastes of first-generation suburbanites who sought material confirmation of their newly elevated status. In solving these problems, they flew beneath the radar of Kaufmann and others who shared the MoMA good design perspective. They worked in a calculus of the familiar, leavened only by enough novelty to distinguish slightly each new model from its predecessor. As Chapman observed, not without a touch of bitterness, if New York was the 'brains' of industrial design, then Chicago was its 'hands'.[36]

Many consultant designers who became prominent in the Midwest after the war—Sundberg, Ferar, Reinecke, Stevens, Latham, Chapman, and others—achieved national leadership during the 1960s and 1970s. They served as presidents of IDSA, and their work and opinions appeared frequently in the pages of *Industrial Design*. Despite the practical workings of American manufacturing and the taste preferences of ordinary consumers, however, editors of the design press turned away from the profession's leaders when seeking the latest design trends. For visual stimulus they preferred the sun-and-surf, redwood-and-fibreglass lifestyle of California, the artificially bright moulded plastic furniture of Italy's *dolce vita*, the clean white rationalism of Germany's Braun and Krups kitchen machines, and eventually the small economy cars and matt-black consumer electronic equipment of Japan. *Fortune* lamented in 1959 that the 'flamboyant era' of the founders was over. Design was 'just a part of business structure', one of the many variables essential to the success of any manufacturing enterprise. In the annual design review for 1964, *Industrial Design* complained that 'whole categories of entries fell short of the minimum standards'; thus the editors illustrated no radios or televisions, no cameras or lighting fixtures, and only a few housewares and appliances. At best, American mass-produced goods reflected a competent aesthetic neutrality. Warning of 'the decline of industrial designers' in 1968, an even more pessimistic *Fortune* review quoted Latham's insistence that 'at any given moment the mass market knows what a product looks like'. As a result of this conservatism, new products blended into a background against which imports from Italy, Germany, or Japan looked strikingly novel and highly competitive. In becoming systematically predictable, American popular design, which initially aspired to burst the confines of post-war containment culture, lost its nerve. As Noyes admitted, 'even the best' commercial designers were 'guilty of parodying themselves'.[37]

105 Anonymous

Edsel automobile, Ford
Motor Company, 1958

Once again, as in 1927, Ford
attempted to catch up with
General Motors, this time by
introducing a car whose ten-
year lead time produced an
automobile completely out of
touch with popular
expectations. Only 60,000
were sold, about 5 per cent of
the market for medium-priced
cars. While faulting the Edsel's
generally bland designed-by-
committee extravagance,
consumers particularly joked
about its vertical radiator grille.

The end of an era

High design and popular design co-existed uneasily into the 1960s
with Nelson as a roving ambassador who spoke to both sides. Kauf-
mann's agenda for good design had always aimed at convincing
designers of their moral duty to exert a beneficial influence over ordi-
nary citizens. He had hoped to win over designers at a 'Conference on
Industrial Design, a New Profession', which he convened at MoMA in
1946 in collaboration with SID. At that event Sakier stated an opinion
on taste and reform that became the virtual creed of every responsible
commercial designer. Sakier insisted 'there isn't one of us' who 'does
not have a burning desire, in spite of his adaptability, to create what I
call the highest possible least common denominator in terms of real
beauty'. Stated more clearly, his proposition became Loewy's 'MAYA'
formula, according to which a designer seeks to move consumers to a
'Most Advanced Yet Acceptable' stage, giving them only as much pro-
gressive style as they can internalize at a particular moment. As a
reformer Kaufmann was in sympathy with this position even if he did
not quite trust the individuals who represented it. But after Kaufmann
left MoMA in 1955, his successor Drexler lacked any desire for accom-
modation, returning instead to a strict concept of timeless beauty that
negated the very idea of change or progress. Drexler actually seemed
quite serious when he joked that he could always depend on the 'un-
reconstructed aesthete' Philip Johnson to help police MoMA's design
collection.[38]

Faced with that attitude, commercial designers with a strong sense
of aesthetic responsibility like John B. Ward (c.1914–70) of the Corning
Glass Works were reduced to making sure their work fell into a small
'overlapping area' of both 'good design' and 'mass market' appeal. They
often suffered from what the sociologist Mills perceptively described
as guilt resulting from an inability to resolve 'the enriched muddle of
ideals they variously profess[ed]'. Mills exhorted designers not to con-
ceive a product 'as if it were an advertisement' and never to forget that
they were responsible for constructing the 'physical frame of private
and public life'. But not all serious observers took the designer's role so
seriously. Promoting a 'throw-away aesthetic' for objects made to be
replaced, the British design critic Reyner Banham (1922–88) advanced
the extreme claim that 'aesthetic qualities are themselves expendable'.
The designer's job was to crystallize 'popular dreams and desires' for a
particular moment only and not for all eternity.[39]

But while the debate continued with the social critic Vance Packard
(1914–96) attacking US industry in 1960 for its 'voluptuous wasteful-
ness', populuxe was losing its lustre.[40] The debacle of the Ford Edsel
[105] two years earlier revealed just how far Detroit had wandered from
public preferences in a blind devotion to arbitrary styling of ever longer,
lower, heavier cars. In reaction the three major car manufacturers all

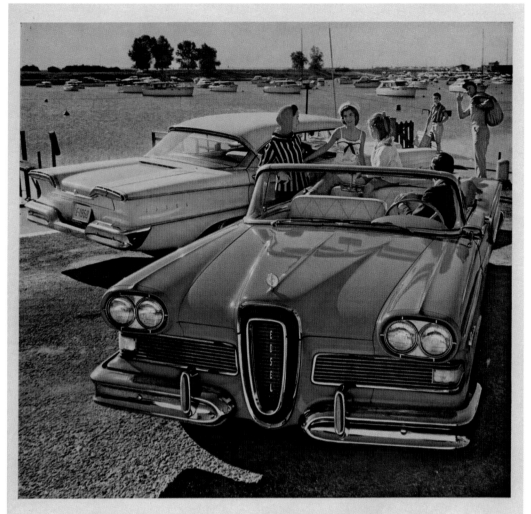

DRAMATIC EDSEL STYLING leads the way
—in distinction, in beauty, in value!

Last August, the photograph above could not have been taken. The Edsel car was still a secret then. But in one short year, Edsel's outstanding design has become as familiar as it is distinctive. In fact, you can recognize the classic Edsel lines much faster, much farther away, than you can any other car in America! This extra value in advanced styling accounts for the many more Edsels you've been seeing on the road lately.

And proud new Edsel owners are getting plenty of extra value *inside* their cars, too—the ease of Teletouch Drive, the power and economy of the all-new engines, the convenience of self-adjusting brakes, the comfort of contour seats. And the satisfaction of having made a great buy. For there's less than fifty dollars difference between the magnificent Edsel and V-8's of the major low-priced makes.*

Why not see your Edsel Dealer this week for sure?

EDSEL DIVISION • FORD MOTOR COMPANY

Less than fifty dollars between Edsel and V-8's of the major low-priced makes *Based on comparison of manufactur-ers' suggested retail delivered prices.*

106 Dave Chapman

Electric knife, Hamilton Beach, c.1965
Although Chapman made sure this small appliance fitted the hand ergonomically and used new plastics to good effect, no one—designer or manufacturer—gave any thought to the social function or relevance of the product.

came out with new compact models in 1960. Middle-class consumers recognized that annual facelifts for washing machines were of little consequence unless they happened to be in the market for a new one. New products like the electric carving knife, given a rakish tilt by Dave Chapman, seemed mere gimmicks [**106**]. While popular design was becoming predictable, high design had also entered a stagnant phase. Except for Saarinen's air terminals, the swanky Miami Beach hotels of Morris Lapidus (1902–2001), and the neon sculptures of the Las Vegas Strip, corporate and government architecture echoed the repetitive lines of Mies's austere Internationalism. And the modernism of Herman Miller or Knoll Associates, much of it nearly 20 years old, furnished the lobbies and offices of those glass boxes. No longer radical, high design expressed a mature corporate culture. If only in terms of a similar tiredness, popular design and high modernism were converging.

Even so, each side continued giving material form to the needs and desires of a particular segment of society. And each summer since 1951 designers of all types and many of their employers had gathered in Aspen, Colorado, for the International Design Conference. Initially sponsored by Paepcke, the conference grew to hundreds of attendees. By 1965 it had presented speakers ranging from Eames, Kaufmann, Nelson, and Noyes, to Chapman, Earl, and Latham, along with such prominent outsiders as sociologist Mills, historian Kouwenhoven, and human biologist Jacob Bronowski (1908–74). As an established profession mediating between humans and an increasingly artificial world, design had attracted cultural interpreters who legitimated its activities both to practitioners and to society as a whole. However, few designers anticipated the social and cultural disruptions that were soon to transform their working lives along with the everyday lives of all Americans. The realities of the Vietnam War, urban poverty, and racial conflict offered unflattering perspectives from which to consider their efforts to proliferate abundance among a large but hardly universal privileged class. In addition, a new youth counterculture disdained the materialism of the world the designers had shaped and generated its own material artefacts that were simultaneously threatening and invigorating to the professionals. In the long run, however, designers also had to struggle with a slow—sometimes difficult, often liberating—realization that their best future efforts would turn away from the material world to give shape to the immaterial realm of information.

This impending shift from material to immaterial was forecast in one of the era's defining moments, the American National Exhibition held in Moscow in 1959 during a temporary thaw in the cold war. Coordinated at short notice by Nelson, the exhibition included a vast multimedia display entitled 'Glimpses of the USA' designed by the Eameses and housed in a huge geodesic dome designed by Fuller. Historians have often commented on the impromptu 'kitchen debate' between US Vice-President Richard M. Nixon and Soviet Premier Nikita S. Khrushchev. According to one interpretation, the Russian was 'utterly baffled' by the American proliferation of products and argued instead 'for a single model, provided it worked'. The American, on the other hand, defended 'the possibility of choice' inherent in a 'multiplicity' of models.[41] In a sense, the kitchen debate encapsulated the meaning of a system of balancing production and consumption of material goods that had reached a state of maturity. On the other hand, the Eameses' multimedia show [107] prefigured a future as yet unglimpsed. Arrayed against one arc of the dome were seven huge screens, each 60 feet (18 metres) across, together stretching nearly the length of a football field. During the 12 minutes that 'Glimpses of the USA' played across those screens, viewers were bombarded by a montage of 2,200 still and moving images depicting a day in the life of ordinary Americans. By all accounts 'Glimpses of the USA' was the hit of the exhibition. For all its apparent realism, however, it left the impression of a larger-than-life dream dissolving at the end into

107 Charles and Ray Eames
Multimedia presentation, 'Glimpses of the USA', American National Exhibition, Moscow, 1959
The Eameses intended that a multiplicity of images would establish trust and persuade wary Russian viewers that scenes of abundance—houses, schools, shopping centres, cities, towns, churches, highways, automobiles, factories, and people in all forms of activity—were truly representative of the American scene and not fabricated as 'Potemkin village' propaganda.

© 2004 Eames Office

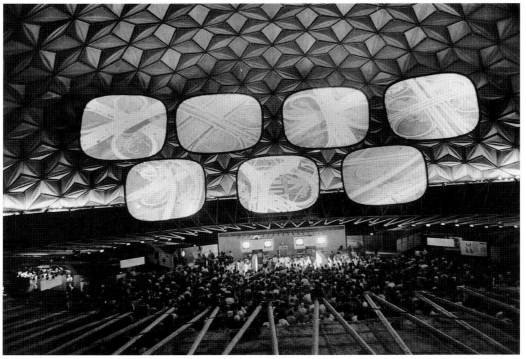

108 Anonymous

Control panel for IBM 305
Random Access Memory
Accounting Machine, 1956
As in 'Machine Art' in 1934,
MoMA again snubbed
commercial designers. This
panel was abstracted from the
computer's room-sized
grouping of cabinets, card
sorter, operator's desk, and a
transparent cylinder holding
fifty 24-inch (61-cm) disks
comprising the world's first
hard drive, the IBM 350, with
a storage capacity of 4.4
megabytes. The ensemble's
competent but somewhat
stodgy styling came from
Sundberg-Ferar.

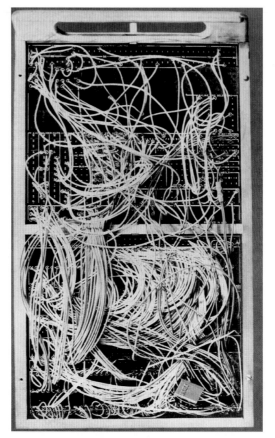

something that could not quite be grasped. The Eameses had worked magic with evanescent images. Most of their projects from that point on involved the careful selection and juxtaposition of bits of information designed for ease of human interface in multimedia, film, and exhibition.

Designers were about to abandon the permanence of matter for the impermanence of images and information. That transformation, only just begun, was materially embodied in a single object whose photograph was selected by Drexler to conclude a book on MoMA's permanent design collection in 1959, the year the Eameses went to Moscow [**108**]. Looking large and industrial by twenty-first-century silicon standards, the aluminium control panel for the IBM 305 Random Access Memory Accounting Machine stood nearly two feet (60 cm) high and bristled with colour-coded wires. Drexler hoped to assimilate it into the modernist tradition of abstraction. But it remained mute, somehow threatening, even alien. In his text Drexler hypothesized a 'new machine aesthetic' based on a 'dematerialization of finite shapes' into 'invisible forces'. Electronics, he argued, had 'altered our conception of how things need to be shaped in order to work, and of how they may be related to each other'.[42] If design had become predictable in

form and function during the middle years of the twentieth century, its practitioners were about to face a major challenge. Just as designers in the late 1920s and 1930s had given formal shape to the machine age through streamlining, those in the century's final decades would find forms expressive of the information age. They could thereby reclaim a sense of adventure and cultural significance that had been obscured in the middle years.

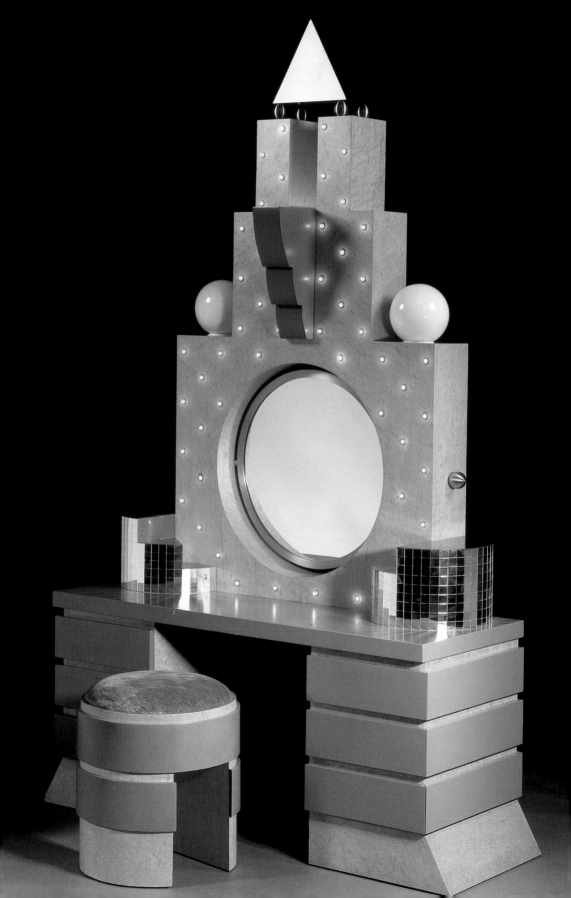

Into the Millennium: Moving beyond Modernism

5

Commercial designers of the early 1960s assumed their profession would develop as smoothly as in the previous thirty years. They did not realize the US was about to experience social, political, and cultural upheaval. All signs indicated steady economic and technological progress towards the 'new frontier' declared by John F. Kennedy in his presidential campaign of 1960. Although the brief Kennedy era witnessed a new awareness of poverty, a sharpening of racial strife, the Cuban missile crisis, and military involvement in Southeast Asia, the nation seemed poised to achieve domestic equality and international harmony through a government directed by talented experts from leading universities and corporations. For Americans who worked in such areas as industrial design and commercial art, the charismatic president and his stylish wife signified national openness to elegance and taste. The nation had finally risen to the challenge of abundance. An expressive culture of democratic inclusiveness seemed to be triumphing over narrow commercialism.

109 Michael Graves
Plaza dressing table, Memphis, 1981
Although Graves became a celebrity, he seemed not to grasp his Memphis colleagues' infatuation with recent American popular culture. In reaching back to Art Deco rather than the 1950s for inspiration, Graves announced the strongly historicist bent of American postmodernism. As in the earlier transmission of European modernism to the US, a partially ideological movement became mostly formal and stylistic.

High modernism in the 1960s

For a few years high modernism reigned as the formal cultural expression of a nation that confidently assumed the moral and material leadership of the non-Communist 'free world'. Planners oversaw urban renewal projects and interstate highways, reshaping cities from New Haven to St. Louis as if fulfilling the visionary projections of the General Motors Futurama. In New York, for example, 'slum clearance' yielded Lincoln Center's theatres and concert halls grouped around a plaza. Although the structures were functionalist boxes of reinforced concrete and glass, they were accented like consumer appliances by applied trim—stylized colonnades, travertine veneer, and glittering metalwork from lighting fixtures to abstract sculptures. A later generation might dismiss Lincoln Center as kitschy, but it projected a

self-congratulatory mood of democratic high culture typical of the era's public architecture.

Corporate office buildings rose across the country in imitation of the Seagram building, a bronzed glass tower in New York completed by Mies van der Rohe in 1958. Rejecting the machine-age romanticism of the Chrysler and Empire State buildings, Mies gave material expression to the confident mastery that suffused post-war American business. The Seagram's soaring slab, set back 90 feet (27 metres) from Park Avenue, left space for a plaza flanked by simple reflecting pools and fountains, a public amenity in a city where real-estate costs had long forced developers to build out to the sidewalk. Rich materials gave public lobbies an understated opulence that carried through into the building's interiors, many designed by Philip Johnson. His Four Seasons restaurant, for example, projected an informal elegance. Its Grill Room, bathed in rich golden light, was defined by the contrast of warm walnut panelling and floor-to-ceiling glass. Suspended from the ceiling, a pair of sculptural assemblages of thin metal rods glinted with an evanescent rippling effect. Similar office buildings followed across the US as corporate executives sought to convey both personal status and public benevolence.

This aesthetic of high modernism achieved expression in the industrial design of the 1960s. Such recent classics as Nelson's Ball clock and the Eameses' rosewood lounge chair remained popular among those who could afford them. But the moral fervour behind Kaufmann's 'good design' programme at MoMA had dried up. Instead, there prevailed an acceptance of tasteful ostentation as a means of demonstrating wealth and social standing. The mainstream industrial designer most closely representative of this high modernist aesthetic was Eliot Noyes. After the war Noyes had worked in Geddes's office, where he was project manager for an electric typewriter for IBM. When Geddes retired, Noyes inherited the commission and subsequently designed many office machines for IBM, most notably the Selectric typewriter of 1961 [110]. His work continued to emphasize clear-headed rational efficiency when he replaced Sundberg & Ferar on the design of IBM's larger office machines, mainframe computer systems, and, assisted by the graphic designer Paul Rand (1914–96), the general image conveyed by showrooms, catalogues, signage, and stationery.

A similar restraint marked a total redesign of Mobil Oil's service stations and gasoline pumps in 1964. Noyes introduced the aesthetic of high modernism to a business marked by populuxe architecture, flapping pennants, and a confusing abundance of signs. The new station was plain but substantial, a rectilinear brick structure accented with a white stripe over the service bays. Except for a large medallion bearing a stylized version of Mobil's winged Pegasus trademark, the building appeared similar to the one-storey brick schools of new suburban

110 Eliot F. Noyes

Selectric typewriter, IBM, 1961

The sculptural integrity and deep rich colour of the Selectric's solid die-cast aluminium housing implied an unprecedented status for modern office workers. Its simple, sensual curves enclosed a fixed platen and echoed the movement of its miraculously fast 'golf ball' typing element. The scooped-out keyboard enclosure visually focused the task of typing.

housing developments. In designing the gas pump, Noyes rejected the usual sheet-metal box tricked up with mouldings and other styling effects. Instead he specified a wide cylinder of brushed stainless steel. Sheltered by a circular canopy, an island of these gleaming pumps afforded a luxurious contrast to the station's crisp brick. Working in conjunction with Noyes, the graphic designers Chermayeff & Geismar (Ivan Chermayeff [b. 1936] and Thomas Geismar [b. 1931]) integrated the company's product packaging and devised a freestanding sign announcing 'Mobil' in a manner so understated as to suggest a non-commercial institution dispensing public service.

High modernist design appealed to a maturing post-war generation tiring of boomerang shapes, flaring lines, and two-tone pastels, and who instead preferred a richer, more textured expression of material abundance. Many upper-middle-class consumers purchased furniture vaguely echoing period styles. High labour costs and rising hardwood prices led manufacturers to introduce synthetic substitutes. 'It looks so good, you'll swear it's wood', claimed a trade advertisement.[1] Poly-styrene panels glued to chipboard fooled no one, but polyurethane foam so convincingly reproduced the density, touch, and sonic quality of wood—not to mention its appearance—that it became the material of choice for expensive television consoles. Such furnishings would seem to clash with a high modernist aesthetic, but they afforded a neutral backdrop for warm, organic, Scandinavian-inspired accessories ranging from rough, nubby textiles and teak bowls to stainless steel flatware and earth-toned ceramics. Household appliances also assumed a more conservative appearance. In contrast to the heavy chrome accents and visually complex controls of the 1950s, they exhibited simple boxy forms, crisp lines, and sharp edges similar to those of high modernist architecture. Appearing in matching organic shades of

111 Anonymous

Refrigerator-freezer, Philco-
Ford Corp., *c.*1969
Decorative panels of wood-
grained plastic oddly imply
that a purchaser might be
motivated to place this
refrigerator in a restrained
high-modern living room. On
the other hand, its crisp,
rectilinear form and simple,
uncluttered interior suggest
the efficiency of Beecher's
kitchen or a Hoosier cabinet.

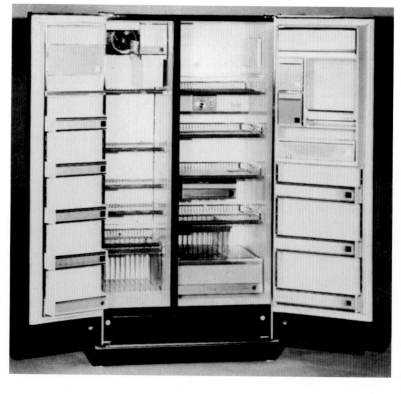

avocado green and (later) harvest gold, they often possessed synthetic wood-grain accents on handles and control panels [**111**].

Even automotive styling exhibited restraint as Detroit abandoned visual excess in favour of the 'sharper creases, the more angular, pointed shapes, the thinner, more delicate roofs, the flatter hoods and decks' of the 1960s. GM's more austere approach under Earl's successor Mitchell was apparent in the 1963 Buick Riviera, a two-door hardtop nominated by *Car and Driver* as 'the best looking car of the whole crop'.[2] Devoid of tailfins, the Riviera was razor-sharp, with a lean silhouette tapering from the roof's leading edge to the rear bumper, and long side creases in place of chrome speed lines. Equally impressive was the Pontiac Grand Prix of the same year, a two-door luxury model with squared-off front and rear, a sharp, flowing silhouette, and a single side crease. A year later, in 1964, Ford introduced the wildly popular, sporty-looking Mustang [**112**] designed by a team headed by Eugene Bordinat Jr. (1920–87). Despite its success, and that of GM's Chevrolet Camaro, 1960s cars lacked the cultural resonance of those of the previous decade. Although car makers appealed to upwardly mobile consumers by offering luxurious comfort through long, wide bodies, padded interiors, and loose, floating suspensions, the trend towards boxy cars with crimped sheet-metal bodies reinforced an impression of design by committee. This dominant aesthetic of programmed abundance projected neither exuberance nor wit. High modernist automobiles contributed to the self-satisfied mood of middle-class society but offered little more than a promise of individual mobility that was already taken for granted.

112 Eugene Bordinat Jr.
et al.

Mustang automobile, Ford Motor Co., 1964

Introduced at the Ford pavilion at the New York World's Fair of 1964, the Mustang possessed an unusually long hood and short rear deck, accented with a jaunty front air scoop and parallel side ridges sweeping back to a slanted row of decorative louvres. It brought sports-car styling to an inexpensive car.

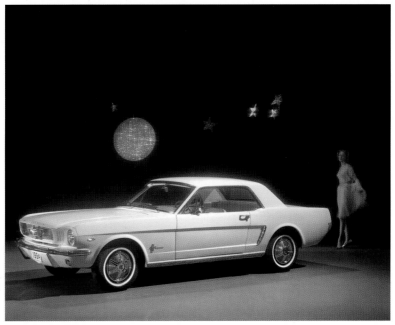

Into the 1970s, automobiles reflected a corporate anonymity of form and style similar to kitchen appliances, furniture, housewares, suburban housing developments, service stations, motel and restaurant chains, convention centres, and office buildings. This aesthetic climate offered designers little room for creative manoeuvring. Except for Noyes and a few others who transcended the norm by offering its most satisfying expressions, most industrial designers worked for in-house corporate design departments, where they devised incremental changes to mundane products originally conceived as innocuous multipliers of suburban abundance. By 1968, however, a significant proportion of the post-war generation's children judged material prosperity to be somehow as immoral as the racism, imperialism, and technocratic hubris which they perceived as responsible for the Vietnam War. Their vocal rejection of American society implied a negative assessment of everything industrial design had accomplished since the 1930s.

Leaders of the industrial design profession lamented their increasing irrelevance to the cause of social justice. Speaking at a meeting of IDSA in 1968, Chapman sympathized with colleagues who could not 'survive out there in the jungle . . . on the basis of selling good design'. Many tried to 'smuggle in virtue' despite narrow-minded profit-seeking clients. Worrying about the alienated youth from whose ranks the next generation of designers would come, Jay Doblin (1920–89), director of the Institute of Design, declared, 'we've got to reconstruct this profession'. Now that American engineers had 'welded together . . . a technology' capable of anything, designers had to find ways to bring everything under control. 'What shall we do with it,' Doblin asked, 'to make it human so we aren't victimized by it?'[3] In the coming years, as designers struggled against the straitjacket of cosmetic styling, the boredom of high modernism, and accusations of social irrelevance, they had to confront this question. At first, a few prophets offered visionary responses. Later, when most designers became involved in shaping hardware and software for the information age, variations on Doblin's question moved to the top of their agenda.

The counterculture and alternative design

The self-styled Age of Aquarius was a difficult, exhilarating time for designers. During the late 1960s and early 1970s, left-wing political activists attacked the so-called military–industrial complex in which many designers were employed. Anti-establishment social critics claimed that consumer goods functioned as an opiate of the masses by providing materialist diversions in place of the rewards of truly satisfying labour. Attacks by environmentalists were even more devastating to professionals who took pride in coordinating mechanical functions, human factors, and aesthetic appeal in the design of consumer prod-

ucts. Critics blamed manufacturers for depleting natural resources, leaving behind toxic by-products, and producing disposable products and packaging. Because designers stimulated unnecessary consumption, they stood accused of contributing to the flow of waste.

On the other hand, the counterculture that developed in tandem with political protest offered a sense of stylistic innovation. The Beatles and other British rock groups fostered awareness of bright, colourful, mock-Edwardian fashions and paisley-patterned extrapolations from Art Nouveau. Simultaneously the psychedelic movement emanating from Timothy Leary and the Haight-Ashbury district of San Francisco inspired a home-grown aesthetic compounded of LSD visions, Native American motifs, and a ragged, often subversive, do-it-yourself individualism. Hippie artists energized American visual culture with rock concert posters, record jackets, and underground newspapers and comics whose graphic images were extravagant, obsessively intricate, and often exuberantly obscene. Such work inspired Milton Glaser (b. 1929), a graphic designer and director of Push Pin Studios, whose famous Bob Dylan poster [113] depicted a silhouette with a Medusa-like tangle of thick, multi-coloured hair suggesting surreal visions exploding from a fertile mind. This day-glo aesthetic achieved mainstream popularity in the 1970s in the prolific work of Peter Max (b. 1937), whose studio of 50 artists applied cheery stylized rainbows, sunrises, and psychedelia to posters and coffee mugs.

A serious do-it-yourself utopianism motivated Stewart Brand (b. 1938), publisher of *The Whole Earth Catalog* from 1968 to 1971. Conceived as 'access to tools' for inhabitants of alternative communes living on the land, the *Catalog* grew to 500 pages offering reviews of everything from books on childbirth, yoga, gardening, and star-gazing, to mail-order sources for carpenter's tools, windmills, and looms—anything that might assist an individual, a family, or a commune seeking to design a way of life. Brand credited 'the insights of Buckminster Fuller' for inspiring the *Catalog* and offered two pages expounding Fuller's 'whole systems' approach and illustrating his Dymaxion car and geodesic dome. Brand also praised the designer's lectures for their 'raga quality of rich, nonlinear endless improvisation full of convergent surprises'.[4] This favourable publicity enhanced Fuller's popularity on the college lecture circuit and introduced 'Bucky', then in his 70s, to a host of new fans who applauded his critique of a society designed haphazardly according to the profit motive.

As a self-described 'comprehensive anticipatory design scientist', Fuller operated from a perspective not available to practising designers. His widely distributed *Operating Manual for Spaceship Earth* offered a critique of industrial capitalism as narrow-minded and wasteful. This guide to 'the real wealth of life aboard our planet' described the earth as 'an integrally-designed machine which to be persistently successful

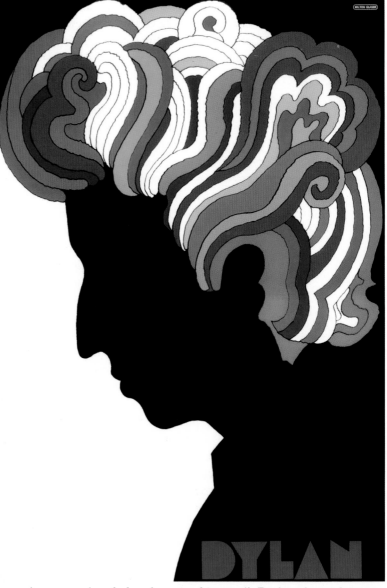

113 Milton Glaser

Poster distributed with *Bob Dylan's Greatest Hits*, Columbia Records, 1967
Many underground artists contributed memorable images to the countercultural scene. R. Crumb's 'keep on truckin'' logo, for example, was endlessly reproduced. The professionally stylized psychedelia of Glaser's image of Dylan—inserted into a record album—appeared on the walls of thousands of dorm rooms across the US.

must be comprehended and serviced in total'. Rather than relying on fossil fuels whose depletion was certain, human beings had to realize their evolutionary goal as managers of a 'forwardly-operative, metabolic, and intellectual regenerating system' with limitless energy from the sun. A liberal programme of design fellowships proposed by Fuller would propel 'a trend of comprehensive ephemeralization—i.e., the doing of ever more with ever less'. Despite Fuller's totalizing vision, his visionary optimism appealed to cultural radicals who anticipated the transformation of human consciousness. The idea of doing more with less spoke to a counterculture claiming to reject American materialism. His geodesic dome also proved attractive to communalists as a simple,

inexpensive dwelling whose unorthodox form joined high technology and the primitivism of nomadic yurts. Fuller's influence on design students during the 1970s was considerable. The chair of Cornell University's department of design, Joseph Carreiro (1920–78), complained that Fuller encouraged students and young instructors to focus on 'problems so large in scale and so comprehensive in their complexity' that 'no one ever has to design anything'.[5]

That was hardly the case with Victor Papanek (1926–98), the profession's harshest critic, whose polemic on *Design for the Real World* (1972) encouraged colleagues to create small-scale tools and appliances for the disabled, the ageing, and inhabitants of underdeveloped regions. 'There are professions more harmful than industrial design,' Papanek declared, 'but only a very few of them'. He claimed industrial design had 'put murder on a mass production basis' by 'designing criminally unsafe automobiles', 'by creating whole new species of permanent garbage to clutter up the landscape, and by choosing materials and processes that pollute the air we breathe'. He urged designers to become 'socially and morally involved' by advancing design as 'an innovative, highly creative, cross-disciplinary tool responsive to . . . true needs'. Although Papanek complained of a throwaway 'Kleenex culture' and blamed designers for creating 'elitist trivia' and 'anti-human devices', he recognized they had to make a living. So he moderated his attack by encouraging them to tithe one-tenth of their time towards satisfying genuine needs of the three-quarters of the human race who did not share in their prosperity. Papanek involved his own students in such projects as a radio receiver made from a tin can and powered by cow dung, intended for remote Indonesian villagers. They were free, Papanek allowed, to decorate it any way they wanted.[6]

The design community's old guard already felt threatened by anti-establishment values. Protesters at the Aspen Conference in 1970 offered a series of hostile resolutions that, according to Reyner Banham, 'invited the conference to vote commercial design virtually out of existence'. Defending the status quo, the editor of *Industrial Design* dismissed Papanek's book as a 'rambling diatribe'. On the other side of the generation gap was Peter Bressler (b. 1946), a Philadelphia designer serving as co-chair of the organizing committee for the national IDSA meeting in 1976, who invited Papanek to give the keynote address. Although Papanek's name appeared in promotional materials, his appearance was abruptly cancelled and his absence falsely attributed to an unspecified illness. IDSA president James Fulton (1930–2003) later explained that the board of directors had rescinded the invitation owing to Papanek's frequent statements 'slandering the society and US industrial designers in general'.[7]

Many designers, young and old, shared Papanek's concerns about safety, pollution, waste, shoddy products, corporate greed, and social

irrelevance. Rick Eiber (1945–99), who later coordinated corporate identity for Boeing, wrote to the editor of *Industrial Design* in 1969, urging colleagues to focus public attention on 'visual and physical pollution of our environment' through 'uncontrolled signage, exposed utility connections, industrial wastes, substandard building and litter'. Don Albinson, who had recently left the Eames office to become design director at Knoll, believed 'designers could be entering into their period of greatest usefulness'. Now that 'American production, sales, and design expertise' had 'achieved the ultimate goal of every thing for everyone', it was time to 'solve real problems' like affordable shelter, efficient mass transportation, and delivery of goods without wasteful packaging.[8]

114 Niels Diffrient *et al.*
Chart showing variances in measurements of human females, *Humanscale*, 1974
In addition to charts such as this, three volumes published by Diffrient and three associates from the Dreyfuss office included an assortment of wheels for calculating various clearances and affordances based on the range of measurements of a target population.

Other established designers also turned away from touting corporate profits to emphasize the safe, efficient, and humane fit of each product to its user. Niels Diffrient (b. 1928), for example, headed a team at Henry Dreyfuss Associates that formalized the firm's long-standing collection of ergonomic or 'human factors' data. This project yielded *Humanscale*, a set of three influential volumes of charts and measurements published from 1974 to 1981 [**114**]. Soon after opening an independent office specializing in ergonomic office furniture and workstations, Diffrient declared the importance of being able to

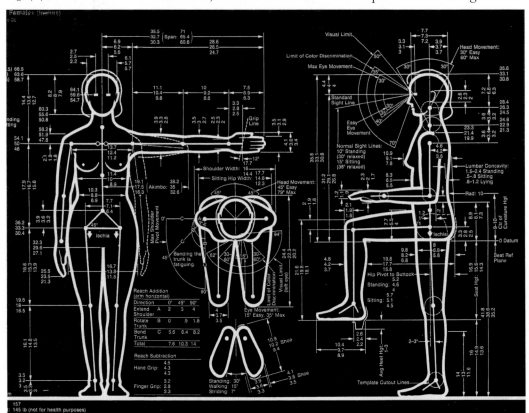

'present . . . concepts to engineers with more than an aesthetic ratio-nale'. Voicing a similar attitude, Arthur N. BecVar (b. 1911), director of in-house appliance design at General Electric, warned that consumers were much too 'savvy' to settle for flashy 'styling'. He advised designers instead to address such issues as 'materials usage, energy conservation, service . . . and human factors'. Although BecVar tried to put a positive spin on the situation, even the most conservative middle-class con-sumers were irritated by shoddy products, bored by predictable styling, and increasingly worried about the environmental costs of society's material abundance.[9]

The human factors movement was reacting in part to threats from consumer activists, government regulators, and the courts. In 1965 the activist Ralph Nader (b. 1934) had galvanized public opinion with a strident attack on the automobile industry, *Unsafe at Any Speed: The Designed-in Dangers of the American Automobile*. According to Nader, the Chevrolet Corvair, introduced as an answer to customer demands for smaller cars, possessed an inferior suspension and was prone to roll-over accidents. Popular success of Nader's exposé prompted formation of 'Nader's Raiders', mostly altruistic young attorneys who investigated safety issues in a range of consumer industries and products. As a result, state and federal governments passed stricter legislation govern-ing product safety, and attorneys won increasingly large settlements for clients who had been injured through their use—or careless mis-use—of various products. Increased regulation and the fear of product liability judgments ranging into millions of dollars shook the world of product design and momentarily contributed to a trend towards prod-ucts so neutralized by multiple safeguards as to seem also boring.

Many designers sensed a need to adjust as countercultural values percolated into society at large. Simultaneously, however, they and their employers confronted unprecedented foreign competition. During the 1970s the industrial cities of the Northeast and Midwest decayed into a 'rust belt' of abandoned factories as consumers rejected US products and embraced foreign imports that were less expensive, better functioning, or aesthetically more provocative. While easy dom-inance had rendered US companies inflexible, Japanese manufacturers adapted quickly to the competitive realities of the American scene. A Japanese designer, one of many to visit the US during the 1950s and 1960s in order to learn American design techniques, told Harper Landell that product forms should emulate the image of Buddha, which had not changed for 3,000 years. But after three months observ-ing Landell's consultant office in Philadelphia, he returned to Japan ready to apply styling to make Sharp's electronic goods competitive in the US.[10] Even more successful was Sony, whose engineers copied the American shirt-pocket transistor radio and sold it for less in 1957. After attracting attention with miniature radios and TVs, Sony became

known for reliable, affordable consumer electronics components. Their understated matt-black cases radiated a 'high-tech' variant of 'good design' suited to the living rooms of middle-class consumers whose upward mobility had taken them beyond 'borax' and chrome. Even more damaging was Japanese penetration of the automobile industry. Toyota and Honda had intuited and satisfied emerging desires of baby-boomers for inexpensive, fun-looking small cars that did not guzzle gas or project a 'vulgar' materialism.

While Japanese firms gained market share in high-volume industries like automobiles and consumer electronics (with Korean and Taiwanese firms soon to follow), European manufacturers excelled in low-volume fields like small appliances and furniture. The German firm Braun, under the design direction of Dieter Rams, became known for small personal appliances like food processors, radios, and shavers. Their forms, textures, and materials conveyed a neutral spirit of precision and rationality that distinguished them from the flashy appearance of most American appliances. While Braun (and its competitor Krups) looked back to the Bauhaus for inspiration, Italian furniture designers anticipated a colourful future of sensuous hedonism. Revelling in the frank artificiality of synthetic plastics, such designers as Joe Colombo (1930–71), Marco Zanuso (1916–2001), and Sebastiano Matta (1912–2002) created interiors of bright injection-moulded polypropylene chairs and tables, inflatable furniture whose vinyl surfaces seemed almost lifelike, and polyurethane foam sofas in the exaggerated forms of Pop Art. This playful futurism gained wide notice in 1972 when MoMA dedicated a major exhibition to 'Italy: The New Domestic Landscape' [115].

The simultaneous popularity of German rationalism and Italian extravagance suggested that design was fragmenting into multiple aesthetics reflecting shifting needs and desires. A countercultural insis-

115 Sebastiano Matta

Cushion system of upholstered polyurethane foam, Gavina, 1966

Italian design celebrated frankly artificial materials, forms, and colours which nonetheless evoked a mood of relaxed and playful human sensuality. This *dolce vita* ignored both the puritan rectitude of Miesian modernism and the earnest organicism of American high modernism.

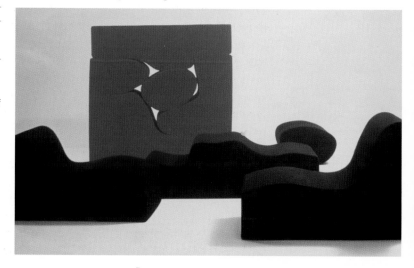

tence on 'doing your own thing' developed into a social theory of multiple lifestyles. Both ran counter to the stylistic coherence that had marked American design at least since the machine age and perhaps as far back as the mid-nineteenth century. Designers had lost the pulse of the society they were supposed to reflect and shape. A sense of failure was strongest in the case of the automobile. After all, the automotive industry had defined styling and stimulated the design profession throughout the twentieth century. And the decline of the American automobile during the 1970s visibly threatened national economic health. With the world an interdependent 'spaceship earth', designers had to learn to think globally as well as nationally. During the century's last two decades, as they tried to revive their profession and renew its economic and social significance, they also shifted their emphasis from industry to information (or, figuratively speaking, from hardware to software). This transformation from the material to the immaterial offered the greatest challenge of all.

The 'Design Decade' of the 1980s

Design moved unexpectedly from obscurity to near celebrity during the 1980s as international competition forced manufacturers to offer more than anonymous products. Not since the 1930s had design seemed so central to business. Under the headline 'Industrial Design Comes of Age', the *New York Times* aimed that 'the look and image of a commodity can mean the difference between a hit and a flop'. In a cover story on 'Smart Design', *Business Week* reported that manufacturers who formerly 'relegat[ed] design to the backseat' now considered it the 'key to industrial competitiveness'. Even Tom Peters (b. 1942), widely celebrated as a management guru after publishing *In Search of Excellence* (1982), told *Newsweek* that 'the fire of design is as important to survival as efficient organization'.[11] Parallels to the 1930s went only so far. In 1930, not even those who claimed the title 'industrial designer' knew quite what it meant, and many business executives distrusted artists telling them what to do. By the 1980s, on the other hand, the profession was well established even if it had become a routine aspect of marketing. Dozens of universities and art schools granted degrees in the field. By 1985 there were about 675 consultant offices across the US, and in-house design units employed 6,000 trained designers. So when manufacturers realized that international competition had provoked the most serious business crisis since the Great Depression, they could take advantage of an existing design infrastructure.

An evangelical fervour suffused the many consciousness-raising events devoted to the economic, social, and cultural potential of design. Typical of these was the Stanford Design Forum, which met for two days in 1988 to consider how 'to advocate the importance of

design in our society in general and to business in particular'. The convener was Colin Forbes (b. 1928), who invited a select group of participants including corporate executives ('those who make the decisions'), independent consultants and in-house design managers ('those who provide the service'), and educators and media representatives ('those who educate and communicate'). Having moved to New York to open a branch of the British firm Pentagram Design, Forbes himself embodied a major characteristic of the group—its global outlook. The Stanford Design Forum, one of many pro-design initiatives during the 1980s, afforded a microcosm of the movement to put design at the top of society's twenty-first-century agenda.[12]

Executives who answered Forbes's call included the heads of several small companies built on design-intensive products intended for niche markets. William Potts had directed Precor's development of a stair-stepping exercise machine [**116**], while Noel Zeller (b. 1936) was responsible for Zelco's 'itty bitty book light'. The executive star was Donald E. Petersen (b. 1926), chairman and CEO of the Ford Motor Company, who had supervised introduction of the Taurus, an auto-

116 Anonymous
Precor 718e Low Impact
Climber exercise machine,
Precor Inc., c.1988
With ageing baby boomers
concerned about staying
healthy, sale of personal
exercise machines increased
during the 1980s and 1990s.
Precor relied for success on
simple structural parts of
extruded aluminium,
microchip-controlled
feedback, and a carefully
orchestrated appearance of
lean competence throughout
its line of exercise machines.

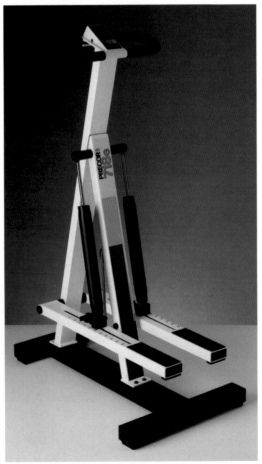

mobile whose relatively radical design restored Ford to serious competition against Japanese and European companies. Other executives included Paolo Viti, who had become president of Olivetti (an Italian business machine company) after serving as design director, and Kazuyoshi Ishizaka (b. 1921), the president of Kenwood, a Japanese electronics firm which marketed a large number of marginally different products under various brand names around the world.

Design managers and consultant designers at the meeting comprised a who's who of practitioners from the US, Europe, and Japan. In-house managers included Ford's Jack Telnack (b. 1937), head of the Taurus design team, and Arnold S. Wasserman (b. 1934), who had recently transformed the user interface of Xerox's photocopiers. After moving up from salesman to head of design at Herman Miller, Robert Blaich (b. 1930) had joined Philips as design director in 1980 with responsibility for all the products of the Dutch company's maze of international subsidiaries. Consultant designers around the table included Fulton, former president of IDSA and a board member at Pratt Institute. Rodney Fitch (b. 1938), a former executive of the Conran Design Group in London, was the head of Fitch, a major British office then merging with RichardsonSmith of Columbus, Ohio, the largest independent office in the US. Among the more specialized consultants were Richard Saul Wurman (b. 1935), an American innovator in the graphic presentation of complex information, and Bill Moggridge (b. 1943), who left the UK to start ID Two in Palo Alto and was best known for the GRiD Compass computer [**117**], a small, rugged laptop used by NASA astronauts on the space shuttle. Japan was equally well represented. As a principal at GK Industrial Design, Shoji Ekuan (b. 1938) was involved in the Japanese effort to learn American styling and marketing. Most emblematic of Forbes's overall

117 Bill Moggridge
GRiD 1100 Compass computer, Grid Systems Corp., 1982

The first laptop, the GRiD pioneered the clamshell form with a case of magnesium alloy and a plasma display. At a cost of $8,000, it was used mostly by the government and the military, but its simple, rugged appearance appealed to executives seeking an exclusive high-tech toy.

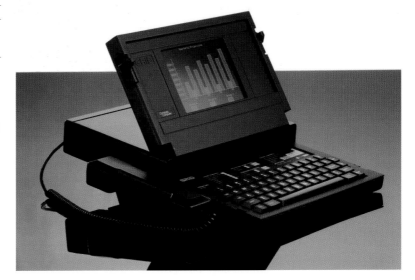

goal in convening the Forum was Motoo Nakanishi (b. 1938), founder and president of the PAOS consultancy, who maintained that design as strategic planning must form the centre of every business.

Publicists and educators who attended the Stanford Design Forum were equally diverse. Among the print journalists was Horace Havemeyer III (b. 1941), publisher of *Metropolis*, a trendy New York magazine focusing on style as the main concern of a media-saturated society. On the other side of the spectrum was Christopher Lorenz (1946–96), management editor at London's *Financial Times*, who had just published a book promoting design as 'the new competitive weapon for business'.[13] Among the educators was David R. Brown (b. *c.*1945), director of the Art Center College of Design in Pasadena, from which graduated a considerable share of US car designers. John Heskett (b. 1937), a British design historian, was researching comparative design practices in the US, western Europe, and Japan with a grant from Harvard Business School. Another participant, Peter Lawrence (b. 1944), was the head of the Corporate Design Foundation, whose goal was integrating design management into business schools by compiling case studies of successful design applications. Finally, Forbes involved individuals at the intersection of government and aesthetics, including J. Carter Brown (1934–2002), director of the National Gallery of Art, and Adele Chatfield-Taylor (b. 1945), head of the Design Arts Program of the National Endowment for the Arts, which contributed funds towards publication of the Forum's proceedings. There were enough movers and shakers of the design community in attendance to suggest the scope of the revival.

The Forum's most impressive conversion narrative recalled that moment in 1927 when Henry Ford abandoned the utilitarian Model T for the more stylish Model A. The story of the 1986 Ford Taurus revolved around a major corporation once again floundering because it no longer understood the marketplace. When Petersen became president of the company in 1980, he faced economic and social fallout from the energy crisis of 1979 and a sales slump that left Ford with a loss of a billion dollars for the year. As he told the story, the US auto industry was 'working with a set of clichés', and American cars had become 'progressively worse in a design sense' relative to Japanese and European competitors. Anticipating a general economic recovery, the entire Ford organization from executives to dealers remained content with current boxy models with heavy grilles, 'vinyl roofs', and 'imitation woodgrained interiors'—cars so awkward they 'couldn't be photographed attractively from any angle'.[14]

Thinking about the design process, Petersen realized that Ford's organization prevented communication among stylists, design engineers, production engineers, marketing people, retail dealers, and repair departments. Stylists offered only predictable changes they

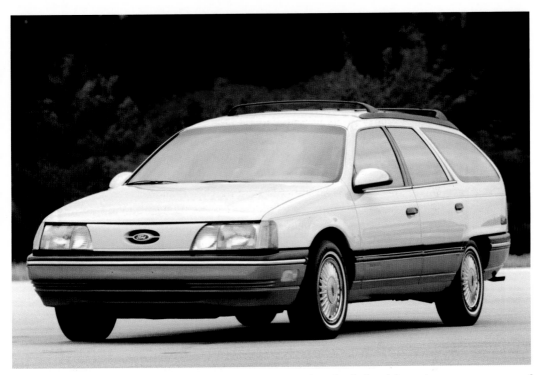

118 Jack Telnack and 'Team Taurus'

Taurus station wagon, Ford Motor Co., 1986

The Taurus introduced a rounded wedge shape, rising gently along the hood, windshield, and roof, then quickly falling away behind. With side panels slightly curved outward and no radiator grille to penetrate its pure volume, the Taurus possessed an integral coherence not seen in vehicle design since the late 1940s.

knew would fit parameters already defined by other components of production and distribution. Applying holistic 'quality' principles of W. Edwards Deming (1900–93), a management consultant whose Japanese fame had spread to the US, Petersen established an interdisciplinary 'Team Taurus' uniting design, engineering, manufacturing, and marketing in the process of conceiving a new car. Feedback from all units reached Telnack and his stylists as they envisioned the shape of a car that might save the company. When Telnack realized Petersen was sincere in his promise to 'empower' them to 'do a really unique car', they became 'emotionally involved . . . almost religious'. Automotive historians regard the Taurus [118] as 'the single most important American production design of the 1980s', marking 'the end of the sheer look' and the advent of 'the aero look'. This so-called 'jelly bean look' was widely imitated into the twenty-first century, not only for all makes of passenger cars but also for smaller objects like the popular point-and-shoot cameras whose curved plastic forms fit so naturally in the hand. The immediate critical acclaim and popular success of the Taurus served notice that design was again a force to be reckoned with.[15]

Those attending the Stanford Design Forum drew several lessons from the Taurus case. If talented designers were allowed to follow their instincts, they would create forms whose rightness for the cultural moment would attract publicity to a company and improve its sales against competitors. And if many competitors employed design

intelligently, then the synergistic results would be positive for all—and for the nation's economic health. But to speak of design as a marketing tool seemed too narrow. Reviving the Ford Motor Company had in fact required the total redesign of the company. More practically, Forum attendees knew that Telnack and Petersen had gained experience working in Ford's international branches, particularly in Europe, where the Ford Sierra had prefigured the Taurus's 'aero' look. Even if the Forum's international membership were not sufficient evidence of global cross-fertilization, one could point to the international perspective characteristic of the success of many products, for example the colourfully variable plastic Swatches that had saved the Swiss watch industry and the miniaturized Sony Walkman which simultaneously addressed the relative scarcity of personal space in Japan and the American desire for personal mobility. Philips and Braun had become the leading suppliers of electric shavers to Japan only after reducing their size to fit smaller Asian hands. It was even rumoured that the Taurus sold in Europe handled with a tighter, more 'European' feel than the car sold in the US. Only companies with designers alert to such complexities could weather competition that by definition would never end. On the other hand, as anti-establishment critics pointed out, to focus on the 'triad' of Japan, western Europe, and the US excluded the 85 per cent of the world's population who were not among the 'most sophisticated and affluent consumers'.[16] But in the flush of business expansion during the presidency of Ronald Reagan, critiques by Papanek and others were ignored as designers catered to an affluent American middle class awash in style.

Postmodern design from high-tech to high-touch

Dissatisfaction with modernism affected architecture and city planning before it reached design. In *The Death and Life of Great American Cities* (1961), the community activist Jane Jacobs (b. 1916) argued against the monolithic uniformity of the modernist vision and in favour of a human-scaled urban patchwork of old, new, and renovated buildings, promoting a diversity of uses best experienced at street level and not discernible from the bird's-eye perspective of an architectural model. Five years later the architect Robert Venturi (b. 1925) issued a manifesto, *Complexity and Contradiction in Architecture*, declaring a similar preference for 'messy vitality' over 'obvious unity'. Venturi overturned Mies's slogan 'less is more' by proclaiming 'less is a bore'. If readers had trouble locating vitality in the contemporary built environment, Venturi suggested they take a look at the 'honky-tonk elements' of the 'commercial strip'. In 1972 he and his partner Denise Scott Brown (b. 1931) expanded that insight in *Learning from Las Vegas*, which launched the postmodern movement by promoting the building

façade as a medium of communication. In its purest form—the huge, extravagant neon signs along the Strip in Las Vegas, dominating the visually insignificant casinos—architecture became an insubstantial, even 'antispatial' form of pure information.[17]

Designers of postmodern furniture and consumer goods abandoned any traditional notion of functionalism. Even during the streamline era, designers like Teague had believed there was one right form for each type of machine, and MoMA had continued to emphasize timeless perfection as the mark of good design. But such principles, the conscience if not the standard practice of the design profession for most of the twentieth century, evaporated quickly. The critic Ralph Caplan (b. 1925), a frequent contributor to *I.D.*, observed that 'boredom' was responsible for an 'impulse' towards flashy, colourful, ephemeral products. He was not surprised that 'after so many years of clean, stark, unlittered design, product designers, like architects, are saying, "Why the hell shouldn't there be some fun in it?"' Or as *Business Week* phrased it, 'form follows function' was yielding to 'form follows emotion'.[18]

This shift involved communication of ideas and images, often as metaphor. Although society was moving from an awareness of the machine as the driving force behind social and cultural change to an equally pervasive awareness of the computer and electronic information, nostalgia for the machine age lingered. In 1978 Joan Kron (b. 1928) and Suzanne Slesin (b. 1944) gave this feeling a name—'high-tech'—and popularized it with a 'source book for the home'. *High-Tech* opened with a dramatic two-page colour photograph of the Pompidou Centre by Richard Rogers (b. 1933) and Renzo Piano (b. 1937), recently completed in Paris. Its exposed frame and ductwork, illustrated without any reference to scale, looked like an unimaginably complex refrigeration unit. Kron and Slesin's handbook promoted the domestic interior use of industrial products such as wire storage systems, rolling tool carts, embossed rubber flooring, perforated steel decking, aluminium panelling, and shop lights with wire guards—all available off-the-shelf from hundreds of listed suppliers [**119**]. Rather than enshrining the machine as MoMA had done in 'Machine Art' in 1934, Kron and Slesin were salvaging the romanticized materials of a vanishing era and using them 'out of context' in domestic arrangements to evoke a mood.[19]

The high-tech style did not invoke modernism's serious utopianism but instead reflected an exaggerated play of artificial forms, surfaces, and textures familiar from science fiction films like *2001* (1968) and other pop culture representations of modernity. High-tech offered a comforting sense of referring to, or serving as a metaphor of, something already known. Within a few years, however, high-tech had become nightmarish, as in Terry Gilliam's (b. 1940) film *Brazil* (1985).

119 MORSA

Loft bed, *c.*1978

Some details of this
assemblage, such as the
caution sign and wire baskets
for magazines and snacks,
indicate the whimsical
romanticism of the brief high-
tech design moment.

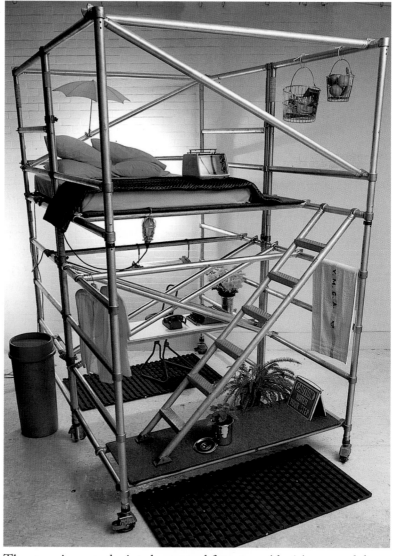

The stunning sets depicted a warped future world with exposed duct-
work looping everywhere, Corbusian apartment blocks gone grimy
and crumbling, and computers assembled from tiny television tubes
with glass magnifiers and clunky manual typewriter keys. Gilliam
extrapolated from the New York World's Fair of 1939 as if its dated
vision of the future had proven disastrously accurate. As the twentieth
century neared its end, postmodern design looped back to the past,
sometimes even to past futures, offering exaggerated two-dimensional
representations of the familiar presented in such a rush, as if real things
had become ephemeral simulations, that nothing remained for long in
the public eye and everything became a matter of style.

The first real hint of the shape of postmodern design came in 1978
when a radically transformed Philip Johnson, then in his early seven-

ties, announced a design for the AT&T building in New York. Abandoning Mies's glass-box modernism, he unveiled a model depicting a masonry shaft with a flat, stylized classical arcade at its base and the gigantic outline of a broken pediment at the roofline. Few people realized Johnson was cleverly alluding to *Learning from Las Vegas*, which had described 'the sign for the Motel Monticello' as 'a silhouette of an enormous Chippendale highboy . . . visible on the highway'. This arcane reference offered evidence of multiple levels of visual metaphor or coding that became typical of postmodern design, but people initially responded to the proposed structure not intellectually but emotionally, with a gleeful smile or a cry of outrage at the insertion of this monstrously inappropriate form into the New York skyline. Johnson's announcement prompted *I.D.* to publish readers' comments on the meaning of 'post-Modernism' for product designers. Most remained puzzled if not downright hostile. An exception was the consultant William Lansing Plumb (b. 1932), who complained that designers, though 'bored with what has gone on in the past 50 years', tended to overlook 'the need for something to be fun to use or fun to look at'. In a spirit of play, he applied vinyl Contact paper in a wood-grain pattern to a newspaper photograph of the AT&T model. Plumb considered this mock-up 'intellectually entirely supportable' because, as he observed of wood-grain vinyl, 'people like it, it makes people feel good, it's "warm," and it certainly is appropriate on a structure that looks like a grandfather clock'.[20]

Although these first hints of postmodern design were home-grown, American tastemakers of the 1980s remained open to European influence. Just as the spread of modernism to the US had depended on Europeans like Le Corbusier and Gropius reflecting back to Americans the modernity of their factory buildings and grain elevators, the quick American acceptance of postmodernism as a design style depended on European enthusiasm for such common elements of American consumer culture as wood-grained or marbleized Formica, cheap plastic products in gaudy colours, and gratuitous chrome accents. The protagonists in this second wave of twentieth-century European influence were the Italian designer Ettore Sottsass (b. 1917) and a shifting array of his collaborators, mostly Italian, collectively known as Memphis. The name evoked iconic aspects of such recent Americana as the blues, Elvis, rock 'n' roll, Dylan, and suburbia; it half seriously proposed a hieroglyphic significance as rich as that of ancient Egypt. The first Memphis show in Milan in 1981 exhibited furniture and accessories intended to confound purity and indulge excess. Assemblages of such planar forms as pyramids and trapezoids were surfaced with plastic laminates in bright solid colours or intricate, explosive patterns of zigzags and squiggles. Metal supports for tables, shelves, and lamps seemed to quiver or wiggle as if to suggest utter lack

120 Ettore Sottsass

Casablanca cabinet, Memphis, 1981

Widely illustrated in the US at the time of Memphis's first show in Milan and subsequently exhibited along with other Memphis artefacts in museums and galleries across the US, this cabinet communicated the movement's exuberant celebration of popular culture even though most of its products were fabricated by hand and thus prohibitively expensive for most people who saw them.

of support. Huge open cabinets by Sottsass [**120**] resembled totemic stick figures, juiced with electricity, their multiple arms of various colours projecting at sharp angles and incapable of holding anything in a functional sense. It all suggested a hallucinated extrapolation from 1950s populuxe though one of Sottsass's Memphis associates, the American Michael Graves (b. 1934), referred to 1920s Art Deco with the 'Plaza' dressing table [**109**].

Talk of Memphis eclipsed other topics among the American design community. The critic Richard Horn (1954–89) established a lofty motive for Memphis when he observed that the group's 'sofas and chaise lounges . . . address themselves not primarily to our backs and buttocks but to our minds'. The group's publicist Barbara Radice (b. 1943) intellectualized what Memphis was trying to accomplish in a glossy survey published in the US in 1984. She clearly distinguished Memphis from the whole modernist tradition. The group had 'abandoned the myths of progress and of a programme of cultural regeneration capable of changing the world according to a rational design'. Instead they were concerned with 'breaking ground, extending the field of action, broadening awareness, shaking things up, discussing conditions, and setting up fresh opportunities'. Towards these ends, their use of materials like plastic laminate offered 'new semantic and metaphoric possibilities, other modes of communication, another language, and even a change of direction'. If such comments seemed

vague, the eye could always scan the book's ravishing colour photographs. After all, as Radice confessed with regard to things in general, 'what matters to us is not their substance but their appearance, their virtual image', their presence in 'the world of TV screens'. Memphis design existed to be photographed, widely reproduced, and consumed as visual images.[21]

This emphasis on design as an opportunity for visual reproduction extended to the earliest American examples of postmodernism. Few people could afford a chair from the Venturi Collection offered by Knoll International in 1984, but the nine chairs in the set, resonating stylistically with Memphis, were widely illustrated even in the popular press [121]. Squat and uncomfortable, Venturi's chairs were fabricated in a pseudo-modernist mode from bent plywood with wide front and back surfaces veneered in rare woods or in patterned plastic laminate. Chair backs were cut out to create exaggerated two-dimensional outlines of historical furniture styles from Chippendale to Art Deco, with stops at Queen Anne, Hepplewhite, Sheraton, Empire, Biedermeier, Gothic revival, and Art Nouveau. Thumbing his nose at the modernists, Venturi quipped, 'Mies did one chair—I did nine'. While Venturi described the chair backs as resembling 'false fronts on the buildings of the old West', a hostile critique called them 'stagey . . . as if they are pieces of theatre design, mere cut-outs'.[22]

The Venturi Collection was only one of many Memphis-flavoured initiatives of the early 1980s. The Formica Corporation sponsored competitions and exhibitions promoting ColorCore, a new plastic laminate with solid colour throughout (lacking the black edge typical of most laminates). ColorCore could be layered, joined, and worked as a solid material, though it was limited to subdued pastels that evoked

121 Robert Venturi
Sheraton and Queen Anne chairs, Venturi Collection, Knoll International, 1984
Venturi's designs ironically combined the cut-out backs of the nineteenth-century Belter, the bent plywood of the Eameses, the Pop patterning of Memphis, and flat pastiches of historical furniture styles.

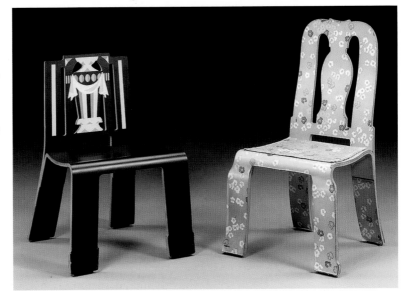

Highgirl dresser for the
exhibition 'Material
Evidence', Renwick Gallery,
Smithsonian Institution,
1985

After making a quick verbal
reference to Philip Johnson's
AT&T 'highboy', Maruyama's
Highgirl evoked 1950s
femininity with a high, narrow
chest of drawers, a precarious
triangular leg, a pink
supporting slab on the
opposite side, and a cream-
coloured front discreetly
marked by the squiggles and
check marks of Memphis—
soon to appear on everything
from watch dials to bed
sheets.

populuxe more accurately than Memphis did. Participants in 'Surface
and Ornament' in 1983 were prominent architects whose professional
dignity seemed to limit them to a dry irony. The young craftspeople
who contributed to 'Material Evidence', a collaboration of Formica
with the Smithsonian Institution in 1985, were more adventurous,
devising architectonic furniture bursting with humorous cultural and
historical references [**122**].

By the mid-1980s, postmodern design was all the rage among upper-
middle-class Americans. That the Memphis style so quickly became
popular served as evidence of the expansion of that segment of the
population which aspired to avant-garde taste when making consump-

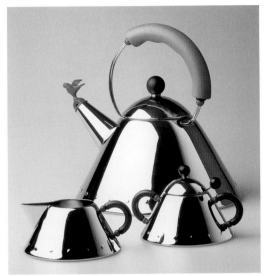

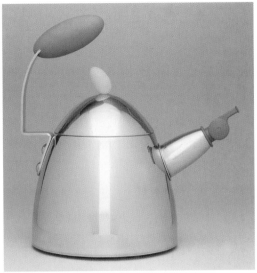

123 (above) **Michael Graves**

Whistling Bird tea kettle,
Alessi, 1985

Named after a bright-red bird-
shaped whistle perched at the
end of the spout, this gleaming
stainless steel kettle appeared
in the shape of a rounded
pyramid surmounted by a
looped handle insulated by a
bright turquoise grip.
Although its form intentionally
referred to Art Deco, it lacked
the hard-edged machine
precision of that era.

124 (above right) **Michael
Graves**

Stainless steel tea kettle,
Target Corp., 1999

Available for only $34.99 and
sold by a large retail chain, this
kettle possessed a playful
shape reminiscent of a host of
plump comic and cartoon
characters from the Little King
and Popeye's associate
Wimpy to the Blue Meanies
and Jeremy of the Beatles'
animated film *Yellow
Submarine* (1968). One need
not recognize the references
to realize postmodern design
had become user-friendly.

tion decisions. Only two years elapsed between the Italian firm Alessi's offering in 1983 of 11 limited-edition silver coffee and tea services, each designed by a prominent postmodern architect, including Graves, and the same firm's subsequent marketing of an 'upscale' but affordable Graves tea kettle [**123**]. There was something soft, cute, even biomorphic about it—an impression strengthened by the creamer and sugar bowl in miniature shapes identical to the kettle, like offspring, with cartoon-like ear-shaped handles. The kettle was sold at trendy houseware shops and museum shops for about $80—well within the splurge range of a poor design student. Despite Graves's considerable reputation, he was not afraid of self-parody. The cartoon reference became explicit in a variation on the Alessi kettle which was sold at outlets of the Disney Store in the 1990s. In this 'Gourmet Collection' edition, the wire handle was bent into a silhouette outline of Mickey Mouse complete with ears, and the whistle at the end of the spout became a red plastic Mickey playing a trumpet. The ultimate parody reached mass-market consumers in 1999 when Graves designed another stainless steel tea kettle with an anthropomorphic silhouette [**124**].

This tea kettle marked the start of a major marketing effort by the Target retail chain, whose executives hoped that a line of Michael Graves 'designer' products, nearly 200 in all, would distinguish Target as up-market next to its competitors Kmart and Wal-Mart. With only nine months to design the entire line, Graves hired the firm Design Guys of Minneapolis to collaborate with his office. After he had set the theme with a single sketch of an egg-like form which he described as 'particularly comfortable to the hand', the team adapted it for dozens of products. They were in such a hurry that in the case of small electrical appliances, they violated standard notions of modern functional design by devising shells to fit around existing Black & Decker

125 William Lansing Plumb
QT-50 portable cassette recorder, Sharp Electronics Corp., 1985
Created by an American designer for a Japanese company operating in the US, the QT-50 offered evidence of the sophistication of global business during the 'design decade' of the 1980s. Its 'retro' styling appealed to baby boomer parents looking for alternatives to a military-styled boom box when shopping for a daughter.

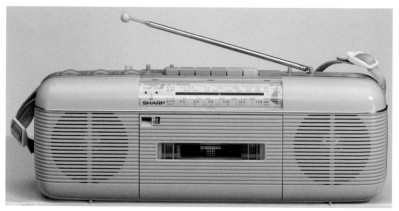

mechanisms. Most of these cheerfully bloated objects recalled the streamlined forms of the late 1930s, though enlivened by oversized handles and knobs. Newspaper advertising supplements proclaimed that Target's 'sensible and sublime objects' offered 'design which tends to transcend'. Above all, the new line enabled consumers to set about 'finding the fun in functional'.[23]

By 1999, the cartoonlike postmodernism of the Graves collection was an exercise in retro styling—a repackaging for ordinary folks of a design mode already outdated. The softening of form typical of Graves's approach to popular design had motivated many other product designers during the 1980s. Plumb, the joker who applied wood-grain vinyl to a photograph of the AT&T model, supervised Sharp's in-house design of the QT-50 portable cassette recorder [**125**] as a take-off on 1950s automotive styling with a horizontally grilled streamlined plastic case available in lime green and other 'ice-cream colours'.[24] Design director Blaich at Philips encouraged development of the Roller Radio, a similar device available in a range of bright, contrasting colours, with a front resembling the side of a 1930s cartoon car with outsized round speakers at each end as the tyres. A variant with a wide arc for a handle [**126**] seems in turn to have inspired Volkswagen's equally cartoon-like New Beetle prototype of 1994 [**127**]. This new anti-modernist soft design was not limited to colourful sound equipment escaping matt-black austerity. At Smart Design, for example, whose partners had first attracted attention with humorously oversized Memphis patterning on inexpensive Copco plastic dinnerware, the challenge of designing kitchen utensils for arthritic hands led to the successful OXO Good Grips line [**128**], proving that even matt black could be functional, humorously large, and sensuously irresistible to the touch.

The phrase 'high touch' gained currency as a way of suggesting design's shift from modernity to postmodernity. John Naisbitt (b. 1929), the futurist author of the bestseller *Megatrends* (1982), may have coined the phrase when he argued that every 'new technology' demanded 'a

126 Philips CID (Corporate Industrial Design)

Moving Sound series, Roller 2 portable cassette recorder, Royal Philips Electronics, 1986

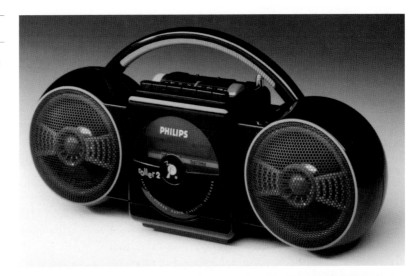

127 J. Mays

Volkswagen Concept 1 automobile, Volkswagen of America, 1994

Mays (b. 1954) designed this prototype of the New Beetle (1998) while heading Volkswagen's Design Center in California. After graduating from Art Center College in 1980, he worked for Audi in Germany during the 1980s when Philips's Rollers 1 and 2 were popular in Europe. The silhouette of Concept 1 bears a distinct resemblance to Roller 2. Both are examples of the 'retrofuturism' for which Mays was known.

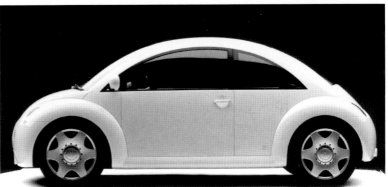

128 Smart Design

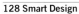

Good Grips vegetable peeler, OXO International, 1989

With the proportion of ageing people in the US population steadily increasing, more designers followed Smart Design's lead in finally responding to Victor Papanek's call for products addressing the needs of the elderly and disabled—though always with humour and style.

counterbalancing human response—that is, high touch'. Three years later, Katherine McCoy (b. 1945), co-director with her husband Michael McCoy (b. 1944) of Cranbrook's design department, was using the phrase in theoretical discussions of contemporary design. She argued that 'high touch' offered a 'compensating balance to the abstraction of the high technology that is shaping our daily experiences'. Industrial designers were 'specialists' at 'humanizing the machine for their users' by going beyond physical ergonomics to engineer 'the psychological, cognitive, and perceptual interface with the user'. Technology had to be 'brought to life, animated and humanized'. It had to be given a 'sensual aspect'. That was especially true for the new information

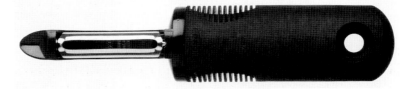

technologies, particularly the personal computer, which came into wide general use in the early 1980s. Just as the automobile had no obvious form in 1900, nor the radio in 1920, there was no obvious form for the computer, other than by analogy with the television set and the typewriter keyboard. McCoy and other theorists realized that the designer's responsibility increased greatly as society's dominant technologies became less mechanical, based more on silicon circuitry, and thus ever more miniaturized. A device's working elements no longer dictated its size and shape as they had throughout the industrial age. Instead the parameters of shape became arbitrary, open to a limitless range of choices so long as designers attended to the need for human interfaces functioning intuitively and appealing to the senses. As Katherine and Michael McCoy articulated the problem, 'if it can be anything, what should it be?'[25]

Initial responses to the design challenge of the digital age were often too literal. At Cranbrook, for example, the McCoys emphasized 'product semantics'—a phrase that became a buzzword among the design community. As defined most clearly by the critic Hugh Aldersey-Williams (b. 1959), to use product semantics simply meant to embed necessary information in the very design of an object: 'how to use a product, how to regard it, where to put it, how it fits into your life and into your culture'. Or as Michael McCoy told the *Wall Street Journal*, 'as the black box becomes a dominant part of our lives, we need visual cues'. For design students at Cranbrook in the 1980s, employing product semantics entailed coding similar to that of Venturi or Sottsass, except that the visual metaphors were as much functional as fun. One student project, the so-called Phonebook [**129**], garnered so much publicity that it became the poster child for product semantics. A

129 Lisa Krohn with Tucker Viemeister

Phonebook answering machine prototype, 1988 Krohn addressed the fact that many users had trouble programming an answering machine. Her proposed solution walked a user through the steps by providing rigid plastic 'pages' hinged to the device, through which one flipped as through the pages of a book, with each 'page' exposing the controls for a specific function.

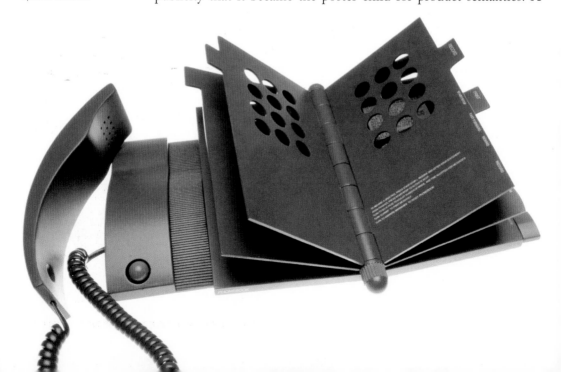

prototype of a telephone answering machine, the Phonebook was designed in 1988 by Lisa Krohn (b. 1964?) with the assistance of Tucker Viemeister (b. 1948) of Smart Design. Although the metaphor of a phonebook communicated clearly, the object itself took up too much desk space and would have become irritatingly obvious after a user had mastered its procedures. Even Michael McCoy later admitted that product semantics too often yielded 'one-liners' based on a 'very obvious analogy or simile'. As a French design critic observed in 1986, postmodern consumers assumed as a bare minimum that a product would be 'understandable', but after that they demanded it 'be capable of being *felt*'. With digital technologies of everyday life becoming more immaterial, designers had to restore a sensuous quality of touch that would feel 'playful, joyful, personal', and above all 'welcoming'.[26]

The shape of the digital: hardware, software, webware

The first personal computers assembled by hobbyists in the early 1970s looked like science fair projects mounted in cigar boxes. By the early 1980s, dozens of small California entrepreneurs as well as a few giants like IBM were trying to attract adventurous consumers with machines boasting one or two 5-inch floppy drives and 64 kilobytes of RAM. Most were housed in ill-proportioned cases, often with flashy decorative trim [**130**]. No one knew what a personal computer ought to look like, nor how to arrange its parts. The 'principal challenge', according to one industrial designer, was 'to give personality and meaning to a technology that was still being treated as though it was anonymous'.[27]

As the design of computers evolved, visual and operational coherence increased steadily as hardware and software designers worked to

130 Anonymous

Kaypro II computer, Kaypro Computer Co., 1982

An exception to the rule of ill-conceived design among the earliest personal computers, the Kaypro II, momentarily a leader in the new industry, was a 26-pound (11.8-kg) 'portable' housed in a heavy-gauge sheet metal case evoking a mid-twentieth-century military field radio. The keyboard fastened face down over the front to form a fully enclosed carrying case.

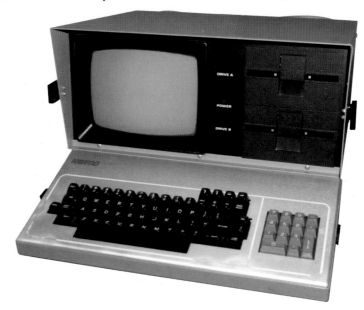

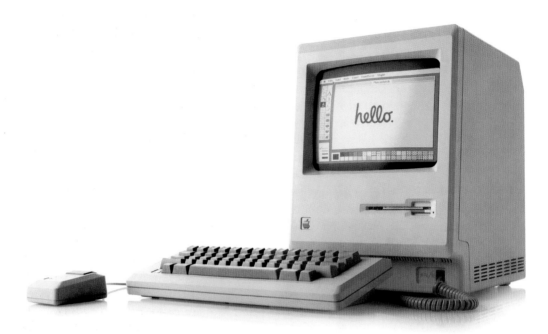

131 Jerry Manock

Macintosh computer, Apple Computer Co., 1984
The original Macintosh possessed such carefully conceived touches as an undercut grip moulded into the top, unnoticed until required. A recessed base projected the front towards the user and created continuity of line with a detached keyboard. Bevelled edges visually united computer, keyboard, and mouse. Everything looked and felt solid, inspiring confidence.

make the devices and their programs more intuitively accessible. Paradoxically, however, the 'output' of personal computers—the online and virtual electronic realms they mediated, the human situations their use generated, and the look and feel of the work they enabled people to create—became more complex, fragmented, layered, collaged, and just plain cluttered. These two trends proceeded simultaneously as if the computer itself, as a tool, was a manifestation of clear, rational, progressive modernity, while its products (whether aesthetic, social, or cultural) promoted a confusingly disjunctive postmodernity. To employ the distinction between modern and postmodern suggested by Venturi, the design of the computer moved towards 'obvious unity' while the designs it facilitated often reflected and stimulated a 'messy vitality'.

The Macintosh computer [**131**] exemplified these conflicting trends of modern input and postmodern output. Just as Henry Ford had democratized the automobile with his Model T, Steve Jobs (b. 1955), a co-founder of Apple Computer, set out to make the personal computer a necessary household appliance 'as easy to use as a toaster'.[28] Jobs, a college dropout who had initially worked from his garage, had already scored a tremendous success in 1977 with the professional-looking Apple II computer, whose blocky, beige case set the first appearance standard for the personal computer. The 'user-friendly' Macintosh, introduced in 1984, possessed a beige plastic case with a simple integral volume enclosing the monitor above an off-centre floppy drive. Jerry Manock (b. 1944), an industrial designer trained at Stanford University, specified a diminutive size and chunky appearance which gave the

computer a reassuring image at once scrappy and cuddly, as if this were a friendly object to be identified with, not an alien object to be brought under control. The mouse invited a user to enjoy a tactile, intimate familiarity with the Mac—an experience that differentiated it from all other personal computers up to that time.

Although the Macintosh as an object attracted rave reviews from journalists, and MoMA added it to the permanent design collection, the computer's most unique design elements involved software and user interface. The standard advertising image represented the Mac with the word 'hello' scrawled across the screen in a cheerful cursive— an unprecedented sight for a public accustomed to tiny green or amber lines of text glowing from black screens. When someone sat in front of the Mac for the first time, hand on mouse, they too could magically produce such writing—or any sort of drawing they wanted—merely by moving the mouse like a pencil. Middle-class consumers soon became familiar with a so-called graphical user interface (GUI), icons, pull-down menus, bitmapped displays, a desktop with folders and files, and the ability to move the cursor anywhere on the screen by clicking and moving the mouse. None of these were Apple innovations. They emerged from the work of Alan Kay (b. 1940) and others at Xerox's Palo Alto Research Center (PARC), but Jobs commercialized them. His team added such concepts as the ability to 'drag-and-drop' a 'file' from one 'place' to another. The Mac's software involved designers as varied as Susan Kare (b. 1954), a graphic designer who devised the Mac's pixelated fonts and amusing icons, and Andy Hertzfeld (b. 1953), a programmer whose dedication to writing the 'tightest, most elegant code possible' led him to spend months reducing the definition of the scrollbar from 80 to 20 pages. Paul Kunkel, the historian of Apple design, has described this as 'perhaps the best example of "elegant simplicity" in the entire product'.[29]

The achievement of the original Mac was seamless integration of hardware and software and the user's simultaneous interaction with both. Apple's design triumph became all the more obvious in 1990 when Microsoft introduced a new operating system, Windows 3.0, clumsily duplicating most features of the Mac's GUI. Despite Apple's more user-friendly operating system, the company steadily lost market share during the late 1980s and 1990s owing to poor business decisions. However, the company saved its reputation by abandoning the beige box, which had become boring as reiterated by every PC clone manufacturer. The company's in-house design director, Jonathan Ive (b. 1967), shook up the design world in 1998 with the iMac [**132**], a desktop machine that restored the original Mac's integration of computer and monitor with a sculptural streamlined shell of translucent 'bondi' blue polycarbonate plastic and a pinstripe monitor surround. Ive's prior experience designing washbasins and bathtubs in the UK

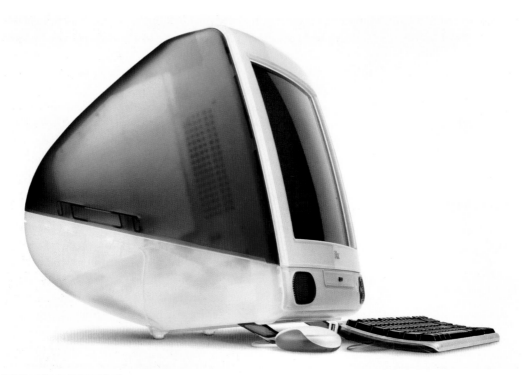

132 Jonathan Ive

iMac computer, Apple
Computer Co., 1998
The gumdrop form and
embossed blue Apple logo
emphasized the sheer
entertainment of surfing the
Web and downloading music,
while the machine's functional
parts, dimly visible through
the casing, reminded
observers this was a serious
piece of equipment. Other
translucent colours soon
followed the original 'bondi'
blue—blueberry, strawberry,
lime, tangerine, and grape—
almost as if Apple were selling
gummi bears.

may have influenced the iMac's shape, but his stated motive remained
that of the original Macintosh: 'to create something accessible, under-
standable, almost familiar'.[30] In one sense, though everything had
changed in computer hardware design—and the iMac sparked a wave
of staplers, CD players, irons, and sewing machines with sculptural
cases of colourful translucent plastic—in another, nothing had changed.
Apple's computers continued to suggest the coherence of the informa-
tion age as a progressive extension of modernity.

However, the use of the Macintosh as a design tool actually marked
a sharp break with the recent past. Rather than encouraging a coher-
ent, rational, integrative aesthetic for the communication of informa-
tion, the Mac instead provoked a sense of fragmentation and sensory
overload. Its innovative interface immediately attracted young graphic
designers. Among them were Rudy VanderLans (b. 1955) and Zuzana
Licko (b. 1961), who in 1983 had just begun publishing *Emigre*, a mag-
azine of experimental literature and punk-inspired graphics, with
VanderLans concentrating on images and Licko on typography. In
calling it 'the magazine that ignores boundaries', they referred in part
to its unfinished scrapbook aesthetic, with bits of typed or printed
copy, torn scraps of found images and photocopies, underlining and
scribbling, all pasted up in an accidental manner that mirrored real-
world chaos. In the process of preparing the second issue when the
original Mac was introduced, they jumped at *MacWorld* magazine's
offer to teach illustrators how to use MacPaint software. The rough,

133 Rudy VanderLans

Poster for *Emigre* magazine, 1989

Using the Mac for designing fonts and laying out issues of *Emigre* enabled Licko and VanderLans to extend the punk aesthetic they had already begun to develop, which relied on juxtaposition, layering of texts and images, frequent shifts in fonts, and a mazelike density and complexity.

amateurish quality of the Mac's low-resolution bitmapped graphics and fonts enabled them to extend the effects they sought [**133**]. As *Emigre* became essential for the digital avant-garde, VanderLans's graphics and Licko's fonts influenced the appearance not only of *Wired* magazine, which began publishing in 1993, but also of more general publications.

Another graphic designer who grasped the Mac's possibilities was April Greiman (b. 1948), who had studied modernist typography in Basel. Even before the advent of inexpensive computers as design tools, she had established herself in Los Angeles as a 'new wave' designer known for layering found images to create complex colourful

134 April Greiman

Detail of poster for Greiman's lecture 'Snow White and the Seven Pixels', 1986

This digital self-portrait captured something of the slipping epistemological frames of material and virtual realities. Designers like Greiman felt they were alternately creating and exploring unprecedented new realms of experience.

assemblages reminiscent of surrealist dreamscapes. Like VanderLans and Licko, she believed computer graphics could be simultaneously 'very sophisticated' because they relied on advanced technology and 'very primitive' because their potential was largely unknown. Greiman's work of the 1980s and 1990s relied on digital manipulation of scanned images and texts, usually heavily pixilated and often juxtaposed in ways that defied rational perception of scale [**134**]. She imagined design as a process rendered democratic by the computer, open to everyone through the mastery of a few basic techniques. Graphic work on the Mac revealed 'a new texture, a new design language, a new landscape in communications'. She recognized, however, that this was not a new vision in the sense that a utopian modernist might have claimed. Instead, she argued that 'all dimensions . . . are present simultaneously' and that 'new techniques typically overlap rather than replace old techniques'. Greiman celebrated chance and contingency. 'You hit the wrong button', she enthused, 'and all of a sudden you've got dots all over your logo'. In her view, 'accidents' were 'usually the best things to happen to my work'.[31]

Such accidents were not yet common events for the average consumer of digital experiences when Greiman made those comments. The psychologist Donald A. Norman (b. 1935) wrote an entire book in 1998 about 'the invisible computer', arguing that designers should make hardware and software so accommodating to bodies and minds that the means of communication would fade from consciousness.[32] By then, however, the physical computer was already shrinking in significance next to the information and entertainment it provided through millions of websites and webpages—every last one of them

consciously designed by someone. The Web's expansion after the design of its protocol by the British software engineer Tim Berners-Lee (b. 1955) had been phenomenal. In the autumn of 1993, when the first graphical browsing software was introduced, the entire World Wide Web had only 200 servers. But the name of that first browser, Mosaic, expressed the essence of the Web and of the experience it offered in ever greater variety and abundance. It was almost as if the images created by VanderLans, Licko, and Greiman, emphasizing hybridity, layering, contingency, and accident, had prefigured the shape of digital experience.

As the architect Peter Anders suggested, the cyberspace for which computer hardware and software served as the portal seemed at first similar to the physical or geographic spaces of cities, buildings, and 'other option-rich environments' in which 'users . . . determine the narrative of their experience' by choosing to move this way or that. To extend that insight, cyberspace might be said to consist of disconnected bits and pieces, some of them well designed, others poorly, constructed by different people at different times. While material buildings and objects remain 'comparatively static' and make strict physical demands on their users, cyberspace yields far more readily in response to its users. According to Anders, 'users of cyberspace are often complicit with the space—by deliberately selecting options'—or by following links from one space to another according to individual need, personal whim, or even random association. Thus cyberspace, unlike the 'static' products of the traditional design process, is 'dynamic' and 'changing'. Rather than providing a 'coherent world view' such as the modernists aspired to, the Web offered a proliferating 'multiplicity of concurrent views' that served to exacerbate postmodern 'ephemerality and fragmentation'.[33]

The information overload of the Web exemplified a society in which, as an Italian design critic observed, 'immateriality takes command'.[34] All the same, the material infrastructure had to be maintained —and designed—even if an increasing proportion of conscious human attention focused on the immaterial. As the twenty-first century opened, at least one philosopher of the digital unexpectedly predicted a 'golden age of industrial design'. Malcolm McCullough (b. 1957), a software designer turned professor of architecture, pointed out that CAD/CAM (computer-aided design and manufacturing) made it possible to move easily from three-dimensional images generated on screen to actual physical prototypes of products intended for possible manufacture. The ability to generate and manipulate such on-screen images, having all the complexity and nearly the density of physical objects, required an almost intuitive degree of hand–eye coordination similar to that of a traditional artisan. The immediacy of such digital designing—unmediated by model-makers or tool-and-die makers—

was unprecedented. It seemed possible that computer hardware and software would finally erase the profound gap between designer and maker that had haunted industry throughout the modern era. Form and function might finally coalesce as the process of designing merged with the products of design.

But McCullough carried his reflections further to encompass the user as well as the designer and maker. Rather than necessarily creating a population of passive consumers of immaterial images, the computer ultimately offered everyone 'a means for combining the skilful hand with the reasoning mind'.[35] In a sense, it seemed that the history of design in the US had come full circle. Although most people could not fathom the complexity of the software that enabled them to design their own websites, or that in the future might enable them to participate in the designing of their own clothes, furnishings, appliances, or automobiles, the transparency of that software's interfaces gave them a feeling of being closer to the source of things, closer to the basic level of the artisan or craftsperson, than at any time since the advent of the Industrial Revolution. Everyday experiences in the digital realms of computing and communications media afforded a feeling that the shape of things was more malleable to individual desires than at any prior time in history. That very belief in malleability, even if it as yet involved mostly the ephemeral experiences of popular culture rather than the necessities of physical survival, fostered explosively proliferating forms of expression addressed to increasingly smaller subcultures. With the possibility of each individual becoming a digital designer in those areas of life personally regarded as most significant, the modernist vision of rational, universal coherence finally dissolved. What remained was the exuberant proliferation that had marked design in the US for the past 200 years.

Notes

Introduction

1. F. Pick quoted by W. H. Mayall, *Principles in Design* (London, 1979), 90.
2. H. A. Simon, *The Sciences of the Artificial* (Cambridge, Mass., 1969), 5; H. Petroski, *The Evolution of Useful Things* (New York, 1993), 22; R. Caplan, *By Design* (New York, 1984; orig. 1982), 15; and D. Pye, *The Nature and Art of Workmanship* (Cambridge, 1968), 71.
3. P. Greenhalgh, 'Foreword' to C. D. Edwards, *Victorian Furniture: Technology and Design* (Manchester, 1993).
4. R. Buchanan, 'Rhetoric, Humanism, and Design', in R. Buchanan and V. Margolin (eds.), *Discovering Design: Explorations in Design Studies* (Chicago, 1995), 26; P. Bourdieu, *Distinction: A Social Critique of the Judgement of Taste* (Cambridge, Mass., 1984; orig. 1979), 5.
5. S. Bayley, *In Good Shape: Style in Industrial Products 1900 to 1960* (London, 1979), 10.

Chapter 1. The Emergence of the American System, 1790–1860

1. T. Coxe, *An Address to an Assembly of the Friends of American Manufactures* (1787), reprinted in M. B. Folsom and S. D. Lubar (eds.), *The Philosophy of Manufactures: Early Debates over Industrialization in the United States* (Cambridge, Mass., 1982), 57.
2. Quoted by J. C. Miller, *The First Frontier: Life in Colonial America* (New York, 1966), 115.
3. *The American Museum* quoted by R. M. Tryon, *Household Manufactures in the United States 1640–1860* (Chicago, 1917), 126.
4. N. Rosenberg, 'Why in America?', in O. Mayr and R. C. Post (eds.), *Yankee Enterprise: The Rise of the American System of Manufactures* (Washington, 1981), 54.
5. Stevenson quoted by C. Pursell, *The Machine in America: A Social History of Technology* (Baltimore, 1995), 79; A. de Tocqueville, *Democracy in America* (New York, 1945; orig. 1835), vol. 2: 34.
6. Grund quoted by M. Fisher, *Workshops in the Wilderness: The European Response to American Industrialization, 1830–1860* (New York, 1967), 172; *London Observer* quoted by R. F. Dalzell Jr., *American Participation in the Great Exhibition of 1851* (Amherst, 1960), 52; immigrant quoted by Fisher, *Workshops in the Wilderness*, 176; and de Tocqueville, *Democracy*, vol. 2: 141.
7. de Tocqueville, *Democracy*, vol. 2: 50, 52, 169–70.
8. de Tocqueville, *Democracy*, vol. 2: 51, 53.
9. J. A. Kouwenhoven, *Made in America: The Arts in Modern Civilization* (Garden City, 1948), 13–14; de Tocqueville, *Democracy*, vol. 2: 137.
10. Broadside reproduced by R. Bishop and P. Coblentz, *American Decorative Arts: 360 Years of Creative Design* (New York, 1982), 146.
11. D. R. Hoke, *Ingenious Yankees: The Rise of the American System of Manufactures in the Private Sector* (New York, 1990), 55.
12. Motto quoted by C. W. Drepperd, *American Clocks and Clockmakers* (Boston, 1958; orig. 1947), 110; C. Jerome, *History of the American Clock Business for the Past Sixty Years* (New Haven, 1860), 40, 49–50.
13. Jerome, *History of the American Clock Business*, 90; quoted by D. A. Hounshell, *From the American System to Mass Production 1800–1932: The Development of Manufacturing Technology in the United States* (Baltimore, 1984), 60.
14. *Punch* quoted by Dalzell, *American Participation*, 43.
15. *The Times*, *Albany Journal*, and *Liverpool Times* quoted by Dalzell, *American Participation*, 48, 49, 52.
16. *The Art Journal Illustrated Catalogue of the Industry of All Nations* (London, 1851), 212, 148, 128; Greeley quoted by C. T. Rodgers, *American Superiority at the World's Fair* (Philadelphia, 1852), 125.
17. Greenough to Emerson (28 December 1851) in N. Wright (ed.), *Letters of Horatio*

Greenough, American Sculptor (Madison, 1972), 400–1; H. Greenough, The Travels, Observations, and Experience of a Yankee Stonecutter (1852; facsimile reprint Gainesville, 1958), 170–1, 19, 15.

18. Greenough, Travels, 33, 138–9, 172.

19. R. W. Emerson, 'Beauty,' in The Prose Works of Ralph Waldo Emerson (Boston, 1875), vol. 2: 472–3; H. D. Thoreau, Walden; or, Life in the Woods (Boston, 1897; orig. 1854), 60.

20. Catalogue quoted by J. G. Shea, The American Shakers and Their Furniture (New York, 1971), 42.

21. Quoted by Rodgers, American Superiority at the World's Fair, 125.

22. G. Wallis, New York Industrial Exhibition: Special Report of Mr. George Wallis (1854), reprinted in N. Rosenberg (ed.), The American System of Manufactures (Edinburgh, 1969), 218, 243, 251.

23. Wallis, New York Industrial Exhibition, 267.

24. Quoted by G. R. Cooper, The Sewing Machine: Its Invention and Development (Washington, 1976), 34.

25. Wallis, New York Industrial Exhibition, 294–5.

26. C. D. Edwards, Victorian Furniture: Technology and Design (Manchester, 1993), 125.

27. Wallis, New York Industrial Exhibition, 281–2, 304.

28. B. Silliman Jr. and C. R. Goodrich (eds.), The World of Science, Art, and Industry Illustrated from Examples in the New-York Exhibition, 1853–54 (New York, 1854), xi.

29. Silliman and Goodrich, The World of Science, Art, and Industry, 169, 15, 16.

30. Quoted by A. J. Pulos, American Design Ethic: A History of Industrial Design to 1940 (Cambridge, Mass., 1983), 119.

Chapter 2. Art and Industry in the Gilded Age, 1860–1918

1. S. J. Bronner, 'Introduction' to Bronner (ed.), Consuming Visions: Accumulation and Display of Goods in America 1880–1920 (New York, 1989), 8.

2. C. E. Beecher and H. B. Stowe, The American Woman's Home; or, Principles of Domestic Science (New York, 1869), 24, 84–5, 89–94.

3. H. P. Spofford, Art Decoration Applied to Furniture (New York, 1878), 215; Spofford quoted by G. Wright, Moralism and the Model Home: Domestic Architecture and Cultural Conflict in Chicago 1873–1913 (Chicago, 1980), 21; and C. L. Eastlake, Hints on Household Taste in Furniture, Upholstery and Other

Details, reprint of 1878 edn (New York, 1986), 118, 174, 19.

4. American Architect quoted by S. Darling, Chicago Furniture: Art, Craft, & Industry 1833–1983 (New York, 1984), 69; C. Cook, The House Beautiful: Essays on Beds and Tables, Stools and Candlesticks (New York, 1878), 282.

5. E. S. Morse, Japanese Homes and Their Surroundings (Boston, 1886), 309, 117; W. Smith, Art Education, Scholastic and Industrial (Boston, 1873), 217; Eastlake, Hints on Household Taste, 206; Smith, Art Education, 216–17; and C. P. Stetson [Gilman], 'The Yellow Wall-Paper: A Story', New England Magazine 11 (January 1892), 648–9.

6. American Architect quoted by J. D. Kornwolf, 'American Architecture and the Aesthetic Movement', in A. Horbar (ed.), In Pursuit of Beauty: Americans and the Aesthetic Movement (New York, 1986), 381.

7. J. A. Hertzman, 'Sources of the Technological Aesthetic: The Architecture of the Reciprocating Engine in the Eighteenth and Nineteenth Centuries', Ph.D. dissertation, University of North Carolina at Chapel Hill (1978), 313, 311, 327.

8. Huneker quoted by A. C. Golovin, 'Foreign Nations', in R. C. Post (ed.), 1876: A Centennial Exhibition (Washington, 1976), 177; W. Smith, The Masterpieces of the Centennial International Exhibition Illustrated: Volume II: Industrial Art (Philadelphia, 1877), 320.

9. G. W. Nichols, Art Education Applied to Industry (New York, 1877), 161–2.

10. Smith, Masterpieces, 122.

11. Quoted by P. Scranton, Endless Novelty: Specialty Production and American Industrialization (Princeton, 1997), 85.

12. Morse, Japanese Homes, xxxv, xxxvii; Nichols, Art Education, 181; and Philadelphia Evening Bulletin (9 June 1877) quoted by W. Halén, Christopher Dresser: A Pioneer of Modern Design (London, 1993), 44.

13. M. G. Humphreys, 'The Progress of American Decorative Art', in C. Wheeler (ed.), Household Art (New York, 1893), 137.

14. Quoted by K. H. F. O'Brien, '"The House Beautiful": A Reconstruction of Oscar Wilde's American Lecture', Victorian Studies 17 (June 1974), 417, 402.

15. C. Dresser, Principles of Decorative Design (London, 1873), 147, 21; C. Dresser, The Art of Decorative Design (London, 1862), 1; Dresser, Principles of Decorative Design, 147; and Dresser, The Art of Decorative Design, 20–1.

16. W. Morris, Hopes and Fears for Art (1882),

reprinted in *The Collected Works of William Morris* (London, 1914), vol. 22: 5, 14, 22, 76.

17. Smith, *Masterpieces*, 6, 30, 228.

18. Smith, *Masterpieces*, 228, 310; Smith, *Art Education*, 27; and I. E. Clarke, *Art and Industry: Instruction in Drawing Applied to the Industrial and Fine Arts: Part I* (Washington, 1885), cxxxvii.

19. Spofford and *Scribner's* quoted by M. Johnson, 'The Artful Interior', in Horbar, *In Pursuit of Beauty*, 116–17; Tiffany quoted by E. Boris, *Art and Labor: Ruskin, Morris, and the Craftsman Ideal in America* (Philadelphia, 1986), 143.

20. Wheeler quoted by A. Callen, *Angel in the Studio: Women in the Arts and Crafts Movement 1870–1914* (London, 1979), 131, and by I. Anscombe, *A Woman's Touch: Women in Design from 1860 to the Present Day* (New York, 1984), 38.

21. Quoted by C. Lynn, 'Surface Ornament: Wallpapers, Carpets, Textiles, and Embroidery', in Horbar, *In Pursuit of Beauty*, 80.

22. N. Harris, 'Louis Comfort Tiffany: The Search for Influence', in A. Duncan, M. Eidelberg, and N. Harris, *Masterworks of Louis Comfort Tiffany* (New York, 1989), 41.

23. Quoted by R. Koch, *Louis C. Tiffany, Rebel in Glass* (New York, 1964), 123.

24. Quoted by A. Duncan, 'Introduction' to *Masterworks of Louis Comfort Tiffany*, 7.

25. Harris, 'Louis Comfort Tiffany', *Masterworks of Louis Comfort Tiffany*, 37.

26. E. Wharton and O. Codman Jr., *The Decoration of Houses* (New York, 1897), unpaginated 'Introduction'; final phrase quoted by B. Brooks, 'Clarity, Contrast, and Simplicity: Changes in American Interiors, 1880–1930', in J. H. Foy and K. A. Marling (eds.), *The Arts and the American Home, 1890–1930* (Knoxville, 1994), 22.

27. Quoted by Anscombe, *A Woman's Touch*, 41.

28. O. L. Triggs, *Chapters in the History of the Arts and Crafts Movement* (Chicago, 1902), 160–1.

29. Booklet quoted by H. Peck, *The Book of Rookwood Pottery* (New York, 1968), 74; *House Beautiful* quoted by E. Cumming and W. Kaplan, *The Arts and Crafts Movement* (London, 1991), 166.

30. Norton and D. Ross quoted by E. S. Cooke Jr., 'Talking or Working: The Conundrum of Moral Aesthetics in Boston's Arts and Crafts Movement', in M. B. Boyd (ed.), *Inspiring Reform: Boston's Arts and Crafts Movement* (New York, 1997), 21, 30.

31. Quoted by Darling, *Chicago Furniture*, 218.

32. *The Upholsterer and Decorator* quoted by Brooks, 'Clarity, Contrast, and Simplicity', 37.

33. Advertisement (7 October 1900) reproduced by D. M. Cathers, *Furniture of the American Arts and Crafts Movement: Stickley and Roycroft Mission Oak* (New York, 1981), 37.

34. Quoted by Darling, *Chicago Furniture*, 235.

35. *Upholstery Dealer and Decorative Finisher* quoted by A. T. D'Ambrosio, '"The Distinction of Being Different": Joseph P. McHugh and the American Arts and Crafts Movement', in B. Denker (ed.), *The Substance of Style: Perspectives on the American Arts and Crafts Movement* (Winterthur, 1996), 147; R. G. Wilson, '"Divine Excellence": The Arts and Crafts Life in California', in K. R. Trapp (ed.), *The Arts and Crafts Movement in California: Living the Good Life* (New York, 1993), 16–17; and catalogue quoted by B. Sanders, *A Complex Fate: Gustav Stickley and the Craftsman Movement* (New York, 1996), 43–4.

36. Craftsman booklet quoted by D. A. Davidoff, 'Maturity of Design and Commercial Success: A Critical Reassessment of the Work of L. and J. G. Stickley and Peter Hansen', in Denker, *The Substance of Style*, 164; Davidoff, 'Maturity of Design and Commercial Success', 163.

37. Quoted by Boris, *Art and Labor*, 62.

38. Hubbard quoted by Boris, *Art and Labor*, 147; Roycroft brochure (1923) quoted by G. Naylor, *The Arts and Crafts Movement: A Study of Its Sources, Ideals and Influence on Design Theory* (Cambridge, Mass., 1971), 114.

39. Quoted by Boris, *Art and Labor*, 62.

Chapter 3. Designing the Machine Age, 1918–1940

1. R. S. Lynd and H. M. Lynd, *Middletown: A Study in Modern American Culture* (New York, 1929), 99–102.

2. Lynd and Lynd, *Middletown*, 253; R. S. Lynd with A. C. Hanson, 'The People as Consumers', in *Recent Social Trends in the United States: Report of the President's Research Committee on Social Trends* (New York, 1933), 857.

3. L. Mumford, 'The Machine and Its Products', *The American Mercury* 10 (January 1927), 64; H. Campbell, *Household Economics* (New York, 1907; orig. 1896), 119, 87, 109, 110, 119–20.

4. Quoted by M. Banta, *Taylored Lives: Narrative Productions in the Age of Taylor, Veblen, and Ford* (Chicago, 1993), 235–40.

5. C. Frederick, 'The New Housekeeping: How It Helps the Woman Who Does Her Own Work', *Ladies' Home Journal* 29 (September 1912), 13.

6. M. Pattison, *Principles of Domestic Engineering; or the What, Why and How of a Home* (Colonia, 1915), 1, 16, 241, 68, 269, 66.

7. *The Hoosier Special*, Penn Furniture Co. (*c*.1910), unpaginated.

8. E. de Wolfe, *The House in Good Taste* (New York, 1975; orig. 1913), 26, 3, 6, 32; final phrase quoted by I. Anscombe, *A Woman's Touch: Women in Design from 1860 to the Present Day* (New York, 1984), 72.

9. Manufacturer quoted by C. R. Richards, *Art in Industry* (New York, 1929), 82; R. F. Bach, *Museums and the Industrial World* (New York, 1926), 1; R. F. Bach, 'What Is the Matter with Our Industrial Art?', *Arts and Decoration* 18 (January 1923), 46; and 'Beauty and the Machine', *The Survey* 51 (15 March 1924), 690.

10. Quoted by R. L. Duffus, *The American Renaissance* (New York, 1928), 116.

11. H. A. Read, 'The Exposition in Paris', *International Studio* 82 (November 1925), 96; R. Wright, 'The Modernist Taste', *House & Garden* 48 (October 1925), 110.

12. Calkins quoted by J. Lears, *Fables of Abundance: A Cultural History of Advertising in America* (New York, 1994), 312; Read, 'The Exposition in Paris', 94–5.

13. US Commission, *International Exposition of Modern Decorative and Industrial Art in Paris, 1925* (Washington, 1926), 16, 21–2.

14. P. T. Frankl, *New Dimensions: The Decorative Arts of Today in Words & Pictures* (New York, 1928), 61; Simonson quoted by W. H. Baldwin, 'Modern Art and the Machine Age', *The Independent* 119 (9 July 1927), 39.

15. The phrase is from the title of R. R. Updegraff, *The New American Tempo: and the Stream of Life* (Chicago, 1929).

16. Deskey quoted by K. Davies, *At Home in Manhattan: Modern Decorative Arts, 1925 to the Depression* (New Haven, 1983), 67.

17. R. F. Bach, 'American Industrial Art', in *The Architect and the Industrial Arts: An Exhibition of Contemporary American Design* (New York, 1929), 22.

18. L. Mumford, 'Culture and Machine Art'; L. Simonson, 'New Materials'; and P. T. Frankl, 'The Home of Yesterday, To-day and To-morrow'; all in R. L. Leonard and C. A. Glassgold (eds.), *Annual of American Design 1931* (New York, 1930), 9, 67, 27.

19. W. B. Stout, 'Art and the Motor Car', *Society of Automotive Engineers Bulletin* (September 1916), 739, 743.

20. Phrase from D. A. Hounshell, *From the American System to Mass Production 1800–1932: The Development of Manufacturing Technology in the United States* (Baltimore, 1984), 263; Grand Rapids analogy from R. Batchelor, *Henry Ford: Mass Production, Modernism and Design* (Manchester, 1994), 69–70.

21. F. P. Keppel, 'The Arts in Social Life', in *Recent Social Trends*, 977; R. Abercrombie, *The Renaissance of Art in American Business* (New York, 1929), 7.

22. R. S. Lynd and H. M. Lynd, *Middletown in Transition: A Study in Cultural Conflicts* (New York, 1937), 46.

23. E. E. Calkins, 'The New Consumption Engineer and the Artist', in J. G. Frederick (ed.), *A Philosophy of Production: A Symposium* (New York, 1930), 109, 113–14, 117, 120, 124; R. Sheldon and E. Arens, *Consumer Engineering: A New Technique for Prosperity* (New York, 1932), 63, 194.

24. J. H. Fairclough, 'Comment', in I. D. Wolf and A. Purves (eds.), *How the Retailer Merchandises Present Day Fashion, Style and Art* (New York, 1929), 8; I. D. Wolf, 'Style Organization from the Executive's Viewpoint', in Wolf and Purves, *How the Retailer Merchandises*, 4; and J. H. Fairclough quoted by J. E. Alcott, '*Style Challenges/Industry Answers*', *Factory and Industrial Management* 77 (March 1929), 466.

25. 'Keeping a Step Ahead of Competitors: Notes on the Case History of the "Coldspot" Refrigerator Developed by Raymond Loewy' (*c*.1939), typescript consulted at the office of Raymond Loewy International, New York, 1975.

26. [G. Nelson], 'Both Fish and Fowl', *Fortune* 9 (February 1934), 90.

27. J. Sinel, 'What Is the Future of Industrial Design?', *Advertising Arts* (9 July 1930), 17; R. Loewy, 'Designing Towards Profits', *Steel* 103 (1 August 1938), 36; H. Van Doren, *Industrial Design: A Practical Guide* (New York, 1940), 54, xvii; and R. Loewy, 'Aesthetics in Industry', *The Architectural Review* 99 (January 1946), lv.

28. W. J. Acker, 'Design for Business', *Design* 40 (November 1938), 12.

29. Quotations taken variously from W. D. Teague, 'Designing for Machines', *Advertising Arts* (2 April 1930), 23; W. D. Teague, 'Rightness Sells', *Advertising Arts* (January 1934), 25; and W. D. Teague, 'Basic Principles of Body Design Arise from Universal Rules', *Society of Automotive*

Engineers Journal 35 (September 1934), supp. 18.

30. Frankl, *New Dimensions*, 16; D. Dohner, 'Modern Technique of Designing', *Modern Plastics* 14 (March 1937), 71; N. B. Geddes, *Horizons* (Boston, 1932), 223; H. Dreyfuss, 'Notes for Boston Lecture' (14 March 1933), 1973.15.22(a), Henry Dreyfuss Collection, Industrial Design Archives, Cooper-Hewitt, National Design Museum, New York; and J. F. Barnes and J. O. Reinecke, 'Does It Sell?', *Art and Industry* 24 (April 1938), 148.

31. W. D. Teague, *Design This Day: The Technique of Order in the Machine Age* (New York, 1940), 105.

32. Geddes, *Horizons*, 24.

33. N. G. Shidle, 'From the Annual S.A.E. Meeting at Detroit Come Many New Ideas', *Automotive Industries* (31 January 1931), 148.

34. A. Klemin, 'How Research Makes Possible the Modern Motor Car', *Scientific American* 151 (August 1934), 62; E. Arens, 'Next Year's Cars', *American Magazine of Art* 29 (November 1936), 736.

35. G. Garrett, 'The Articles of Progress', *Saturday Evening Post* 207 (28 July 1934), 5.

36. C. Arens letter to E. Arens (21 March 1936), box 5, Egmont Arens Papers, Special Collections Research Center, Syracuse University Library, Syracuse, New York.

37. Quotations taken variously from draft of E. Arens telegram to F. D. Roosevelt (14 November 1934), box 27; copy of E. Arens letter to Industries' Sales Committee (23 November 1934), box 19; and copy of E. Arens letter to K. Morgan, Warm Springs Foundation (27 November 1934), box 27; all from Arens Papers.

38. Advertisement for National Alliance of Art and Industry, *Advertising Arts* (January 1934), 48.

39. P. Johnson, *Machine Art* (New York, 1934), unpaginated.

40. A. H. Barr Jr. letter to N. B. Geddes (4 December 1934), file 296, Norman Bel Geddes Papers, Harry Ransom Humanities Research Center, University of Texas at Austin.

41. Van Doren, *Industrial Design*, 137–8.

42. P. Sparke, *As Long as It's Pink: The Sexual Politics of Taste* (London, 1995), 12, 136, 134.

43. W. D. Teague, 'Exhibition Technique', *American Architect and Architecture* 151 (September 1937), 33.

44. D. E. Nye, *American Technological Sublime* (Cambridge, Mass., 1994), 199; 'The New York World's Fair', *Architectural Review* 86 (August 1939), 62; D. Haskell, 'To-morrow and the World's Fair', *Architectural Record* 88 (August 1940), 71; and *Life* quoted by W. I. Susman, 'The People's Fair: Cultural Contradictions of a Consumer Society', in H. A. Harrison (ed.), *Dawn of a New Day: The New York World's Fair, 1939/40* (New York, 1980), 24.

45. R. L. Blaszczyk, *Imagining Consumers: Design and Innovation from Wedgwood to Corning* (Baltimore, 2000), 159.

Chapter 4. High Design versus Popular Styling, 1940–1965

1. D. Deskey, untitled, undated 3-page typescript, Donald Deskey Collection, Industrial Design Archives, Cooper-Hewitt, National Design Museum, New York.

2. 'ConvAIRCAR 1948: Preliminary Design Report' (3 July 1947), 1972.88.232 A.1, Henry Dreyfuss Collection, Industrial Design Archives, Cooper-Hewitt, National Design Museum, New York.

3. D. Deskey, 'Production and Distribution of Modern Shelter' (c.1942), 13-page typescript, Deskey Collection.

4. G. Nelson and H. Wright, *Tomorrow's House: A Complete Guide for the Home-Builder* (New York, 1946), 2, 79–80.

5. 'Life Presents . . .', *Life* 18 (22 January 1945), 63.

6. Moholy-Nagy quoted by S. Moholy-Nagy, *Moholy-Nagy: Experiment in Totality* (New York, 1950), 144; E. M. Benson, 'Chicago Bauhaus', *Magazine of Art* 31 (February 1938), 83; and Moholy-Nagy quoted in typed transcript of 'Conference on Industrial Design, A New Profession' (November 11–14, 1946), 194, Library, Museum of Modern Art, New York.

7. E. F. Noyes, *Organic Design in Home Furnishings* (New York, 1941), inside front cover and 4; Eames quoted by E. Demetrios, *An Eames Primer* (New York, 2001), 40.

8. D. Wallance, 'Case Study No. 31-B' (18 August 1950), 7-page typescript, Donald Wallance Collection, legal size files, box 6, Industrial Design Archives, Cooper-Hewitt, National Design Museum, New York.

9. A. B. Saarinen (ed.), *Eero Saarinen on His Work* (New Haven, 1962), 68.

10. 'New Furniture Designs and Techniques Have Initial Showing at Museum of Modern Art' [March 1946], press release in file 314 ('New Furniture Designed by Charles Eames'), Study Center, Museum of Modern Art, New York.

11. *Interiors* (March 1947) quoted by S. Abercrombie, *George Nelson: The Design of Modern Design* (Cambridge, Mass., 1995), 93; G. Nelson, 'The Furniture Industry', *Fortune* 35 (January 1947), 107, 172, 111.

12. G. Nelson, 'Business and the Industrial Designer', *Fortune* 40 (July 1949), 95.

13. Albinson interviewed (21 October 1994) and quoted by V. F. Pearcy, 'Manufacturing Modern: The Eames Office and the Herman Miller Furniture Company, 1940–1960', M.A. thesis, University of Texas at Austin (May 1995), 20.

14. J. L. Larsen, 'Textiles', in K. B. Hiesinger and G. H. Marcus (eds.), *Design since 1945* (New York, 1983), 174.

15. 'Useful Objects under Ten Dollars', press release (*c.*December 1939), scrapbook 100, Study Center, Museum of Modern Art, New York.

16. E. Kaufmann Jr., 'Introduction', *Good Design: An Exhibition of Home Furnishings Selected by The Museum of Modern Art New York for The Merchandise Mart Chicago* (New York, 1950), unpaginated.

17. H. Van Doren letter to W. D. Teague (27 November 1950), microfilm reel 16.32, Walter Dorwin Teague Papers, Special Collections Research Center, Syracuse University Library, Syracuse, New York.

18. A. Drexler and G. Daniel, *Introduction to Twentieth Century Design from the Collection of the Museum of Modern Art New York* (New York, 1959), 4–5; H. J. Gans, 'Design and the Consumer: A View of the Sociology and Culture of "Good Design"', in Hiesinger and Marcus, *Design since 1945*, 32; and J. Masheck, 'Embalmed Objects: Design at the Modern', *Artforum* 13 (February 1975), 52.

19. E. McCoy, 'The Rationalist Period', in *High Styles: Twentieth-Century American Design* (New York, 1985), 154; *Interiors* (April 1952) quoted by Pearcy, 'Manufacturing Modern', 77.

20. Zeisel quoted by K. A. Marling, 'Organic Glitz: Designing Popular Culture in the Postwar Era', in B. K. Rapaport and K. L. Stayton (eds.), *Vital Forms: American Art and Design in the Atomic Age, 1940–1960* (Brooklyn, 2001), 221; Zeisel quoted by R. T. Labaco, '"The Playful Search for Beauty": Eva Zeisel's Life in Design', *Studies in the Decorative Arts* 8 (Fall–Winter 2000–1), 126; and Wright quoted by W. J. Hennessey, *Russel Wright: American Designer* (Cambridge, Mass., 1983), 65.

21. S. Nickles, 'More Is Better: Mass Consumption, Gender, and Class Identity in Postwar America', *American Quarterly* 54 (December 2002), 581.

22. 'Design Review: Major Appliances', *Industrial Design* 1 (February 1954), 133. The author's first refrigerator, a secondhand International Harvester from this period, bore a small plaque proclaiming its 'femineered' status.

23. R. Malone, 'A Review of Ten Years', *Industrial Design* 10 (December 1963), 86, 88–9.

24. Loewy quoted by T. Hine, *Populuxe* (New York, 1986), 93.

25. Schlumbohm quoted by A. J. Pulos, *The American Design Adventure: 1940–1975* (Cambridge, Mass., 1988), 148; L. Jackson, *The New Look: Design in the Fifties* (Manchester, 1991), 8; P. Sparke, *As Long as It's Pink: The Sexual Politics of Taste* (London, 1995), 188; and A. J. Clarke, *Tupperware: The Promise of Plastic in 1950s America* (Washington, 1999), 48–9.

26. 'New Products: Prometheus Unbound', *Time* 76 (19 September 1960), 94–5; Hine, *Populuxe*, 3–6.

27. 'Trends, 1955: The Meaning of New Traditions in Design', *Industrial Design* 2 (December 1955), 34.See also A. Nadel, *Containment Culture: American Narratives, Postmodernism, and the Atomic Age* (Durham, 1995).

28. *Interiors* quoted by C. E. Armi, *The Art of American Car Design: The Profession and Personalities* (University Park, 1988), 53; Allen quoted by N. Whiteley, *Pop Design: Modernism to Mod* (London, 1987), 59.

29. P. Müller-Munk, '"O wad some power the giftie gie us . . ."', *Arts & Industry* 50 (April 1951), 136; Nelson quoted in 'Conference on Industrial Design, A New Profession', 157.

30. 'Industrial Design in New Role', *Business Week* (11 January 1947), 38.

31. See Society of Industrial Designers, *US Industrial Design 1949–1950* (New York, 1949), 4–5, for a list of the 98 members (all male except for Peggy Ann Rohde [b. 1911], widow of Gilbert Rohde).

32. Later Jane Fiske McCullough Thompson.

33. C. W. Mills, 'Man in the Middle: The Designer', *Industrial Design* (November 1958), reprinted in *Power, Politics, and People: The Collected Essays of C. Wright Mills* (New York, 1963), 379; Whitney Publications, 'The publishers of INTERIORS announce a significant *new magazine*' (*c.*1953), flier, Wallance Collection.

34. Anonymous designer quoted by M. Lamm

and D. Holls, *A Century of Automotive Style: 100 Years of American Car Design* (Stockton, 1996), 96; Landell interview with the author (17 November 1986).

35. Introduction, special issue on Detroit, *Industrial Design* 2 (October 1955), 36.

36. Chapman paraphrased by B. Allen, 'Dave Chapman, Goldsmith & Yamasaki Inc.', *Industrial Design* 13 (June 1966), 84.

37. S. Freedgood, 'Odd Business, This Industrial Design', *Fortune* 59 (February 1959), 204; 'The Eleventh Annual Design Review', *Industrial Design* 11 (December 1964), 38; Latham quoted in 'The Decline of Industrial Designers', *Fortune* 77 (February 1968), 149; and Noyes quoted by W. McQuade, 'An Industrial Designer with a Conspicuous Conscience', *Fortune* 68 (August 1963), 137.

38. Sakier quoted in 'Conference on Industrial Design, A New Profession', 20; R. Loewy, *Never Leave Well Enough Alone* (New York, 1951), 278; and Drexler quoted by R. Lynes, *Good Old Modern: An Intimate Portrait of the Museum of Modern Art* (New York, 1973), 322.

39. J. B. Ward, 'Product Design in the Corning Glass Works' (c.1952), typescript in *SAP* files, box 4 ('Case Study [13A]: Corning Glass Works/Notes, Clippings, and Related Material'), Wallance Collection; Mills, 'Man in the Middle', 374, 379, 383; and R. Banham, 'A Throw-Away Aesthetic' (1960), in R. Banham, *Design by Choice* (ed. P. Sparke) (London, 1981), 92–3.

40. V. Packard, *The Waste Makers* (New York, 1960), 42.

41. K. A. Marling, *As Seen on TV: The Visual Culture of Everyday Life in the 1950s* (Cambridge, Mass., 1994), 278–9.

42. Drexler and Daniel, *Introduction to Twentieth Century Design*, 94.

Chapter 5. Into the Millennium: Moving beyond Modernism

1. Quoted by P. H. Prugh, 'Against the Grain', *Wall Street Journal* (21 July 1966), 1.

2. M. Lamm and D. Holls, *A Century of Automotive Style: 100 Years of American Car Design* (Stockton, 1996), 118; *Car and Driver* quoted by P. C. Wilson, *Chrome Dreams: Automobile Styling since 1893* (Radnor, 1976), 265.

3. Chapman and Doblin both quoted by A. J. Pulos, *The American Design Adventure* (Cambridge, Mass., 1988), 190.

4. S. Brand (ed.), *The Last Whole Earth Catalog: Access to Tools* (Menlo Park, 1971), 3.

5. R. B. Fuller, *Operating Manual for Spaceship Earth* (New York, 1970; orig. 1969), 22, 79, 47,

79; R. B. Fuller, *Utopia or Oblivion: The Prospects for Humanity* (New York, 1969), 3; and J. Carreiro, 'Survey: An Educator Views US Design Schools', *Industrial Design* 21 (November 1974), 28.

6. V. Papanek, *Design for the Real World: Human Ecology and Social Change* (New York, 1973; orig. 1972), 14, 19, 15, 96, 113.

7. R. Banham (ed.), *The Aspen Papers: Twenty Years of Design Theory from the International Design Conference in Aspen* (London, 1974), 109; J. R. Guilfoyle, 'One Man's Reality . . .', *Industrial Design* 19 (March 1972), 19; and Fulton paraphrased in editors' response to 'Letters', *Industrial Design* 24 (January/February 1977), 6.

8. R. Eiber, 'What about Tomorrow?', in 'Letters', *Industrial Design* 16 (April 1969), 6; Albinson quoted in 'Design: What Lies Ahead', *Industrial Design*, 17 (April 1970), 30.

9. Diffrient quoted by Pulos, *The American Design Adventure*, 406; BecVar quoted in 'Who's Got the Business?', *Industrial Design* 22 (May/June 1975), 34.

10. Anecdote from Landell interview with the author (17 November 1986).

11. N. R. Kleinfield, 'Industrial Design Comes of Age', *New York Times* (10 March 1985), F4; B. Nussbaum, 'Smart Design: Quality Is the New Style', *Business Week* (11 April 1988), 102; and Peters quoted by D. Davis, 'High Technology Dressed to Kill', *Newsweek* 111 (14 March 1988), 57.

12. C. Forbes, 'Preface', *Design in the Contemporary World* (New York, 1989), 11.

13. C. Lorenz, *The Design Dimension: The New Competitive Weapon for Business* (Oxford, 1986).

14. Quoted by J. Meikle, 'Design in the Contemporary World: An Essay', in *Design in the Contemporary World*, 22.

15. Petersen quoted by Meikle, 'Design in the Contemporary World', 23, except for 'do a really unique car', which is Telnack quoted by G. Witzenburg, 'The Art of Automaking Redefined', *Automobile Quarterly*, 25 no. 1 (1987), 101; Lamm and Holls, *A Century of Automotive Style*, 266.

16. H. Kehrl, vice-chairman of General Motors, critically quoted by V. Margolin, 'Corporate Interests Dominate Worldesign '85 Congress in D.C.', *New Art Examiner* (March 1986), 33.

17. R. Venturi, *Complexity and Contradiction in Architecture* (New York, 1977; orig. 1966), 16–17, 104; R. Venturi, D. S. Brown, and S. Izenour, *Learning from Las Vegas: The Forgotten Symbolism of Architectural Form*

(Cambridge, Mass., 1977; orig. 1972), 8.

18. Caplan quoted by A. M. Freedman, 'Forsaking the Black Box: Designers Wrap Products in Visual Metaphors', *Wall Street Journal* (26 March 1987), 39; B. Nussbaum, 'California Design: Funk Is In', *Business Week Innovation 1990* (New York, 1990), 172.

19. J. Kron and S. Slesin, *High-Tech: The Industrial Style and Source Book for the Home* (New York, 1978), 1.

20. Venturi, Brown, and Izenour, *Learning from Las Vegas*, 8; Plumb quoted in 'Editorial: Post-Modern Industrial Design?', *I.D.* 25 (July/August 1978), 26.

21. R. Horn, *Memphis: Objects, Furniture, and Patterns* (New York, 1986), 51; B. Radice, *Memphis: Research, Experiences, Results, Failures and Successes of New Design* (New York, 1984), 141, 35, 187.

22. Venturi quoted by M. Collins and A. Papadakis, *Post-Modern Design* (New York, 1989), 104; Venturi quoted by S. Holt, 'From a Single Root', *I.D.* 31 (May/June 1984), 32; and Collins and Papadakis, *Post-Modern Design*, 107–8.

23. Quoted by IDSA, *Design Secrets: 50 Real-Life Projects Uncovered* (Gloucester, 2001), 20; 'Michael Graves Design', Target newspaper advertising supplement (1999).

24. A. Bangert and K. M. Armer, *80s Style: Designs of the Decade* (New York, 1990), 212.

25. Naisbitt quoted by R. Janjigian with L. J. Haney, *High Touch: The New Materialism in Design* (New York, 1987), 2; K. McCoy, 'Foreword' to P. Whitney (ed.), *Design in the Information Environment: How Computing Is Changing the Problems, Processes and Theories of Design* (Carbondale, 1985), 4–5; and M. and K. McCoy, 'Introduction: Design in the Information Age', in H. Aldersey-Williams (ed.), *New American Design: Products and Graphics for a Post-Industrial Age* (New York, 1988), 16.

26. Aldersey-Williams, *New American Design*, 29; McCoy quoted by Freedman, 'Forsaking the Black Box', 39; McCoy quoted by C. T. Mitchell, *New Thinking in Design: Conversations on Theory and Practice* (New York, 1996), 3; and F. Burkhardt, 'Design and "Avant-Postmodernism"', in J. Thackara (ed.), *Design After Modernism: Beyond the Object* (New York, 1988), 149.

27. J. Ive quoted by P. Kunkel, *AppleDesign: The Work of the Apple Industrial Design Group* (New York, 1997), 255.

28. J. Raskin as quoted by Kunkel, *AppleDesign*, 21.

29. Kunkel, *AppleDesign*, 25.

30. Quoted in 'Apple iMac and G3 Computers', *I.D.* 46 (July/August 1999), 96.

31. Quoted by Aldersey-Williams, *New American Design*, 183; A. Greiman, *Hybrid Imagery: The Fusion of Technology and Graphic Design* (New York, 1990), 55, 133.

32. D. A. Norman, *The Invisible Computer* (Cambridge, Mass., 1998).

33. P. Anders, *Envisioning Cyberspace: Designing 3D Electronic Spaces* (New York, 1999), 101, 107, 108, 116.

34. M. Diani, 'Immateriality Takes Command', *Design Issues* 4, no. 1/2 (1988), 6.

35. M. McCullough, *Abstracting Craft: The Practiced Digital Hand* (Cambridge, Mass., 1996), 189, 81.

Further Reading

General

Periodicals
Design Issues
Industrial Design (now *I.D.*)
Journal of Design History
Studies in the Decorative Arts
Winterthur Portfolio

Theoretical and general works
I. Anscombe, *A Woman's Touch: Women in Design from 1860 to the Present Day* (New York, 1984).
R. L. Blaszczyk, *Imagining Consumers: Design and Innovation from Wedgwood to Corning* (Baltimore, 2000).
R. Buchanan and V. Margolin (eds.), *Discovering Design: Explorations in Design Studies* (Chicago, 1995).
R. S. Cowan, *A Social History of American Technology* (New York, 1997).
A. Forty, *Objects of Desire* (New York, 1986).
S. Giedion, *Mechanization Takes Command: A Contribution to Anonymous History* (New York, 1948).
D. A. Hanks, *Innovative Furniture in America from 1800 to the Present* (New York, 1981).
N. Harris, *Cultural Excursions: Marketing Appetites and Cultural Tastes in Modern America* (Chicago, 1990).
S. Heller and S. Chwast, *Graphic Style: From Victorian to Post-Modern* (New York, 1988).
J. Heskett, *Industrial Design* (New York, 1980).
D. Horowitz, *The Morality of Spending: Attitudes toward the Consumer Society in America 1875–1940* (Baltimore, 1985).
W. Leach, *Land of Desire: Merchants, Power, and the Rise of a New American Culture* (New York, 1993).
J. Lears, *Fables of Abundance: A Cultural History of Advertising in America* (New York, 1994).
S. Lubar and W. D. Kingery (eds.), *History from Things: Essays on Material Culture* (Washington, 1993).

E. Lupton, *Mechanical Brides: Women and Machines from Home to Office* (New York, 1993).
E. Lupton and J. A. Miller, *The Bathroom, the Kitchen and the Aesthetics of Waste: A Process of Elimination* (Cambridge, Mass., 1992).
G. H. Marcus, *Functionalist Design: An Ongoing History* (Munich, 1995).
V. Margolin (ed.), *Design Discourse: History, Theory, Criticism* (Chicago, 1989).
V. Margolin, *The Politics of the Artificial: Essays on Design and Design Studies* (Chicago, 2002).
V. Margolin and R. Buchanan (eds.), *The Idea of Design* (Cambridge, Mass., 1995).
P. B. Meggs, *A History of Graphic Design* (New York, 1992).
D. E. Nye, *American Technological Sublime* (Cambridge, Mass., 1994).
A. J. Pulos, *American Design Ethic: A History of Industrial Design to 1940* (Cambridge, Mass., 1983).
C. Pursell, *The Machine in America: A Social History of Technology* (Baltimore, 1995).
P. Scranton, *Endless Novelty: Specialty Production and American Industrialization* (Princeton, 1997).
S. Strasser, *Never Done: A History of American Housework* (New York, 1982).

Twentieth century

C. E. Armi, *The Art of American Car Design: The Profession and Personalities: 'Not Simple Like Simon'* (University Park, 1988).
L. Cohen, *A Consumer's Republic: The Politics of Mass Consumption in Postwar America* (New York, 2003).
G. Cross, *An All-Consuming Century: Why Commercialism Won in Modern America* (New York, 2000).
C. and P. Fiell, *Design of the 20th Century* (Cologne, 1999).
D. Gartman, *Auto-Opium: A Social History of American Automobile Design* (London, 1994).
High Styles: Twentieth Century American Designs (New York, 1985).

P. Kirkham (ed.), *Women Designers in the USA 1900–2000: Diversity and Difference* (New Haven, 2000).

M. Lamm and D. Holls, *A Century of Automotive Style: 100 Years of American Car Design* (Stockton, 1996).

V. K. Matranga with K. Kohn, *America at Home: A Celebration of Twentieth-Century Housewares* (Rosemont, 1997).

J. L. Meikle, *American Plastic: A Cultural History* (New Brunswick, 1995).

T. A. R. Neff (ed.), *The Alliance of Art and Industry: Toledo Designs for a Modern America* (Toledo, 2002).

S. Nichols with E. Agro and E. Teller, *Aluminum by Design* (Pittsburgh, 2000).

M. Pawley, *Buckminster Fuller* (London, 1990).

R. Sexton, *American Style: Classic Product Design from Airstream to Zippo* (San Francisco, 1987).

P. Sparke, *As Long as It's Pink: The Sexual Politics of Taste* (London, 1995).

P. Sparke, *A Century of Design: Design Projects of the 20th Century* (London, 1998).

G. Votolato, *American Design in the Twentieth Century: Personality and Performance* (Manchester, 1998).

P. C. Wilson, *Chrome Dreams: Automobile Styling since 1893* (Radnor, 1976).

J. M. Woodham, *Twentieth-Century Design* (Oxford, 1997).

Chapter 1. The Emergence of the American System, 1790–1860

Colonial period and early nineteenth century

S. Blumin, *The Emergence of the Middle Class: Social Experience in the American City, 1760–1900* (New York, 1989).

C. Bridenbaugh, *The Colonial Craftsman* (New York, 1950).

D. Calhoun, *The Intelligence of a People* (Princeton, 1973).

W. A. Cooper, *Classical Taste: America, 1800–1840* (New York, 1993).

J. E. Crowley, *The Invention of Comfort: Sensibilities & Design in Early Modern Britain & Early America* (Baltimore, 2001).

D. F. Hawke, *Everyday Life in Early America* (New York, 1989).

A. H. Jones, *Wealth of a Nation to Be: The American Colonies on the Eve of the Revolution* (New York, 1980).

J. C. Miller, *The First Frontier: Life in Colonial America* (New York, 1966).

C. Shammas, *The Pre-Industrial Consumer in England and America* (Oxford, 1990).

The American System

C. H. Bailey, *Two Hundred Years of American Clocks & Watches* (Englewood Cliffs, 1975).

G. R. Cooper, *The Sewing Machine: Its Invention and Development* (Washington, 1976).

W. H. Distin and R. Bishop, *The American Clock: A Comprehensive Pictorial Survey 1723–1900* (New York, 1976).

C. W. Drepperd, *American Clocks and Clockmakers* (Boston, 1958).

C. Edwards, *Victorian Furniture: Technology and Design* (Manchester, 1993).

M. J. Ettema, 'Technological Innovation and Design Economies in Furniture Manufacture', *Winterthur Portfolio* 16 (Summer–Autumn 1981), 197–223.

R. B. Gordon and P. M. Malone, *The Texture of Industry: An Archaeological View of the Industrialization of North America* (New York, 1994).

D. R. Hoke, *Ingenious Yankees: The Rise of the American System of Manufactures in the Private Sector* (New York, 1990).

D. A. Hounshell, *From the American System to Mass Production 1800–1932: The Development of Manufacturing Technology in the United States* (Baltimore, 1984).

O. Mayr and R. C. Post (eds.), *Yankee Enterprise: The Rise of the American System of Manufactures* (Washington, 1981).

K. D. Roberts, *Eli Terry and the Connecticut Shelf Clock* (Bristol, 1973).

M. R. Smith, *Harpers Ferry Armory and the New Technology: The Challenge of Change* (Ithaca, 1977).

The Great Exhibition and an American vernacular

J. A. Auerbach, *The Great Exhibition of 1851: A Nation on Display* (New Haven, 1999).

R. F. Dalzell Jr., *American Participation in the Great Exhibition of 1851* (Amherst, 1960).

H. Greenough, *Form and Function*, ed. H. A. Small (Berkeley, 1947).

J. A. Kouwenhoven, *Made in America: The Arts in Civilization* (Garden City, 1948).

D. Rieman and J. M. Burks, *The Complete Book of Shaker Furniture* (New York, 1993).

H. Schaeffer, *Nineteenth Century Modern: The Functional Tradition in Victorian Design* (New York, 1970).

Chapter 2. Art and Industry in the Gilded Age, 1860–1918

The House beautiful

K. L. Ames, *Death in the Dining Room and*

Other Tales of Victorian Culture (Philadelphia, 1992).

C. A. Brandimarte, *Inside Texas: Culture, Identity, and Houses, 1878–1920* (Fort Worth, 1991).

S. J. Bronner (ed.), *Consuming Visions: Accumulation and Display of Goods in America 1880–1920* (New York, 1989).

S. Darling, *Chicago Furniture: Art, Craft, & Industry 1833–1983* (New York, 1984).

J. H. Foy and K. A. Marling (eds.), *The Arts and the American Home, 1890–1930* (Knoxville, 1994).

J. H. Foy and T. J. Schlereth (eds.), *American Home Life, 1880–1930: A Social History of Spaces and Services* (Knoxville, 1992).

H. Green, *The Light of the Home: An Intimate View of the Lives of Women in Victorian America* (New York, 1983).

K. C. Grier, *Culture & Comfort: Parlor Making and Middle-Class Identity, 1850–1930* (Washington, 1997).

M. J. S. Madigan, 'The Influence of Charles Locke Eastlake on American Furniture Manufacture, 1870–90', *Winterthur Portfolio* 10 (1975), 1–22.

M. J. S. Madigan (ed.), *Nineteenth Century Furniture: Innovation, Revival and Reform* (New York, 1982).

T. J. Schlereth, *Victorian America: Transformations in Everyday Life 1876–1915* (New York, 1991).

D. E. Sutherland, *The Expansion of Everyday Life, 1860–1876* (New York, 1989).

G. Wright, *Moralism and the Model Home: Domestic Architecture and Cultural Conflict in Chicago 1873–1913* (Chicago, 1980).

The Centennial Exposition

R. C. Post (ed.), *1876: A Centennial Exhibition* (Washington, 1976).

The Aesthetic movement

Artistic Houses: Being a Series of Interior Views of a Number of the Most Beautiful and Celebrated Homes in the United States, 2 vols (New York, 1971; orig. 1883).

Q. Bell, *The Schools of Design* (London, 1963).

M. W. Blanchard, *Oscar Wilde's America: Counterculture in the Gilded Age* (New Haven, 1998).

F. G. Chalmers, 'The Early History of the Philadelphia School of Design for Women', *Journal of Design History* 9 (1996), 237–52.

A. Duncan, M. Eidelberg, and N. Harris, *Masterworks of Louis Comfort Tiffany* (New York, 1989).

A. Horbar (ed.), *In Pursuit of Beauty: Americans and the Aesthetic Movement* (New York, 1986).

R. A. Mayer and C. K. Lane, 'Dissociating the "Associated Artists": The Early Business Ventures of Louis C. Tiffany, Candace T. Wheeler, and Lockwood de Forest', *Studies in the Decorative Arts* 8 (Spring–Summer 2001), 2–36.

A. Peck and C. Irish, *Candace Wheeler: The Art and Enterprise of American Design 1875–1900* (New York, 2001).

R. G. Wilson, D. H. Pilgrim, and R. N. Murray, *The American Renaissance 1876–1917* (Brooklyn, 1979).

The Arts & Crafts movement

E. Boris, *Art and Labor: Ruskin, Morris, and the Craftsman Ideal* (Philadelphia, 1986).

M. B. Boyd (ed.), *Inspiring Reform: Boston's Arts and Crafts Movement* (New York, 1997).

A. Callen, *Angel in the Studio: Women in the Arts and Crafts Movement 1870–1914* (London, 1979).

D. M. Cathers, *Furniture of the American Arts and Crafts Movement: Stickley and Roycroft Mission Oak* (New York, 1981).

G. Clark, R. A. Ellison Jr., and E. Hecht, *The Mad Potter of Biloxi: The Art and Life of George E. Ohr* (New York, 1989).

R. J. Clark (ed.), *The Arts and Crafts Movement in America 1876–1916* (Princeton, 1972).

E. Cumming and W. Kaplan, *The Arts and Crafts Movement* (London, 1991).

B. Denker (ed.), *The Substance of Style: Perspectives on the American Arts and Crafts Movement* (Winterthur, 1996).

D. A. Hanks, *The Decorative Designs of Frank Lloyd Wright* (New York, 1979).

W. Kaplan (ed.), *'The Art That Is Life': The Arts & Crafts Movement in America, 1875–1920* (Boston, 1987).

D. Marek, *Arts and Crafts Furniture Design: The Grand Rapids Contribution 1895–1915* (Grand Rapids, 1987).

G. Naylor, *The Arts and Crafts Movement: A Study of Its Sources, Ideals and Influence on Design Theory* (Cambridge, 1971).

N. E. Owen, *Rookwood and the Industry of Art: Women, Culture, and Commerce, 1880–1913* (Athens, 2001).

H. Peck, *The Book of Rookwood Pottery* (New York, 1968).

C. Reed, *Henry Chapman Mercer and the Moravian Pottery and Tile Works* (Philadelphia, 1987).

B. Sanders, *A Complex Fate: Gustav Stickley and the Craftsman Movement* (New York, 1996).

M. A. Smith, *Gustav Stickley: The Craftsman* (Syracuse, 1983).

Chapter 3. Designing the Machine Age, 1918–1940

Art Deco

C. Benton, T. Benton, and G. Wood (eds.), *Art Deco 1910–1939* (London, 2003).

A. Brown, 'Ilonka Karasz: Rediscovering a Modernist Pioneer', *Studies in the Decorative Arts* 8 (Fall–Winter 2000–1), 69–91.

J. Cantor, 'Art and Industry: Reflections on the Role of the American Museum in Encouraging Innovation in the Decorative Arts', in I. M. G. Quimby and P. A. Earl (eds.), *Technological Innovation and the Decorative Arts* (Charlottesville, 1974), 331–54.

K. Davies, *At Home in Manhattan: Modern Decorative Arts, 1925 to the Depression* (New Haven, 1983).

D. A. Hanks with J. Toher, *Donald Deskey: Decorative Designs and Interiors* (New York, 1987).

C. Long, 'The New American Interior: Paul T. Frankl in New York, 1914–1917', *Studies in the Decorative Arts* 9 (Spring–Summer 2002), 2–32.

N. Maffei, 'John Cotton Dana and the Politics of Exhibiting Industrial Art in the US, 1909–1929', *Journal of Design History* 13, no. 4 (2000), 301–17.

P. Sparke, 'The "Ideal" and the "Real" Interior in Elsie de Wolfe's *The House in Good Taste* of 1913', *Journal of Design History* 16, no. 1 (2003), 63–76.

Ford, General Motors, and mass production

M. Banta, *Taylored Lives: Narrative Productions in the Age of Taylor, Veblen, and Ford* (Chicago, 1993).

R. Batchelor, *Henry Ford: Mass Production, Modernism and Design* (Manchester, 1994).

S. Bayley, *Harley Earl* (London, 1992).

S. Clarke, 'Managing Design: The Art and Colour Section at General Motors, 1927–1941', *Journal of Design History* 12 (1999), 65–79.

Industrial design and consumer engineering

S. P. Benson, *Counter Culture: Saleswomen, Managers, and Customers in American Department Stores, 1890–1940* (Urbana, 1986).

M. H. Bogart, *Artists, Advertising, and the Borders of Art* (Chicago, 1995).

H. Dreyfuss, *Designing for People* (New York, 1974; orig. 1955).

F. Engler and C. Lichtenstein (eds.),

'Norman Bel Geddes 1893–1958', *Rassegna* 16, no. 60 (1994), 2–72.

R. Flinchum, *Henry Dreyfuss: Industrial Designer: The Man in the Brown Suit* (New York, 1997).

N. B. Geddes, *Horizons* (Boston, 1932).

J. S. Johnson, *American Modern: 1925–1940: Design for a New Age* (New York, 2000).

R. L. Leonard and C. A. Glassgold (eds.), *Annual of American Design* (New York, 1930).

R. Loewy, *Never Leave Well Enough Alone* (New York, 1951).

R. Loewy, *Industrial Design* (London, 1979).

R. Marchand, *Advertising the American Dream: Making Way for Modernity, 1920–1940* (Berkeley, 1985).

R. Marchand, *Creating the Corporate Soul: The Rise of Public Relations and Corporate Imagery in American Big Business* (Berkeley, 1998).

J. L. Meikle, *Twentieth Century Limited: Industrial Design in America, 1925–1939* (Philadelphia, 1979).

C. K. Narkiewicz-Laine, *Anne Swainson: Master Designer: Montgomery Ward's Bureau of Design 1931–1955* (Chicago, 1994).

S. Nickles, '"Preserving Women": Refrigerator Design as Social Process in the 1930s', *Technology and Culture* 42 (October 2002), 693–727.

G. Porter, *Raymond Loewy: Designs for a Consumer Culture* (Wilmington, 2002).

A. Schönberger (ed.), *Raymond Loewy: Pioneer of American Industrial Design* (Munich, 1990).

T. Smith, *Making the Modern: Industry, Art, and Design in America* (Chicago, 1993).

W. D. Teague, *Design This Day: The Technique of Order in the Machine Age* (New York, 1940).

W. D. Teague Jr., *Industrial Designer: The Artist as Engineer* (Lancaster, 1998).

H. Van Doren, *Industrial Design: A Practical Guide* (New York, 1940).

R. G. Wilson, D. H. Pilgrim, and D. Tashjian, *The Machine Age in America 1918–1941* (New York, 1986).

Streamlining

D. J. Bush, *The Streamlined Decade* (New York, 1975).

C. Cogdell, *Eugenic Design: Streamlining America in the 1930s* (Philadelphia, 2004).

H. A. Harrison (ed.), *Dawn of a New Day: The New York World's Fair, 1939/40* (New York, 1980).

C. Lichtenstein (ed.), *Streamlined: A Metaphor for Progress: The Esthetics of Minimized Drag* (Baden, *c.*1992).

F. Weingartner (ed.), *Streamlining America: A Henry Ford Museum Exhibit* (Dearborn, 1986).

Chapter 4. High Design versus Popular Styling, 1940–1965

Design for war and peace

D. Albrecht (ed.), *World War II and the American Dream: How Wartime Building Changed a Nation* (Cambridge, Mass., 1995).
F. W. Fox, *Madison Avenue Goes to War: The Strange Military Career of American Advertising 1941–45* (Provo, 1975).

High design

S. Abercrombie, *George Nelson: The Design of Modern Design* (Cambridge, Mass., 1995).
J. S. Allen, *The Romance of Commerce and Culture: Capitalism, Modernism, and the Chicago–Aspen Crusade for Cultural Reform* (Chicago, 1983).
R. Caplan, *The Design of Herman Miller* (New York, 1976).
H. De Pree, *Business as Usual: The People and Principles at Herman Miller* (Zeeland, 1986).
E. Demetrios, *An Eames Primer* (New York, 2001).
Design in America: The Cranbrook Vision 1925–1950 (New York, 1983).
The Design Collection: Selected Objects (New York, 1970).
A. Drexler and G. Daniel, *Introduction to Twentieth Century Design from the Collection of the Museum of Modern Art, New York* (New York, 1959).
M. Eidelberg (ed.), *Design 1935–1965: What Modern Was: Selections from the Liliane and David M. Stewart Collection* (New York, 1991).
K. B. Hiesinger and G. H. Marcus (eds.), *Design since 1945* (New York, 1983).
P. Kirkham, *Charles and Ray Eames: Designers of the Twentieth Century* (Cambridge, Mass., 1995).
R. Kostelanetz (ed.), *Moholy-Nagy* (New York, 1970).
G. H. Marcus, *Design in the Fifties: When Everyone Went Modern* (Munich, 1998).
V. Margolin, *The Struggle for Utopia: Rodchenko, Lissitzky, Moholy-Nagy 1917–1946* (Chicago, 1997).
J. Neuhart, M. Neuhart, and R. Eames, *Eames Design: The Work of the Office of Charles and Ray Eames* (New York, 1989).
T. Riley and E. Eigen, 'Between the Museum and the Marketplace: Selling Good Design', in *Studies in Modern Art 4: The Museum of Modern Art at Mid-Century: At Home and Abroad* (New York, 1994), 150–79.

The Work of Charles and Ray Eames: A Legacy of Invention (New York, 1997).

Populuxe

R. Banham, *Design by Choice*, ed. P. Sparke (London, 1981).
R. Banham, *A Critic Writes: Essays by Reyner Banham*, ed. M. Banham, P. Barker, C. Price, and S. Lyall (Berkeley, 1996).
A. J. Clarke, *Tupperware: The Promise of Plastic in 1950s America* (Washington, 1999).
M. P. Eidelberg, *Eva Zeisel: Designer for Industry* (Montreal, 1984).
C. Greenberg, *Mid-Century Modern: Furniture of the 1950s* (New York, 1984).
W. J. Hennessey, *Russel Wright: American Designer* (Cambridge, Mass., 1983).
T. Hine, *Populuxe* (New York, 1986).
R. Horn, *Fifties Style: Then and Now* (New York, 1985).
L. Jackson, *The New Look: Design in the Fifties* (Manchester, 1991).
R. T. Labaco, '"The Playful Search for Beauty": Eva Zeisel's Life in Design', *Studies in the Decorative Arts* 8 (Fall–Winter 2000–1), 125–38.
K. A. Marling, *As Seen on TV: The Visual Culture of Everyday Life* (Cambridge, Mass., 1994).
S. Nickles, 'More Is Better: Mass Consumption, Gender, and Class Identity in Postwar America', *American Quarterly* 54 (December 2002), 581–622.
B. K. Rapaport and K. L. Stayton (eds.), *Vital Forms: American Art and Design in the Atomic Age, 1940–1960* (Brooklyn, 2001).
Russel Wright: Creating American Lifestyle (New York, 2001).
N. Whiteley, *Pop Design: Modernism to Mod* (London, 1987).
N. Whiteley, *Reyner Banham: Historian of the Immediate Future* (Cambridge, Mass., 2002).

The industrial design profession

H. Adams, *Viktor Schreckengost and 20th-Century Design* (Cleveland, 2000).
G. Adamson, *Industrial Strength Design: How Brooks Stevens Shaped Your World* (Cambridge, Mass., 2003).
R. Banham (ed.), *The Aspen Papers: Twenty Years of Design Theory from the International Design Conference in Aspen* (London, 1974).
R. Caplan (ed.), *Design in America* (New York, 1969).
J. Doblin, *One Hundred Great Product Designs* (New York, 1970).
R. Haddow, *Pavilions of Plenty: Exhibiting*

American Culture Abroad in the 1950s (Washington, 1997).

J. G. Lippincott, *Design for Business* (Chicago, 1947).

J. L. Meikle, 'Donald Deskey Associates: The Evolution of an Industrial Design Firm', in D. A. Hanks with J. Toher, *Donald Deskey: Decorative Designs and Interiors* (New York, 1987), 121–56.

A. J. Pulos, *The American Design Adventure: 1940–1975* (Cambridge, Mass., 1988).

Society of Industrial Designers, *US Industrial Design 1949–1950* (New York, 1949).

D. Wallance, *Shaping America's Products* (New York, 1956).

Chapter 5. Into the Millennium: Moving beyond Modernism

Design decade of the 1980s

R. Blaich with J. Blaich, *Product Design and Corporate Strategy: Managing the Connection for Competitive Advantage* (New York, 1993).

J. Heskett, *Philips: A Study of the Corporate Management of Design* (London, 1989).

C. Lorenz, *The Design Dimension: The New Competitive Weapon for Business* (Oxford, 1986).

Postmodernism

D. Albrecht, E. Lupton, and S. S. Holt, *Design Culture Now: Material Design Triennial* (New York, 2000).

H. Aldersey-Williams (ed.), *New American Design: Products and Graphics for a Post-Industrial Age* (New York, 1988).

P. Antonelli, *Mutant Materials in Contemporary Design* (New York, 1995).

A. Bangert and K. M. Armer, *80s Style: Designs of the Decade* (New York, 1990).

M. Collins and A. Papadakis, *Post-Modern Design* (New York, 1989).

R. Horn, *Memphis: Objects, Furniture, and Patterns* (New York, 1986).

IDSA, *Design Secrets: Products: 50 Real-Life Projects Uncovered* (Gloucester, 2001).

R. Janjigian with L. J. Haney, *High Touch: The New Materialism in Design* (New York, 1987).

J. Kron and S. Slesin, *High-Tech: The Industrial Style and Source Book for the Home* (New York, 1978).

R. C. Miller (ed.), *US Design 1975–2000* (Munich, 2001).

B. Radice, *Memphis: Research, Experiences, Results, Failures and Successes of New Design* (New York, 1984).

J. Thackara (ed.), *Design after Modernism: Beyond the Object* (New York, 1988).

Hardware, software, webware

P. Anders, *Envisioning Cyberspace: Designing 3D Electronic Spaces* (New York, 1999).

M. Benedikt (ed.), *Cyberspace: First Steps* (Cambridge, Mass., 1991).

A. Greiman, *Hybrid Imagery: The Fusion of Technology and Graphic Design* (New York, 1990).

P. Kunkel, *AppleDesign: The Work of the Apple Industrial Design Group* (New York, 1997).

P. Kunkel, *Digital Dreams: The Work of the Sony Design Center* (New York, 1999).

M. McCullough, *Abstracting Craft: The Practiced Digital Hand* (Cambridge, Mass., 1996).

Timeline
Museums and Websites
List of Illustrations

	Design and Designers	Exhibitions, Publications, Events	General History
1607			First permanent English settlement in Virginia
1752			Benjamin Franklin invents lightning rod
1775–83			Revolutionary War
1789–93			George Washington's presidency
1793			Eli Whitney invents cotton gin
1798	Eli Whitney promises muskets with interchangeable parts		
1801–9			Thomas Jefferson's presidency
1807			Robert Fulton invents steamboat
1812–15			War of 1812
1814			Steam locomotive invented (England)
1816	Pillar-and-scroll clock by Eli Terry		
1822	Blanchard lathe		
1824	John H. Hall delivers rifles with interchangeable parts		
1825	Bronze looking-glass clock by Chauncey Jerome		Erie Canal completed
1826	Lambert Hitchcock establishes chair factory		First photograph (France)
1829–37			Andrew Jackson's presidency; widening of democracy
1830			First steam railroad in US
1833	Balloon-frame construction developed in Chicago		
1837			Economic depression
1844			Samuel F. B. Morse invents telegraph
1846–8			Mexican War
1851		Great Exhibition, Crystal Palace, London Boston School of Design founded	
1852		Horatio Greenough coins phrase 'form follows function'	
1853		Exhibition of the Industry of All Nations, New York	Commodore Matthew Perry's visit to Japan; opening of trade
1854		George Wallis reports on 'American System'	
1856	Home sewing machine introduced by Isaac M. Singer		
1861–5			Civil War; Abraham Lincoln's presidency

Timeline

	Design and Designers	Exhibitions, Publications, Events	General History
1863			Emancipation Proclamation
1868		Charles Eastlake, *Hints on Household Taste*	
1869		Catharine Beecher and Harriet Beecher Stowe, *The American Woman's Home*	Transcontinental railroad completed
1873–8			Economic depression
1873		Massachusetts Normal School of Art founded	
1875	Willam Cullen Bryant Vase by James Whitehouse for Tiffany & Co.		
1876		Centennial Exhibition, Philadelphia Pennsylvania School of Industrial Art founded Christopher Dresser lectures in Philadelphia	Alexander Graham Bell invents telephone
1877			Thomas Edison invents phonograph
1879			Thomas Edison invents incandescent light bulb
1879–83	Tiffany & Wheeler interior design firm		
1880	Rookwood Pottery founded, Cincinnati		
1882		Oscar Wilde's ten-month lecture tour	
1883		*Artistic Houses* published	
1888			George Eastman introduces box camera with roll film
1890			Battle of Wounded Knee US Census Bureau declares end of the western frontier
1893–7			Economic depression
1893		World's Columbian Exposition, Chicago	
1895	Tiffany lamps introduced		
1897		Society of Arts and Crafts, Boston founded Chicago Arts and Crafts Society founded	
1898	Moravian Pottery and Tile Works founded, Bucks County, Pa. Hoosier Manufacturing Co. introduces first Hoosier cabinet		Spanish-American War
1900	Mission furniture of Gustav Stickley introduced	Exposition Universelle, Paris	
1901–9			Theodore Roosevelt's presidency
1901–16		Stickley publishes *The Craftsman*	
1901			First transatlantic wireless telegraphy (radio)

	Design and Designers	Exhibitions, Publications, Events	General History
1903			Wright Brothers' first heavier-than-air flight
1904	Sears, Roebuck offers mail-order mission furniture		
1907			Leo Baekeland invents Bakelite phenolic plastic
1908			Henry Ford introduces Model T Ford car
1910	Scarab vase crafted by Adelaide Alsop Robineau	Deutscher Werkbund exhibition, Newark Museum	
1912		Christine Frederick, *The New Housekeeping*	
1913		Elsie de Wolfe, *The House in Good Taste*	
1913–21			Woodrow Wilson's presidency
1914–18			First World War
1915		Mary Pattison, *Principles of Domestic Engineering*	Albert Einstein's general theory of relativity
1917		Metropolitan Museum of Art establishes industrial art division	
1919	Bauhaus opened, Weimar, Germany		First non-stop transatlantic flight
1920			19th Amendment ratified: women's suffrage
1923		Herman Miller Co. founded, Zeeland, Michigan	
1925		Exposition Internationale des Arts Décoratifs et Industriels Modernes, Paris	
1926		French Art Deco furniture exhibited, Metropolitan Museum of Art	
1927	Art Deco display windows on Fifth Avenue Henry Ford replaces Model T automobile with Model A Art and Color Section established, General Motors Corp.	Art-in-Trade Exposition, Macy's department store, New York Le Corbusier, *Towards a New Architecture* published in translation Weissenhofsiedlung housing exhibition, Stuttgart, Germany	First solo transatlantic fight by Charles Lindbergh
1928–30		Art Deco skyscrapers erected in New York	
1928		American Union of Decorative Artists and Craftsmen founded	
1929		Museum of Modern Art (MoMA), New York, founded Robert and Helen Lynd, *Middletown*	
1929–37			Economic depression
1930		Art Center School founded in Los Angeles	
1930–44	Gilbert Rohde design director at Herman Miller		

	Design and Designers	Exhibitions, Publications, Events	General History
1931	Anne Swainson directs Montgomery Ward's Bureau of Design		
1932		Cranbrook Academy of Art founded in Michigan by Eliel Saarinen Norman Bel Geddes's *Horizons* promotes streamlining Roy Sheldon and Egmont Arens, *Consumer Engineering* Modern Architecture exhibition at MoMA	
1933–45			Franklin D. Roosevelt's presidency
1933–4		Chicago Century of Progress Exposition	
1933	Toperator washing machine by Henry Dreyfuss for Sears, Roebuck Dymaxion automobile by Buckminster Fuller and Starling Burgess		
1934	Union Pacific and Burlington streamliners Airflow Chrysler automobile	*Fortune* magazine publicizes industrial design Machine Art exhibition, MoMA	
1935	Coldspot refrigerator by Raymond Loewy for Sears, Roebuck		Social Security Act passed
1936	Service stations by Walter Dorwin Teague for Texaco		
1937		New Bauhaus founded at Chicago by László Moholy-Nagy	
1938	Sling or butterfly chair by Jorge Ferrari-Hardoy		
1938–48		Detroit Institute of Automobile Styling	
1939–40		New York World's Fair of 1939–40	
1939	Futurama by Norman Bel Geddes for General Motors Corp.	American Designers Institute (ADI) founded	First regular television broadcast in US
1939–45			Second World War
1939–59	American Modern dinnerware by Russel Wright for Steubenville Pottery		
1941		Organic Design in Home Furnishings exhibition, MoMA	
Dec. 7, 1941			Pearl Harbor attack; US entry into war
1942	Chemex coffee pot designed and marketed by Peter Schlumbohm Lucky Strike cigarette pack redesigned by Loewy Plywood splints by Charles and Ray Eames for US Navy		
1944		Society of Industrial Designers (SID) founded	
1945	Storagewall publicized by George Nelson		Atomic bomb dropped on Hiroshima and Nagasaki

	Design and Designers	Exhibitions, Publications, Events	General History
1946	Hallicrafters S-40A short-wave receiver by Richard S. Latham	New Furniture Designed by Charles Eames exhibition, MoMA	
1947	George Nelson design director at Herman Miller Town and Country dinnerware by Eva Zeisel for Red Wing Pottery 'New Look' in women's fashions by Christian Dior		
1948	Womb chair by Eero Saarinen for Knoll Associates	John A. Kouwenhoven identifies American design vernacular	
1949	Loewy on cover of *Time* magazine	ADI becomes Industrial Designers Institute	
1950–3			Korean War
1950–4		Good Design exhibitions by MoMA in Chicago and New York	
1950	Fibreglass-reinforced polyester chairs by the Eameses for Herman Miller Eames Storage Unit for Herman Miller Ball clock by Irving Harper (of George Nelson) for Howard Miller Clock Co.		
1951		First International Design Conference, Aspen, Colorado	
1953–61			Dwight D. Eisenhower's presidency
1953			Watson and Crick's discovery of DNA's double helix
1954	Coffee Service 2000 by Latham for Rosenthal	*Industrial Design* magazine founded	Transistor radio introduced
1955	Coconut chair by Nelson for Herman Miller	SID becomes American Society of Industrial Designers (ASID)	
1956	Tulip chair by Saarinen for Knoll Associates Lounge Chair and Ottoman by the Eameses for Herman Miller Marshmallow sofa by Harper (of George Nelson) for Herman Miller		Interstate Highway Act passed
1957	Comprehensive Storage System by Nelson for Herman Miller Frigidaire division of GM introduces 'sheer' appliances		
1958	Ford Edsel design rejected by consumers	Seagram building, New York, completed by Ludwig Mies Van der Rohe	Silicon chip invented
1959	Glimpses of the USA, multimedia program by the Eameses	American National Exhibition, Moscow	
1961–3			John F. Kennedy's presidency
1961–73			Vietnam War

Timeline

	Design and Designers	Exhibitions, Publications, Events	General History
1961	Selectric typewriter by Eliot F. Noyes for IBM Corp.	Jane Jacobs, *The Death and Life of Great American Cities*	
1963–9			Lyndon B. Johnson's presidency
1964	Service stations by Noyes for Mobil Oil Corp. Ford Mustang introduced	New York World's Fair of 1964	
1965		ASID and IDI merge into Industrial Designers Society of America	
1966		Robert Venturi, *Complexity and Contradiction in Architecture*	
1967			*The Graduate*, directed by Mike Nichols
1968			Assassination of Martin Luther King *2001: A Space Odyssey*, directed by Stanley Kubrick
1968–71		*Whole Earth Catalog* publicizes Buckminster Fuller	
1969–74			Richard M. Nixon's presidency
1969			Manned landing on the moon
1972		Victor Papanek, *Design for the Real World* Italy: The New Domestic Landscape exhibition, MoMA	
1973			First oil crisis Roe *v.* Wade legalizes abortion Watergate break-in
1976			US Bicentennial Introduction of video cassette recorder
1978	'High-tech' design fad	AT&T 'Chippendale' building announced by Philip Johnson	
1979			Iranian Revolution
1981–9			Ronald Reagan's presidency
1981		Memphis furniture show, Milan	
1983		Design Since 1945 exhibition, Philadelphia Museum of Art	Introduction of compact discs
1984	Venturi Collection of chairs for Knoll International Macintosh computer introduced by Apple Computer Co.		
1985	Whistling Bird tea kettle by Michael Graves for Alessi		*Brazil*, directed by Terry Gilliam
1986	Ford Taurus and 'aero look'; design coordinated by Jack Telnack	Thomas Hine, *Populuxe*	
1988	Lisa Krohn's Phonebook ('product semantics' at Cranbrook)	Stanford Design Forum promotes a new 'design decade'	

	Design and Designers	Exhibitions, Publications, Events	General History
1989	Good Grips vegetable peeler by Smart Design for OXO International		Fall of Berlin Wall
1991			Gulf War
1993			Introduction of first Web browser
1993–2001			Bill Clinton's presidency
1995		Mutant Materials in Contemporary Society exhibition, MoMA	
1997		Guggenheim Museum Bilbao completed by Frank Gehry	
1998	Apple's iMac computer introduced; designed by Jonathan Ive New Beetle automobile by J. Mays promotes 'retrofuturism'		
1999	Michael Graves, 'designer' products for Target stores		World Trade Organization protest, Seattle
2001			George W. Bush inaugurated as president
Sept. 11, 2001			Destruction of World Trade Center
2003			US invasion of Iraq
2004		Expansion of Museum of Modern Art	

Museums	Website

Starred museums maintain particularly substantive websites.

A + D (Architecture and Design) Museum *www.aplusd.org*
8560 W. Sunset Boulevard
West Hollywood, California 90069
Changing exhibitions devoted to contemporary design.

*** Auburn Cord Duesenberg Museum** *www.acdmuseum.org*
1600 South Wayne St.
Auburn, Indiana 46706
Classic luxury cars housed in an Art Deco automotive dealership.

*** The Charles Hosmer Morse Museum of** *www.morsemuseum.org*
American Art
445 North Park Avenue
Winter Park, Florida 32789
Collections include Louis Comfort Tiffany, the Aesthetic movement, and the Arts & Crafts movement.

Cooper-Hewitt, National Design Museum *www.ndm.si.edu*
Smithsonian Institution
2 East 91st St.
New York, NY 10128
Major collections and special exhibitions devoted to industrial design and decorative arts in the US.

*** Design Museum** *www.designmuseum.org*
Shad Thames
London SE1 2YD
Occasional special or travelling exhibitions devoted to American design and designers.

Henry Ford Museum *www.hfmgv.org*
20900 Oakwood Blvd.
Dearborn, Michigan 48124-4088
Vast collections of automobiles and consumer products interpreted from social and cultural history perspectives.

*** The Metropolitan Museum of Art** *www.metmuseum.org*
1000 Fifth Avenue at 82nd Street
New York, NY 10028-0198
Major collection of decorative arts, particularly from the Aesthetic movement.

The Mint Museum of Craft + Design *www.mintmuseum.org*
220 North Tryon St.
Charlotte, North Carolina 28202
Collections and special exhibitions cover unique craft objects and both high and popular design.

Musée des beaux-arts de Montréal *www.mbam.qc.ca*
Pavillon Liliane et David M. Stewart
1379, rue Sherbrooke Ouest
Montreal, Quebec H3G 2T9
Major collection of twentieth-century design and decorative arts.

Museum of Arts and Design
40 West 53rd St.
New York, NY 10019
Formerly the American Craft Museum, it is
expanding its collections and special
exhibitions to encompass commercial design.

www.americancraftmuseum.org

Museum of Fine Arts, Boston
Avenue of the Arts
465 Huntington Avenue
Boston, Massachusetts 02115-5523
Major decorative arts collections largely
displayed through period rooms.

www.mfa.org

*** The Museum of Modern Art**
11 West 53rd St.
New York, NY 10019
Known for its permanent design collection,
MoMA frequently initiates exhibitions related to
twentieth-century and contemporary design.

www.moma.org

National Building Museum
401 F Street NW
Washington, DC 20001
Changing exhibitions devoted to architecture
and the building arts sometimes address
smaller-scale design issues.

www.nbm.org

Renwick Gallery
Smithsonian American Art Museum
Pennsylvania Avenue at 17th St. NW
Washington, DC 20006
Primarily devoted to changing exhibitions about
craft.

americanart.si.edu/collections/renwick/main.html

Victoria and Albert Museum
Cromwell Road
South Kensington
London SW7 2RL
Permanent collections encompass some
American materials, particularly from the
nineteenth and twentieth centuries; special
exhibitions often address issues relevant to the
US.

www.vam.ac.uk

Vitra Design Museum
Charles-Eames-Str. 1
D-79576 Weil am Rhein
Known for its twentieth-century chair
collection, it sponsors special and travelling
exhibitions which often focus on US designers
and their work.

www.vitra.com

**William F. Eisner Museum of Advertising &
Design**
208 N. Water St.
Milwaukee, Wisconsin 53202
Special exhibitions concerning advertising,
graphic arts, and poster design.

www.eisnermuseum.org

Winterthur Museum, Garden & Library
Winterthur, Delaware 19735
Large collection of furniture and decorative arts
from the colonial period through the late
nineteenth century, many displayed in period
rooms.

www.winterthur.org

*** The Wolfsonian-FIU**
1001 Washington Avenue
Miami Beach, Florida 33139
European and American 'decorative and
propaganda arts', 1885–1945, including
furniture, consumer products, glass, ceramics,
posters, books, and ephemera, with emphasis
on international exhibitions, political themes,
and transportation.

www.wolfsonian.fiu.edu

Websites

American Institute of Graphic Arts
Resource Archives
*www.aiga.com/content.cfm?contentalias=
lookingcloserarchives*

Design Addict
www.designaddict.com

Design and Technology on the Web
www.design-technology.info

Dezignare Interior Design Collective
www.dezignare.com

Emrich Transport Design (automotive design
and concept cars)
www.emrichdesign.com

Industrial Designers Society of America
100 Years of Design
*www.idsa.org/webmodules/articles/anmviewer.
asp?a=51&z=28*

Jet Set Modern
jetsetmodern.com
Intelligent webzine on populuxe design and
architecture.

Machines for Living
*xroads.virginia.edu/~MA01/Lisle/30home/
front.html*
Streamlining and the machine age.

The Victorian Web
Victorian Design: An Overview
www.victorianweb.org/art/design/designov.html

Virtual Design Museum
www.io.tudelft.nl/public/vdm

List of Illustrations

The publisher would like to thank the following individuals and institutions who have kindly given permission to reproduce the illustrations listed below.

1. Chermayeff & Geismar. Pioneer section, 'A Nation of Nations' exhibition, National Museum of History and Technology, Smithsonian Institution, 1976. Photo © Chermayeff & Geismar, New York.

2. Chermayeff & Geismar. Neon signs, 'A Nation of Nations' exhibition, National Museum of History and Technology, Smithsonian Institution, 1976. Photo © Chermayeff & Geismar, New York.

3. Chermayeff & Geismar. Commercial images, 'A Nation of Nations' exhibition, National Museum of History and Technology, Smithsonian Institution, 1976. Photo © Chermayeff & Geismar, New York.

4. Thomas Blanchard. Blanchard lathe, 1822. National Museum of American History, Smithsonian Institution, Washington, DC (neg. 24437).

5. Anonymous. Balloon-frame construction, c.1833, from S. Sloan, *The Model Architect: A Series of Original Designs for Cottages, Villas, Suburban Residences, etc* (Philadelphia, 1852), vol. 2, pl. XXVII, pp. 8–9.

6. Anonymous. Greek revival centre table and lamp stand, 1820–30. Table: wood, polychrome, stencilled and freehand gilt decoration, bronzing, painted composition 0top. Diameter 82.55 cm. Lamp stand: wood, grained with stencilled and freehand gilt and polychrome decoration, freehand bronzing. Height 158 cm. The Baltimore Museum of Art, Friends of the American Wing (BMA 1992.214 and 1992.215), MD.

7. Anonymous. Nineteenth-century engraving of a peddler displaying his wares, from *Harper's Weekly* (20 June 1868), 393. The New York Public Library. © 2004, Photo The New York Public Library/Art Resource/Scala Florence.

8. Anonymous. Tinware box, c.1825. Tin, paint, brass, 5.75 × 8.75 × 4.75 cm. The Western Reserve Historical Society (53.18), Cleveland, OH.

9. Lambert Hitchcock. Chair, c.1826–35. The Hitchcock Chair Co. Ltd, New Hartford, CT.

10. Eli Terry. Pillar-and-scroll clock, c.1816: exterior, and wooden works. The American Clock and Watch Museum, Bristol, CT.

11. Chauncey Jerome. Bronze looking-glass clock, c.1827. The American Clock and Watch Museum, Bristol, CT.

12. Cyrus McCormick. McCormick mechanical reaper, 1851, from J. Tallis, *History and Description of the Crystal Palace and the Exhibition of the World's Industries in 1851* (1854 edition), vol. 3, opp. 19. Cambridge University Library (Eb.29.14).

13. George Steers. Racing schooner *America*, 1851, from *The Illustrated London News* (30 August 1851). Mary Evans Picture Library, London.

14. Cornelius & Baker. Gas chandelier exhibited in the Crystal Palace, 1851, from *The Crystal Palace and Its Contents* (London, 1852), 294. The British Library (7955.ee.11), London.

15. Cleveland Foundry Co. 'Puritan' gas stove, 1898, from a catalogue of *Puritan Gas Stoves and Ranges* (Cleveland, 1898).

16. Isaac M. Singer. Sewing machine for household use, 1856. National Museum of American History, Smithsonian Institution, Washington, DC (neg. 48091-H).

17. Anonymous. Pressed glassware, 1830–50: compote, candlestick, covered casket with tray. Collection of the Corning Museum of Glass, Gift of Louise S. Esterly (compote and candlestick), Corning, NY.

18. John Henry Belter. Rosewood sofa, c.1850. Rosewood and laminated rosewood (carved

and pierced); upholstery. 137.2 × 237.5
× 101.6 cm. Milwaukee Art Museum, WI.
Purchase, through the bequest of Mary Jane
Rayniak in memory of Mr and Mrs Joseph G.
Rayniak (M1987.16)/photo Larry Sanders.
19. Gustav Herter. Carved oak sideboard,
1853, from B. Silliman, *The World of Science,
Art and Industry* (New York, 1854), 168. Rare
Books Division, New York Public Library.
© 2004, photo The New York Public
Library/Art Resource/Scala, Florence.
20. Georg Carstensen and Charles
Gildemeister. New York Crystal Palace, 1853,
interior, from B. Silliman, *The World of
Science, Art and Industry* (New York, 1854),
10–11. Rare Books Division, New York Public
Library. © 2004, photo The New York Public
Library/Art Resource/Scala, Florence.
21. Clara Driscoll. Dragonfly lamp, c.1906.
Leaded glass, turtleback tile, mosaic, and
bronze. Tiffany Studios. Height 85 cm.
Christie's Images, London and New York.
22. Sears, Roebuck and Co. Cover of
Consumers Guide: Catalogue No. 108, 1899.
Sears, Roebuck & Co., Hoffman Estates, IL.
23. Catharine Beecher and Harriet Beecher
Stowe. Food preparation and cleaning
facilities for the ideal kitchen, from *The
American Woman's Home* (New York, 1869), 34,
fig. 13.
24. Anonymous. Entry hall of the
Van Alstyne–Dickson house, Houston,
Texas, c.1900. Courtesy Houston
Metropolitan Research Center, Houston
Public Library, TX.
25. Daniel Pabst. Bedroom suite in the
Eastlake style, c.1875. Philadelphia Museum of
Art, Gift of Charles P. Shenkle in memory of
his mother, Mrs Edna H. Shenkle, 1975.
26. Phoenix Furniture Co. Typical factory-
built bedroom suite, 1878. Grand Rapids
History and Special Collections Center
(Archives), Grand Rapids Public Library, MI.
27. George H. Corliss. Corliss Engine, 1876.
National Museum of American History
(Department of Engineering and
Environmental History), Smithsonian
Institution, Washington, DC
(neg. MAH-X3552).
28. James Whitehouse. William Cullen
Bryant Vase, 1875. Tiffany & Co. Silver,
height 84.8 cm. The Metropolitan Museum of
Art, New York, Gift of William Cullen
Bryant, 1877 (77.9). Photograph © 1989 The
Metropolitan Museum of Art.
29. Mason & Hamlin. Organ crafted for the
Centennial Exhibition, 1876, from W. Smith,
The Masterpieces of the Centennial

International Exhibition (Philadelphia,
1876–8), vol. 2: 204. The Library Company of
Philadelphia, PA.
30. Charles Hess. Convertible bedroom
piano, patented 1866. US Patent no. 56,413.
31. Anonymous. Interior, Connecticut
Cottage, Centennial Exhibition,
Philadelphia, 1876. The Connecticut
Historical Society, Hartford, CT.
32. Anonymous. Japanese screen and bronzes,
Centennial Exhibition, Philadelphia, 1876.
Print and Picture Collection, The Free
Library of Philadelphia, PA.
33. Hopkins & Dickinson Manufacturing Co.
Ornamental door knobs, 1879, from *Illustrated
Catalogue of Locks, Builders' Hardware and Cast
Bronze and Brass Work* (New York, October
1879), 202. Hagley Museum and Library,
Wilmington, DE.
34. Tiffany & Wheeler. Veterans' Room and
Library, Seventh Regiment National Guard
Armory, New York, 1880. Photo Jaime
Ardiles-Arce, New York.
35. Candace Wheeler for Associated Artists.
Panel (section from a portiere or curtain), silk
and metallic cloth appliquéd with silk velvet
and embroidered with silk and metallic-
wrapped cotton threads, c.1884. 188 × 128.3 cm.
Ground fabric by Cheney Brothers, Hartford,
CT. The Metropolitan Museum of Art, Gift
of the family of Mrs Candace Wheeler, 1928
(28.34.2), New York. Photograph © 2000 The
Metropolitan Museum of Art.
36. Herter Brothers. Library, William H.
Vanderbilt house, New York, 1882, from
Artistic Houses (New York, 1883–4), vol. 1,
pt. 2. Art and Architecture Collection, New
York Public Library. © 2004 Photo New York
Public Library/Art Resource/Scala, Florence.
37. J. H. Boughton Co. Parquet flooring
commercially manufactured in 'Japanese
pattern', 1893, from catalogue *Interior
Decorations & Artistic Wood Floors*
(Philadelphia, 1893). Hagley Museum and
Library, Wilmington, DE.
38. Albert R. Valentien. Vase, 1898.
Stoneware, standard glaze line, height
50.8 cm.
Philadelphia Museum of Art (Gerald and
Virginia Gordon Collection, 1999-58-11), PA.
39. Rookwood Pottery. Figural humidor with
lid, 1902. Stoneware, modeled mat glaze line,
height 21.6 cm. Philadelphia Museum of Art
(Gerald and Virginia Gordon Collection,
2002-21-16a, b), PA.
40. Adelaide Alsop Robineau. Scarab vase
('The Apotheosis of the Toiler'), 1910.
Porcelain, 41.9 × 15.24 cm. Everson Museum

of Art (museum purchase; 30.7.78a–c), Syracuse, NY.

41. George Ohr. Vase, c.1895–1900, height 12.7 cm. Ohr–O'Keefe Museum of Art, Biloxi, MS.

42. L. & J. G. Stickley Co. Morris chair, c.1910. Oak, with adjustable back with bar and four horizontal slats, upholstered in leather, height 108 cm. Christie's Images, London and New York.

43. J. W. Mason & Co. Mission settee, 1879. Hagley Museum and Library, Wilmington, DE.

44. Charles P. Limbert Co. Oak table, c.1905. Collection Don Marek/photo David Lybbers.

45. Roycrofters. Copper smoking set, c.1909, height 10.2 × length 35.56 cm. Elbert Hubbard Roycroft Museum/photo Aurora Historical Society, East Aurora, NY.

46. Anonymous. Arts & Crafts domestic interior, Dallas, Texas, c.1908. Dallas Historical Society (A68.28.144), TX.

47. Buckminster Fuller and Starling Burgess. Dymaxion automobile, 1933, exhibited at the Chicago Century of Progress Exposition in 1934. Courtesy The Estate of R. Buckminster Fuller.

48. Hoosier Manufacturing Co. Hoosier kitchen cabinet, c.1910, from catalogue, The Hoosier Special. The Winterthur Library, Printed Book and Periodical Collection (RBR TX656.H78 t.c.), Winterthur, DE.

49. Anonymous. Breakfast room, Sam Bell Maxey house, Paris, Texas, c.1915. Texas State Library and Archives Commission, Austin, TX.

50. Joseph Hiriart, Georges Tribou, and Georges Beau. Pavilion for Galeries Lafayette, Exposition Internationale des Arts Décoratifs et Industriels Modernes, Paris, 1925. Musée des Arts Décoratifs (Albert Lévy Photographic Archive), Paris. All rights reserved. Photo UCAD.

51. Lee Simonson. Installation for 'Art-in-Trade Exposition', Macy's department store, New York, 1927, from Architectural Record 64 (August 1928), 140. Royal Institute of British Architects Library, London/photo A. C. Cooper.

52. Paul T. Frankl. Skyscraper desk and bookcase, c.1928. Walnut, paint, brass handles, 208.28 × 123.82 × 53.97 cm. Museum of Fine Arts (Collection of John P. Axelrod), Boston, MA. Photograph © 2004 Museum of Fine Arts, Boston.

53. Norman Bel Geddes. Window display, Franklin Simon store, New York, 1927. Harry Ransom Humanities Research Center, The

University of Texas at Austin, TX. Photograph Vandamm Studios (courtesy Billy Rose Theatre Collection, The New York Public Library for the Performing Arts, Astor, Lenox and Tilden Foundations). Courtesy the Estate of Edith Lutyens Bel Geddes (c/o Coffin, Inman & Christiana).

54. Erik Magnussen. Silver coffee service, 'The Lights and Shadows of Manhattan', Gorham Manufacturing Co., 1927. Silver with patinated, oxidized, and gilt decoration, height of coffeepot 12.04 cm. Museum of Art, Rhode Island School of Design, Gift of Textron, Inc., Providence, RI/photo Cathy Carver.

55. Ruth Reeves. Block-printed cotton fabric, 'Manhattan', W. & J. Sloan, 1930. Victoria and Albert Museum (T.57-1932), London/photo V&A Picture Library.

56. Donald Deskey. Decorative screen, c.1929. Oil paint and metal leaf on canvas, wood, 197.5 × 149.2 × 2.9 cm. Virginia Museum of Fine Arts (Gift of the Sydney and Frances Lewis Foundation), Richmond, VA/photo Katherine Wetzel. © Virginia Museum of Fine Arts.

57. Ford Motor Co. Model T Tudor (two-door) sedan, 1926, from the Saturday Evening Post (19 September 1926), p. 131. The Advertising Archive, London. Courtesy Ford Motor Co., Dearborn, MI.

58. Ford Motor Co. Model A Tudor (two-door) sedan, 1928, from the Saturday Evening Post (1 September 1928). The Advertising Archive, London. Courtesy Ford Motor Co., Dearborn, MI.

59. Norman Bel Geddes. Dressing table, Simmons Furniture Co., 1932. Enamelled and chrome-plated steel, 75.2 × 111.8 × 48.3 cm. The Metropolitan Museum of Art, Gift of Paul F. Walter, 1984 (1984.263), New York. Photograph © The Metropolitan Museum of Art.

60. Walter Dorwin Teague. Camera and package, Eastman Kodak Co., 1930. Metal, lacquer, camera 4.8 × 9.5 × 21 cm; box 6.4 × 11.1 × 22.5 cm. The Metropolitan Museum of Art, New York, John C. Waddell Collection, Gift of John C. Waddell, 1998 (1998.537.38–39a–c), Photograph © 1999 The Metropolitan Museum of Art.

61. Henry Dreyfuss. Toperator washing machine, Sears, Roebuck and Co., 1933. Cooper-Hewitt, National Design Museum (Henry Dreyfuss Collection), Smithsonian Institution, New York, Gift of Henry Dreyfuss, 1972.

62. Raymond Loewy. Coldspot refrigerator,

87. Charles and Ray Eames. Installation for 'New Furniture Designed by Charles Eames' exhibition, Museum of Modern Art, 1946. © 2004 Eames Office (www.eamesoffice.com).

88. Charles and Ray Eames with Don Albinson. Rosewood lounge chair and ottoman, Herman Miller, 1956. Laminated rosewood and aluminium with leather upholstery. Christie's Images, London and New York.

89. Anonymous. Interior, T. G. Owen & Son, Mississippi, c.1952. Author's Collection.

90. Irving Harper for George Nelson. Ball clock, Howard Miller Clock Co., 1950. Painted birch, steel, brass, 35.56 × 35.56 × 5.72 cm. Brooklyn Museum of Art (H. Randolph Lever Fund 2000.101.1), New York.

91. Irving Harper for George Nelson. Marshmallow sofa, Herman Miller, 1956. Brushed and enameled steel, 76.5 × 132.1 × 83.8 cm. Christie's Images, London and New York.

92. Jorge Ferrari-Hardoy. Sling or butterfly chair, 1938. Photo Knoll International.

93. Museum of Modern Art, New York. Installation for 'Good Design', 1952. Photo Museum of Modern Art, New York.

94. Peter Schlumbohm. Chemex coffee pot, Chemex Corp., 1942. Glass, wood, and leather, 27.9 × 16.5 × 15.2 cm. Brooklyn Museum of Art, New York (Gift of Dr Barry R. Harwood, 1997.117).

95. Russel Wright. American Modern dinnerware, Steubenville Pottery, 1939. Glazed earthenware. Brooklyn Museum of Art, New York (Gift of Russel Wright, Paul F. Walter, and Ina and Andres Feuerstein, 80.169.2).

96. Eva Zeisel. Town and Country dinnerware, Red Wing Pottery, 1947. Glazed earthenware. Brooklyn Museum of Art, New York (Gift of Eva Zeisel, 85.75.7).

97. Anonymous. Kelvinator Foodarama refrigerator, Nash-Kelvinator Corp., 1955, from *House Beautiful* (May, 1955). Photo The Advertising Archives, London.

98. Anonymous. Cadillac Eldorado automobile, General Motors Corp., 1958. Photo General Motors.

99. Anonymous. Sylvania Dualette television, Sylvania Electric Products, Inc., c.1959, advertisement for Catalin Corporation, from *Modern Plastics* (March 1959).

100. Martin Stern Jr. Ship's Westwood Coffee Shop, Los Angeles, 1958 (demolished in 1984). Photo, collection of Alan Hess.

101. Sundberg-Ferar. Air compressor, DeVilbiss Co., 1940. Painted steel and copper wire, 30.48 × 35.56 × 20.32 cm. Toledo Museum of Art, OH, Gift of John C. Waddell.

102. Richard S. Latham for Raymond Loewy. s-40A short-wave radio receiver, Hallicrafters, 1946. National Museum of American History (Department of Electronics and Modern Physics), Smithsonian Institution, Washington, DC (neg. 79-2904).

103. Richard S. Latham for Raymond Loewy. Coffee Service 2000, Rosenthal, 1954. Photo Rosenthal AG.

104. Brooks Stevens. Evinrude Lark outboard motors, 1959–62. Milwaukee Art Museum (Brooks Stevens Archive), MI.

105. Anonymous. Edsel automobile, Ford Motor Company, 1958. Advertisement from the *Saturday Evening Post*. The Advertising Archive, London. Courtesy Ford Motor Company, Dearborn, MI.

106. Dave Chapman. Electric knife, Hamilton Beach, c.1965. Photo International Housewares Association, Rosemont, IL.

107. Charles and Ray Eames. Multimedia presentation 'Glimpses of the USA', American National Exhibition, Moscow, 1959. Photo © 2004 Eames Office (www.eamesoffice.com).

108. Anonymous. Control panel for IBM 305 Random Access Memory Accounting Machine, 1956. Museum of Modern Art, New York (SC 13.58, Gift of the manufacturer).

109. Michael Graves. Plaza dressing table, Memphis, 1981. Height 244 cm. Christie's Images, London and New York. Courtesy Memphis.

110. Eliot F. Noyes. Selectric typewriter, IBM, 1961. Die-cast aluminium housing, length 38.7 cm. Photo the IBM Corporation, Armonk, NY.

111. Anonymous. Refrigerator-freezer, exterior and interior views, Philco-Ford Corp., c.1969.

112. Eugene Bordinat Jr. *et al.* Mustang automobile, Ford Motor Co., 1964. Photo Ford Motor Co., Dearborn, MI.

113. Milton Glaser. Poster distributed with *Bob Dylan's Greatest Hits*, Columbia Records, 1967. Photo Milton Glaser Inc.

114. Niels Diffrient *et al.* Chart showing variances in measurements of human females, from *Humanscale 1*, by N. Diffrient, A. R. Tilly, and J. C. Bardagjy (Cambridge, MA., 1974), 17, fig. 8c. The British Library, London (Cup. 900.y.20).

115. Sebastiano Matta. Cushion system of upholstered polyurethane foam, Gavina 1966. Photo Knoll International.

116. Anonymous. Precor 718e Low Impact Climber exercise machine, Precor Inc., c.1988. Photo Precor, Inc.

117. Bill Moggridge. GRiD 1100 Compass computer, Grid Systems Corp., 1982. Photo © Ideo.

118. Jack Telnack and 'Team Taurus'. Taurus station wagon, Ford Motor Co., 1986. Photo Ford Motor Co., Dearborn, MI.

119. MORSA. Loft Bed, c.1978. Photo by Dan Wynn reprinted courtesy of Joan Kron and Suzanne Slesin, co-authors of *High-Tech* © 1978.

120. Ettore Sottsass. Casablanca cabinet, Memphis, 1981. Photo Memphis.

121. Robert Venturi. Sheraton and Queen Anne chairs, Venturi Collection, Knoll International, 1984. Christie's Images, London and New York.

122. Wendy Maruyama. Highgirl dresser for the exhibition 'Material Evidence', Renwick Gallery, Smithsonian Institution, 1985. ColorCore, Baltic birch, plywood, lacquer. Photo courtesy Wendy Maruyama.

123. Michael Graves. Whistling Bird tea kettle, Alessi, 1985. Photo Alessi.

124. Michael Graves. Stainless steel tea kettle, Target Corp., 1999. Photo reprinted with permission by Target Corporation and Michael Graves.

125. William Lansing Plumb. QT-50 portable cassette recorder, Sharp Electronics Corp., 1985. Photo Sharp Corporation.

126. Philips CID (Corporate Industrial Design). Moving Sound series, Roller 2 portable cassette recorder, Royal Philips Electronics, 1986. Photo Royal Philips Electronics.

127. J. Mays. Volkswagen Concept 1 automobile, Volkswagen of America 1994. Courtesy Volkswagen of America. © 1993 Rodney Rascona.

128. Smart Design. Good Grips vegetable peeler, OXO International, 1989. Photo OXO International.

129. Lisa Krohn with Tucker Viemeister. Phonebook answering machine prototype, 1988. Cranbrook Art Museum, Bloomfield Hills, MI. Gift of Lisa Krohn (CAM 1994.76). © Lisa Krohn with Tucker Viemeister.

130. Anonymous. Kaypro II computer, Kaypro Computer Co., 1982.

131. Jerry Manock. Macintosh computer, Apple Computer Co., 1984. Photo courtesy Apple Computer, Inc.

132. Jonathan Ive. iMac computer, Apple Computer Co., 1998. Photo courtesy Apple Computer, Inc.

133. Rudy VanderLans. Poster for *Emigre* magazine, 1989. 'Non-Stop Design' poster. Photo courtesy Rudy VanderLans/Emigre.

134. April Greiman. Detail of poster for Greiman's lecture 'Snow White and the Seven Pixels', 1986. Photo courtesy April Greiman Made in Space.

The publisher and author apologize for any errors or omissions in the above list. If contacted they will be pleased to rectify these at the earliest opportunity.

Index

Twentieth-Century American Art
Erika Doss

Jackson Pollock, Georgia O'Keeffe, Andy Warhol, Julian Schnabel, and Laurie Anderson are just some of the major American artists of the twentieth century. From the 1893 Chicago World's Fair to the 2000 Whitney Biennial, a rapid succession of art movements and different styles reflected the extreme changes in American culture and society, as well as America's position within the international art world.

This exciting new look at twentieth-century American art explores the relationships between American art, museums, and audiences in the century that came to be called the 'American century'. Extending beyond New York, it covers the emergence of Feminist art in Los Angeles in the 1970s; the Black art movement; the expansion of galleries and art schools; and the highly political public controversies surrounding arts funding. All the key movements are fully discussed, including early American Modernism, the New Negro, Regionalism, Abstract Expressionism, Pop Art, and Neo-Expressionism.

151 illustrations with 91 in full colour
ISBN 0-19-284239-0

Fashion
Christopher Breward

This provocative new survey of the past 150 years of fashion covers everything from Haute Couture to the High Street, from Coco Chanel to Alexander McQueen. Christopher Breward explores fashion as a significant cultural force, examining the glamorous world of *Vogue* and advertising, the relationship between fashion and art, and fashion as a global enterprise.

Venturing beneath the surface, Breward considers how our ideas about hygiene and comfort have influenced the direction of style, and how important dress is in forming our identity and status—from Flapper to New Look, Dandy to Punk.

144 illustrations with 71 in full colour
ISBN 0-19-284030-4

'Christopher Breward is one of the most respected fashion scholars working today. This latest book provides an excellent introduction to the world of modern fashion'
Valerie Steele, chief curator and acting director, The Museum at the Fashion Institute of Technology, State University of New York

Twentieth-Century

ım

ventieth century are not those in
The Coca-Cola bottle and the
er the world, and designs such as the
1924, the 1954 streamlined and tail-finned
ble chair ubiquitous in the late 1960s, tell
narrowly defined canon of classics.

Drawing on the most up-to-date scholarship (not only in design history
but also in social anthropology and women's history), Jonathan M.
Woodham takes a fresh look at the wider issues of design and industrial
culture throughout Europe, Scandinavia, North America, and the Far East.
He explores themes such as national identity, the 'Americanization' of
ideology and business methods, the rise of the multi-nationals, Pop and
Postmodernism, and contemporary ideas of nostalgia and heritage. In the
history which emerges design is clearly seen for what it is: the powerful and
complex expression of aesthetic, social, economic, political, and
technological forces.

164 illustrations with 69 in full colour
ISBN 0-19-284204-8

'an excellent framework for understanding the development of design in
this century . . . destined to become the standard text in this field'
Professor Dennis Doordan, University of Notre Dame

Architecture in the
United States
Dell Upton

American architecture is astonishingly varied. From Indian sites in New Mexico and Arizona, and the ancient earthworks of the Mississippi Valley, to the most fashionable contemporary buildings of Chicago and New York, the United States boasts three thousand years of architectural history. It is characterized by the diversity of its builders and consumers who include Native American men and women, African, Asian, and European immigrants, as well as renowned professional architects and urban planners.

Dell Upton's revolutionizing interpretation examines American architecture in relation to five themes: community, nature, technology, money, and art. In giving particular attention to indigenous, folk, ethnic, and popular architectures like Chaco Canyon, Brooklyn Bridge, and Native American houses, in addition to the great monuments of traditional histories such as Jefferson's Monticello and Wright's Fallingwater, *Architecture in the United States* reveals the dazzling richness of America's human landscape.

144 illustrations with 56 in full colour, plus 50 line drawings
ISBN 0-19-284217-X

'the thematic structure and innovative historiographical method will fundamentally transform our understanding of American architecture and urbanism'
Professor Daniel Bluestone, University of Virginia